Art in Detail
100 MASTERPIECES

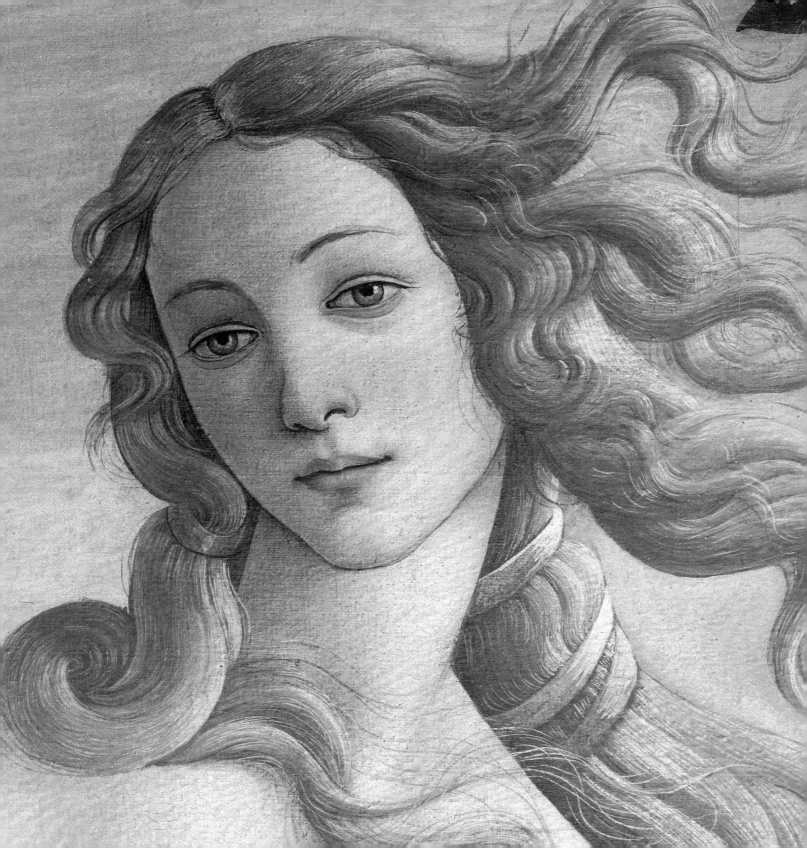

Art in Detail

100 MASTERPIECES

Thames & Hudson

SUSIE HODGE

Contents

Introduction

Imagine having some of the best works of art in the world in your hands so you can look at them in close up. Imagine also having a personal guide with you, pointing out details, telling you more about each work, giving you all kinds of information and insights, and so helping you to view each one with fresh eyes and greater understanding.

That is what this book sets out to do. Wonderful works of art are in galleries, museums, churches and other locations all over the world, and to see all the art you might wish to could take a lifetime. So this book brings images of one hundred of the finest works of art from across the globe together and places them into your hands, giving you the opportunity to study them in detail in your own time. Including paintings and sculptures, some of these one hundred works are world famous and some are less well known. Each was groundbreaking in some way, featuring elements – whether materials, subjects, methods or meanings – that had not been done before.

Underlying meaning and interpretation

Every work of art is investigated closely. Each work featured is considered in terms of details such as its underlying allegorical or symbolic meaning, technical skill, choice and handling of materials, use of perspective, autobiographical elements, depictions of space and light, inspiration and influences, who commissioned it, any alterations and adjustments, and the interpretation of contemporary events.

Looking at any work of art is a personal experience, but one that always benefits from a wider knowledge and awareness. The more you know and the closer you look, the more you will see and enjoy. This book is intended to help you to do all that, to act as your guide, drawing your attention to specific details and helping you to scrutinize and learn more about these acclaimed works of art. It is an accessible and stimulating examination of a wide spectrum of art, made by a comprehensive range of artists from the 14th to the 21st centuries, from various countries, produced for different purposes. Delving into each work's many layers, the book reveals in-depth information, from where was it made, when and who for, to why certain brushstrokes were used, why a reflection was placed at a strange angle and who is featured standing in the background.

Window on society

Combining close engagement of the works with an analytical overview, the book begins with art produced in the 14th century in Tuscany, when certain artists were starting to experiment with images beyond the iconographic traditions of Byzantine art. It continues chronologically through the centuries, investigating art produced in response to the Protestant Reformation, the Russian and French Revolutions, two world wars, civil wars and technological inventions, and ends with the 21st century, when people are saturated every day with visual media. Trying to make sense of it, artists have naturally always reflected and commented on contemporary culture, necessarily changing as they present their own societies in personal ways.

Never produced in a vacuum and rarely created in an impromptu moment of inspiration, art is conceived by artists with personal aims and intentions. Yet art is also shaped

"The question is not what you look at, but what you see."

–Henry David Thoreau (*Journal*, 5 August 1851)

by artists' situations, backgrounds, locations, materials and religions, and frequently by the artist's own irreverence. Art is often influenced by rules, tradition, convention, patronage or financial constraints. As a window on society, over time and place, such goals and intentions have varied widely. Art's function is constantly in a state of flux and what might be acceptable or welcomed in some instances, can be offensive or repugnant in others. Dramatic events unquestionably force attitudes to alter, but even seemingly negligible occurrences, such as the expansion of train travel or the rise of an art school have had similarly radical effects.

Key aspects identified

The one hundred works of art included in this book are exemplary creations by outstanding artists, and represent a broad overview of human expression, endeavour and the embodiment of key moments in history. The most important art movements are covered, such as Pop art, the Renaissance, Expressionism, Cubism, Mannerism, Impressionism, Post-Impressionism, Abstract Expressionism, De Stijl and Suprematism, and many of the greatest artists, are included, such as Sandro Botticelli, Andy Warhol, Masaccio, Rembrandt van Rijn, Wassily Kandinsky, Pablo Picasso, Diego Velázquez, Caravaggio, Paul Cézanne, Michelangelo and Edvard Munch.

Each work of art is unpicked and analysed so that its rich layering of purposes, intentions and methods are divulged. Each work is discussed over four pages. A brief biography of the artist, along with the work's historical and contextual background are introduced on the first pages, and often some comparisons are drawn with another work. On the next two pages, several key aspects of the artwork are identified and shown with numbered close-ups. Each close-up highlights and explores details that you may not have noticed or been aware of, such as a deliberate mistake, a pose copied from another artist, a new or particular way of depicting light or depth, certain colours used or a method of carving, a double meaning, an unexplained shadow or a symbolic reason for a seemingly commonplace element to be included.

These and many other factors disclose what the work is really about, the artist's thinking and how it was made. For instance, an environmental occurrence a decade before Munch produced his most famous work affected his approach; James Abbott McNeill Whistler's creation of a blend of substances he called his 'sauce' made his work completely different from others at the time; Michelangelo's insight into how we perceive things made him greatly distort one of his most admired sculptures; and a seemingly mundane object in one of Jan van Eyck's paintings represents both wealth and the Virgin Mary.

Tools to enable comprehension

This book casts new light that even those familiar with the works may have missed. All these details and considered analysis will enrich your enjoyment of the art featured in this book, but additionally, they will give you accessible tools with which to view and make links with other works of art. After reading these pages, you will have a better idea about what to look for, how to find out more and how to gain more pleasure when viewing any work of art from any time and in any location, making this a book you will want to return to again and again.

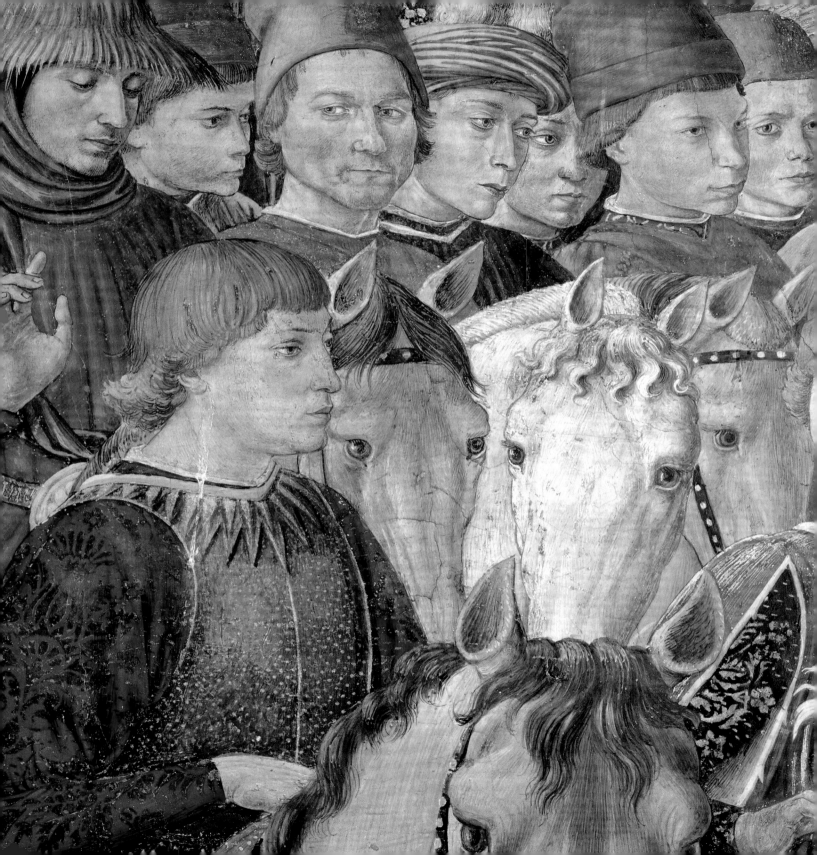

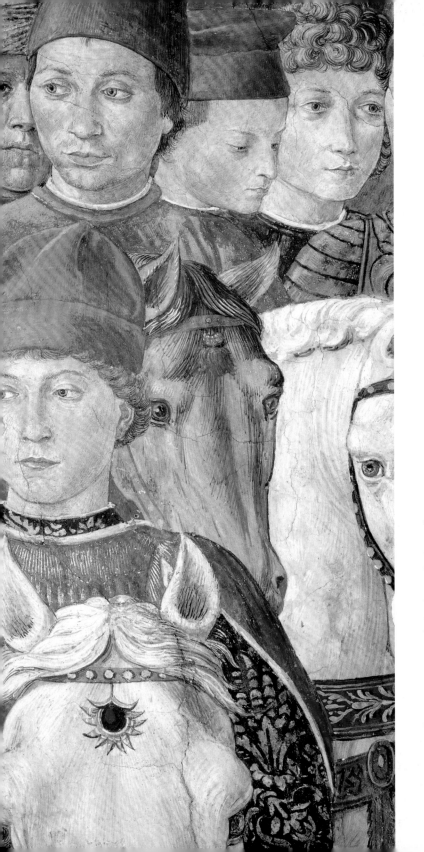

PRE–1500

DURING THE MEDIEVAL PERIOD spanning the 5th to 16th centuries, the greatest influence on European art was religion. The Church commissioned the majority of art and, usually, monks produced it. Illuminated manuscripts, wall paintings and carvings were characterized by the flat, decorative style of the Byzantine Empire. From 1150 to *c*. 1499, what became known as Gothic art flourished. Originally a term of contempt, the word 'Gothic' describes the elaborate architectural styles, ornate altarpieces, embellished paintings, sculpture, stained glass, illuminated manuscripts and tapestries that focused on Christian beliefs. Apprentices trained with master artists and learnt to follow accepted approaches. Then, as humanist ideas began to spread, some artists started creating more realistic art, looking to ancient Greece and Rome. Centuries later, this rebirth of interest in art, science, architecture, literature, music and invention became known as the Renaissance.

THE ADORATION OF THE MAGI

GIOTTO DI BONDONE

c. 1303–05

fresco
200 x 185 cm (78 ¾ x 72 ¾ in.)
Cappella degli Scrovegni, Padua, Italy

GIOTTO DI BONDONE (*c.* 1270–1377) is one of the key figures of art history. He worked during the period described as Gothic or Pre-Renaissance and was the first artist since Roman times to create naturalistic depictions of the world around him. Not much is known about his life. He was born either near or in Florence, and while few works have been ascribed to him definitively, it is known that he had a large, well-organized workshop and became the most celebrated artist of his day, changing traditions of flat-looking, stylized painting to portrayals that are more lifelike.

Working around Italy and hiring assistants wherever he went, Giotto's ideas spread quickly. Many of his illustrious contemporaries, including the writers Dante Alighieri, Petrarch, Giovanni Boccaccio and Franco Sacchetti, promoted his achievements. For instance, in the *Divine Comedy* (*c.* 1308–20), Dante wrote: 'Once Cimabue believed that he held the field in painting, and now Giotto has the cry, so the fame of the former is obscure.' The banker and chronicler Giovanni Villani wrote that he was: 'The most sovereign master of painting in his time, who drew all his figures and their postures according to nature.' In his book *Lives of the Most Excellent Painters, Sculptors and Architects* of 1550, Giorgio Vasari wrote that Giotto broke with the prevalent Byzantine style, initiating: 'The great art of painting as we know it today, introducing the technique of drawing accurately from life, which had been neglected for more than 200 years.'

This is one of twenty-two frescoes in the Cappella degli Scrovegni, or Arena Chapel, built for the Paduan moneylender Enrico Scrovegni, each illustrating an episode from the life of Christ. This shows the Magi paying homage to the newborn Saviour. In the Bible, the Magi are described as coming 'from the east' looking for a child whose star they saw rising. After King Herod duplicitously asks them where the child is, the Magi follow the star to Bethlehem. Warned in a dream not to go back to Herod, they return home by a different route. As devout Christians, contemporary Italians perceived art as an extension of their religion. Giotto's animated paintings helped them to understand and empathize with Bible stories.

The Adoration of the Magi, Lorenzo Monaco, 1420–22, tempera on panel, 115 x 183 cm (45 x 72 in.), Uffizi, Florence, Italy

Lorenzo Monaco (*c.* 1370–1425) painted this expressive work more than one hundred years after Giotto painted the Arena Chapel. It is not clear who commissioned it, but Giotto's legacy of colour, sense of depth, gesture and expression are evident. Mary is depicted according to convention in a blue garment with three stars symbolizing her virginity (one on the forehead and one on each shoulder, although here the Christ Child hides one on her left shoulder). She sits on a stone, showing the baby to the crowd. Joseph sits nearby, in a gold robe, looking up at them. Dominating the scene is the procession of the Magi; they are represented as three men of different ages and nationalities.

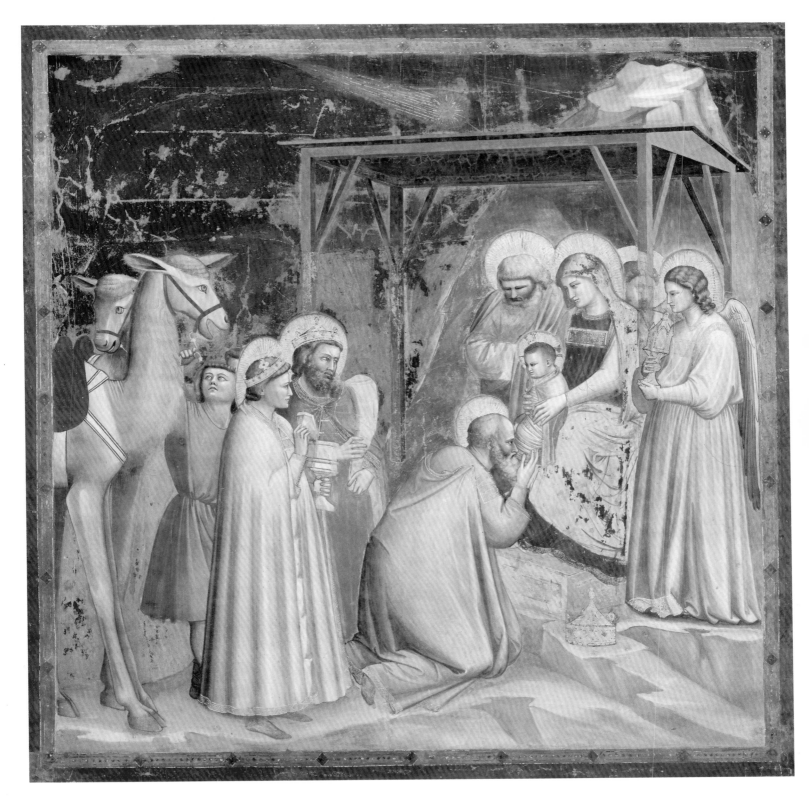

IN DETAIL

② GASPAR

In portraying the Magi with varying ages, Giotto represented the milestones of life. Gaspar, the eldest here, kneels at Christ's feet as his mother holds him up. With a respectful gesture, Gaspar has removed his crown and placed it on the ground as he bends forward to kiss the swaddled feet. Haloes radiate their divine inner light but the holy figures are depicted in a naturalistic manner.

① THE MAGI

The Bible does not call the Magi kings, but in Giotto's time, they were perceived as such. Giotto adheres to medieval tradition, with them paying homage to a baby. The New Testament does not give them names, but Christian custom calls them Gaspar, or Caspar, often described as Indian; Melchior, as Persian; and Balthasar, or Balthazar, as Arabian. Here, Melchior and Balthasar wait to kneel before the child, holding their gifts of frankincense and myrrh. Emotions and thoughts are revealed through understated hand gestures and facial expressions.

③ THE STAR

Giotto's portrayal of the Star of Bethlehem is another attempt at authenticity and naturalism. In 1301, two years before he began the work, Halley's Comet appeared. His depiction of the star is his recollection of the comet with its fiery tail streaking across the sky. Incorporating a portrayal of a real event underlines how Giotto's paintings are based on personal experience.

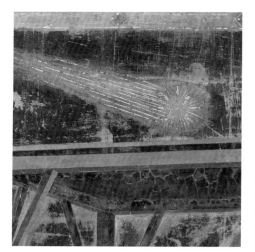

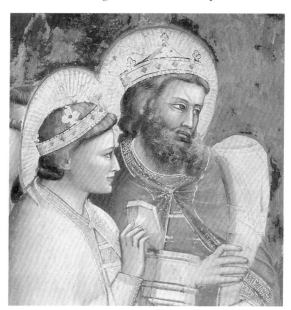

④ GROOM AND CAMELS

Most aspects of Giotto's imagery were drawn from life. For instance, the groom is a naturalistic boy with an earnest face. However, the camel has bright blue eyes, so it is clear that Giotto had never seen a camel, and used blue to add a sense of theatrical wonder. The Bible does not suggest that the Magi rode camels, but they add to the exoticism of the imagery.

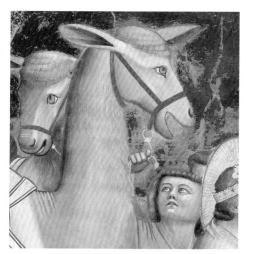

Giotto's breakthrough approach created a rational sense of space, integrating figures within their surroundings and suggesting interaction through gesture and expression.

 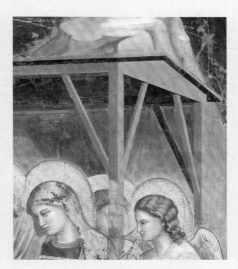

⑤ DRAPERY

The suggestion of draping cloth, individual expressions and tonal contrasts are all Giotto's ideas, whose only precedents were seen in ancient Greek and Roman art. His fabrics appear to fold and crease through gradating tonal contrasts. The figures' garments hang naturally in angular folds, suggesting form and weight.

⑥ SPATIAL ARRANGEMENT

Giotto made great advances in the representation of three dimensions on flat surfaces. The stable (or canopy) where the Holy Family sits is viewed from below, allowing him to depict its structure. The angel and the members of the Holy Family overlap, indicating depth. This also helps unite the groups of figures with each other.

⑦ LAPIS LAZULI

Due to its expense, lapis lazuli was only used for *fresco secco*, or painting onto dry plaster, rather than *buon fresco* or true fresco, which was painting on wet plaster, so pigments became integral to the wall. Instead, Giotto mixed the rich blue pigment with egg to form tempera and painted it onto dry plaster, which reduced its longevity.

The Adoration of the Magi, artist unknown, c. 526, mosaic, the Basilica of Sant'Apollinare Nuovo, Ravenna, Italy

Built during the early 6th century, this basilica became known for its glittering mosaics depicting Christian stories. Vividly coloured glass cubes depict the Adoration of the Magi, demonstrating ideas that subsequently became forgotten until Giotto resurrected them, including overlapping figures to suggest three dimensions, details of clothing, shading to imply folds and drapery, and facial expressions to suggest realism. The Magi are named here and are also of three different generations. In fact, the Bible does not specify how many Magi there were. In Eastern Christianity they often number twelve; Western Christianity numbers them at three.

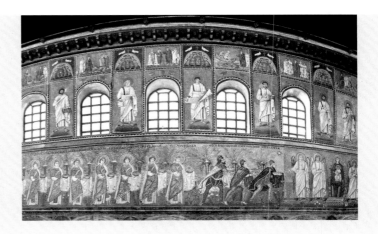

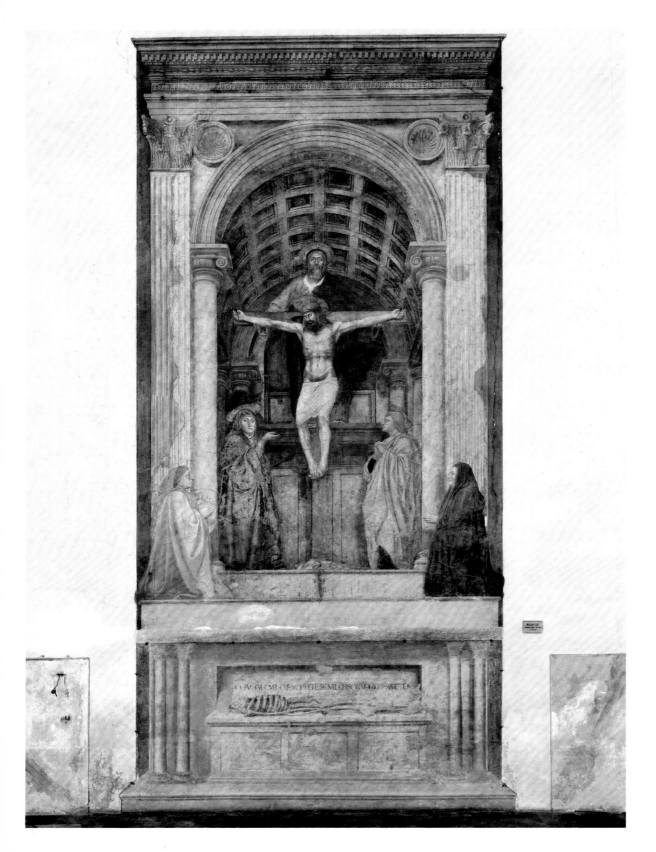

THE HOLY TRINITY WITH THE VIRGIN AND ST JOHN AND DONORS

MASACCIO

c. 1425–26

fresco
667 x 317 cm (262 ½ x 124 ¾ in.)
Santa Maria Novella, Florence, Italy

BORN TOMMASO DI SER Giovanni di Simone, Masaccio (1401–28) was the first great painter of the early Italian Renaissance – a period often referred to as the Quattrocento. His nickname, which means 'Big' or 'Clumsy' Tom, distinguished him from Tommaso di Cristoforo Fini with whom he often collaborated, whose nickname was Masolino da Panicale – or 'Little' Tom.

Despite his brief, seven-year career, Masaccio was profoundly influential in the development of art. One of the earliest Renaissance artists to use linear perspective in painting, he made flat surfaces appear uncannily three-dimensional. He also moved away from the elaborate, fashionable International Gothic style, to a plainer, more naturalistic approach.

Perceived as Masaccio's greatest masterpiece, *The Holy Trinity* was one of his last major commissions. It is a magnificent architectural creation and the first painting known to feature correctly constructed one-point perspective, a technique that allows artists to depict three-dimensional depth on flat surfaces. First practised by the designer, architect and engineer Filippo Brunelleschi in the year before this was painted, the technique of linear perspective was developed further by Masaccio here. Two themes are incorporated: one is the portrayal of the Catholic Holy Trinity – Christ on the cross, the Holy Father above him and the Holy Spirit in the form of a white dove, all below a classical triumphal arch. The second theme is the intercession of the saints. Catholics traditionally pray to saints to intercede for them to God. Here this is shown in the presence of the Virgin Mary and John the Evangelist on either side of the cross. Mary gestures with her hand towards her crucified son, the only movement in the painting. She can be identified with as a mother, but she is also the mother of God, so she represents a link between the spiritual and the earthly. In front of the pillars are life-sized portraits of the two (unidentified) donors. The work was influential for generations of Florentine artists, but in 1570, a stone altar was built in the church, which covered it up. It remained hidden until 1861, when the altar was removed during restoration works and the painting was revealed.

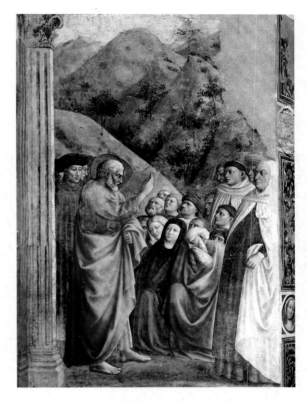

St Peter Preaching, **Masolino da Panicale, 1426–27, fresco, 255 x 162 cm (100 x 63 ¾ in.), Brancacci Chapel, Florence, Italy**

Part of the Church of Santa Maria del Carmine, the Brancacci Chapel is named after the family who commissioned Masaccio and Masolino da Panicale (*c.* 1383–1440) to produce a cycle of frescoes on the life of St Peter on its walls. Masolino's paintings reflect the prevalent approach of elegant figures, dignified poses and subdued facial expressions, contrasting with Masaccio's dramatic bravura, knowledge of perspective and figures that express emotions.

THE DONORS

Little is known about the commission or the altarpiece's patrons. The two donors featured in the work have not been positively identified. They were almost certainly locals. It is probable that they were from one of two Florentine families, either the Lenzi or the Berti. The Berti family was from the Santa Maria Novella quarter and owned a tomb at the foot of Masaccio's fresco, while the Lenzi family had a tomb near the altar.

3 MEMENTO MORI

Beneath the main scene is a skeleton lying in a tomb with the inscription: '*Io fui gia quel che voi siete e quel ch'io sono voi anco sarete*' (I once was what you are now and what I am, you shall yet be). It is a memento mori and a reference to Adam, whose sin brought death to humans, and a reminder to viewers that their time on earth is transitory. It is only through faith that one overcomes earthly death.

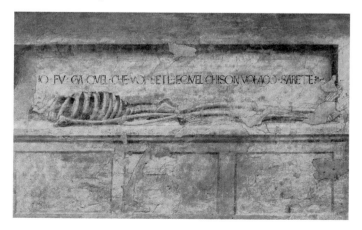

1 CLASSICAL ROME

The whole image creates a *trompe l'oeil* effect. Framed by Ionic columns, Corinthian pilasters and a barrel-vault ceiling, this is a triumphal arch inspired by classical Roman buildings, as Masaccio refers to Christ's triumph over death through his Crucifixion and Resurrection. Triumphal arches are usually barrel-vaulted structures, often decorated with carvings, sculpted reliefs and inscriptions commemorating victories.

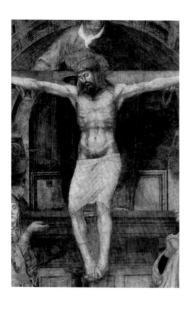

4 EARLY HUMANISM

The figure of Christ is a realistic-looking body, not a symbol. This is typical of the new beliefs in humanism, and one of the ways in which Renaissance artists combined faith and science. God's left foot is visible behind Christ's left knee. The fact that God is standing and supporting his son physically, as a mortal father might, is original. Masaccio has not depicted him as a wondrous celestial being, but as a man.

Doni Tondo, **Michelangelo, *c.* 1507, oil and tempera on panel, 120 cm (47 ¼ in.) diameter, Uffizi, Florence, Italy**

In a circular format that became popular during the Renaissance, Michelangelo has depicted the Holy Family with John the Baptist and nude male figures in the background. It is not clear what they are doing in the painting. Michelangelo was profoundly influenced by Masaccio, and particularly by Masaccio's methods of showing drama, pathos and emotion in religious scenes.

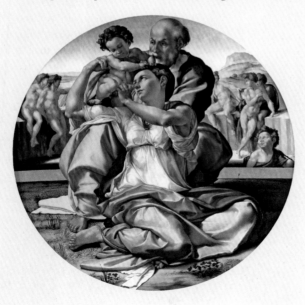

Masaccio was one of the first artists to use linear perspective in his painting. He also moved away from the elaborate International Gothic style, to create more credible and naturalistic appearances. His use of perspective and chiaroscuro stunned onlookers when his paintings were revealed as they seemed so lifelike.

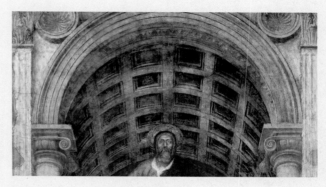

5 OPTICAL PERSPECTIVE

When it was first unveiled, the painting's effect on contemporary viewers was dramatic. Many believed that Masaccio had cut a hole into the wall of the church and created another chapel beyond. Painting from a low viewpoint, he makes viewers look up at Christ and the ceiling with its converging perspective lines, or orthogonals.

6 INITIAL DRAWING

Masaccio first produced a rough drawing on the wall of the composition with precise perspective lines. The drawing was then covered with fresh plaster. To ensure the accuracy of his final perspective lines, he followed his sketch beneath the plaster by inserting a nail in the vanishing point and attaching strings to it, which he pressed into the plaster.

THE ARNOLFINI PORTRAIT

JAN VAN EYCK

1434

oil on oak panel
82 x 60 cm (32 ⅜ x 23 ⅝ in.)
National Gallery, London, UK

THE EARLY LIFE OF Jan van Eyck (*c.* 1390–1441) is a mystery. It is thought he was born in Maaseik in present-day Belgium. He first worked with his elder brother, the painter Hubert van Eyck (1370–1426), but after Hubert's death, he was hired by the Duke of Burgundy, Philip the Good, the most powerful ruler and patron of arts in the region. He worked for the duke in Bruges and Lille as a court artist and equerry. The duke gave him an annual salary – a remarkable indicator of Van Eyck's status. He remained in the duke's service for the rest of his life and died in Bruges.

An intelligent, educated and travelled man, who also undertook many diplomatic missions, Van Eyck's artistic output was small; he only undertook religious commissions and portraits such as this one. Only some twenty-three paintings are considered to be solely by him, but his influence was enormous. His meticulous work was greatly studied and copied, particularly his revolutionary handling of oil paint, which he made by mixing pigment with linseed oil.

This is a double portrait of Giovanni di Nicolao Arnolfini and probably his wife, Costanza Trenta, although she died in 1433 before the work was completed. Arnolfini was a member of a prosperous merchant family from Lucca living in Bruges, who combined trade with finance, and were among the first merchant bankers. The couple were married in 1426. The picture does not depict Costanza as pregnant, as is often suggested, but holding up her full-skirted dress in the contemporary fashion. However, scholars continue to debate the painting's significance. The couple are in an upstairs room during early summer, indicated by the fruit on the cherry tree outside the window. The room probably functioned as a reception room, because in Burgundy, beds were used as seating. The couple came from successful mercantile families and theirs was a commercial union, too. Their wealth is displayed openly: their clothes are of fine quality and the room displays many valuable material possessions, including the mirror, the Anatolian rug on the floor, the large brass chandelier, elaborate bed-hangings and the carvings on the chair and bench.

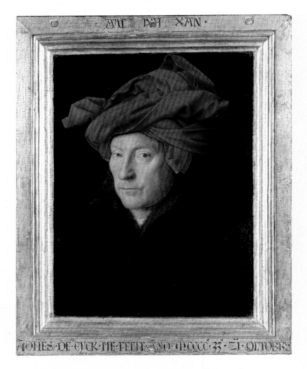

Portrait of a Man, **Jan van Eyck, 1433, oil on oak panel, 26 x 19 cm (10 ¼ x 7 ½ in.), National Gallery, London, UK**

Believed to be a self-portrait of Van Eyck, on the frame is an inscription that is a pun on his name: '*Als Ich Can*' (I/Eyck can). The bottom inscription, in Latin, gives his name and the date: 'Jan van Eyck made me on 21 October 1433'. The letters are painted to look as though they have been carved. Portraits and evidence of wealth were fashionable in the 15th century in northern Europe, as it saw the rise of capitalism and a burgeoning middle class, which affected the themes, styles and subjects of art. Some of the most active artistic centres developed in the area. Portraits became especially popular.

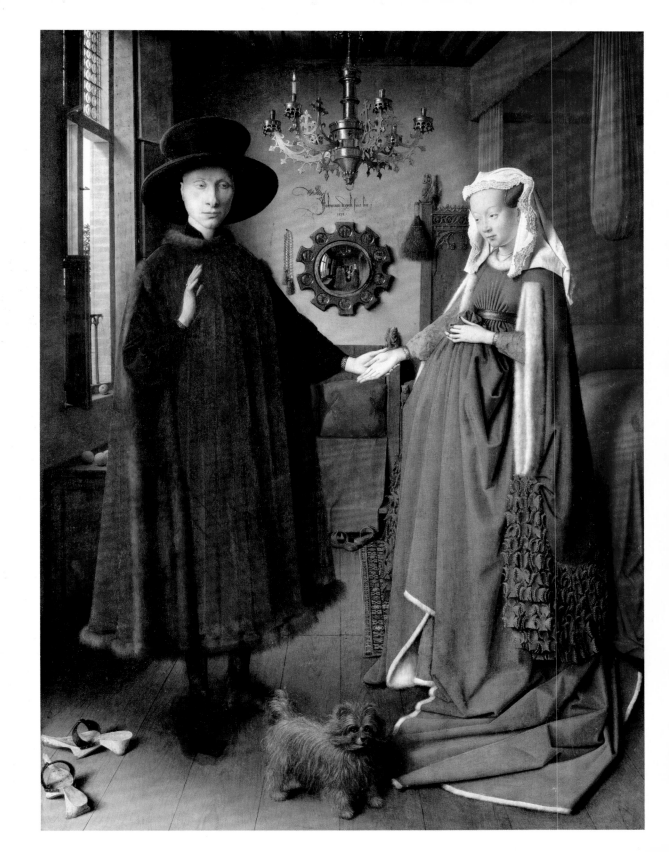

IN DETAIL

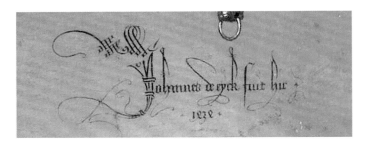

② SIGNATURE

Above the mirror is the ornate Latin signature: '*Johannes van Eyck fuit hic 1434*', which translates as 'Jan van Eyck was here 1434'. It confirms Van Eyck's presence and is one of the characteristically witty ways he signed his work. The flourish lies above the part of the painting he used to show his skill in rendering detail.

③ SIGNS OF WEALTH

Lying on a side table are some oranges imported from the south. Oranges were a scarce delicacy in northern Europe, and so display wealth. The fruit and its blossom were also symbols of love, marriage and fertility.

④ SYMBOLS OF FERTILITY

Giovanni and Costanza had no recorded children, but the green of her dress implies hope and fertility, while the red-covered bed was associated with birthing chambers. This may imply that she died in childbirth. The figure carved on the chair is St Margaret, the patron saint of pregnant women and childbirth.

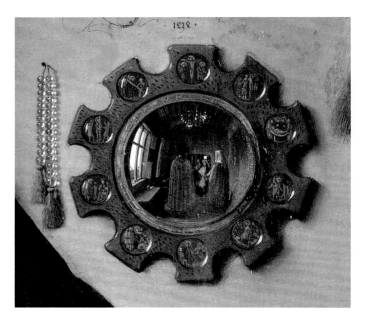

① THE MIRROR

Only the wealthy could afford mirrors and this reflects two figures in the doorway. One is probably Van Eyck himself. Arnolfini raises his right hand as he faces them, perhaps in greeting. The circular, slightly convex surface was the only shape available for glass mirrors. The medallions in the wooden frame depict scenes from the Passion of Christ and represent God's promise of salvation. A spotless mirror was a symbol of Mary, referring to her Immaculate Conception and purity. The string of amber beads by the mirror is a paternoster – a form of rosary.

⑤ COSTLY CLOTHES

Flanders was the centre of a great trading empire and Van Eyck depicts some of its merchandise, including fur, silk, wool, linen, leather and gold. Costanza's heavy gown is lined with squirrel fur. The husband's tabard is lined with pine marten. Although the colours have faded, the fur was dyed in a plum colour; another statement of wealth, because dark dyes were more expensive to produce than lighter colours. Beneath his tabard, Arnolfini wears a silk damask doublet. Costanza's blue underdress is trimmed with white fur. Her frilled white headdress shows that they are married: unmarried women wore their hair loose. Their modest jewelry befitted their merchant status, even though their garments were extravagant. The Oriental rug was a rare commodity in 15th-century northern Europe.

Van Eyck painted with precision and confidence. His handling of oil paint was masterful and he used varied techniques, including wet–in–wet and dry brush in order to portray numerous textures and effects of light. He has been called the first genre painter.

⑥ TRANSLUCENT GLAZES

Van Eyck applied layers of thin, translucent glazes to build intensity of both tone and colour, to create credible realism. Painting wet-in-wet, he achieved subtle variations in light and shade to heighten the illusion of three-dimensional forms and to capture textures, which were remarkable and revolutionary for the time.

⑦ EFFECT OF LIGHT

Van Eyck was one of the first painters to use oil paint rather than tempera. It allowed him to depict light with subtlety and detail, such as on the gleaming brass chandelier, mirror and Costanza's headdress. He enhanced the painting's realism by portraying direct and diffuse light from the window reflected by various surfaces.

⑧ SYMBOLS

One of Van Eyck's techniques was the incorporation of symbols that viewers could hunt for, enabling them to read his paintings. This work is full of such symbols, including Arnolfini's expensive sandals pointing to the outside world, implying his career; and his wife's pointing inwardly, suggesting the woman's role of caring for the home and family.

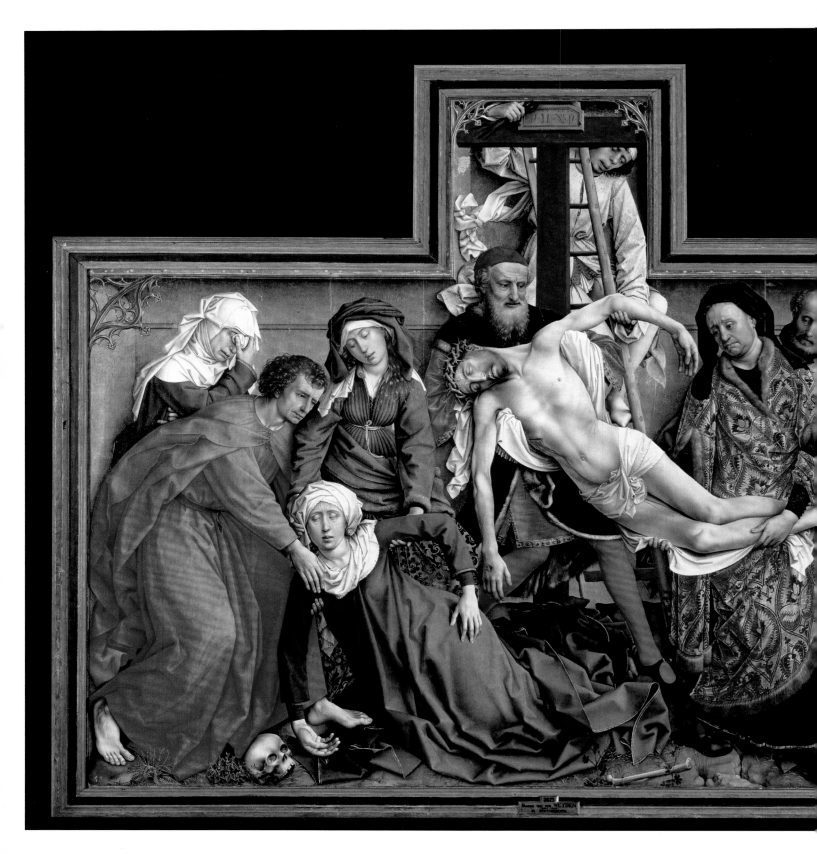

DESCENT FROM THE CROSS

ROGIER VAN DER WEYDEN

c. 1435–38

oil on oak panel
220 x 262 cm (86 ⅝ x 103 ⅛ in.)
Museo Nacional del Prado, Madrid, Spain

THE MOST INFLUENTIAL ARTIST of the mid 15th century, Rogier van der Weyden (*c.* 1399–1464) became internationally famous during his lifetime. Born in Tournai in Belgium, he apprenticed to Robert Campin (*c.* 1375–1444) from 1427 to 1432. Three years later he was made painter to the city of Brussels; following this, he was commissioned by Philip the Good of Burgundy and, while working in Italy, by the powerful Estes and Medici families. Drawing from life, his renditions of humans are expressive and lifelike, yet he also heightened colours and idealized features to inspire greater empathy. Unfortunately, he did not sign his work, so many of his paintings cannot be conclusively verified. His art had a profound effect on European painting, but he was almost completely forgotten by the mid 18th century. Nonetheless, his reputation gradually recovered and today he is considered one of the greatest Early Flemish artists.

This is the central panel of a triptych. The two side panels have been lost. It shows a medieval interpretation of the Deposition. Ten figures occupy a shallow space with Christ's corpse as the central focus. According to the Bible, Joseph of Arimathea donated his own prepared tomb for Christ's burial.

Portrait of a Lady, **Rogier van der Weyden, *c.* 1460, oil on oak panel, 34 x 25.5 cm (13 ⅜ x 10 in.), National Gallery of Art, Washington, DC, USA**

Recognized for his realism, sense of tension and expressive pathos, Van der Weyden followed the northern approach of painting precise, vivid details. The subject's lowered eyes suggest a respectably demure young woman, while her slender figure, with narrow shoulders and high forehead shows some idealization as Van der Weyden flattered his sitter.

IN DETAIL

② THE VIRGIN

The 'Swoon of the Virgin' developed from an apocryphal gospel, the *Acts of Pilate* (*c.* 350). The idea became popular in later medieval art and some literature, but as it was not mentioned in the Canonical Gospels, it later became controversial. Here, the curve of Mary's unconscious body mirrors that of her son's corpse.

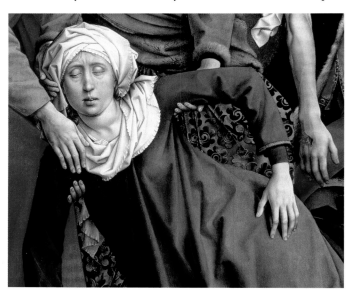

③ CROSSBOWS

Commissioned by the Crossbowmen's Guild in Leuven, the panel features tiny crossbows in the painted tracery, and also evokes the crossbow's shape in the poses of Jesus and his mother. The tracery marks the boundary between the realm of the sacred figures and the viewers' own, earthly world.

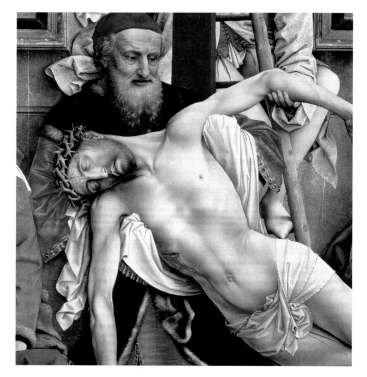

① JESUS

The almost life-sized figures are linked – some echo each other's poses, some touch or help each other and some have particular biblical connections. Christ's pale body stretches diagonally across the image. The bearded Joseph of Arimathea supports his corpse under his arms, while a servant holds his arm at the elbow. Crisp folds and delicate tonal contrasts create a sense of depth and form, even though this appears to be against a flat gold background.

4 CONTRIVANCES

To conceal the points at which the cross and the ladder meet the landscape, Van der Weyden lengthened the Virgin's left leg so that this and her mantle hide the base of the cross and one upright of the ladder. The pose of Nicodemus the Pharisee is distorted so that his right foot and the furred hem of his brocade robe partially conceal the other upright of the ladder.

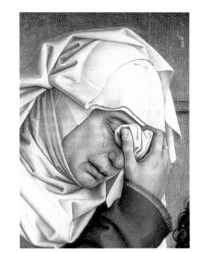

6 MARY OF CLOPAS

With tears streaming down her face, the female disciple Mary of Clopas or Cleophas (half-sister to the Virgin Mary) expresses her inconsolable feelings of sorrow. With incredible attention to detail, Van der Weyden uses applications of tone and colour to depict the folds in her habit and minutiae including the pin, individual tears and creases around her eyes.

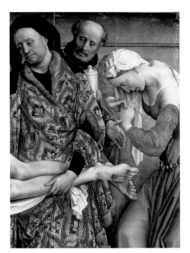

5 THREE FIGURES

In the Gospel of John, Nicodemus helps Joseph of Arimathea prepare Christ's body for burial. Here, a crying Nicodemus helps him to carry the body down from the cross, clad in a sumptuous costume. The bearded man behind him holds a jar containing the ointment that Mary Magdalene used to anoint Christ's feet. Her low-necked dress reminds viewers of her previous life.

7 SYMBOLIC COLOUR

Red appears as accents throughout the painting, symbolically representing Christ's blood and carrying viewers' eyes around the picture. Greens are made of mixtures of lead-tin yellow and indigo, often blended with touches of white. White, the colour of purity and innocence, recurs across the composition to create a balanced placement of colours.

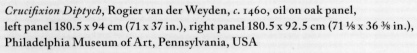

Crucifixion Diptych, **Rogier van der Weyden, _c._ 1460, oil on oak panel, left panel 180.5 x 94 cm (71 x 37 in.), right panel 180.5 x 92.5 cm (71 ⅛ x 36 ⅜ in.), Philadelphia Museum of Art, Pennsylvania, USA**

This painting shows Van der Weyden's continued technical skill and ability to create an impact. Not much is known about the work, but it is possible that the two panels formed the outer wings of a carved altarpiece. Once again, Van der Weyden shows Mary's swoon and a skull at the base of the cross. Christ's Crucifixion took place at Golgotha, 'the place of a skull'. According to an ancient Eastern tradition, Adam was buried there and on his grave his son, Seth, planted a tree, which was later used to make Christ's cross. From the late 10th century, many Western artists painted Adam's skull at the foot of Christ's cross to remind viewers that Adam was cast out of Paradise after eating the forbidden fruit, but Christ sacrificed himself on the cross to redeem the world from that original sin.

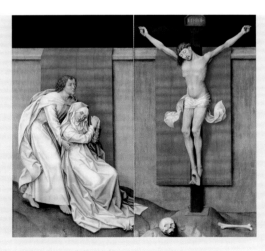

THE BATTLE OF SAN ROMANO

PAOLO UCCELLO

c. 1438–40

THE EARLY FLORENTINE PAINTER Paolo Uccello
(*c.* 1396–1475) was born Paolo di Dono, but nicknamed after
his love of animals and birds – *uccello* is Italian for bird. After
serving an apprenticeship with the sculptor Lorenzo Ghiberti
(*c.* 1378–1455) from *c.* 1407 to 1414, he began painting, showing
a fascination for the new methods of linear perspective. From
1425 to 1430, he designed mosaics in Venice for the Basilica di
San Marco and soon attracted many painting commissions.

Depicting the first part of the battle fought between
Florence and Siena in 1432, this painting's full title is *Niccolò
Mauruzi da Tolentino at the Battle of San Romano*. Three panels
celebrating the battle of San Romano were commissioned by
the wealthy Lionardo Bartolini Salimbeni, but Lorenzo de'
Medici so coveted them that he had them taken and installed
in his newly built Medici palace. In 1495, Lionardo's brother,
Damiano Bartolini Salimbeni, claimed that he and his brother
jointly owned the three panels. Lionardo had been persuaded
to give Lorenzo his share of the paintings, but Damiano had
refused, yet they had been forcibly removed from his house.
The paintings were never returned.

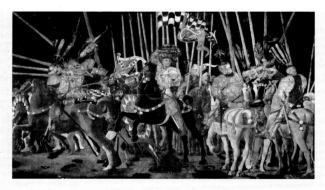

*The Counterattack of Micheletto da Cotignola at the Battle of
San Romano*, Paolo Uccello, *c.* 1435–40, tempera on poplar,
182 x 317 cm (71 ¾ x 124 ¾ in.), Louvre, Paris, France

This is another panel of Uccello's triptych. It shows the
retaliation of Florence's ally Micheletto da Cotignola.
The tapestrylike depiction is deliberate because at the time,
tapestries were considered to be superior to paintings.

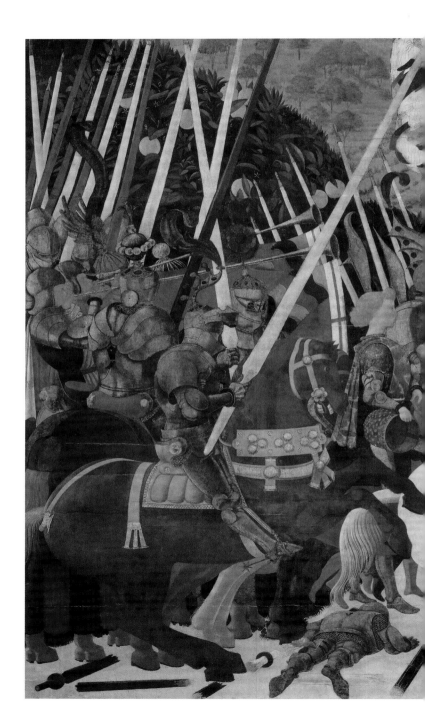

tempera with walnut and linseed oil on poplar
182 x 320 cm (71 ¾ x 126 in.)
National Gallery, London, UK

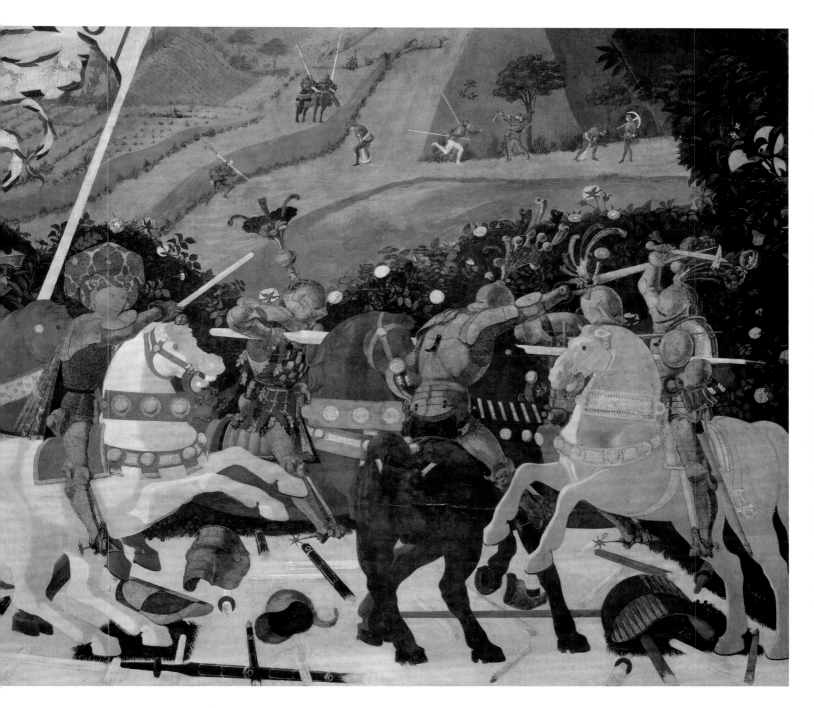

② LANCE PATTERNS

The criss-cross pattern of the lances against the dark green leaves and luminous oranges form a decorative backdrop. The three panels were designed to be hung above eye level with the bottom edges roughly 2 metres (7 feet) from the ground. In this position, the diagonal lines created by the lances and Da Tolentino's rearing horse lead viewers' eyes upward and add dramatic impact.

③ FORESHORTENING

Most of the action is concentrated in the foreground, although there is little evidence of human suffering. This soldier is probably the first example of a foreshortened human figure in a painting. Uccello placed him on an orthogonal, or line of perspective. With no blood in evidence, there is a large hole in the back of his armour where he has been run through with a lance.

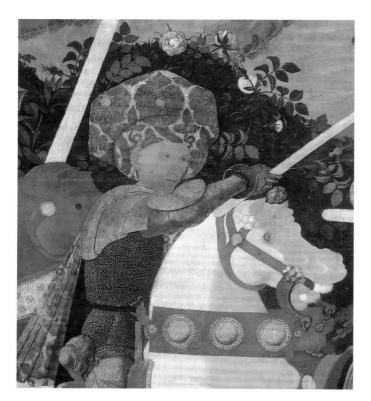

① THE COMMANDER

The Florentine commander, Niccolò Mauruzi da Tolentino, is the central figure on the white charger. Early on in the battle, he had been surprised by Sienese troops, and with barely twenty horsemen, he held off a larger force for eight hours before reinforcements arrived. His red and gold headdress, and his raising of his baton of command, draw the eye into the centre of the image. Such impractical headgear would never have been worn in battle, but it distinguishes the hero.

④ SERVANT

Behind Da Tolentino is his squire, a boy with golden curls, reminiscent of an angel. Over time, Uccello's careful tonal contrasts have faded, but they originally gave the painting a three-dimensional quality.

⑤ EMBOSSED GOLD

The gold decorations on the harnesses are embossed – round and raised – on the surface of the painting. Renaissance warfare was conducted with ostentation and ceremony. By highlighting the pageantry, he endows the scene with the atmosphere of a jousting tournament.

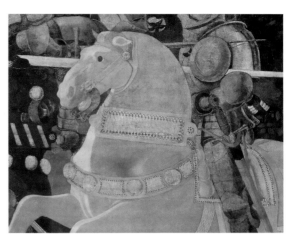

⑥ HORSES

Uccello's figures in action appear realistic, but his horses are stiff and unnatural-looking. Prior to the photographic studies of motion by Eadweard Muybridge in the 19th century, most people were unaware of how animals move. Uccello paints the horses moving with their two front legs rising and two back legs on the ground.

⑦ BACKGROUND

The fight continues in the background, with little foot soldiers reloading their crossbows and generally taking action. Medieval artists found it difficult to paint middle ground.

⑧ SOLOMON'S KNOT

Da Tolentino charged into battle with his insignia emblazoned on his flag. The Knot of Solomon is a flowing, twisted symbol, carried by his standard bearer. Uccello's careful depiction of armour, heraldic banners, crests and fashionable fabrics appealed to Florentine pride.

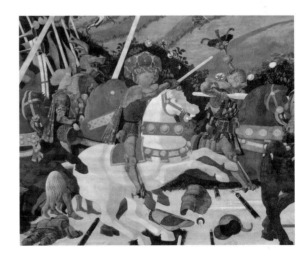

⑨ VANISHING POINT

If one were to use a ruler to draw lines along all the orthogonals – receding lines – made easy in this painting through the positions of the lances and bits of armour on the ground, they would meet at Da Tolentino's white steed's chin. This meeting at a single vanishing point in the painting helps viewers to understand the picture.

THE ANNUNCIATION

FRA ANGELICO

c. 1438–45

fresco
230 × 321 cm (90 ½ x 126 ¼ in.)
Museo del Convento di San Marco, Florence, Italy

FRA ANGELICO (*c.* 1387–1455) is most celebrated for his series of frescoes in the Convento di San Marco – a religious complex with a church and monastery that now houses a museum – in Florence. Born Guido di Pietro, he became a Dominican friar and was known for most of his life as Fra Giovanni, but was posthumously called Fra Angelico – 'the Angelic Brother' – after his saintly reputation. Initially training as a manuscript illuminator, he became one of the most important artists in Florence and Rome. His work was admired for its brilliant colouring, dignified figures, mathematical treatment of linear perspective, and rational depiction of space, light and shadow. He blended the Gothic style with progressive Early Renaissance ideas. Fra Angelico was influenced by the sculptors Ghiberti and Donatello (1386–1466), as well as Brunelleschi and Masaccio.

The Annunciation is the moment in the Bible when the Archangel Gabriel appears to the Virgin Mary and announces that she will give birth to a son by miraculous means. The story was frequently portrayed during the Renaissance and Fra Angelico painted several versions. This painting is at the top of the stairs on the first floor of San Marco. It is intended to be viewed under low light and was created for contemplation.

Convento di San Marco, Florence, Italy

In 1437, Cosimo de' Medici commissioned the architect and sculptor Michelozzo to rebuild a monastery that had been occupied by Benedictine monks since the 12th century, but was being used as a Dominican monastery. In 1439, Cosimo commissioned Fra Angelico to decorate the interior, including the altarpiece and corridors.

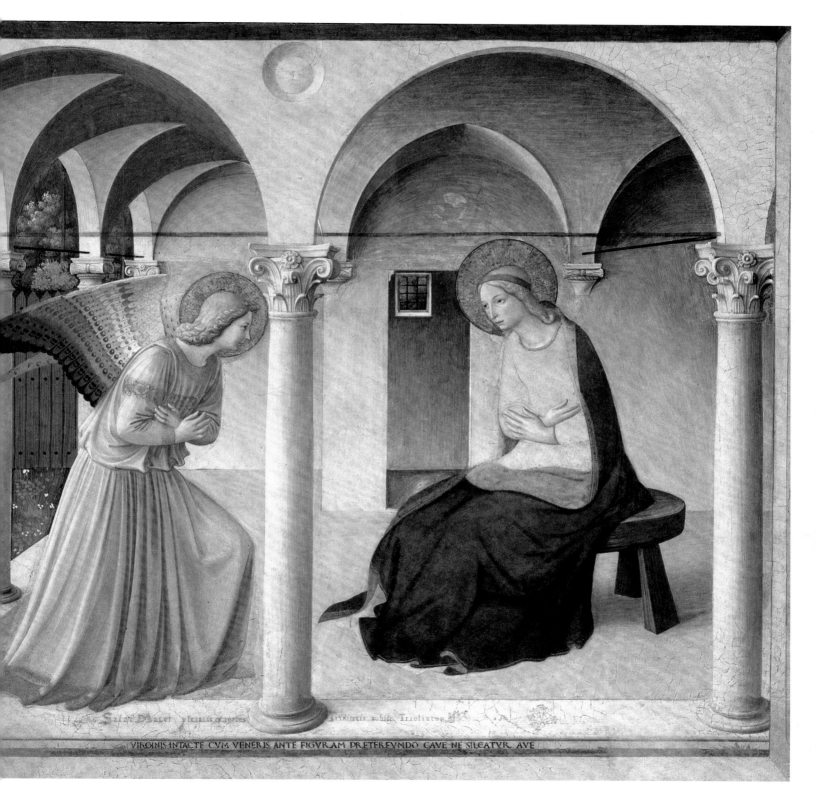

VIRGINIS INTACTE CVM VENERIS ANTE FIGVRAM PRETEREVNDO CAVE NE SILEATVR AVE

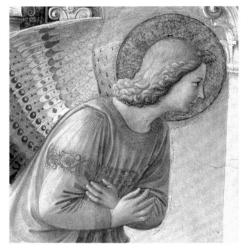

② THE ANGEL GABRIEL

Slender and refined, like Mary, the Angel Gabriel was drawn from life, although his pink-cheeked face is idealized. God's chief messenger is portrayed as youthful and businesslike, and appears to be engaging in a private conversation with Mary, leaning towards her as if exchanging a confidence. His pink and gold robe is as credible as his angel's wings.

③ THE VIRGIN MARY

There is a calmness about the scene illustrated by the Virgin Mary's serene acceptance of her future. Mary sits on a simple, low wooden bench, in an attitude of graceful humility, inclining her head and folding her hands across her chest to signal that she submits to the duties God has placed upon her. The intense ultramarine of Mary's cloak is the colour of royalty and purity.

① OUTDOOR SETTING

Fra Angelico is credited as the inventor of this interpretation of the Annunciation story, in which he puts Gabriel and Mary in an outdoor, rather than indoor, setting. He has reproduced a cloister with a cell that looks like those in San Marco. The fenced garden resembles a medieval tapestry and serves to symbolize Mary's purity.

④ CORINTHIAN COLUMNS

Calmness is implied through the curves of both the figures and the architecture. Gabriel approaches Mary in a cloister next to the loggia, which was an open-sided room of the convent with a vaulted ceiling supported by Corinthian columns. The central column in the foreground separates Mary and Gabriel, yet keeps the holy pair together and sets them apart from viewers.

5 SENSE OF DEPTH

Displaying Fra Angelico's keen observational skills and fine craftsmanship, the work features a sense of light and glowing colour, while natural poses animate and give weight to the figures. The architectural structure also reveals the artist's command of perspective. With its receding columns and open chamber at the back, the composition has a convincing sense of real, physical space.

6 LIGHT AND SHADOWS

Although the picture indicates a good understanding of linear perspective—and the influence of both Brunelleschi and Masaccio—the lighting is inconsistent. Mary casts a shadow, but Gabriel does not—perhaps because he is a messenger of God. In addition, the interior of the arcade is evenly lit throughout, despite daylight coming from the left.

7 HALOES

Haloes in art are circles or disks that surround holy people, especially emitting from their heads, and represent their spiritual character through a radiant aura of light. Convention in Renaissance art showed the Virgin and the Archangel Gabriel with round gold discs, and here, the delicate gold haloes have been intricately punched with decorative patterns.

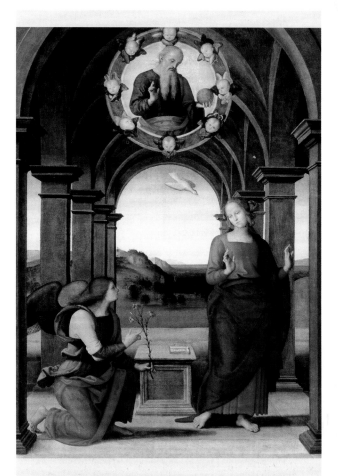

The Annunciation, **Pietro Perugino, c. 1488–90, oil on panel, 212 x 172 cm (83 x 68 in.), Church of Santa Maria Nuova, Fano, Italy**

Set within an open-air portico, this version of the Annunciation by Pietro di Cristoforo Vannucci, known as Perugino (c. 1446–1523), was directly inspired by Fra Angelico. His influence is evident in the natural light effects, the gentle-faced Virgin tilting her head downward, and the Angel Gabriel kneeling by her in reverence and holding a white lily as a symbol of purity. Above them, God is shown in a circular medallion, surrounded by cherubim and seraphim, and sending the Holy Spirit down to Mary in the form of a dove. It is likely that Raphael was later apprenticed to Perugino, but even if not, he was highly influenced by both him and Fra Angelico.

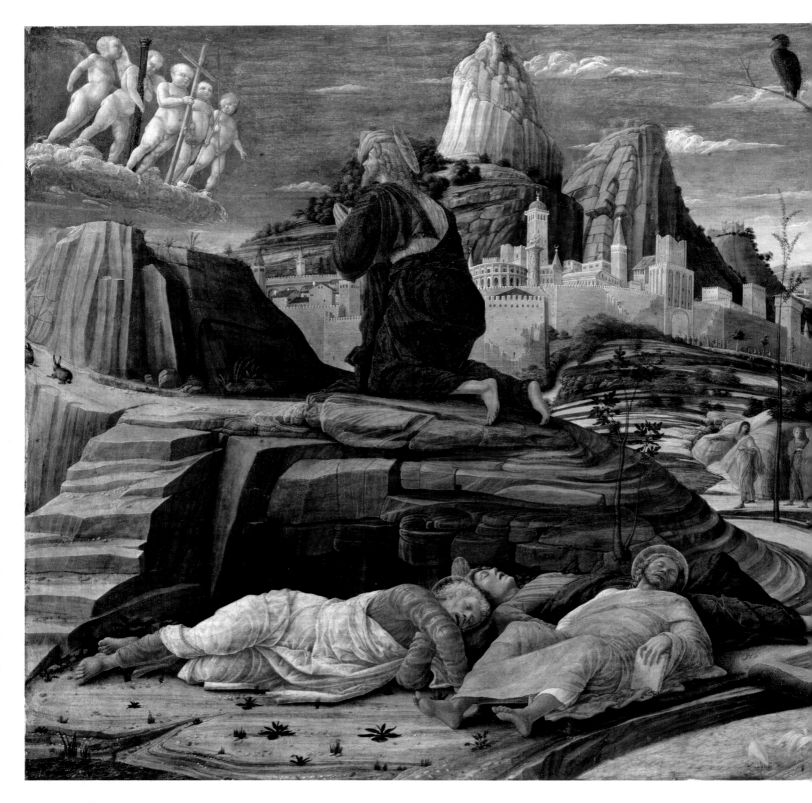

THE AGONY IN THE GARDEN

ANDREA MANTEGNA

c. 1458–60

tempera on wood
63 x 80 cm (24 ¾ x 31 ½ in.)
National Gallery, London, UK

ANDREA MANTEGNA (*c.* 1431–1506) is perceived as the first Renaissance artist of northern Italy. The second son of a carpenter, he was legally adopted by the Paduan artist Francesco Squarcione (*c.* 1395–*c.* 1468) as a child. Yet by the time he was seventeen-years-old, he had disassociated himself from Squarcione and established his own workshop in Padua, later taking legal proceedings against Squarcione, citing exploitation. That year, he was commissioned to paint an altarpiece for the Church of Santa Sofia. Proud of his achievements, he inscribed the work: 'Andrea Mantegna from Padua, aged 17, painted this with his own hand, 1448'.

Donatello moved to Padua from Florence in 1443, remaining there for ten years, and leaving a series of works in bronze and marble that became crucial to Mantegna's development. Also fascinated by classical antiquity, Mantegna often depicted specific examples of Roman architecture and sculpture in his paintings, and he explored ways of using linear perspective dramatically. In 1453, he married Nicolosia, the daughter of Jacopo Bellini (*c.* 1400–71) and sister of Giovanni and Gentile (*c.* 1430–1507), the leading family of Venetian painters. Yet Mantegna remained in Padua, continuing to pursue his independent practice until 1459, when the ruler of Mantua, Ludovico Gonzaga, persuaded him to move there. He worked for the Gonzaga family for the rest of his life, his art and attitude towards classical antiquity providing a model for other artists, including Giovanni Bellini in Venice and Albrecht Dürer in Germany.

Mantegna and his brother-in-law Giovanni used a drawing of Jacopo Bellini's as a basis for *The Agony in the Garden* paintings. Their resulting works are different, with Mantegna's displaying his sculptural approach. Before the 15th century, the biblical story was not widely represented in art. It was a subject that suited Mantegna's vivid imagination and this painting became one of his best known. It depicts a dream had by Peter, James and John while Jesus prays. Jesus had asked them to keep watch but they fell asleep. Here, Mantegna created a craggy landscape, with Jesus praying on a rocky ledge above the three sleeping men.

① ANGELS

In the Bible, this is the moment when Christ experienced human weakness and was torn between fear and resignation. The Bible states that 'an angel appeared to Him from heaven, strengthening Him'. Mantegna created a group of five, interpreting them as young cherubs, or putti, who show aspects of Christ's Passion – the next part of this story. Four of the angels hold an instrument of his imminent torture and death: the pillar where he will be scourged, the cross on which he will be crucified, the sponge on a cane that will be dipped in vinegar and offered to him to quench his thirst, and the spear that will pierce his side.

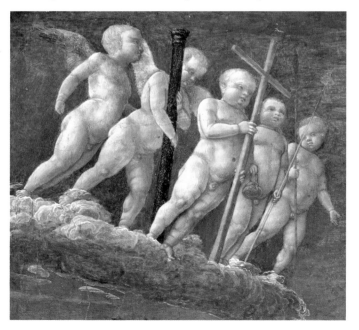

② THE ARRESTING PARTY

In the distance, a group of soldiers led by Judas can be seen on its way towards Jesus and the disciples. According to the Gospel of Matthew, Judas had betrayed Jesus for 'thirty pieces of silver'. Here he leads them, pointing to where they will be able to find and arrest Jesus.

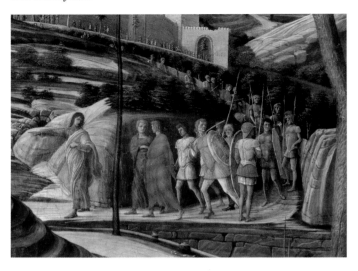

③ TOWERING CITADEL

In the distance, Jerusalem rises like a mythical citadel on the side of a mountain, with a golden equestrian statue, a Colosseum-like building and a carved triumphal column similar to Trajan's Column in Rome. There are also other buildings that are reminiscent of Rome and Florence, but have been narrowed and extended. The pink and white pearly vision heightens the notion of the disciples' dream.

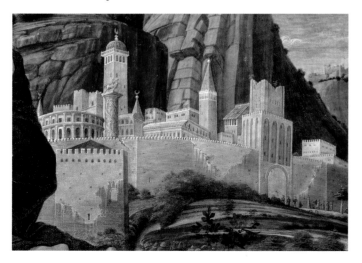

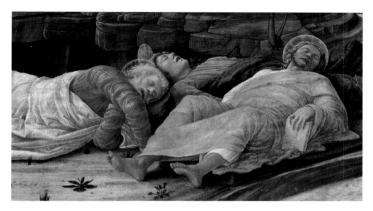

4 COLOURS AND CHARACTER

Although this work is painted in tempera on wood, the forms and colours are all carefully separated as in frescoes. Yellows and browns dominate the image, but strikingly, the apostles and the figures in the advancing party are in bright colours. James and John wear garments of red and green, and vivid yellow and a soft mauve. Peter is depicted in blue and pink. Mantegna's brilliant colours were highly influential to his relatives in Venice. A humorous touch to the dark, foreboding image is his depiction of the snoring apostles whom Jesus had asked to keep watch for him. Viewers would know that the mood changes when Jesus wakes them and says they should pray not to 'come into the time of trial'.

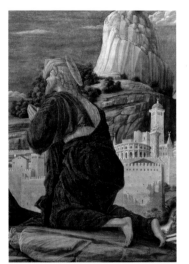

5 JESUS AND THE ROCKS

Jesus is praying on a rocky altarlike platform, his back to his disciples and viewers. Mantegna delineates every curl in his hair and beard, every line on his face, every detail in his delicate halo and even the sheen on his two-tone silk robe. Emphasizing the structure of the stone, Mantegna paid detailed attention to the striated, barren landscape and natural rock formations.

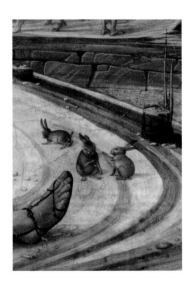

6 SOFTENING SYMBOLS

As if to lighten the sombre mood, Mantegna also features rabbits playing nearby the stream. They are on the path that leads up to Jerusalem. They have symbolic purposes: rabbits represent future followers of Christ. The three rabbits are also near three tree stumps, which may refer to the Crucifixion, because Christ was crucified beside two thieves and so three crosses were used.

The Dead Christ and Three Mourners, **Andrea Mantegna, 1470–74, tempera on canvas, 68 x 81 cm (26 ¾ x 31 ⅞ in.), Pinacoteca di Brera, Milan, Italy**

This late work by Mantegna displays his use of dramatic foreshortening and his fascination with ancient Greek and Roman forms. Laid out on a marble slab, Christ's corpse is watched by a weeping Virgin Mary, John the Evangelist and a third mourner, who is partly hidden and is possibly Mary Magdalene. According to tradition, John took care of Christ's mother after the Resurrection. The figures are not idealized, and Mantegna plays close attention to anatomical detail depicting the holes in Christ's hands and feet. Arrestingly, the body almost entirely fills the space; this strong foreshortening and sense of drama became Mantegna's lasting legacy.

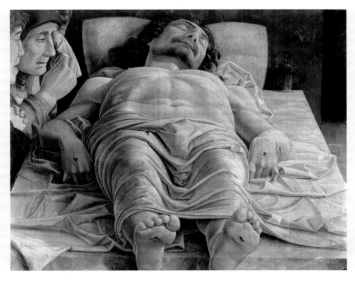

PROCESSION OF THE MAGI

BENOZZO GOZZOLI

1459–61

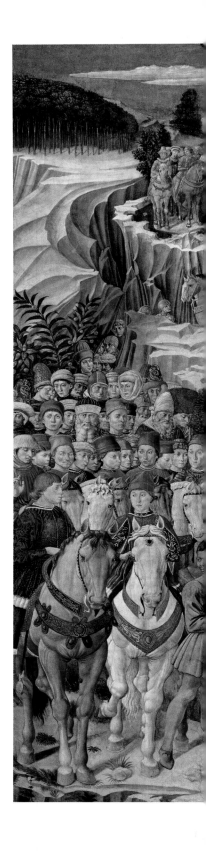

fresco secco (tempera and oil)
405 x 516 cm (159 ½ x 203 in.)
Palazzo Medici Riccardi, Florence, Italy

THE SON OF A tailor, Benozzo Gozzoli (*c.* 1421–97) was
born Benozzo di Lese in the Tuscan village of Sant'Ilario, and
moved with his family to Florence in 1427, where he became
a pupil and assistant of Fra Angelico. From 1444 to 1447,
he collaborated with Ghiberti on the *Gates of Paradise* – the
bronze Florence Baptistery doors. He worked in various
towns in Umbria and Tuscany, creating art that demonstrates
an original interest in realistic details in landscape, the
costumed figure, and portraiture. In 1459, he was summoned
back to Florence from Rome by the city's most illustrious
patrons, the Medici, to decorate the walls of the chapel in
their palace. The subject was the journey of the Magi and
with the incorporation of portraits of members of the family,
the colourful, lavish painting became Gozzoli's greatest
work. Gozzoli used the annual Epiphany procession as the
inspiration behind his decorative scheme, blending images
of the procession with the Christian story of the Magi.
He spent most of the rest of his life in Tuscany, but despite
his other extensive and prestigious commissions, he became
remembered for his vibrant Medici murals, for their decorative
details and pronounced International Gothic style.

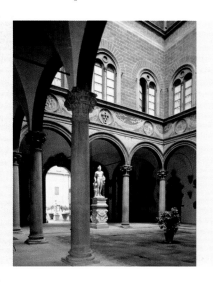

Palazzo Medici Riccardi, Florence, Italy

Between 1444 and 1484, the Florentine sculptor
and architect Michelozzo di Bartolomeo designed
the Medici Palace for Cosimo de' Medici,
blending elements of the earlier Italian Gothic
style with the more rational, classical style of the
Renaissance. With a huge cornice and arched
windows, it features an internal courtyard and
garden filled with orange trees. Perhaps the most
important part of the palace was the chapel,
where Gozzoli painted his frescoes, but overall
the building reflects the increasing wealth and
significance of the Medici family.

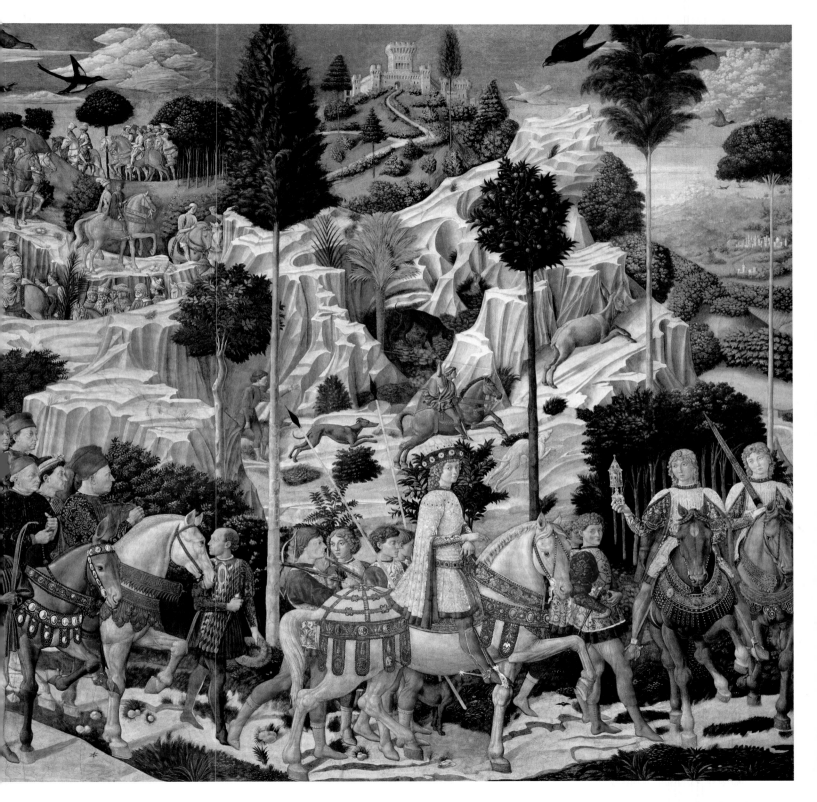

The Magi carry their traditional gifts of gold, frankincense and myrrh for the Christ child. Following medieval custom, they are presented here as the three ages of man, but differ from Giotto's representations of them (see pp. 10–13); Gaspar is the youngest here, leading the procession in white and gold. He is probably a portrait of the young Lorenzo de' Medici, although this has not been verified.

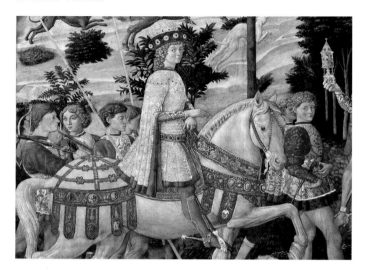

3 MEDICI PORTRAITS

The three Magi are probably portraits of the Medici. Melchior is Cosimo de' Medici, wearing his customary black garments and riding a humble donkey. On a white horse is Balthasar, a depiction of Piero, Cosimo's son and Lorenzo's father. Portrayed elsewhere in the fresco are Piero's three daughters and elder son, Giuliano. Medici symbols appear in the image, including the laurel bush, which was Lorenzo's emblem.

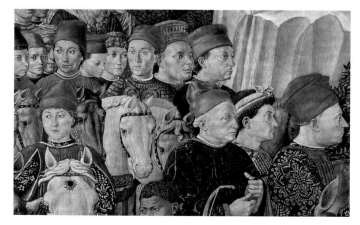

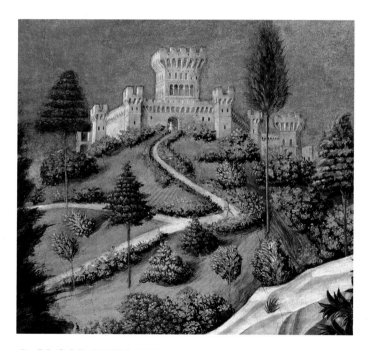

1 CLOSE DETAILS

The procession weaves its way across the composition. The journey began in Jerusalem and continued towards Bethlehem, but the landscape is recognizable as the hills that surround Florence, including castles and villas owned by the Medici. The details within the landscape – plants, flowers, animals, costumes and figures – invite close attention, and must have given the Medicis something to contemplate during long services.

In the creation of this artwork, Gozzoli used a combined technique beginning with fresco, and then adding finishing touches in tempera and oil-based paints. In this way, despite completing the work rapidly in the course of a few months, Gozzoli built up a complex and subtle image.

❹ WET AND DRY

Gozzoli probably only worked with one assistant to produce the work. Mixing some *buon fresco* with predominantly *fresco secco*, his additions of tempera and oils enabled him to create decorative effects. Once the work was completed he applied gold leaf, so that it would shine in the dim candlelight of the chapel.

❺ METICULOUS

Using rare and costly materials, including lapis lazuli, Gozzoli mixed decorative details and accurate linear perspective to create a colourful image of splendour – combining a devout Christian story with a sense of ornamentation. He worked meticulously, delineating every green leaf and luscious fruit in the trees.

❻ UNDERPAINTING

Gozzoli painted directly onto fresh plaster with a full brush loaded with watery green, red or yellow ochre paint before using *verdaccio* to define tonal values. *Verdaccio* is a mix of black, white and yellow pigment that was used as a monochromatic underpainting during the Renaissance to mark out darker areas.

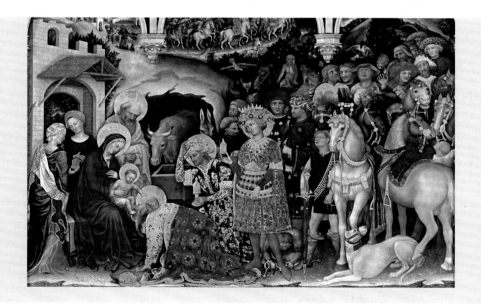

Detail from *The Adoration of the Magi*, **Gentile da Fabriano, 1423, tempera on panel, 203 x 282 cm (80 x 111 in.) Uffizi, Florence, Italy**

It is probable that Piero de' Medici suggested that Gozzoli use *The Adoration of the Magi* by Gentile da Fabriano (*c.* 1370–1427) as a model for the Medici chapel frescoes. So complex in content, decoration and execution, the painting is often described as the culmination of the International Gothic style. In several scenes the journey of the Magi can be followed. The figures wear magnificent costumes, including richly embellished brocades. In addition, exotic animals, including a leopard, a dromedary, apes and a lion mingle with the more expected creatures. Layers of silver and gold create glittering textures.

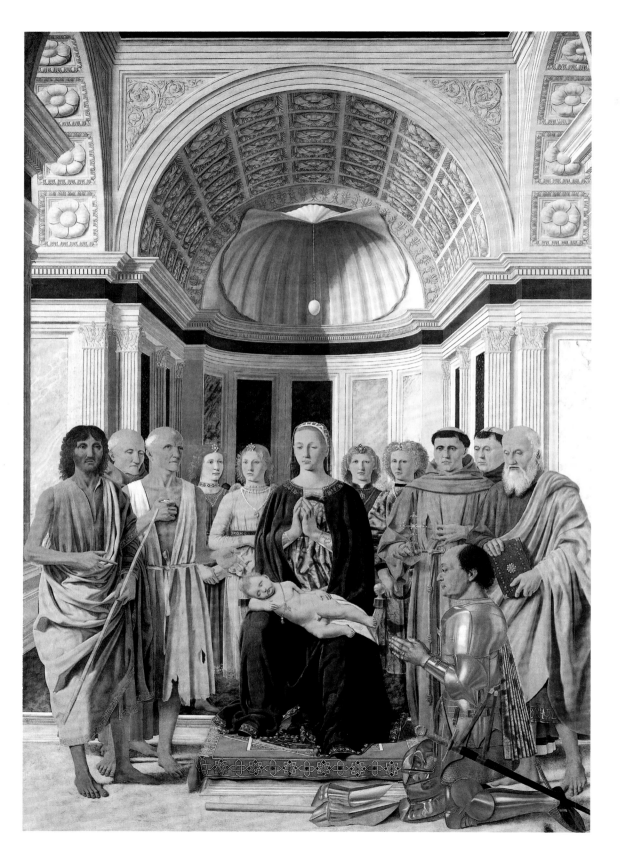

MADONNA AND CHILD WITH SAINTS

PIERO DELLA FRANCESCA

1472–74

oil and tempera on panel
248 x 170 cm (97 ¾ x 67 in.)
Pinacoteca di Brera, Milan, Italy

HIGHLY ESTEEMED THROUGHOUT HIS career, Piero della Francesca (*c.* 1415–92) was employed by many of the most eminent and wealthy Italian patrons, including the Duke of Urbino, Federico da Montefeltro; the Lord of Rimini, Sigismondo Pandolfo Malatesta and Pope Nicholas V. Born in Sansepolcro in Tuscany, Piero worked in several Italian towns, but most of his commissions came from his native Sansepolcro. Nothing is known of his training, and as many of his works have been lost, the chronology of his output is difficult to establish. However, by 1439, he was working in Florence with Domenico Veneziano (*c.* 1410–61), who in turn was influenced by Gozzoli, and whose treatment of space clearly influenced Piero, who became renowned for his cool colour palette and calm geometric compositions. As a mathematical theorist, Piero's accurate perspective, simplified forms and geometric compositions similarly influenced many successive artists, and although his fame was eclipsed after his death, he was never forgotten. In his *Lives of the Artists* of 1550, Vasari says that Piero became blind in later life and stopped painting in the 1470s.

Also known as the *Brera Madonna*, this painting was commissioned by Federico da Montefeltro, either to celebrate the birth of his son, Guidobaldo or to commemorate his conquest of several castles in the Maremma, an area of Italy bordering the Ligurian and Tyrrhenian Seas. If it was painted for the birth of his son, the Christ child represents Guidobaldo, while the Virgin resembles Battista Sforza, Federico's wife, who died soon after the birth of Guidobaldo and was buried in the Monastery of San Bernardino, where the painting was originally located. Called a *sacra conversazione*, or holy conversation, the style of this painting developed in the Renaissance period and describes a traditional altarpiece where saints are grouped around the Virgin and Child and appear to be interacting by speaking, reading or meditating in a companionable group, even though the saints themselves were not necessarily alive concurrently. Their hand gestures are often towards the Virgin and Child in order to direct viewers' attention to their presence.

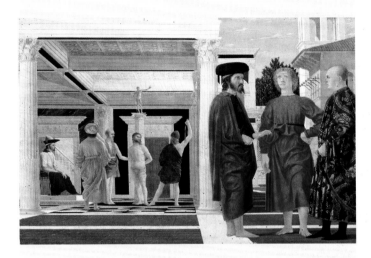

Flagellation of Christ, **Piero della Francesca, *c.* 1455–65, oil and tempera on wood, 58.5 x 81.5 cm (23 x 32 in.), Galleria Nazionale delle Marche, Urbino, Italy**

This is the moment when Christ was scourged before Pontius Pilate. While the Bible only mentions that Pilate ordered Christ to be flogged, later writers expanded on the event, adding that he was tied to a column while being whipped. Through tonal contrasts, accurate depiction of linear perspective and elements of classicism (especially in the architecture and golden statue above Jesus), the painting moves into the Renaissance. The flagellation takes place in the background and there are three men in the foreground. Jesus is in a covered courtyard with black and white floor tiles, and the men stand outside on terracotta tiles. Orthogonal perspective lines divide the painting in half, also marking the interior and exterior space. The men in the foreground are unidentified, although they are most commonly believed to be Oddantanio da Montefeltro, the ruler of Urbino, flanked by his advisors.

Set in the apse of a classical-style Renaissance church, Piero portrays a complex architectural background, using exacting perspective to suggest depth. At the centre of the apse, hanging by a thread is an egg. It is possibly an ostrich egg, as this was one of the heraldic symbols of the Montefeltro family. It may also be an emblem of the Creation to celebrate Guidobaldo's birth, Mary's fertility and the promise of regeneration and immortality. Visually, it echoes the oval of Mary's head, which is positioned beneath it. Another theory is that together with the shell-like roof, the egg represents a pearl and symbolizes Mary's beauty.

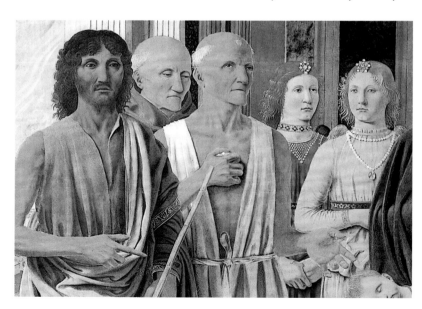

① THE BABY

Wearing a necklace of coral beads, the baby lays across his mother's lap. The red of the beads alludes to blood, which was accepted at the time as a symbol of life and death, but also of redemption attained by Jesus after his Crucifixion. Coral had a more practical purpose, too; it was often worn and chewed on by teething babies.

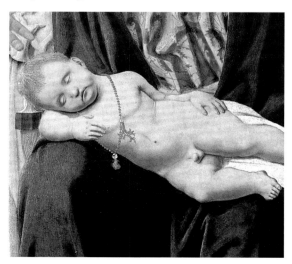

③ SAINTS AND ANGELS – LEFT

These saints are usually identified as John the Baptist, Bernardino of Siena (the patron saint of the painting's original location) and St Jerome. Two angels adorned with jewels stand behind them. John the Baptist was the patron saint of Battista, while St Jerome was the protector of humanists and Federico promoted humanistic institutions.

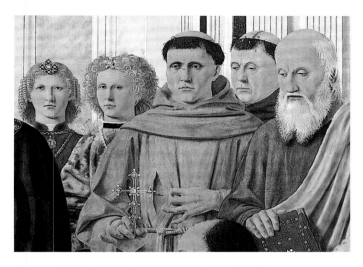

④ SAINTS AND ANGELS – RIGHT

Here are Saints Francis, Peter the Martyr and Andrew with two angels adorned with jewels. The Renaissance period was defined by the rapid rise of humanism. St Francis is present as the painting was originally intended for the Franciscan church of San Donato degli Osservanti, where Federico was later buried.

⑤ WHITE AREAS

Characterized by use of clear linear perspective and geometric forms, Piero's painting style emerged from his interests. He wrote books on geometry and perspective. Every one of his paintings incorporates areas of white or almost white, and all his work projects a sense of serenity, order and clarity.

⑥ FEDERICO

Federico was one of the most successful *condottieri* (military leaders) of the Renaissance. Clad in his armour, he kneels before the holy figures, his helmet and gauntlets removed in respect.

⑦ HIGH VANISHING POINT

The vanishing point is at a high level, approximately at the same height as the figures' hands. This makes the sacred characters seem less overpowering than in many religious paintings.

⑧ INFLUENCES

The exacting perspective, scrupulous details, representation of light and varied textures reflect the popularity of Netherlandish painting in Urbino at the time.

PORTINARI ALTARPIECE

HUGO VAN DER GOES

c. 1475–76

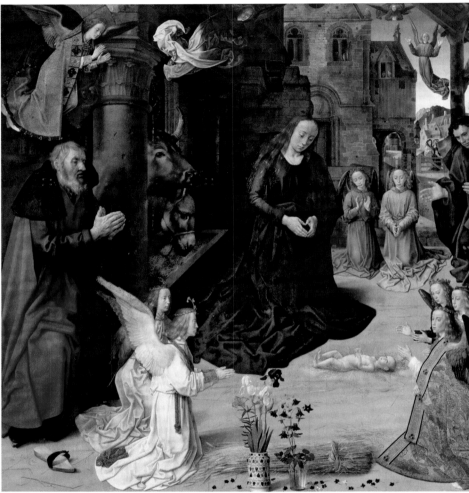

AFTER JAN VAN EYCK, Hugo van der Goes (*c.* 1440–82) was the most important Ghent painter of the Early Renaissance period. His strange and expressive religious works are profound but also often disturbing.

Van der Goes is thought to have been born in Ghent in Belgium. After becoming a master of the painters' guild of Ghent in 1467, he received many commissions, including decorating the city of Bruges to celebrate the marriage between Charles the Bold, Duke of Burgundy, and Margaret of York. In *c.* 1475, he entered Rood Klooster, a monastery near Brussels. He remained there for the rest of his life as a lay brother. He continued to paint and received distinguished visitors, including the Archduke of Austria. However, in his later years, he suffered from bouts of depression.

This large triptych is Van der Goes's only definitively attributed work. Usually called the *Portinari Altarpiece* because it was commissioned by Tommaso Portinari, a member of a prominent Florentine family and an agent for the Medici

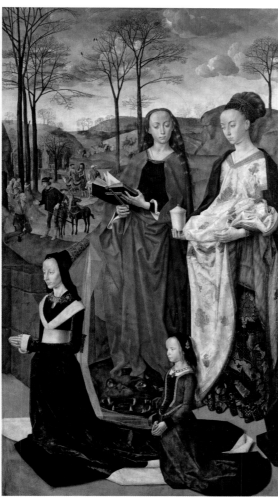

oil on wood panel
central panel 253 x 304 cm (99 ¾ x 119 ¾ in.)
each side panel 253 x 141 cm (99 ¾ x 55 ½ in.)
Uffizi, Florence, Italy

Back of the Portinari Altarpiece, the Annunciation,
Hugo van der Goes, *c.* 1479, oil on panel,
each panel 253 x 141 cm (99 ¾ x 55 ½ in.),
Uffizi, Florence, Italy

Bank in Bruges, it was commissioned for the church in the hospital of Santa Maria Nuova in Florence. It was a way for Portinari, living so far away, to remind his fellow Florentines of his existence and loyalty. Painted in Bruges then shipped to Florence, the painting significantly influenced Italian Renaissance art. The central panel depicts a common Christian theme, the Adoration of the Shepherds, with Portinari and his family and patron saints on the two outer panels, plus small vignettes of related stories from the Nativity behind them.

When the side panels of Van der Goes's *Portinari Altarpiece* are closed, his painting of the Annunciation can be seen. It is of the Virgin Mary and the Archangel Gabriel, painted in grisaille – that is, entirely in monochrome, deliberately rendered to resemble stone sculpture in arched recesses. The figures wear flamboyantly folded and draped fabrics. This *trompe l'oeil* effect was unknown in Florentine Renaissance art until then, and it inspired many Italian painters.

② SYMBOLISM

In great detail, a vase and a glass containing orange lilies are a symbol of the Passion. Three white irises symbolize purity, some purple irises and columbine stalks represent the Christian belief of the seven sorrows of the Virgin. The sheaf of corn represents the Eucharist, or Last Supper, when Jesus broke bread the night before his Crucifixion. The shoe indicates that this is holy ground.

③ THE SHEPHERDS

Rather than portray the shepherds with the Magi as in most other contemporary paintings, Van der Goes presents them on their own, reaching the Holy Family before everyone else. The first artist to depict the shepherds as dishevelled, unsophisticated peasants, he also gave them equal prominence with hallowed saints. Each shepherd is portrayed as an individual, in contrast with the usual idealized depictions of them.

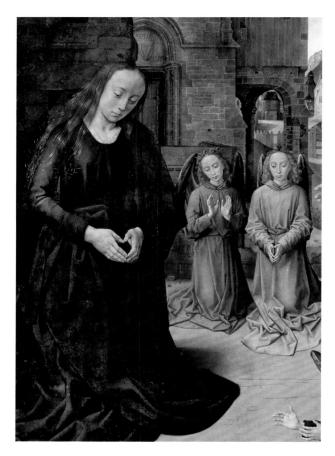

① HIERARCHY OF SCALE

Medieval hierarchy of scale was employed to incorporate all the figures in the work and to illustrate their significance; the custom was to portray patrons on a smaller scale than holy figures. So Joseph and Mary are the largest figures in the painting. Mary leans over her child; her plucked forehead is the height of contemporary fashion. Behind her, two tiny angels pray over the Christ child.

④ THE PATRON

This is the patron of the work, Tommaso Portinari, a descendant of Beatrice Portinari, who more than a century earlier, had featured in the *Divine Comedy* (c. 1308–20) written by Dante Alighieri. In terms of scale, Tommaso and his family were depicted as almost as large as the Holy Family and the protector saints.

⑤ LEFT PANEL

These are the protectors of Tommaso and his two sons, Antonio and Pigello. They are St Thomas (with a spear) and St Anthony. Behind them in the background is another scene from the nativity. Joseph helps his pregnant wife Mary as they travel to Bethlehem. Although it is said that Leonardo da Vinci was the first to show aerial or atmospheric perspective (see p. 63), it can be seen here that Van der Goes observed how distant landscapes appear blue.

⑥ RIGHT PANEL

Fashionably attired, these ladies are actually saints. Mary Magdalene, with her hair up, and St Margaret, holding a book, are the protector saints of Tommaso's wife, Maria Baroncelli, and the couple's elder daughter, Margherita. St Margaret is identified by her traditional symbol, a dragon. To St Margaret's right is a vignette of the nativity: the three Magi travel to Bethlehem. They are shown passing through a northern landscape with the bare trees of winter.

⑦ LIGHT AND COLOUR

Strong, golden light illuminates the holy child who is alone in front of his mother on the ground, not in a crib as is usually portrayed. Radiating from him is a halo, which could also be interpreted as straw. The light radiating from the newborn reflects on the richly dressed angels nearby who are worshipping him. Van der Goes's effects of chiaroscuro were highly influential to Italian artists. The strong colours indicate the costliness of the work: earth tones were easily obtained, but bright hues came from more expensive precious and semi-precious stones. With his lifelike renditions, and depiction of light and rich colour, Van der Goes offered a new direction in painting.

Detail from *Adoration of the Shepherds*, Domenico Ghirlandaio, 1483–85, tempera on panel, 167 x 167 cm (65 ¾ x 65 ¾ in.), Santa Trinità, Florence, Italy

In 1478, the wealthy Florentine banker Francesco Sassetti acquired the chapel of St Francis in the Church of Santa Trinità. Two years later, he commissioned the most famed artist of the city, Domenico Ghirlandaio (1449–94) to decorate it. This altarpiece, illustrating the Adoration of the Shepherds is the main artwork from the chapel, and was later copied extensively by other artists. Starting the work in 1483, Ghirlandaio had been particularly inspired by the *Portinari Altarpiece*, which arrived in Florence that year. Within the altarpiece, he portrayed numerous figures of contemporary Florentine society as well as himself leading the shepherds.

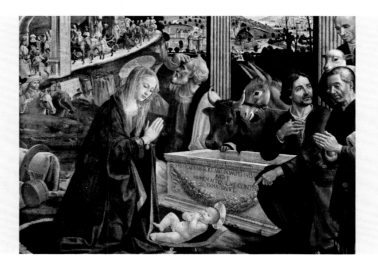

PRIMAVERA

SANDRO BOTTICELLI

c. 1481–82

oil tempera on panel
203 x 314 cm (80 x 123 ½ in.)
Uffizi, Florence, Italy

BORN ALESSANDRO DI MARIANO FILIPEPI, Sandro Botticelli (*c.* 1445–1510) was the first artist to create large-scale mythological scenes, and to treat them with as much sincerity as religious themes.

This painting was first called *Primavera* by the art historian Vasari in 1550. He described it as showing: 'Venus as a symbol of spring being adorned with flowers by the Graces'. Drawing inspiration from classical and contemporary poems, including works of Ovid, Lucretius and Angelo Poliziano, the painting symbolizes the lush growth of spring, and the ideals of Neoplatonic love, popularized at that time. The central theme is love and marriage which, when conducted properly, will generate fertility. Another key theme is the triumph of love over brutality. With her hand raised as if in blessing, Venus wears the headdress of a respectable married Florentine woman: she is the goddess who protects, and cares for, the institution of marriage and marital love. She is framed by the dark leaves of a myrtle bush. Myrtle was sacred to her, and is traditionally thought to represent sexual desire, marriage and fertility. The positions of the surrounding figures and the light between the trees behind all lead viewers' eyes towards her.

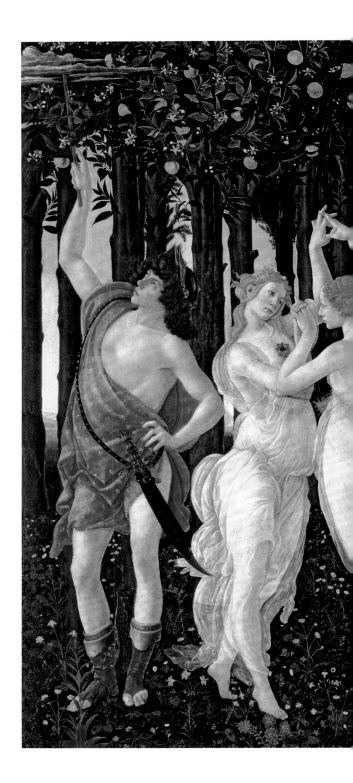

***Abundance or Autumn*, Sandro Botticelli, *c.* 1480–85, chalk and ink on paper, 31.5 x 25 cm (12 ½ x 10 in.), British Museum, London, UK**

Botticelli's drawing closely resembles *Primavera* and may have been drawn for a pendant painting. The finished painting may have been one of several the artist threw onto Girolamo Savonarola's Bonfire of the Vanities in 1497.

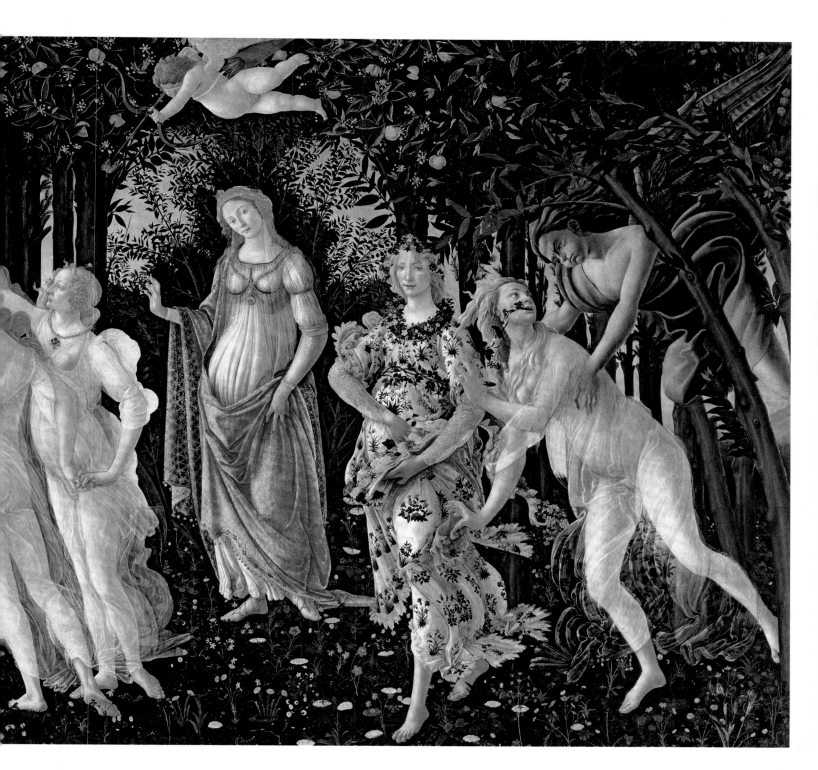

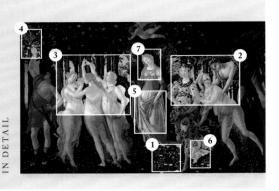

① FLOWERS

There are 500 plant species in this painting, including approximately 190 different flowers. Many of these grow in Florence in the spring and were drawn from life, including roses, daisies, cornflowers, German irises, coltsfoot, wild strawberries, carnations, hyacinths and periwinkles. Wild oranges do not ripen at the same time as the flowers shown but the orange tree is the symbol of the Medicis, who were the patrons of the work.

② TRANSFORMATION

Zephyr, god of the west wind (right), is attracted to the nymph, Chloris (centre). He violates her but regrets his action and turns her into Flora, goddess of flowers (left). The metamorphosis is shown by the women's clothes blowing in different directions and the flowers emerging from Chloris's mouth. The source of this tale is Ovid's *Fasti* (AD 8). Botticelli may have become aware of the myth from Poliziano, a poet who gave lectures on Ovid in 1481.

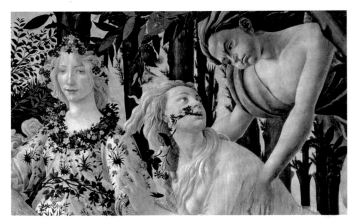

③ THE THREE GRACES

Aglaea, Euphrosyne and Thalia – their names mean, respectively, splendour, joy and festivity – symbolize the beauty and fertility of spring. Botticelli's use of egg tempera helps to give the translucent quality to their bare skin. Their scanty clothing made this trio risqué. Their elongated fingers, rounded stomachs and alabaster skin demonstrate the contemporary ideal of beauty. Elegance is prioritized over realistic proportions.

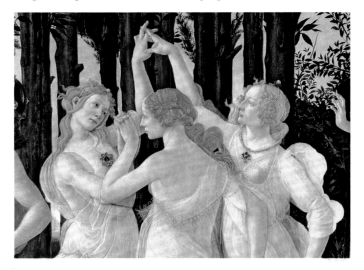

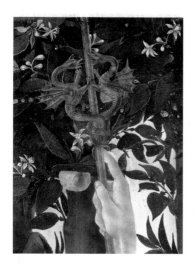

❹ MERCURY'S ROD

The garden is guarded by Mercury, the messenger of the gods. His sword remains sheathed at his side but the wooden rod he brandishes here in his right hand is a caduceus, or herald's staff, which is carved into the shape of two entwined snakes and two wings at the top. He holds it up against the threatening grey clouds, thereby banishing them from the idyllic scene.

❺ VENUS'S ROBES

The reddish colour is deliberately similar to that of Mercury's cloak and symbolically references the way in which increasing barometric pressure – rising mercury – hastens the transformation of late spring into early summer. Venus's belly is beginning to bulge slightly, too, because the Earth's fecundity increases in the middle months of the year.

❻ SCUMBLING

Botticelli applied his paint in thin opaque layers in techniques known as scumbling (a dry coat of paint as a final layer, allowing some of the lower colours to show through) and glazing (a transparent layer of paint applied over a dry, opaque layer beneath). The scumbling technique was popularized by the pointillists some 400 years after Botticelli's death.

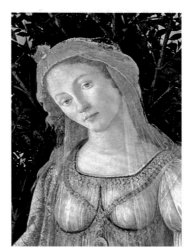

❼ SKIN TONES

Botticelli's skin tones were built up with semi-transparent applications of ochre, white, cinnabar and red lake, layered painstakingly with small brushstrokes. The skin of all the female figures is pale, with softly blushing cheeks. The males depicted have darker skins, while Botticelli's babies and children are always rosy-cheeked, created with glazes of his two reds and white.

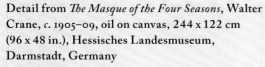

Detail from *The Masque of the Four Seasons*, Walter Crane, *c.* 1905–09, oil on canvas, 244 x 122 cm (96 x 48 in.), Hessisches Landesmuseum, Darmstadt, Germany

After Botticelli's rediscovery by the Pre-Raphaelites in the 19th century, many of his ideas appeared in their work and that of their contemporaries, the Arts and Crafts designers, particularly Walter Crane (1845–1915). Botticelli's figures and setting can be directly compared with Crane's *The Masque of the Four Seasons*. Botticelli's oeuvre also inspired the symbolic flowers in the Pre-Raphaelite painting *Ophelia* (1851–52; see pp. 218–221) by John Everett Millais.

16TH CENTURY

AS EUROPEAN ARTISTS REJECTED the medieval past
and initiated a rebirth of styles, their work became more
idealistic and dextrous. Although there is no distinct transition
from the Early to the High Renaissance, artists became more
intent on realism. The term 'Renaissance' was first used in 1858
by the French historian Jules Michelet. Renaissance artists
reached a peak of technical competence in northern Italy
at first, but the ideas soon spread to other parts of Italy and
northern Europe, where specifically oil paints were introduced.
Oil paint is a smooth, forgiving and bright medium, which
soon replaced tempera as artists' preferred type of paint. From
the 1520s, a new style of painting emerged in reaction to the
harmonious classicism and idealized naturalism of High
Renaissance art. From the Italian *maniera*, meaning 'manner'
or 'style', Mannerism was more elongated and stylized.

THE GARDEN OF EARTHLY DELIGHTS

HIERONYMUS BOSCH

c. 1500–05

oil on oak panel
central panel 220 x 196 cm (86 ½ x 77 in.)
each side panel 220 x 96.5 cm (86 ½ x 38 in.)
Museo del Prado, Madrid, Spain

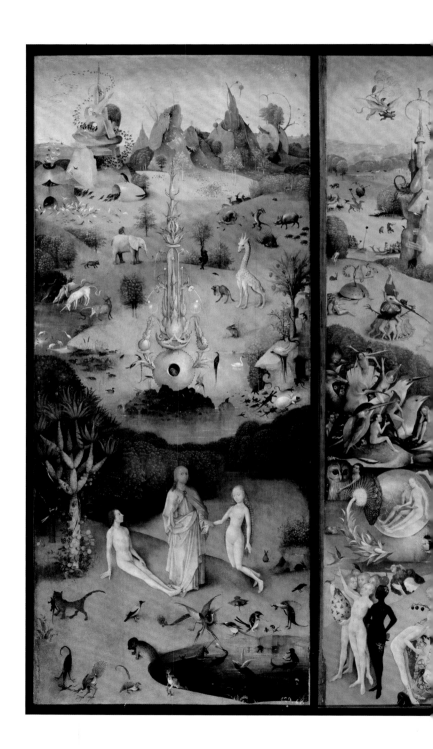

BORN JHERONIMUS VAN AKEN (*c.* 1450–1516) in
the small Dutch town of 's-Hertogenbosch, Hieronymus
Bosch was the son of a painter. Renowned within his
lifetime for his fantastic imagery, his work was collected
in the Netherlands, Austria and Spain, and widely
copied from the many prints made from his paintings.
Little is known of his life or training, as he left behind
no letters or diaries; what has been identified has been
taken from brief references to him in the civic records of
's-Hertogenbosch and in the account books of the local
order of the Brotherhood of Our Lady. He became a
member of the Brotherhood, with which he was closely
associated for the rest of his life, in 1486. A large and
wealthy organization, it contributed significantly to
the religious and cultural life of the city. He spent most
of his life in the town where he was born. Attribution of
his work is difficult and only about twenty-five paintings
have been confirmed as his. His work particularly
influenced Pieter Bruegel the Elder, and was collected
by King Philip II of Spain. In the 20th century, the
Surrealists saw Bosch as their forerunner.

Bosch projects the moralizing attitude of his age.
The overriding belief in the Bible in Europe meant that
most people accepted Adam and Eve's expulsion from the
Garden of Eden–and so non-Christians (or non-practising
Christians) faced eternal damnation. In the three panels
of this ambitious work, he illustrates the consequences of
living a sinful life. Clearly organized, the left panel depicts
Paradise, the square central panel portrays the realities
of sin and the right panel shows the consequences: eternal
damnation in hell. The right panel strikes a harsh contrast
with the other two panels. Set at night, it presents a scene of
cruel torture and ghastly retribution; its chilling quality is
created through cold colours and icy waters.

The patron of the work is not known, but the extreme
subject matter makes it unlikely that it was an altarpiece.
When folded, the outer panels feature a monochrome, or
grisaille, painting of the biblical Creation of the Earth.

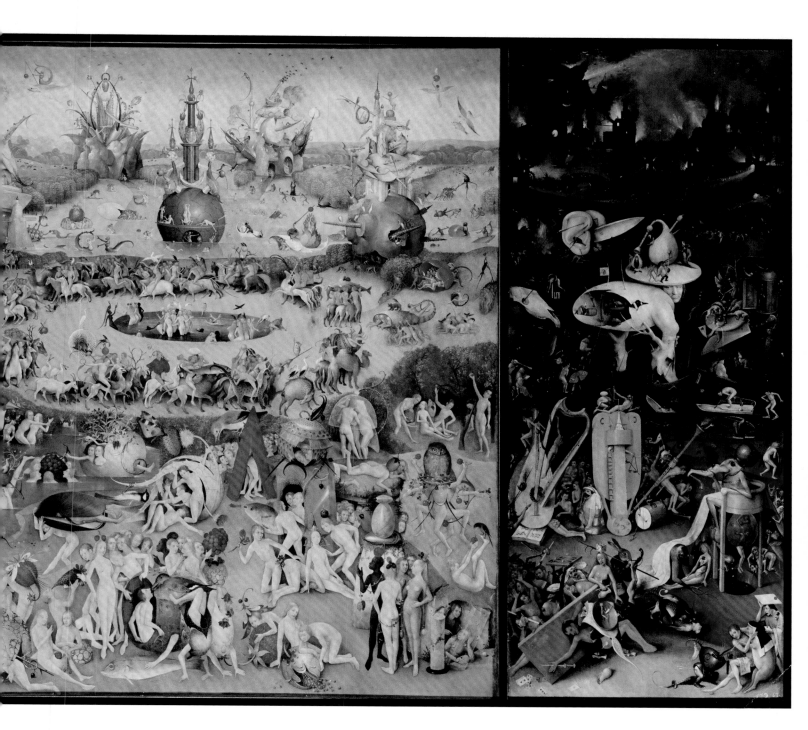

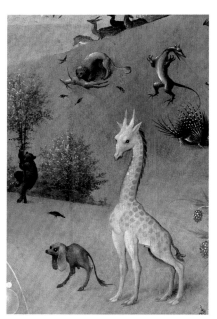

② MENAGERIE

The unspoiled land is populated with all sorts of creatures, including fictional animals, such as the unicorn; animals that Bosch had never seen, such as the giraffe; animals that he had, such as the cat; and imaginary animals, such as the two-legged doglike creature left of the giraffe. It is thought that Bosch used contemporary travel literature as reference sources for the exotic animals.

③ THE FOUNTAIN OF LIFE

Pink represents divinity. This is the fountain of life, rising from the water (blue symbolizes the Earth). It is a fragile, delicate, strange structure rising from mud that sparkles with precious gemstones. It is probably Bosch's interpretation of a medieval description of an Indian landscape and structure, as India was popularly believed to be the location of the Garden of Paradise.

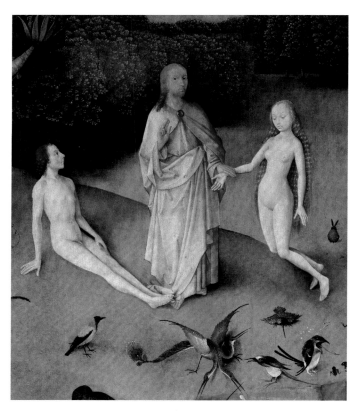

① ADAM AND EVE

This is the moment when God presents Eve to Adam. Waking from sleep, Adam sees God holding Eve by the wrist and blessing their union with his other hand. Eve avoids making eye contact with Adam, while he looks at her in amazement and lust. It is the last day of God's creation; he has brought into being flowers, fruit, fish, animals, birds, Adam and Eve.

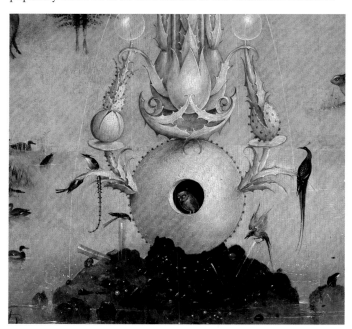

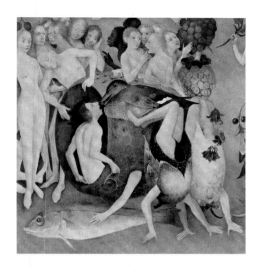

④ SCALE

In the central panel – a playground of corruption abundantly filled with male and female nudes and fantastic and realistic species of animals, plants and fruit – scales are confused. Here are giant strawberries (red represents passion and strawberries in particular symbolize the pleasures of the flesh), blackberries, raspberries, a bird and a fish. Perspective and logic are abandoned.

⑤ BATH OF VENUS

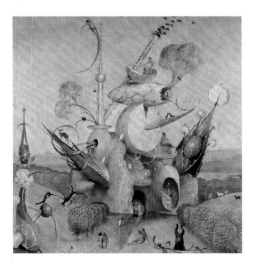

As an illustration of lust and man's fall from grace, the pool in the centre of the garden is filled with bathing women and men on various animals riding around them. Riding was a metaphor for copulation and the 'bath of Venus' was a euphemism for falling in love. Other metaphors symbolizing the sexual act occur across the work, including the plucking of flowers and fruit.

⑥ OUTCROPS

At the back of the central panel grow strange outcrops that could be made of mineral or animal and that protrude in unsettling ways, featuring sexual symbols. As with the entire panel, cavorting figures clamber over and around them, indulging themselves without a glance at anyone else; the people who inhabit this central panel are completely self-absorbed.

⑦ THE TREE-MAN

The Tree-Man's hollow torso is made of eggshell and his legs are tree trunks. His head supports a disc populated by demons and victims. He looks out sideways. The moral message is that the pleasures of this world are a false paradise, and becoming too involved with them leads to eternal damnation.

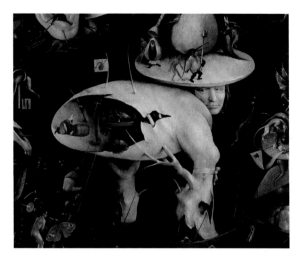

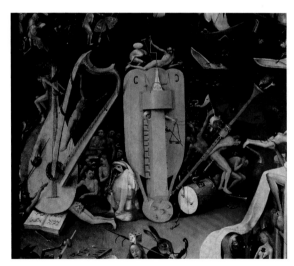

⑧ DEADLY PUNISHMENT

Musical instruments are traditional symbols of love and lust, but here they have grown to enormous proportions and those who have indulged in the pleasures of the flesh are being crucified on them. A birdlike creature is eating humans, then defecating them. This is the punishment for those who indulge in the sin of gluttony.

MONA LISA

LEONARDO DA VINCI

c. 1503–19

oil on white Lombardy poplar
77 x 53 cm (30 ⅜ x 21 ⅞ in.)
Louvre, Paris, France

PAINTER, SCULPTOR, ENGINEER, ARCHITECT, scientist and inventor, Leonardo da Vinci (1452–1519) was one of the great creative minds of the Italian Renaissance. Born near the Tuscan town of Vinci, the illegitimate son of a local lawyer, he was apprenticed to the sculptor and painter Andrea del Verrocchio in Florence when he was fourteen years old, qualifying as a master in the Guild of Saint Luke six years later. In 1483, he moved to Milan to work for the ruling Sforza family as an engineer, sculptor, painter and architect, remaining there until the city was invaded by the French in 1499, when the Sforza family was forced to flee. He subsequently returned to Florence, but went back to Milan after a short time until 1513 when he spent three years in Rome. In 1517, at the invitation of King Francis I, he moved to the Château of Cloux, near Amboise in France, which is where he spent the rest of his life.

The diversity of Leonardo's genius meant that he completed relatively few paintings, but his many drawings and notebooks that combine scientific accuracy with his vivid imagination reflect the vast range of his ideas on a broad spectrum of subjects including geology, anatomy, gravity and optics. As well as accomplishing great feats of painting and engineering, Leonardo designed diving equipment, a parachute and a flying machine – centuries before such inventions could actually be made.

The most famous painting in the world, the *Mona Lisa* is protected by bulletproof glass and is viewed by thousands every day, who queue to see it from the moment the Louvre opens. The small work has inspired poetry, songs, stories, films, advertisements, forgeries and theft. When it was first painted, it was perceived as bringing a new dimension to the depiction of reality. Since then, its enigmatic appeal has been variously attributed to the sitter's smile, identity, gender and hands; to the background, the method and appearance of the shading, and even to the intricate depiction of the embroidery. Leonardo took it with him when he moved to France and continued working on it there. He evidently never felt he finished it, though; late in life he said he regretted 'never having completed a single work'. The painting was subsequently acquired by Francis I.

The Baptism of Christ, **Andrea del Verrocchio, 1470–75, tempera and oil on wood, 180 x 152 cm (70 ⅞ x 59 ⅞ in.), Uffizi, Florence, Italy**

A sculptor, goldsmith and painter who ran a workshop in Florence, Andrea del Verrocchio (1436–88) taught pupils including Botticelli as well as Leonardo. In the 1568 edition of *Lives of the Artists*, Vasari describes Leonardo assisting Verrocchio on this work, and painting an angel that was 'so superior to the rest of the work that Andrea resolved he would never take up a brush again'.

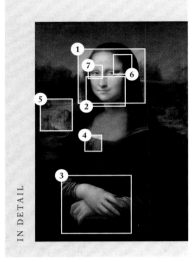

② THE SMILE

No one is sure what it is that makes the *Mona Lisa*'s smile so mysterious. Her eyes do not crinkle and her lips appear to curve slightly at the edges. Leonardo hired musicians to entertain his models as he worked, and perhaps he painted her lips when she was smiling.

① THE SITTER

The sitter herself has never been irrefutably identified. In the 1550 edition of *Lives of the Artists*, Vasari wrote: 'Leonardo undertook to paint, for Francesco del Giocondo, the portrait of Mona Lisa, his wife.' Francesco del Giocondo was a cloth and silk merchant and Lisa di Antonio Maria Gherardini his third wife. She is the *Mona Lisa* or *La Gioconda* of the title, although this is not authenticated. The Italian name for the painting, *La Gioconda*, means 'jocund' or 'jovial', a pun on the feminine form of Lisa's married name. However, some have suggested she could be Isabella d'Este, Duchess of Mantua, or a mistress of a member of the Medici family.

③ HANDS

Especially admired in the 16th century, hands were perceived as an important aspect of feminine beauty. Beautiful hands were pale, slender and long-fingered as here. Leonardo has also depicted the hands as being relaxed and composed.

Leonardo was the first artist to achieve a sense of volume, depth and luminosity through the depiction of light. This presentation of light to dark to define three dimensions is known as 'chiaroscuro'. From his study of anatomy, he developed a mathematical system for determining ratios.

④ DETAIL

Recreating the elaborate embroidery of the dress, Leonardo worked with careful, painstaking detail using the tip of a brush and fluid paint. He painted a fine, intricate design of a series of knots and the connecting thread can be traced from one end to the other.

⑤ ATMOSPHERE

One of the first portraits to depict a sitter before an imaginary landscape, Leonardo broke new ground in portraying aerial perspective – a blurring in the distance adds an illusion of depth. The muted colours and hazy outlines of the vast landscape seem to recede.

⑥ SMOKY EFFECTS

Leonardo's method of depicting shadows and other tonal effects is soft and smoky. His smoky style is called *sfumato*, from the Italian *fumo*, meaning smoke. Created with layers of transparent colour, this soft blending creates ambiguity and a glowing quality.

⑦ EYEBROWS

With no clearly visible eyebrows or eyelashes, the sitter may have been extremely fashionable. However, it is more likely that her eyebrows and lashes disappeared as a result of the painting's previous over-cleaning or that the pigment Leonardo used has faded.

Stealing the *Mona Lisa*

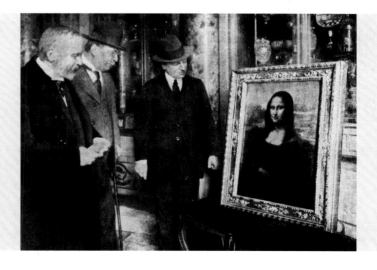

In August 1911, the *Mona Lisa* was stolen from the Louvre, but this was not discovered until the following day. Two years later, the thief was found. Louvre employee Vincenzo Peruggia had stolen the painting during regular opening hours, hidden it and then walked out with it under his coat after the museum had closed. He was an Italian patriot who believed the portrait belonged in Italy. After keeping it in his apartment for two years, he was caught when he attempted to sell it to the directors of the Uffizi in Florence. It was exhibited there first and returned to the Louvre in January 1914. Peruggia served six months in prison, but was hailed for his patriotism in Italy. Before the robbery, the *Mona Lisa* was not widely known outside the art world.

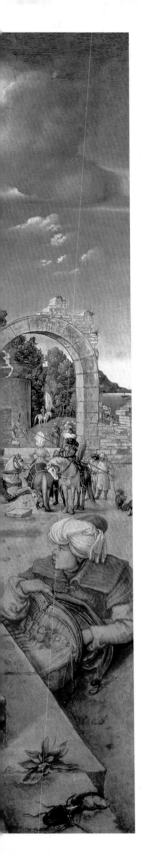

ADORATION OF THE MAGI

ALBRECHT DÜRER

1504

oil on wood
99 x 113.5 cm (39 x 44 ⅝ in.)
Uffizi, Florence, Italy

THE PRE-EMINENT PAINTER AND printmaker of his
era in Germany, Albrecht Dürer (1471–1528) established
his reputation across Europe while he was still in his twenties.
Born in Nuremberg, he apprenticed with his goldsmith
father, and the leading local painter and printmaker Michael
Wolgemut (c. 1434–1519). Dürer also mixed with prominent
German humanists. His career developed rapidly, and from a
young age he worked as a painter, printmaker, writer, illustrator,
graphic artist and theorist, became well known through his
widely distributed woodcut prints. After befriending many
of the major Italian artists of his time, including Raphael,
Giovanni Bellini and Leonardo, he introduced classical motifs
into Northern art, reinforced by his theoretical treatises. His
skills of observation were strengthened by his Northern taste
for detail and two visits to Italy, where he developed his
interests in colour, proportion and perspective.

Commissioned by Frederick the Wise, Elector of Saxony
for the altar of the Schlosskirche in Wittenberg, *The Adoration
of the Magi* is considered one of Dürer's most important
paintings from the period between his visits to Italy from
1494 to 1495 and 1505 to 1507.

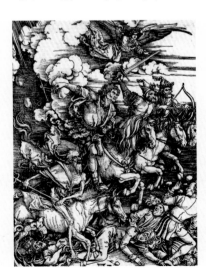

The Four Horsemen of the Apocalypse,
**Albrecht Dürer, 1498, woodcut, 39 x
29 cm (15 ¼ x 11 ½ in.), Metropolitan
Museum of Art, New York, USA**

This is the most famous of the fifteen
woodcuts that make up Dürer's series
The Apocalypse. It is his illustration
from the Book of Revelations. The
story had been a relatively restrained
image in previous illustrated Bibles,
but through his composition and
mastery of visual effects, Dürer
created action and excitement.

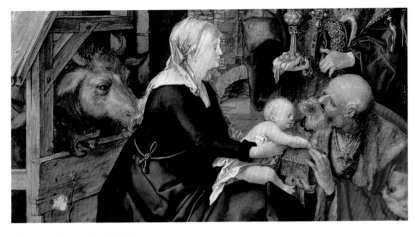

❶ FOCAL POINT

Behind Mary are an ass and an ox, clearly drawn from life. Mary is wearing a deep blue gown, with a white veil on her head. She holds out the baby Jesus, who is wrapped in her veil, to the eldest, balding, bearded king. He kneels close, seeming to talk gently to the child, offering him a golden casket, which the baby clutches in his right hand. The figures have strong, dignified faces that have been modelled with care.

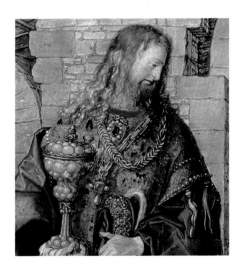

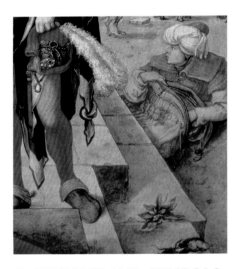

❷ BACKGROUND AND SKY

Dürer created a setting of crumbling, ancient arches in exacting perspective. The classical, ruined buildings represent the idea of Christianity rising from the ruins of paganism. The sky is almost scientific in its detail. The painting gave Dürer the opportunity to demonstrate his dexterity with perspective.

❸ SELF-PORTRAIT

The central Magi, or king, is young with long, blond curly hair and is a self-portrait. Lavishly dressed, with intricate detailing on his garments and adorned with precious jewels, he holds his gift, an ornate casket, which draws upon Dürer's expertise as a goldsmith. Humble, he looks towards his fellow king.

❹ SERVANT AND SYMBOLS

Coming up the steps behind the Magi is a servant, who appears to be taking more gifts from a bag. In front of the servant, sprouting from between the paving stones is a plantain plant, well known at the time for its healing properties, but more specifically, it represented the path of Christians towards Christ.

Fascinated by nature, Dürer believed that the study of the natural world would help him achieve the realism he aimed for in his art. He wrote: 'Nature holds the beautiful, for the artist who has the insight to extract it. Thus, beauty lies even in humble, perhaps ugly things. . . .'

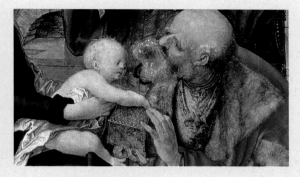

⑤ DRAWING FROM LIFE

Dürer loved to include details, landscape and natural forms. Even the horses in the background of the Magi's entourage move naturally and appear credible. Dürer carefully recorded everything he represented from life, and whether in prints or drawings – or, as here, in his painting – showed every hair, whisker and leaf.

⑥ COLOUR

Dürer's work demonstrates his knowledge of the Italian Renaissance, and he clearly absorbed many of the developments of Italian art. The influence of Venetian colour is particularly apparent in the strong contrasts of reds, greens and blues.

⑦ CONVENTIONS

A prestigious commission for a royal patron, this painting was nevertheless for the Church, so Dürer could not exercise the freedom he had with his *Apocalypse* woodcuts. Instead, he was constrained to work within the accepted parameters for representing a story that had developed from medieval times. By Dürer's time, it was the convention to represent the three ages of man in the forms of the Magi, with the eldest usually kneeling in homage to the holy infant.

Frari Triptych, Giovanni Bellini, 1488, oil on panel, 184 x 79 cm (72 ½ x 31 in.), Santa Maria Gloriosa dei Frari, Venice, Italy

At the age of twenty-three, from 1494 to 1495, Dürer spent several months in Venice, where he became familiar with the aesthetics of the Italian Renaissance. There, he became acquainted with various artists including the Venetian painter Giovanni Bellini. Dürer's esteem for Bellini is documented in several letters, where he relates how Bellini treated him with respect and admiration. Among many of Bellini's works that inspired Dürer, this altarpiece, the *Frari Triptych*, places carefully depicted Saints Nicholas and Peter (left) and Saints Mark and Benedict (right) on either side of the enthroned Madonna and Child, displaying exacting representations of figures and perspective. Bellini is thought to have designed the painting's wooden frame. The intense colours, strong tonal contrasts, detailed architectural representation, effects of light and realism were especially influential on Dürer.

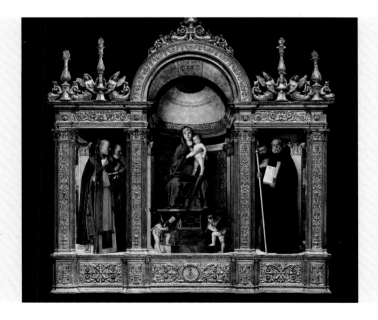

SAN ZACCARIA ALTARPIECE

GIOVANNI BELLINI

1505

oil on canvas transferred from wood
402 x 273 cm (200 ¼ x 107 ½ in.)
San Zaccaria, Venice, Italy

GIOVANNI BELLINI (*c.* 1431–1516) was the best known
of the Bellini family of Venetian painters, who included his
father Jacopo and his brother Gentile, as well as his brother-
in-law Mantegna. Jacopo, who studied with Gentile da
Fabriano (*c.* 1370–1427), brought the principles of Renaissance
Florence to Venice, yet Giovanni revolutionized Venetian
painting, developing the intense colourings for which it
became known. His paintings are sumptuous works of colour
and tonal contrasts, and his influence was powerful, especially
on his pupils Giorgione and Titian.

In his early paintings, Bellini used tempera to produce
engaging Madonnas and other religious images, illuminated
by natural light effects. In 1475, he met the Sicilian painter,
Antonello da Messina, who stayed in Venice that year, and
the two artists were mutually influential. The art historian
Vasari credits Antonello with the introduction of oil painting
into Italy and it was then that Bellini changed to oils from
tempera. Unlike tempera, the rich colours and transparency
of oil paints allowed him to apply thin layers, creating subtle
blends of colour and tone. In 1479, he continued his brother's
paintings of historical scenes in the hall of the Great Council
in Venice; but although they earned him his reputation, which
lasted throughout his six decades of painting, they were
destroyed when the hall was gutted by fire in 1577. Meanwhile,
Bellini continued painting important commissions, portraying
both idealism and realism, close details, enigmatic scenes and
light-filled landscapes, and he became particularly celebrated
for his ability to convey subtle human emotions. His long and
successful career was propelled by his ability to assimilate new
painting techniques into his work. In 1506, Dürer wrote of him:
'He is very old, and still he is the best painter of them all.'

Positioned above a side altar in the Church of San Zaccaria
in Venice, the *San Zaccaria Altarpiece* is also known as the
Virgin and Child Enthroned with Saints. It appears to be set in
a large niche, depicting a *sacra conversazione* with the Madonna
and Child enthroned, an angel and four saints surrounding
them, including Peter the Apostle, Catherine of Alexandria,
Lucy and Jerome.

San Cassiano Altarpiece, **Antonello da Messina,
1475–76, oil on panel, 56 x 35 cm (22 x 13 ¾ in.),
Kunsthistoriches Museum, Vienna, Austria**

Originally a larger altarpiece, this now comprises only
the central panel with the Virgin Enthroned and four
saints. Painted while Antonello da Messina (*c.* 1430–79)
was in Venice, it is believed to have been inspired by
one of Bellini's altarpieces, and subsequently influenced
Bellini and other Venetian artists. Even though in
fragments, the work's realism and monumentality
is apparent. The four saints featured are Nicholas of
Bari, Mary Magdalene (or perhaps Ursula), Lucy and
Dominic. The pyramidal composition is dramatized by
powerful light effects and precise details, picked out in
smooth, imperceptible brushstrokes. Antonello's glazing
with oil paints, clear colours and focus on natural light
gave Bellini's work a new dimension.

② HOLY FIGURES

A *sacra conversazione* traditionally represents a gathering of holy figures who did not necessarily live at the same time in history. For example, on the left of the painting are St Peter from the 1st century, and from the 4th century, St Catherine of Alexandria. Bellini depicts a landscape on the left of the figures, which enabled him to suggest a scene bathed in natural light.

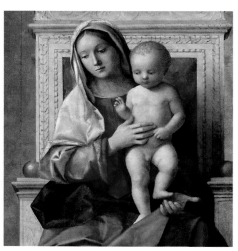

③ MADONNA

The Virgin Mary's tender and contemplative face reminds viewers that she knew her son's fate but accepted it. Bellini's lifelike and thoughtful expressions and gentle gestures appealed particularly to contemporary tastes. Here, the gracious and elegant young Virgin sits with her naked baby on her lap. He lifts his hands to bless worshippers who would be praying in front of the altar.

④ MUSICAL ANGEL

Sitting on the steps at Mary's feet is an angel dressed in green and pink playing a viola. Her presence and activity represents the general preference of Venetians for sensual pleasures over scholarly ones. The surrounding figures are shown with lowered or inclined heads and appear to be listening to the music the angel is playing, except for St Jerome, who is reading.

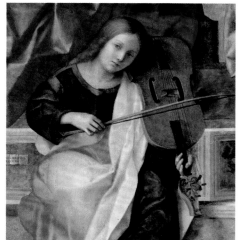

① ARCHITECTURAL DETAILS

Bellini painted this with great delicacy and realism to create the illusion that the altarpiece has been built into the architecture of the building. Visually convincing, a soft radiance touches everything, and churchgoers would approach the side altar and experience the scene as if it was happening before them.

Once Bellini exchanged tempera for oils, his work took on a richer intensity. His application of translucent glazes meant that he could create details and realism that had not been possible before, all bathed in a naturalistic glow.

⑤ PAINT APPLICATION

Oil paints allowed Bellini to create seamlessly blended shadows and highlights in smooth layers. Slower-drying than tempera, oils enabled him to use a relatively reduced palette and deftly blend colours together to create a wide range of natural-looking tones. He built up light and shadow with close attention to real life and a delicate layering of paint.

⑥ TEXTURES

St Lucy, from the 4th century, wears a gown of shimmering pale blue silk with gold patterning, overlaid with a similarly glistening brown cloak. Bellini's deftness in portraying variegated textures is apparent, for example, in St Jerome's soft red garments, heavy book and fuzzy beard, St Lucy's gold rope belt and the stone wall behind them.

⑦ COMPOSITION

Bellini draws on the Renaissance tradition of pyramidal groupings of figures, with the Virgin and Child forming the apex, seemingly set back in the picture plane. This was enhanced by the accurate implementation of one-point linear perspective, which can be followed in the orthogonal lines of the floor tiles to their vanishing point near Mary's foot.

Detail from *Madonna and Child*, Albrecht Dürer, *c.* 1496–99, oil on panel, 52 x 42 cm (20 ⅝ x 16 ⅝ in.), National Gallery of Art, Washington, DC, USA

Bellini's work has a high degree of realism with a harmonious and balanced presentation of colour and light, close attention to detail, a working knowledge of architecture and a skilful dissolving of outlines. As well as inspiring and changing Venetian art, Bellini influenced German art, and particularly Dürer's work after he visited Italy in 1494. The influence can be seen clearly in Dürer's painting here of the Virgin and Child, with the pyramidal composition, athletic-looking holy infant, sculptural modelling of figures, and the strong red and blue colours emphasizing Mary's shape. The approach went on to inspire other artists of northern Europe. The open window reveals a detailed view of an Alpine landscape.

SISTINE CHAPEL CEILING

MICHELANGELO

1508–12

ONE OF THE MOST exalted artists of all time, whose influence has remained undiminished, Michelangelo Buonarroti (1475–1564) was a sculptor, painter, architect and poet with a prodigious output. Born in Caprese, Tuscany, to a family of moderate means, Michelangelo was apprenticed to Ghirlandaio, and then studied in the Medici palace sculpture gardens. Although he saw himself as a sculptor, his paintings

and architecture were equally accomplished. Soon recognized for his artistic virtuosity, he was the first Western artist to have biographies published during his lifetime. One was by Vasari, who claimed that 'he was the pinnacle of all artistic achievement.' He became nicknamed 'Il Divino' (the Divine One) and his style was described as his *terribilità*, which translates as 'awe-inspiring grandeur'.

fresco
40 x 13.5 m (132 x 44 ft)
Apostolic Palace, Vatican City

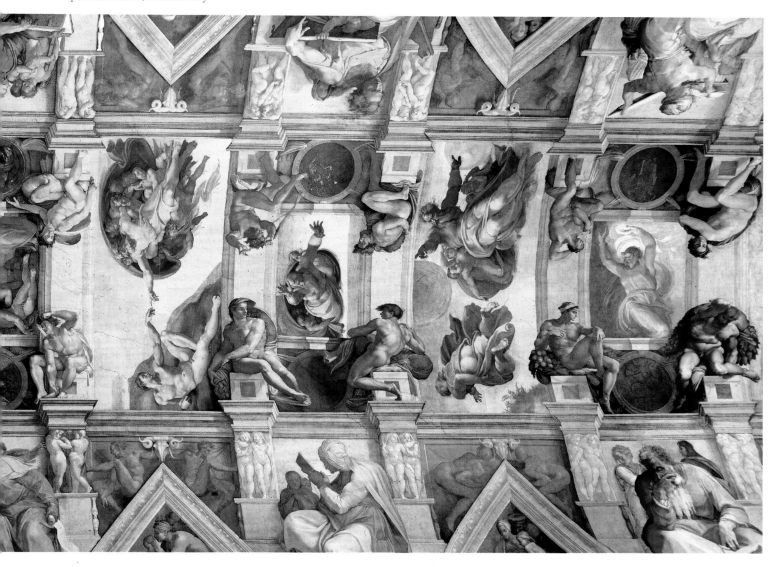

Michelangelo was commissioned to paint the twelve apostles on the ceiling of the Sistine Chapel in the Vatican by Pope Julius II in 1508. Already decorating the chapel were wall paintings by artists including Botticelli, Ghirlandaio and Perugino, and tapestries by Raphael. Inexperienced in fresco painting, he suspected the commission was a plot by jealous rivals to make him look foolish. He expressed his frustration with the task allotted to him, declaring: 'I am not a painter!' Michelangelo completed the vast and dramatic work, unveiling it on All Saints' Day in 1512. A rhythmic division of the ceiling into large pictures and smaller, flanking scenes, it is a unique representation of stories from the Book of Genesis, including 343 figures. His jewel-like palette, chiaroscuro and broad, clearly defined outlines make each subject easily visible from the floor.

❶ THE DELUGE

The earliest images that Michelangelo painted were complex, comprising many figures as here. Noah's Ark is in the background, surrounded by people fleeing the Great Flood. The ark is an allegory of the Church – a place of salvation. Elsewhere, people are trying to escape the rising waters, clutching what possessions they could, such as a frying pan, a stool and a loaf of bread. Some carry each other, others huddle together under an inadequate shelter. A small boat is about to capsize.

❷ THE CREATION OF ADAM

One of the most iconic images in Western art, this is the moment when God, a venerable old man, surrounded by angels, bestows life on Adam by reaching out to touch his hand. Adam, looking directly into God's eyes, is physically perfect, an example of Michelangelo's classical idealization of figures – especially the male nude. His figures, poses and gestures often derive from examples of ancient Greek and Roman sculpture, while strong tonal contrasts emphasize his understanding of form as a sculptor.

❸ THE CREATION OF EVE

In Michelangelo's version of this moment, Eve is not created from one of Adam's ribs as stated in the Bible, but at a sign from God. She emerges from behind the sleeping Adam; a complete woman. She seems surprised, but thanks her creator, an upright, elderly man with a flowing beard, swathed in a voluminous cloak. This was one of Michelangelo's later sections of the ceiling, where he painted only the essential figures. He designed his own scaffold, a flat wooden platform on brackets built out from holes in the wall near the top of the windows.

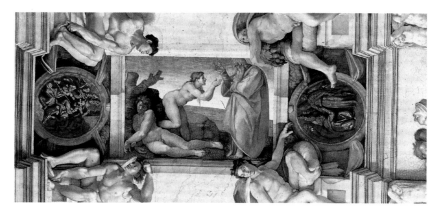

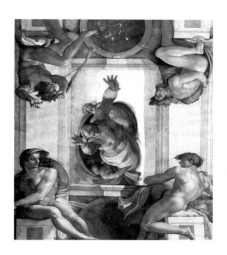

4 METHOD

At the start of this commission, Michelangelo decided that traditional fresco methods did not suit him, and he questioned the abilities of his assistants, so he developed individual methods and painted the whole work virtually by himself, using scaffolding secured close to the roof. He painted standing, tilting his head uncomfortably backwards.

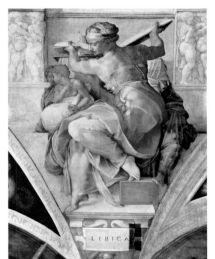

5 THE SIBYLS

Around the centre of the ceiling are twelve prophetic figures all representing the coming of Christ. Seven are Old Testament Prophets, five are the female Sibyls of the classical world. The Sibyls show that Jesus came for everyone, not just the Jews. This is the Libyan Sibyl, half mortal, half divine. As with all Michelangelo's figures, this was modelled on a male. With powerful, naked shoulders and arms, she holds up a book.

6 PLASTER

Michelangelo produced this as a 'true' or *buon fresco*, when paint is applied to damp plaster. The final thin layer of plaster is called *intonaco*, but his first attempt went mouldy, as his *intonaco* was too wet, so he had to redo it. His new plaster formula resisted mould. Only small sections of *intonaco* were made at a time, each section being called a *giornata*, for a day's work.

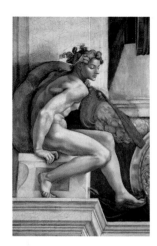

7 NUDES

From the Italian adjective *nudo*, meaning naked, *ignudi* is a word used by Michelangelo to describe twenty seated male nudes he incorporated into the work. Each represents an idealized male human figure, with no connection to the Bible. They sit at the edges of the ceiling, reacting to nearby scenes. This one looks down on the drunkenness of Noah.

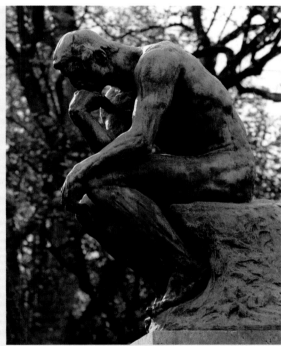

The Thinker, Auguste Rodin, 1903, bronze, 189 cm (74 ½ in.) high, Musée Rodin, Paris, France

During his first trip to Italy in 1875, French sculptor Auguste Rodin (1840–1917) studied the work of Michelangelo. The influence lasted throughout his career, as can be seen here in his bronze of a man lost in thought. In 1889, Rodin exhibited it as an independent sculpture, and then subsequently cast it in bronze in three different sizes, including this monumental version.

THE SCHOOL OF ATHENS

RAPHAEL

1510–11

fresco
500 x 770 cm (197 x 303 in.)
Apostolic Palace, Vatican City

RAFFAELLO SANZIO DA URBINO, known as Raphael (1483–1520), was an Italian painter and architect of the High Renaissance. Especially skilled at assimilating influences and styles, his work is refined, lifelike, richly coloured and amenably composed. With Michelangelo and Leonardo, he is classified as a trinity of the greatest masters of the Renaissance. Remarkably productive, he ran a large workshop and, despite his early death aged only thirty-seven, left a large body of work.

Born in Urbino, through his artist father, the young Raphael – a child prodigy – had access to the art of one of the most powerful courts in Italy, that of Duke Federico da Montefeltro, who died the year before Raphael was born. After his father's death in 1494, it is believed that he entered the workshop of the leading painter of Perugia, Perugino. By the age of twenty-one, Raphael was in Florence and was soon perceived as the equal of the two older artists, Leonardo and Michelangelo. In 1508, while Michelangelo was painting the Sistine Chapel (see pp. 72–75) ceiling next door, Raphael had started to decorate a room in the Vatican, the Stanza della Segnatura, which was used as a library. On each wall, Raphael painted a theme to reflect the room's business: philosophy, theology, poetry and law. *The School of Athens* represents philosophy, depicting great men of the past and contemporary times.

Madonna of the Chair, Raphael, 1514, oil on panel, 71 cm (28 in.) diameter, Pitti Palace, Florence, Italy

Tondos were popular formats during the Renaissance; the term was invented at the time, deriving from the Italian word *rotondo*, meaning 'round'. This work shows Raphael's dexterity, with the Madonna and Child closely entwined. Credibility of their mother and child relationship is created through their embrace, their heads touching and the baby wiggling his toes. Behind is Christ's cousin, John the Baptist.

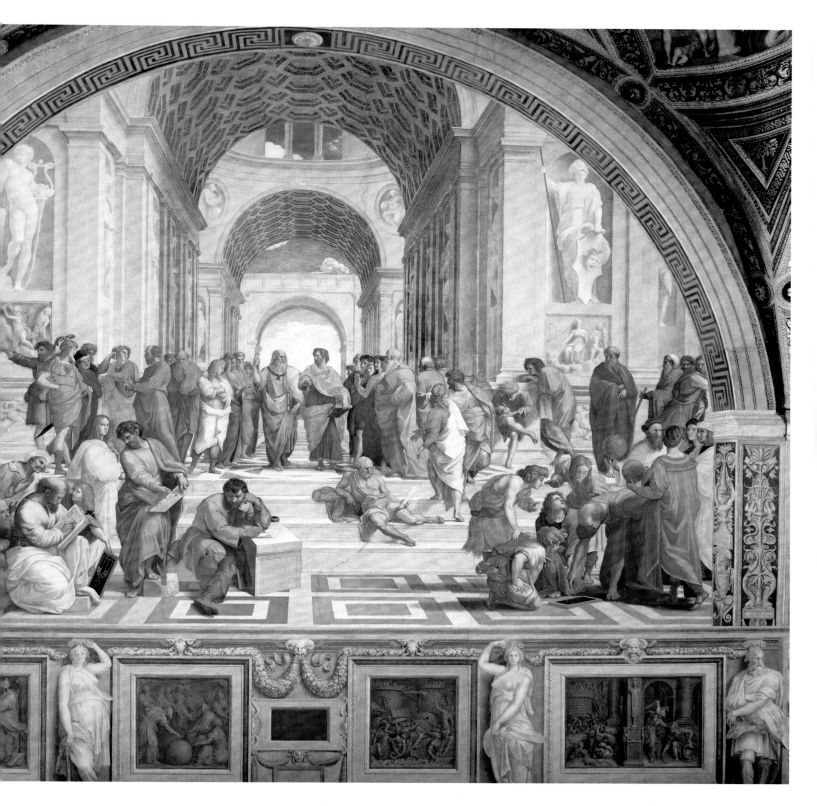

IN DETAIL

② ALEXANDER AND SOCRATES

The helmeted figure in blue is thought to be Alexander the Great, the King of Macedonia who conquered most of the ancient world, and a pupil of Aristotle. He listens intently to Socrates in an olive-coloured robe, who makes points by counting on his fingers. The group with them includes Chrysippus, Xenophon and Aeschines – all eminent philosophers.

③ DIAGORAS

The School of Athens has become seen as the incarnation of the Renaissance fascination with ancient classicism. Dashing past Critias, a 5th-century BC Athenian political writer and leader (wearing the small hat), is Diagoras, a 5th-century BC Greek poet who became an atheist after he experienced an injustice and the gods did not admonish the culprit.

① PLATO AND ARISTOTLE

At the centre of the composition are the two great philosophers of the classical world. With the face and physique of Leonardo, Plato points to the sky, holding the *Timaeus* (*c.* 360 BC) in his other hand, while Aristotle, standing beside him, points to the ground, holding a copy of *Nicomachean Ethics* (*c.* 350 BC). Their gestures indicate the contrast between Plato's idealism and Aristotle's realism.

4 THE GODDESS OF WISDOM

In a niche on the right, this is a statue of Athena in her Roman guise of Minerva, the goddess of wisdom, who presides over peace and defensive warfare. She is also the patron of institutions that are devoted to the pursuit of knowledge and artistic achievement. The design of the pattern in the arch above originated in Greek pottery and featured in friezes.

5 HERACLITUS

This lone figure on the steps was not included in Raphael's preliminary drawings. It is a portrait of Michelangelo, and represents Heraclitus, a pre-Socratic Greek philosopher, who often wept over human folly. Michelangelo was not aware that Raphael had sneaked into the Sistine Chapel to see his fresco in progress and he strictly forbade anyone seeing his work before it was finished.

6 EUCLID

The ancient Greek mathematician Euclid is teaching some of his pupils, bending over a writing slate and demonstrating one of his theories with a compass. The contemporary architect Donato Bramante was the model for Euclid here. Bramante was architectural advisor to Pope Julius II and a distant relative of Raphael's, who was responsible for his summons to Rome.

7 PTOLEMY AND ZOROASTER

Identified by his crown is the 2nd-century AD astronomer and geographer Ptolemy, holding a globe of the Earth. Ptolemy believed that the Earth was the centre of the universe. Next to him is the ancient Persian prophet Zoroaster, holding a celestial globe. By the side of Ptolemy is a self-portrait of Raphael, squeezed between figures and looking out of the picture.

The Apotheosis of Homer, **Jean-Auguste-Dominique Ingres, 1827, oil on canvas, 386 x 512 cm (152 x 202 in.), Louvre, Paris, France**

A state commission, this grand painting, *The Apotheosis of Homer* by Jean-Auguste-Dominique Ingres, depicts Homer being crowned by a winged figure personifying Victory or the Universe. Ingres conceived the idea quickly, but researched and prepared for it extensively. A symmetrical grouping of figures in front of an ancient Greek temple, it was originally described as *Homer receiving homage from all the great men of Greece, Rome and modern times.* Surrounding the poet Homer, who is presented as a god, are forty-six poets, artists and philosophers, both ancient and modern, including Raphael and Michelangelo. Ingres revered Raphael and this painting draws heavily on *The School of Athens.*

ISENHEIM ALTARPIECE

MATTHIAS GRÜNEWALD

c. 1512–16

oil on panel
500 x 800 cm (198 x 312 in.)
Musée d'Unterlinden, Colmar, France

ONLY TEN PAINTINGS AND thirty-five drawings survive
by Matthias Grünewald (1470–1528), a German painter
who became one of the greatest 16th-century Renaissance
artists, and who ignored the popularity of classicism, instead
creating paintings in the late Gothic style. After his death,
his reputation became obscured until the late 19th century,
and much of his work was attributed to Dürer, even though
their styles are quite different. Born in the city of Würzburg,
Grünewald was successful as both an artist and engineer and
for a time was employed regularly at the court of the Elector
of Mainz, Archbishop Uriel von Gemmingen, but unusually
for a painter of his significance and recognition in his lifetime,
little has been documented about him.

This altarpiece was painted for the monastic order of
St Anthony at Isenheim for the hospital chapel. It can be
viewed in three ways. When closed, the central panel shows
the Crucifixion, with side panels depicting St Anthony and
St Sebastian. Other views show the Annunciation and
Resurrection, and a pre-existing carved wooden altarpiece
flanked by Grünewald's paintings of the Temptation of
St Anthony and the Meeting with Anthony and Paul.

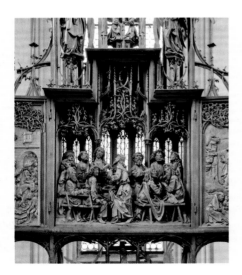

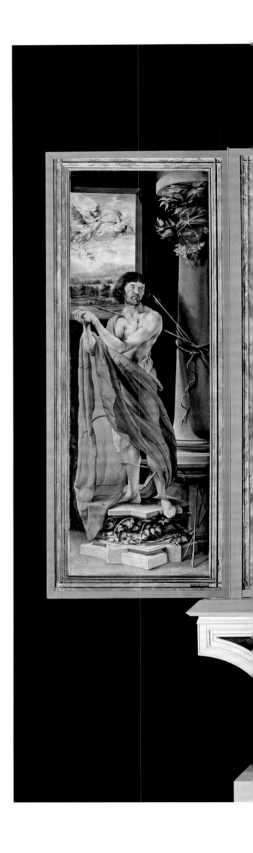

**Detail from *The Holy Blood Altar*, Tilman
Riemenschneider, 1501–05, carved
limewood, 1,050 x 600 cm (420 x 234 in.),
St Jakob's Church, Rothenburg, Germany**

This intricately carved altarpiece depicts
the Last Supper. Holding a purse, Judas is
in the centre talking to Jesus, who has just
announced that a traitor is among them.
Tilman Riemenschneider (*c.* 1460–1531)
was a German sculptor and woodcarver.
His expressive, detailed forms and modelling
show similarities to Grünewald's paintings,
especially their focus on medieval traditions.

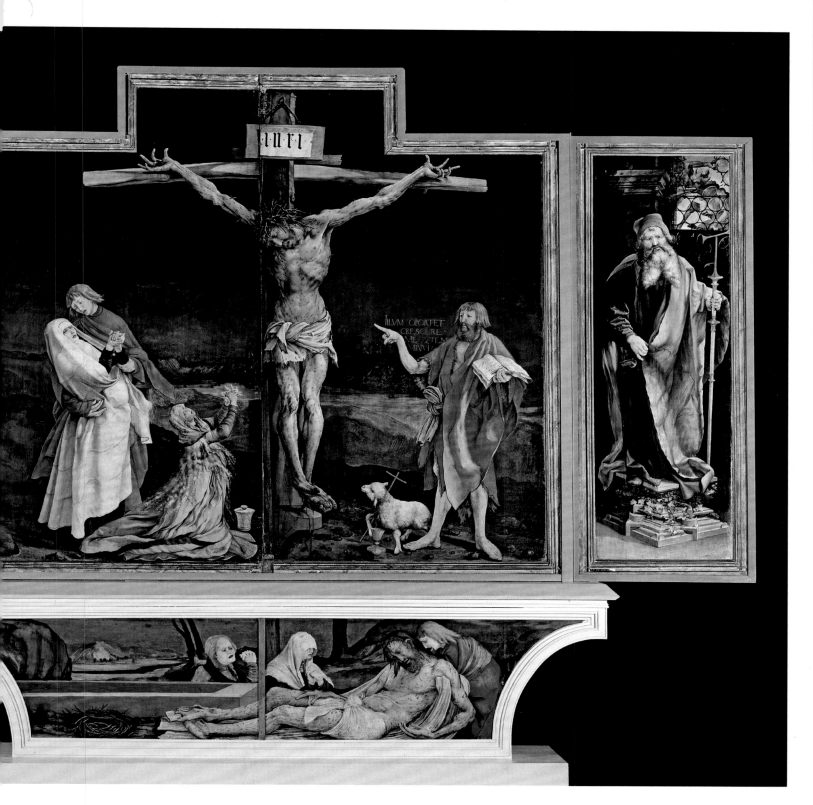

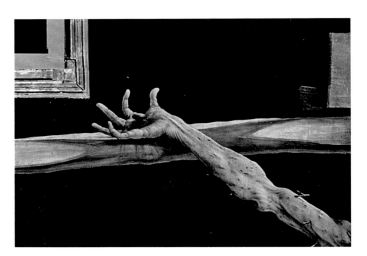

② EXPRESSIVE HANDS

Christ's physical suffering is emphasized as he writhes in agony. His hands, pinned with large nails to the cross, are especially expressive and attract attention with their curling, pointed fingers that stress the torment and pain he has just experienced. Chiaroscuro creates a sculptural effect that can be seen to be influenced by the carved wooden altarpieces that abounded in Germany at the time.

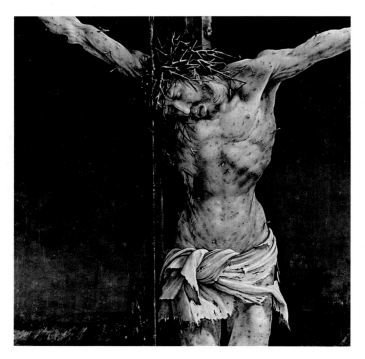

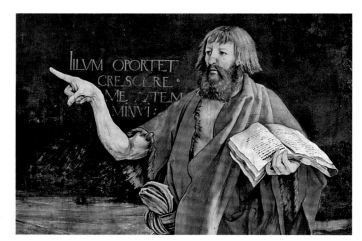

① JESUS

This is the front of Grünewald's altarpiece and was the most common view of it in the hospital. The night-time Crucifixion shows Christ, with lesions and contortions, suffering even more than the victims of disease who were praying in front of it. With a greenish tinge to his skin, Jesus is covered with splinters and sores, his limbs stretched and twisted, his extremities contorted, showing the agony of his death.

③ JOHN THE BAPTIST

Grünewald's altarpiece was intended to bring patients comfort. According to the Bible, John the Baptist was beheaded by Herod long before Christ's Crucifixion, but his presence in this painting symbolizes the message of redemption. He gestures towards Christ's body, and behind him written in Latin is the biblical text, '*illum oportet crescere me autem minui*', meaning 'He must increase, but I must decrease', suggesting he has done his work.

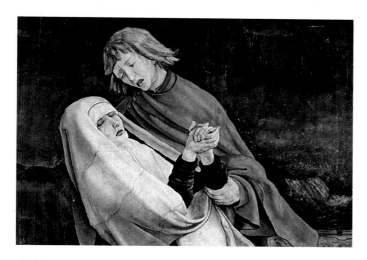

④ THE VIRGIN AND ST JOHN

Using a hierarchy of scale that was common in medieval art, the Virgin Mary and John the Evangelist are smaller than the figure of Christ in the centre. Before he died, Jesus asked John the Evangelist to look after his mother, and here, John holds the grieving woman, as overwhelmed, she swoons. The emphatic physical suffering of all in the image was intended to reassure patients in the hospital.

⑤ ST ANTHONY THE ABBOT

Skilled in the depiction of light, Grünewald portrays the patron saint of the religious order that ran the Isenheim hospital. St Anthony the Abbot was a Christian monk from Egypt. He is appealed to in order to protect against infectious diseases, particularly those of the skin, such as ergotism, popularly known as 'St Anthony's fire'. Behind him, a monster, representing the Black Death, breaks the window and breathes his poison.

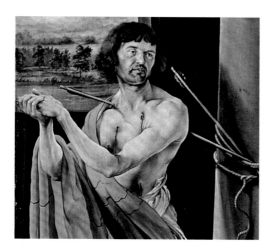

⑥ ST SEBASTIAN

Sebastian was a Roman soldier who converted to Christianity. As a punishment, he was tied to a pillar and shot at with arrows. He survived and told the emperor that he remained a Christian. As a result, he was put to death; because his body was marked by arrows, he became seen as a protector against the plague.

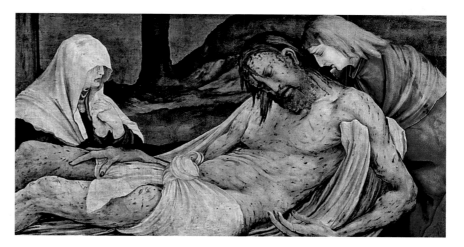

⑦ THE LAMENTATION

The predella panel is set below an altarpiece and is intended to supplement and augment the image and message of the main panel. This is the Lamentation, the time after Christ's lifeless body has been brought down from the cross and is about to be buried. Grünewald's representation of the corpse continues his emphasis on physical suffering with its horrifically festering, pock-marked and splintered skin. This image is presented as an invitation to contemplate one's mortality. Plague was rife during Grünewald's time – and was what eventually killed him.

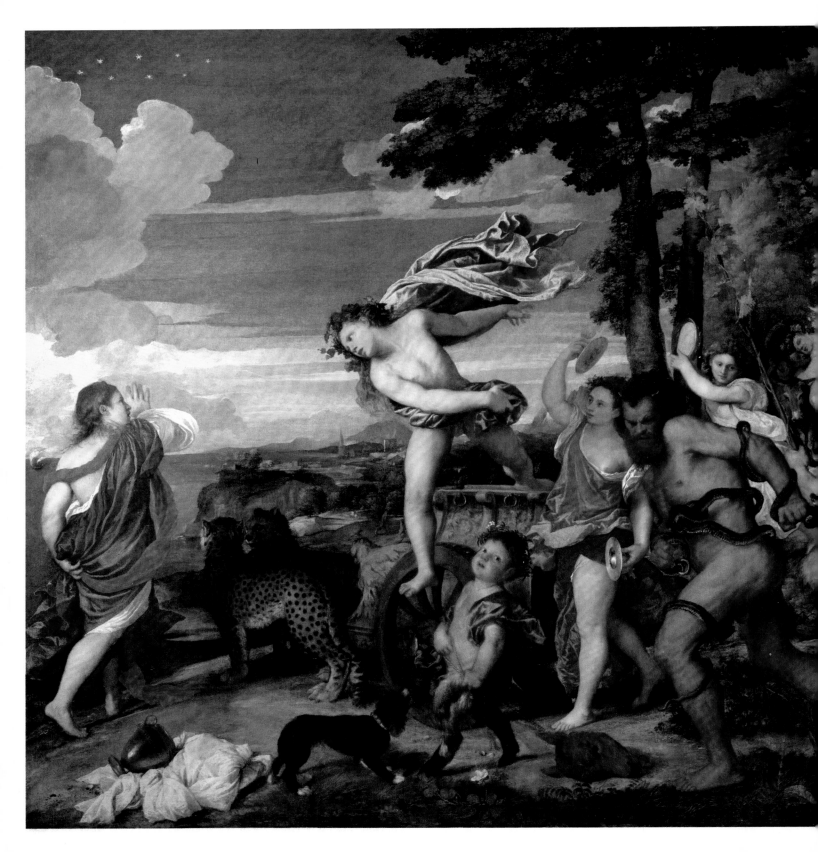

BACCHUS AND ARIADNE

TITIAN

c. 1520–23

oil on canvas
176.5 x 191 cm (69 ½ x 75 ¼ in.)
National Gallery, London, UK

ONE OF THE MOST influential artists of the 16th century, who introduced the High Renaissance to Venice, and was the first painter to achieve international fame, Tiziano Vecellio, known as Titian (*c.* 1488–1576), was based in Venice for his entire life. He became recognized for his experimentations with many different painting styles, his brilliant colours, complex compositions, fluid brushwork and portrayals of the clear light of his city, building on the examples of Giovanni Bellini to whom he was apprenticed and Giorgione, with whom he worked as an assistant.

Born in humble circumstances in Pieve di Cadore, a small town near Venice, Titian was exceptionally versatile, equally adept at painting portraits and mythological and religious subjects. Over the course of his sixty-year career, he became described as 'The Sun Amidst Small Stars' after the final line of Dante's *Paradiso* (*c.* 1308–20). He was patronized by the Venetian state, the papacy and major rulers across Europe, including the Holy Roman Emperor Charles V and his son, King Philip II of Spain, as well as other influential figures, and he unrelentingly strove to raise the status of artists from mere craftsmen to respected professionals. His loose brushwork, suggestion of atmosphere and his use of colour in particular, exerted a profound influence on both contemporary and subsequent artists.

One of five paintings commissioned by Alfonso I d'Este, the Duke of Ferrara, to decorate the Alabaster Chamber in the ducal palace, this is one of Titian's most dynamic and vibrantly coloured works, illustrating a mythological story by the Roman poets Catullus and Ovid. Princess Ariadne, the daughter of the King of Crete, abandoned her home to follow the Athenian hero Theseus, with whom she had fallen in love. Although she helped him to kill the terrifying Minotaur at the Palace of Knossos, Theseus heartlessly abandoned her while she slept on the island of Naxos. Heartbroken, she looks out to sea to watch her lover's ship sailing away, when Bacchus, the god of wine, comes along with his entourage. Seeing her, he leaps from his chariot, instantly in love. When she turns to see him, she too falls in love with him at first sight.

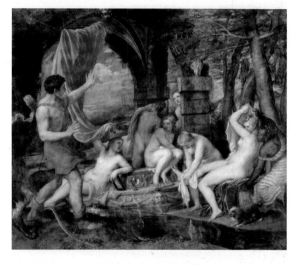

Diana and Actaeon, Titian, 1556–59, oil on canvas, 184.5 x 202 cm, (72 ⅝ x 79 ⅝ in.), National Gallery, London, UK

Painted more than thirty years after *Bacchus and Ariadne*, this work shows Titian's mature style of more fluid, expressive brushwork and softer, often deeper, or subtler colours. Made for Philip II of Spain while he was reluctantly married to Mary Tudor, the Queen of England, Titian deliberately emphasized the voluptuousness of the young women to amuse him. The painting is one of six mythological scenes from Ovid's *Metamorphoses* (AD 8). Actaeon, a young, handsome hunter has accidentally walked in on the virtuous goddess Diana, while she bathes with her entourage of nymphs. He tries to look away, but it is too late, Diana has seen him.

❷ ARIADNE

Interrupted from her tearful realization that her lover has deserted her, Ariadne is overwhelmed by the rowdy group approaching. Twisted away from viewers, her hand raised to wave to her lover's departing ship, she sees Bacchus, and Theseus is forgotten in a moment. Titian, a famed colourist, used costly ultramarine for the vibrant blue of her robe.

❶ BACCHUS

Powerful, energetic and in a contrapposto pose that echoes Ariadne's, Bacchus is discernible by his crown of laurel and vine leaves. The Roman god of wine is fun loving, young and powerful, and the focal point of the image as he leaps from his chariot in one lively movement.

❸ CHEETAHS

Underscoring the notion of love at first sight, Titian's cheetahs gaze into each other's eyes. Using real cheetahs as his models, he captured the appearance of their fur, delicate markings and strong bodies. Alfonso d'Este, this painting's patron, had a menagerie of animals and Titian included his cheetahs as a compliment because traditionally, leopards pulled the chariot.

❹ LAOCOÖN

As the god of wine, Bacchus was characteristically lively and always surrounded by revellers. This muscular man wrestling with a snake, is based on an ancient Roman statue of the Trojan priest, Laocoön who with his two sons, was attacked by giant serpents sent by the gods. Rediscovered in 1506, the statue caused a sensation, with many Renaissance artists featuring elements of it in their work.

One of the first artists to exploit the expressive possibilities of oil paint, Titian used the finest pigments because his patron was extremely wealthy. This painting glows with colour and exuberance through his expressive application and dynamic composition.

⑤ COLOUR

Titian's palette includes ultramarine in the azure sky, Ariadne's deep blue robe and the cymbal-player's skirt. He created bright reds and pinks with vermilion and crimson lake. He also used realgar, which is a reddish-orange mineral, and lead-tin yellow, which is an oxide of lead. The greenery is made with malachite and copper resinate.

⑥ SIGNATURE

The bronze urn resting on the crumpled yellow fabric (painted predominantly in lead-tin yellow), bears a Latin inscription: '*TICIANUS F(ecit)*', which translates as 'Titian made this'. For an artist to sign his name on his works was rare at that time, and Titian was one of the earliest artists to do so in an attempt to raise artists' reputations.

⑦ COMPOSITION

A classical X-shaped composition, this is handled in an original way. Most of the activity is on the right as the merrymakers cavort through the Greek countryside. Bacchus's right hand is at the centre of the painting, but he leans towards Ariadne on the left part of the composition. High above her is the eight-star constellation that she will become.

The Adoration of the Shepherds, Giorgione, 1505–10, oil on panel, 91 x 110.5 cm (35 ¾ x 43 ½ in.), National Gallery of Art, Washington, DC, USA

One of the greatest artists of the Renaissance, Giorgio da Castelfranco, known as Giorgione (*c.* 1477–1510), had considerable influence although he died young. Little is known about his life and only a few paintings can be definitively attributed to him. He studied with Giovanni Bellini, was influenced by Leonardo, and possibly taught Titian and Sebastiano del Piombo (*c.* 1485–1547). There are many similarities in Titian and Giorgione's styles. This composition, for instance, is a traditional X-shape, full of action on the right but more open on the left, with a glowing ultramarine sky and a vivid Venetian landscape. Joseph and Mary's garments gleam against the dark background. Similar to *Bacchus and Ariadne*, there are unexpected elements: the shepherds occupy the central position rather than the child.

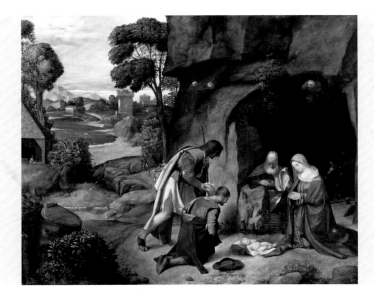

THE AMBASSADORS

HANS HOLBEIN THE YOUNGER

1533

oil on oak panel
207 x 209.5 cm (81 ½ x 82 ½ in.)
National Gallery, London, UK

A GERMAN PAINTER, DRAUGHTSMAN, designer and printmaker, Hans Holbein the Younger (*c.* 1497–1543) was born in Augsburg, southern Germany into a family of artists, and began training with his father, Hans Holbein the Elder (*c.* 1465–1524). From 1515, he lived in Basel, Switzerland, where he became the leading painter, producing murals, religious paintings, designs for stained-glass windows, book illustrations and occasional portraits. When the Reformation reached Basel, he worked for reformist clients as well as Catholic patrons. His Late Gothic style was augmented by artistic influences from Italy, France, the Netherlands and from humanism. He spent two periods of his life in England, from 1526 to 1528, and again from 1532 until the end of his life. His compelling realism secured him the role of King's Painter to Henry VIII from 1535, for whom he also designed precious items including jewelry and festive decorations. His portraits of the Tudor court are a record of the period when Henry was asserting his supremacy over the Church in England.

A meticulously rendered double portrait, *The Ambassadors* depicts two wealthy, educated and powerful young men. Jean de Dinteville was a French nobleman, posted to London as ambassador, while his friend Georges de Selve was a brilliant classical scholar and diplomat to the papacy, who had been created Bishop of Lavaur some years earlier. Dinteville commissioned the painting to hang in his family home, a château near Troyes in France. A subtle blend of realism and idealism, the portrait includes numerous symbols to give insight into the lives and personalities of the subjects. De Selve visited his friend in London in the spring of 1533 and, ostensibly, the painting was commissioned to mark the occasion. Yet the underlying meaning of the painting is unclear. The scientific and musical instruments shown testify to the men's learning and culture. However, many of the instruments have settings that pertain to Good Friday in 1533, which was 1,500 years after the Crucifixion. When considered alongside the allusions to death in the picture, such as the distorted skull in the foreground, this suggests that the painting had a deeper religious purpose.

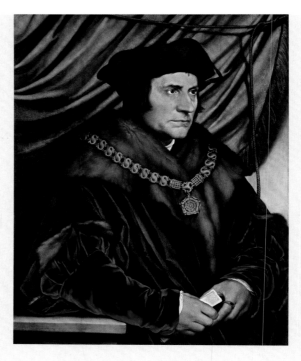

Portrait of Sir Thomas More, **Hans Holbein the Younger, 1527, oil on oak panel, 75 x 60.5 cm (29 ½ x 23 ¾ in.), Frick Collection, New York, USA**

With a letter of introduction from Desiderius Erasmus, a Dutch humanist, Catholic priest, teacher and theologian, Holbein travelled to London from Switzerland in 1526, where he became part of Thomas More's circle. A year later, Holbein completed this portrait of the influential humanist, scholar, author and statesman. With his intense colours and intricate details, Holbein presents More robed in rich velvet and fur, with a gold chain of office displaying his status and service to the king. When this portrait was painted, More was Chancellor of the Duchy of Lancaster.

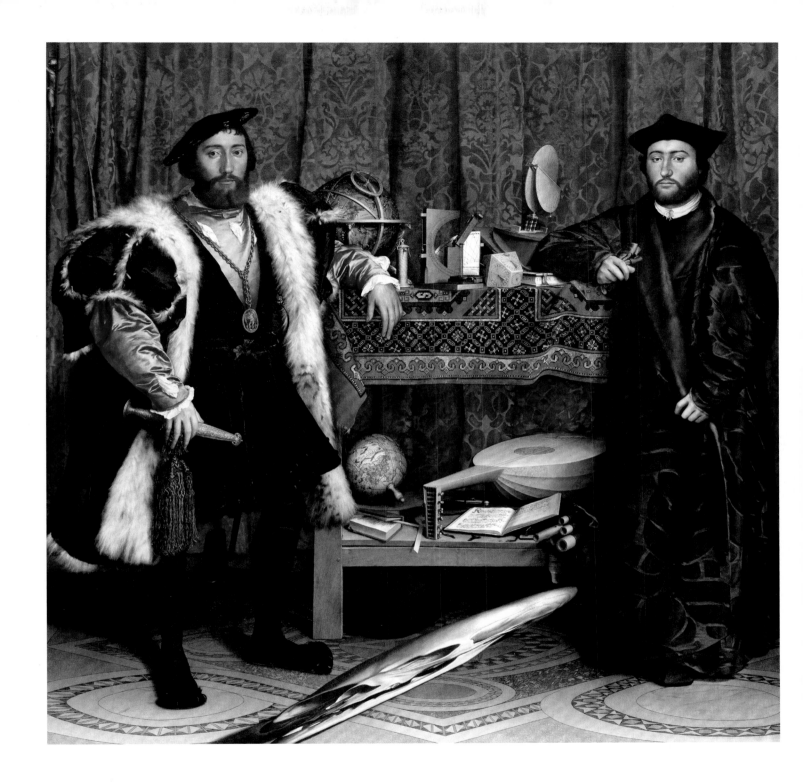

❷ LUTE

Any instrument in a Renaissance painting symbolizes harmony, but with its broken string, this lute is a comment on the discord between Catholics and Protestants. The hymn book is open at the page of 'Come, Holy Ghost' and the Ten Commandments, which express beliefs that both Catholics and Protestants share – so it is a hint about trying to remain harmonious.

❸ GLOBE

Positioned to show the countries that were important to Dinteville and De Selve, Europe is in a prominent position, Africa is below it, and Rome is in the centre. Although copied from an actual globe, Holbein altered elements and included features such as the name of Dinteville's château in Polisy, France, where the painting was destined to hang in the grand salon.

❹ DINTEVILLE

Dinteville was a member of the French nobility. He inherited his position as a member of the Order of St Michael. At the French court, he met De Selve. Dinteville's family motto was '*Memento mori*' meaning 'Remember thou shalt die' and as the patron of this portrait, elements of that sentiment are emphasized. He wears the chain of the Order of St Michael.

❶ HIDDEN CRUCIFIX

The crucifix, almost hidden behind the green brocade curtain is there to suggest Christ's presence in the lives of the two ambassadors. It is included for reassurance that their endeavours are being overseen and guided. However, it is also a warning: live a Christian life, because after death it will be too late.

⑤ SCIENTIFIC INSTRUMENTS

The two men rest their elbows on an item of furniture called a 'whatnot'. On top of it is a Turkish carpet and a group of scientific objects, suggesting the culture and discoveries of the age, and indicating that the subjects are men of learning. The objects include a celestial globe and a portable sundial.

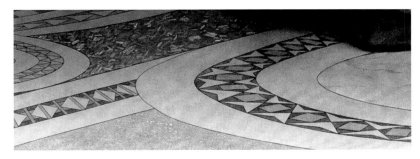

⑥ MOSAIC FLOOR

This is an accurate copy of the medieval mosaic of the floor in London's Westminster Abbey. It shows Holbein's expertise in depicting foreshortening, and gives viewers a credible sense of depth. It is an intricate pattern and demonstrates how far the portrayal of linear perspective had developed.

⑦ DISTORTED SKULL

In the foreground is an anamorphic, or distorted image, of a skull. The extreme foreshortening renders the shape meaningless when viewed from the front, but when seen from a point to the right of the picture, the distortion is corrected. It is an example of a *memento mori*, or reminder of mortality.

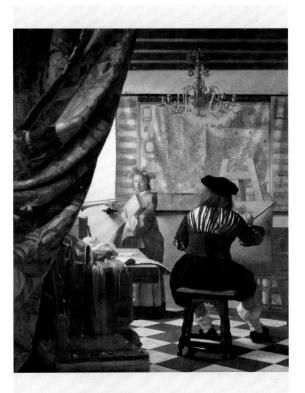

The Art of Painting, Jan Vermeer, 1665–68, oil on canvas, 130 x 110 cm (51 ⅛ x 43 ¼ in.), Kunsthistorisches Museum, Vienna, Austria

Holbein influenced generations of later artists, including Jan Vermeer. Like Holbein, Vermeer created intricate surface texture and detail. Here an artist paints a female figure in his studio, by a window, with a large map of the Low Countries on the wall. Vermeer signed the painting on the map, behind the woman's neck. It has been suggested the figure painting is a self-portrait of Vermeer. A tapestry hangs like a heavy curtain across the left of the painting, covering a corner of the map, a small part of the trumpet, and part of the table and chair. Vermeer's mastery of depicting fictive space, his suggestions of clear, natural light, the inclusion of meticulous details and precise use of linear and aerial perspective echo elements of Holbein's *The Ambassadors*.

NETHERLANDISH PROVERBS

BRUEGEL THE ELDER

1559

oil on oak panel
117 x 163 cm (46 ⅛ x 64 ⅛ in.)
Staatliche Museen, Berlin, Germany

PIETER BRUEGEL THE ELDER (*c.* 1525–69) was sometimes called 'Peasant Bruegel' after his unusual, unsentimental depictions of peasants and village life, and his habit of dressing up like one in order to socialize with them and gather material for his paintings. He also painted landscapes and religious scenes. 'The Elder' distinguishes him from his elder son. Although he is believed to have been a cultured and intelligent man, there is little evidence about his life. Born during the Protestant Reformation, Bruegel lived amid increasing religious antagonism and political manoeuvring, which eventually resulted in the outbreak of the Eighty Years' War (1568–1648) near the end of his life. In 1551, he became a free master in the Guild of St Luke of Antwerp and the following year travelled to Italy, returning through the Alps. Famed during his lifetime, he was very influential.

Proverbs were exceptionally popular in 16th-century Northern Europe, and collections of proverbs were published and prints illustrated them. Bruegel's painting *Netherlandish Proverbs* is a humorous work crammed with approximately one hundred of the most best-known idioms of the period. This style of painting busy with figures gave rise to the term *wimmelbild* to describe artworks crowded with people and animals, all involved in separate incidents.

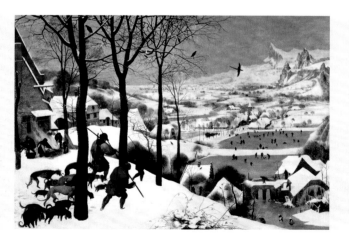

Hunters in the Snow (Winter), **Bruegel the Elder, 1565, oil on wood, 117 x 162 cm (46 ⅛ x 63 ¾ in.), Kunsthistorisches Museum, Vienna, Austria**

The first of a series of paintings illustrating the months of the year, this is January. Activity is everywhere. Skaters enjoy themselves on the frozen ponds, while elsewhere some peasants try to douse a fire.

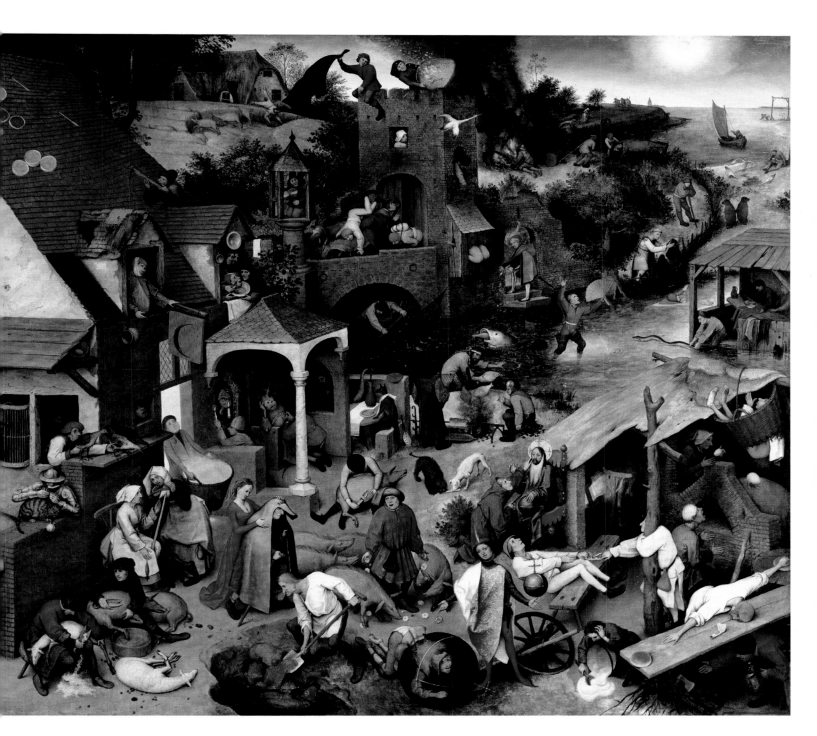

❷ HEAD BANGER

'To bang one's head against a brick wall' means to waste time trying to accomplish something that is hopeless. Here, a man with a breastplate over his nightshirt is depicted banging his head against a brick wall. Another expression illustrated here is: 'One foot shod, the other bare.' In his right hand, he holds a sword, while wearing only one shoe: he is trying to achieve the impossible and not considering the importance of balance.

❶ THE BLUE CLOAK

Running themes in Bruegel's paintings include the wickedness and foolishness of humans. The painting's original title, *The Blue Cloak or The Folly of the World*, indicates that his intention was to show human folly. The *Blue Cloak* comes from the phrase 'She puts the blue cloak on her husband', which means she deceives him. In art, blue can connote deceit. This woman in a red dress is putting a blue cloak on her husband and contemporary viewers would have understood that she was cuckolding him.

❸ THREE PROVERBS

A man in red is 'throwing his money down the drain', while a mean-spirited man resents the sun shining on the water, so is trying to block the light with a large fan. Another man behind is 'swimming against the tide', which means he is not conforming, or going against general consensus.

④ THE DEVIL

Although exploration and scientific developments meant that remarkable things were being discovered about the world, ordinary people remained superstitious. Many physical deformities, diseases and epidemics were perceived as demonic work. Here, a woman is tying a devil to a cushion, which implies that she is a nagging wife, who found it difficult to cope with the devil – or a man.

⑤ BELL THE CAT

The man 'belling the cat' is also 'armed to the teeth'. Belling a cat was a dangerous activity. In a Dutch fairy tale, it had been undertaken by a brave mouse. Here, an especially cautious man over-protects himself as he risks angering the cat. Bruegel's method of depicting his figures in noticeably diminishing size creates an illusion of depth across the busy painting.

⑥ ON THE ROOF

Those who lived together out of wedlock – or in sin – was commonly referred to as 'living under the brush'. 'Having one's roof tiled with tarts' meant to have an abundance of everything, while an archer aims arrows at the 'pie in the sky', meaning that he is being overly optimistic.

⑦ THREE BLIND MEN

Based on the biblical parable of the blind leading the blind from Matthew 15:14, this implies that fools follow each other. Three years after completing this, Bruegel painted a canvas on the subject. Here, three blind men are lost and are walking dangerously close to the edge of a cliff while holding on to each other's shoulders.

Detail from *Peasants Brawling over a Game of Cards*, Adriaen Brouwer, 1630, oil on wood, 26.5 x 34.5 cm (10 ⅜ x 13 ⅝ in.), Gemäldegalerie Alte Meister, Dresden, Germany

Influenced directly by Bruegel, Adriaen Brouwer (*c.* 1605–38) painted peasants behaving immorally. In the mid 17th century, drinking, smoking, card playing and gambling were seen as immoral and frivolous, and Brouwer builds on Bruegel's legacy with his vacant-looking, but stubborn and confident peasants. Rather than depicting them as singly foolish like Bruegel did, Brouwer shows problems in society. With brisk brushstrokes and strong colours, the work has immediate appeal. The triangular composition and the action portrayed, beginning with the man with his arm raised, are strengthened by the organization of colour and tones.

THE WEDDING AT CANA

PAOLO VERONESE

1562–63

oil on canvas
677 × 994 cm (266 ½ × 391 ⅜ in.)
Louvre, Paris, France

PAOLO CALIARI, KNOWN AS Paolo Veronese (1528–88)
was born in Verona, but based in Venice, and became famous
for large-scale history paintings of both religious and
mythological subjects, and of elaborate ceiling paintings.
With the two older painters, Titian and Tintoretto, he is
perceived as one of the great trio of 16th-century Venetian
artists. A supreme colourist, his most famous works were
painted for monastery refectories and for the Doge's Palace
in Venice. All his paintings are dramatic, with majestic
architectural settings, skilful foreshortening, vivid colouring,
exuberant light effects and lively pageantry. Originally
apprenticed to his stonecutter father, by the age of thirteen,
Veronese was training with two local painters, Antonio Badile
(*c.* 1518–60) and Giovanni Battista Caroto (*c.* 1480–1555). As
a professional painter, he ran a large workshop assisted by his
brother Benedetto (1538–98) and his sons Gabriele (1568–1631)
and Carlo (1570–96). His influence continued after his death.

Commissioned in 1562 by the Benedictine Monastery
of San Giorgio Maggiore in Venice, this monumental
painting was completed by Veronese in only fifteen months.
The transformation of water into wine at the Wedding at
Cana is the first of Christ's miracles in the New Testament.
Jesus and his mother were at a wedding when the wine ran
out and Jesus then turned water into wine.

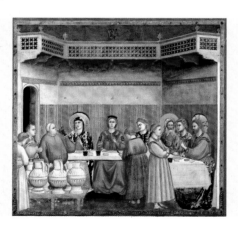

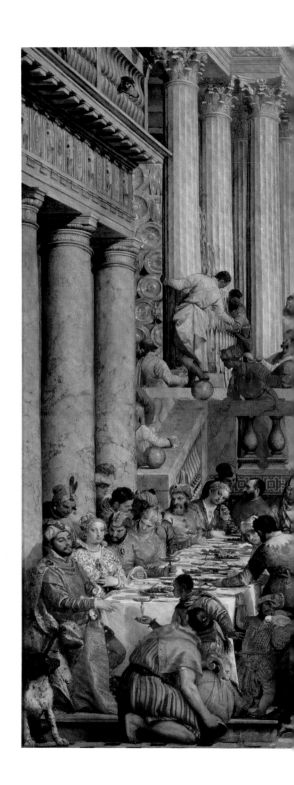

The Wedding at Cana, **Giotto di
Bondone**, *c.* 1304–06, fresco,
200 x 185 cm (78 ¾ x 72 ⅞ in.),
Cappella degli Scrovegni, Padua, Italy

This intimate wedding takes place
in a small, homely interior. Giotto
broke new ground in his attempts at
three-dimensional depictions, paving
the way for artists such as Veronese to
create more complex settings.

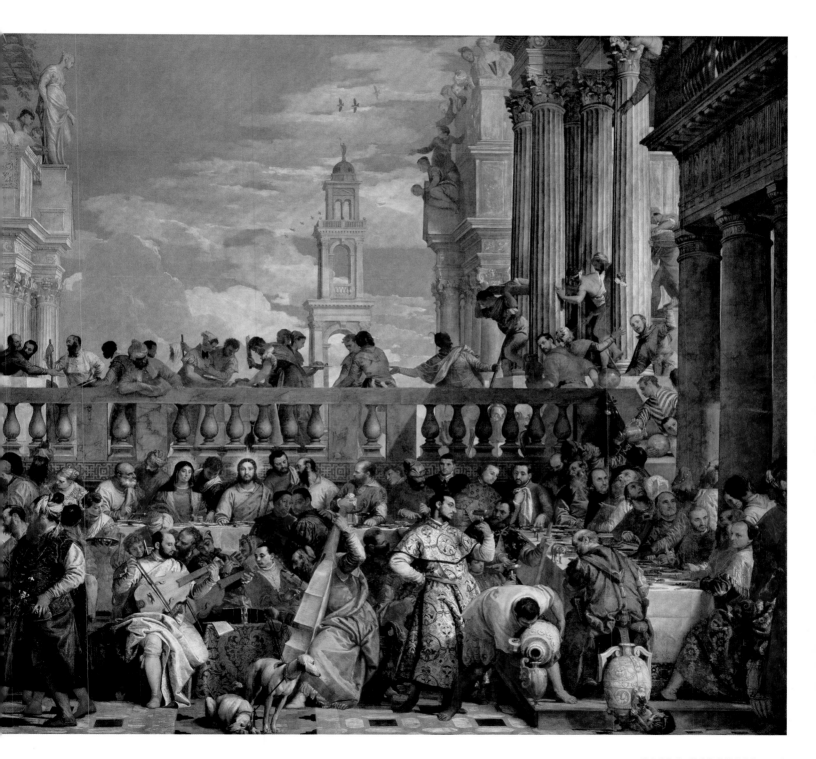

IN DETAIL

② MUSICAL ACCOMPANIMENT

In the foreground, a group of five musicians sit and play musical instruments, providing the wedding guests with a tuneful background to their feast. They are also portraits of respected Venetian artists. In white, playing a viola da gamba, is Veronese himself as a self-portrait. Titian, in red, sits opposite him, playing the double bass. The bearded Tintoretto in green plays another viola da gamba behind Veronese and, further back, the painter Jacopo Bassano tilts his head as he plays a flute. The hourglass on the table between them is a reference to Christ's comment to his mother in the story: 'Mine hour has not yet come.'

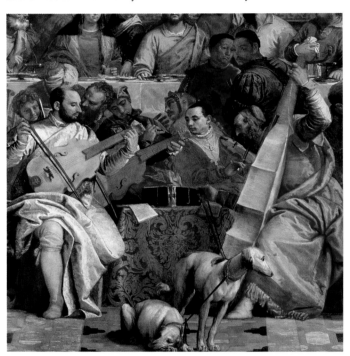

① CLASSICAL ARCHITECTURE

With a mixture of contemporary and antique details, the architecture features Doric and Corinthian columns as well as classical statues and friezes. Figures lean from balconies to watch the activity below. It is a biblical story set in opulent surroundings, with contemporary Venetians taking part.

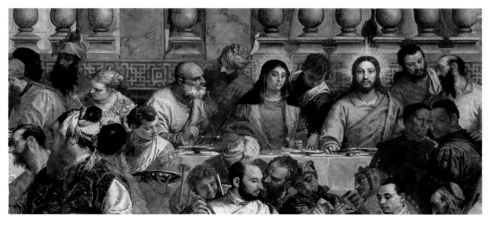

③ TOP TABLE

Behind the musicians, at the centre of the table, Jesus and his mother are discernible because of their golden radiating haloes. Flanked by several apostles, Jesus is the only figure looking out of the scene. He and the biblical figures are dressed in simple, classical costumes, whereas the other wedding guests are clad in contemporary finery, including sumptuous fabrics and exotic jewelry. The bride, dressed in gold, is possibly the late Eleanor of Austria.

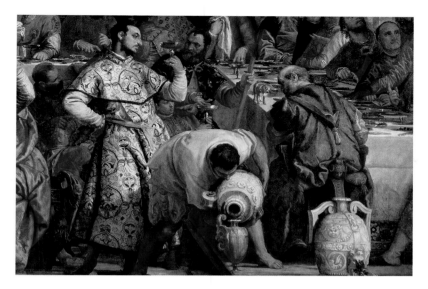

④ THE MIRACLE

Veronese's depiction of the story appears like a great play, a busy scene set against grand classical architecture. A sumptuously dressed man – a portrait of Veronese's brother Benedetto – examines the red wine in his glass. In front of him, a servant pours liquid into a smaller flagon and it is apparent that this is red wine, not water. Between them, a child holds up a glass of wine.

⑤ MEAT

Above Jesus, on an elevated balcony, several men butcher an unidentified animal. Some have suggested it is a lamb. This is the meat for the banquet. The scene serves also to symbolize Christ's sacrifice on the cross as the Lamb of God.

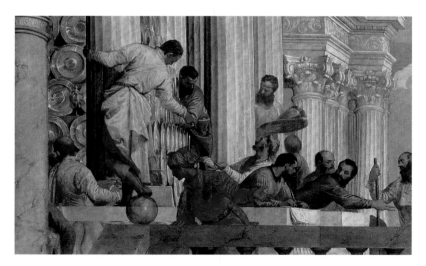

⑥ PALETTE

Veronese used costly pigments. Many were imported from the Orient by Venetian merchants and some were available from the rich Venetian soil, such as bright yellows, oranges, reds, greens and blues. His palette here includes ultramarine made from crushed lapis lazuli from Afghanistan, which was more expensive even than gold. He also used smalt, which was another blue and a by-product of Venice's glass industry.

⑦ DOG

Wherever possible, Veronese packed in humorous, lifelike scenarios. Here, an unrestrained dog peers through the balustrade, sniffing the meat and trying to get a better view of the scene. Elsewhere in the painting are other dogs, a cat, a parrot, parakeets and birds that frolic among the crowd of feast-goers.

CRUCIFIXION

TINTORETTO

1565

ALTHOUGH TINTORETTO (1518–94) WAS born
Jacopo Comin, he was called Jacopo Robusti in recognition
of his father's robust courage against imperial troops in
Padua during the War of the League of Cambrai (1509–16).
His better-known nickname 'Tintoretto' means little dyer
and is connected to his father's profession of *tintore* (silk
dyer). Although he is often described as the last great artist
of the Italian Renaissance, he is also seen as one of the

greatest exponents of Mannerism and, through his dramatic
application of perspective and effects of light, a precursor of
Baroque art. According to his early biographers, he posted
a sign on his studio door declaring with self-confidence:
'Michelangelo's design and Titian's colour.' Nothing is known
of Tintoretto's early training. Apart from visiting Mantua
in 1580, he remained in Venice all his life. Legend claims that
in 1533, Titian expelled him from his workshop after only ten

oil on canvas
536 x 1,224 cm (211 x 482 in.)
Scuola Grande di San Rocco, Venice, Italy

Although predominantly a portrait painter,
German artist Peter Gertner (*c.* 1495–after
1541) painted this *Crucifixion* twenty-eight
years before Tintoretto's version of the
same theme. Similarities in the two works
include a multinational crowd, rich colour,
intricate detail and complex compositions.
Although Gertner worked in a more Gothic
than Renaissance style, the costumes, facial
expressions and gestures are naturalistic,
and like Tintoretto, he projects diversity and
inclusion reminding viewers of the universal
message of the scene. The notion of painting
the Crucifixion scene showing the ground
teeming with figures of different races was
unusual at that time.

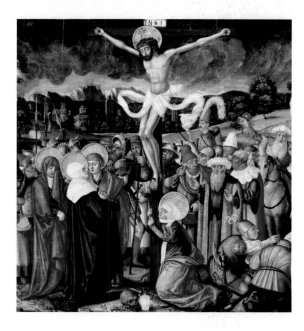

days for being too talented. Tintoretto went on to specialize
in large-scale religious scenes, altarpieces, mythological
subjects and portraits, characterized by muscular figures,
dramatic gestures and perspective and intense colour and light.

In 1564, he was commissioned to decorate the interior of the
Scuola Grande di San Rocco. He worked on the commission
for twenty-four years and *Crucifixion* is one of the sixty works
he painted there.

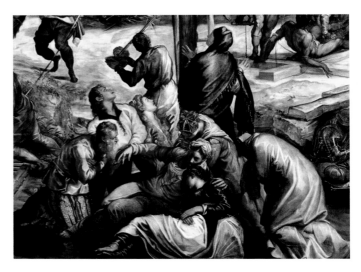

② BASE OF THE CROSS

The mourners at the base of the cross are grouped in a pyramid, huddled together. Christ's mother Mary stands looking up at her son, while Mary Magdalene kneels. Next to her, is John the Evangelist holding the hand of a third Mary, the wife of Clopas and the Virgin Mary's half-sister, who lies overwhelmed with grief in the arms of another woman, with Joseph of Arimathea looking on.

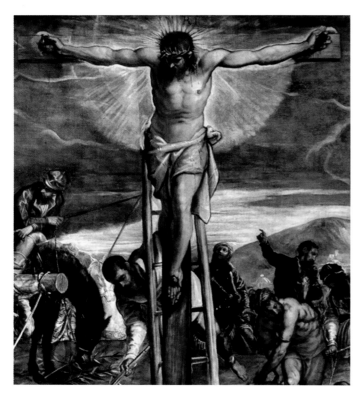

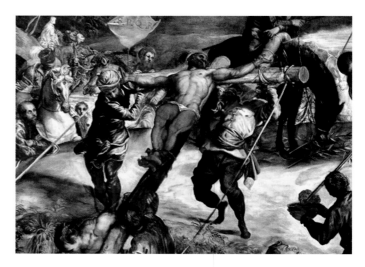

① JESUS

Although Tintoretto sometimes used cadavers to model his figures, he was expert at modelling in wax and clay, and he made models to help him organize his figures and compositions. A muscular Jesus is nailed to the cross, radiating light in a halo that contrasts with traditional golden, platelike versions. These delicate rays appear almost as wings, suggesting his divine status.

③ PENITENT THIEF

At the left of the cross, a condemned man is being lifted and tugged into place by soldiers with ropes. This is the penitent, or 'good thief', one of the two figures the Bible describes as being crucified next to Jesus. In some accounts, the thieves join the crowd in mocking him, but in the Gospel of Luke, the penitent says: 'Jesus, remember me when you come into your kingdom.'

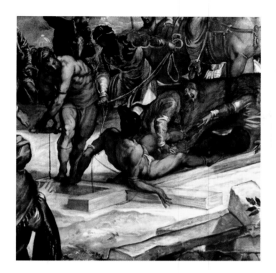

4 IMPENITENT THIEF

To reinforce the stages of Christ's Crucifixion, Tintoretto represents the two thieves in the process of being crucified. This is the impenitent thief, who is about to be tied to his cross. In the Bible, the thief taunts Jesus about not saving himself although he claims to be the Messiah.

5 DRAWING LOTS

To the right of the group of mourners in the foreground, a man digs a hole for the impenitent thief's cross. By his foot is Christ's tunic and in front of him are two crouching soldiers, casting lots for Christ's robe to determine who would keep it.

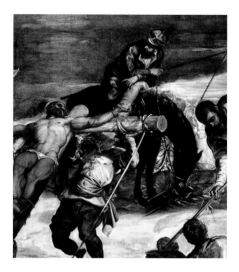

6 DONKEY

On his first visit to Venice, British art critic John Ruskin wrote to his father of this painting: 'There is an ass in the distance, feeding on the remains of strewed palm leaves. If that isn't a master's stroke, I don't know what is.'

7 THE CROWD

The painting is a panorama of Golgotha, populated by a crowd of soldiers, executioners, horsemen and apostles. To most of the crowd, it is simply a common execution. Many are not even looking at Jesus and some work at menial tasks.

Resurrection, El Greco, 1597–1600, oil on canvas, 275 x 127 cm (108 ¼ x 50 in.), Museo del Prado, Madrid, Spain

El Greco was born on Crete, which was then a Venetian possession. As a young man, he painted icons in the Byzantine style for the Greek community. On travelling to Venice, he became inspired by the work of Titian and Tintoretto, and developed a singular style. Here, Christ strides through the air holding the white banner of victory over death. The soldiers guarding his tomb run in fear. The influence of Tintoretto's rich palette and chiaroscuro can be discerned clearly in this work.

THE BURIAL OF THE COUNT OF ORGAZ

EL GRECO

1586–88

oil on canvas
460 x 360 cm (181 ⅛ x 141 ¾ in.)
Church of Santo Tomé, Toledo, Spain

DOMÉNIKOS THEOTOKÓPOULOS, KNOWN AS El Greco
(*c.* 1541–1614), 'The Greek', was born at Phodele in Crete,
which was then part of the Venetian Republic. After working
as an icon painter in the Eastern Orthodox style, in 1568 he
travelled to Venice, where he studied under Titian and became
heavily influenced by both him and Tintoretto, embracing
their rich colours, dramatic tonal contrasts and perspective,
and free, sketchy manner. In 1570, El Greco moved to Rome,
where he opened a workshop and also became inspired by
Michelangelo and Raphael, but success eluded him, and seven
years later, he moved to Madrid and then Toledo in Spain,
where he lived and worked for the rest of his life as a painter,
sculptor and architect. He worked primarily to commissions
from religious institutions, but also produced many portraits
for religious and secular patrons. He gained notoriety for his
highly expressive and visionary painting style, recognized
for its undulating forms, epic scale and elongated, tortured
distortions. This intense, colourful style is usually described as
Mannerist, although it is so individual and distinctive that it
cannot be categorized conclusively. The emotion he portrays
vividly expresses the intense zeal of Counter-Reformation
Spain as the Catholic Church sought to reinstate its authority.
Although he was highly respected during his lifetime, after his
death his work fell into obscurity. During the late 19th century,
interest in his work was revitalized and he is often variously
described as a mystic and a prophet of modern art, and that
his distortions were the result of acute astigmatism – all
misconceptions, although he can be seen as a precursor of
both Expressionism and Cubism.

This huge painting was commissioned by Andrés Núñez,
the parish priest of the Church of Santo Tomé in Toledo,
which was then the ecclesiastical capital of Spain. It is a
commemoration of the burial of Don Gonzalo Ruíz de Toledo,
Count of Orgaz, who had died 250 years previously and who
was a generous benefactor of the church. Legend told that
during the count's funeral, Saints Stephen and Augustine
descended from heaven and carried his body to its final resting
place in the churchyard.

Christ Driving the Traders from the Temple, El Greco,
1600, oil on canvas, 106.5 x 129.5 cm (41 ⅞ x 51 ⅛ in.),
National Gallery, London, UK

The haunting intensity of this painting, created through
El Greco's elongated figures and strong contrasts
of colour and light, demonstrate his move from
the Mannerist to the Baroque style. The painting is
dominated by the contrapposto figure of Christ, poised
to unleash his whip. The traders are on the left and the
Apostles on the right. At the time, this subject was used
as a symbol of the Catholic Church's need to reform. The
story is from the Book of Matthew, which describes Jesus
driving away undesirables from the porch of the temple
in Jerusalem because they were using it as a market for
buying sacrificial animals and changing money: 'Jesus
entered the temple courts and drove out all who were
buying and selling there. He overturned the tables of the
money changers and the benches of those selling doves.'

② HOLY AND ROYAL

The Virgin Mary presides over the burial from a cloud, taking the soul of Count Orgaz from a golden-haired angel. Jesus is above her in an angel's white robe. Next to her is John the Baptist and, behind her in a yellow robe, St Peter holds the keys of heaven. In the crowd behind St John is King Philip II of Spain who was trying to unite Europe in Catholicism under Spanish leadership.

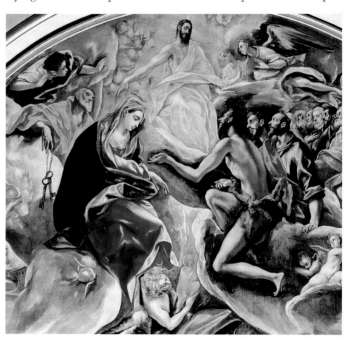

① THE BURIAL

Don Gonzalo Ruíz, Count Orgaz, paid for the Church of Santo Tomé to be rebuilt, and was buried in one of its side chapels. Here, at his funeral, in his magnificent armour, his body is being lifted by two saints in gold vestments: St Augustine on the right and St Stephen. On Stephen's golden robe, a panel depicts the angry mob that stoned him to death.

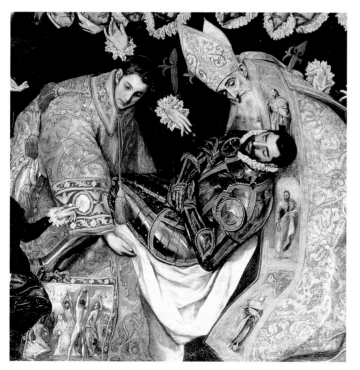

③ ILLUSTRIOUS FIGURES

These men in traditional Spanish attire are some of the most eminent dignitaries of the time. The red crosses show that they belonged to the elite military-religious Order of Santiago. The second figure from the left is a self-portrait of El Greco. The frieze of faces serves to separate heaven from Earth.

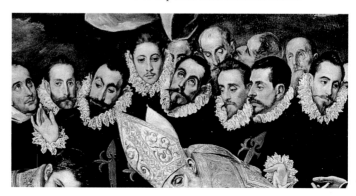

4 ANDRÉS NÚÑEZ

With his back to viewers in a surplice, this is Andrés Núñez, the parish priest of the Church of Santo Tomé who commissioned the painting. He had recently won a legal case against Count Orgaz's descendants who had refused to pay money he had bequeathed to the church.

El Greco was inspired by the Italian Mannerist painter Parmigianino (1503–40). In Mannerism, space is compressed, colours are unusual, and figures are elongated and in complex poses.

5 COLOUR

El Greco's palette here included red ochre, yellow ochre, lead-tin yellow, earth brown, raw umber and asphaltum (black). He applied rich, translucent oil glazes directly onto a light, opaque underpainting, which was a simplification of the Venetian method of layering.

6 SPACE

There are no empty spaces in this painting. The composition is packed with figures, and any spaces are filled with diaphanous clouds. There is no ground, horizon or sky – and no perspective. El Greco eliminated any description of space, which broke with Renaissance traditions.

Adoration of the Kings, Jacopo Bassano, *c.* 1540, oil on canvas, 183 x 235 cm (72 x 92 ½ in.), National Gallery of Scotland, Edinburgh, UK

Perceived as the first modern landscape painter, and one of the least known of the great 16th-century Venetian artists, Jacopo Bassano (*c.* 1515–92) created magnificent scenes of colour and pageantry that had a marked influence on El Greco. There are clear similarities in this work and in El Greco's *The Burial of the Count of Orgaz*. The general bustle here is controlled through repeated areas of rich colour, a technique also practised by Titian, Tintoretto and El Greco. El Greco was also inspired by Bassano's complex foreshortened poses, especially in the figures and animals seen from behind.

17TH
CENTURY

THE TERM 'BAROQUE' IS probably derived from *barroco*, the Portuguese word for misshapen pearl. Baroque art succeeded Mannerism and infused emotion, dynamism and drama with strong tonal contrasts. It developed as a consequence of religious tensions in Europe after the Protestant Reformation – a 16th-century religious, political, intellectual and cultural upheaval that splintered Catholic Europe. After the Council of Trent, held between 1545 and 1563, it was decided that religious art must encourage piety. The Counter-Reformation occurred from *c.* 1560 to the close of the Thirty Years' War in 1648 and with it came the radical new style of Baroque art that developed first in Italy, then spreading to France, Germany, the Netherlands, Spain and Britain. Baroque art deliberately aimed to strengthen the image of Catholicism. Focusing on the Catholic doctrine, it was visually and emotionally appealing.

THE SUPPER AT EMMAUS

CARAVAGGIO

1601

oil and tempera on canvas
141 x 196 cm (55 ½ x 77 ¼ in.)
National Gallery, London, UK

BORN IN CARAVAGGIO, ITALY, Michelangelo Merisi da Caravaggio (1571–1610) was arrogant and rebellious, but his work was unparalleled. In Milan, he was apprenticed to Simone Peterzano (*c.* 1540–96), and in 1592, he moved to Rome, where he began working as an assistant to Giuseppe Cesari (*c.* 1568–1640). As an independent artist, he painted with a radical naturalism enhanced by dramatic chiaroscuro and tenebrism.

Although he was extremely successful, Caravaggio's use of peasant models for holy figures offended more traditional tastes. For his brawling, he was jailed on several occasions and had a death sentence pronounced against him by the pope after killing a man in a fight in 1606. He fled from Rome, but died in mysterious circumstances when returning a few years later to receive the pope's pardon. His influence was profound. After he died many emulated him, and several became called 'Caravaggisti' or 'Caravagesques' in recognition of this.

The Supper at Emmaus is a biblical story that occurs after Christ's Crucifixion. Two disciples meet a stranger on the road and invite him to join them for supper. When he blesses the bread, they realize that he is the risen Christ.

Detail from *St Francis of Assisi in Ecstasy*, Caravaggio, 1595–96, oil on canvas, 94 x 130 cm (37 x 51 in.), Wadsworth Atheneum, Hartford, Connecticut, USA

This was the first of Caravaggio's religious canvases. It represents St Francis of Assisi at the moment he received the signs of the stigmata, the wounds left on Christ's body by the Crucifixion. An angel bends over Francis and the intimate composition projects a spiritual atmosphere.

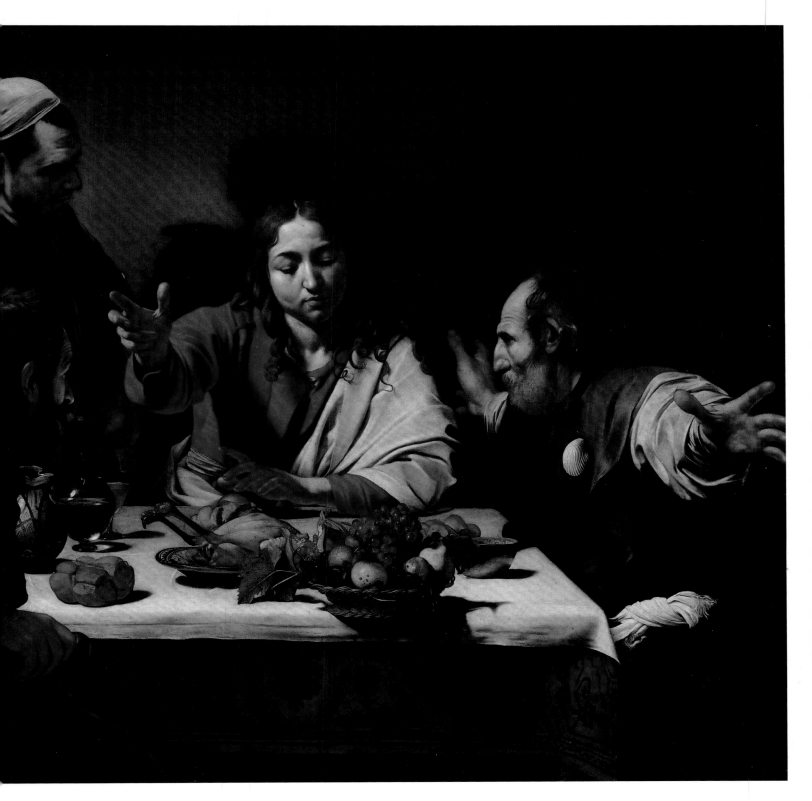

① ROUGH HANDS

One of the reasons Caravaggio caused controversy was that he painted holy, sacred figures as peasants. He used impoverished models and portrayed their rough, wrinkled skin and dirty fingernails. However, he was following the guidelines of the Council of Trent (1545–63), by showing more realism in religious paintings to help the pious understand and accept Catholicism.

② STILL LIFE

In exquisite detail and dramatically close to the edge of the table, this still life of fruit is full of symbolism. For example, the decaying apples and figs represent original sin, the pomegranate implies Christ's Resurrection, grapes mean charity and pears signify Christ. Overall, fruit represents fertility and new life. In front of the basket of fruit, the table is in view, indicating that a place is available for viewers to join in.

③ CHRIST

Christ unusually has no beard. Caravaggio has dramatically modelled his head with strong chiaroscuro to emphasize the features. The innkeeper's shadow is cast behind it like a dark halo – it does not darken his face, but serves to suggest the dark events that have recently occurred. He extends his left hand out towards viewers, as if to welcome everyone into the image.

4 A PILGRIM

The cockle or scallop shell on the apostle's tunic is the traditional badge of a pilgrim, which suggests that he could be St James the Greater. He might alternatively be Cleopas, who, according to the Bible, was one of the disciples who met Jesus on the road to Emmaus.

5 BLESSING THE BREAD

The meal was a spontaneous one. Two weary, grieving travellers had simply invited a stranger to join them at an inn and he agreed. They invited him to bless the bread. This is the moment his gesture and manner of blessing the bread shows them who he really is.

6 A DISCIPLE

This disciple, in threadbare clothes, has pushed his chair back in shock that he is in the presence of the resurrected Jesus. He is probably either Cleopas or Luke.

7 THE INNKEEPER

Painted in detail from life as with all the figures in the work, the innkeeper stands and watches Jesus. He does not understand what is happening, does not know who Jesus is and he does not realize the significance of the moment. He represents the unbelievers.

The Penitent Magdalene, Georges de La Tour, *c.* 1640, oil on canvas, 133.5 x 102 cm (52 ½ x 40 ¼ in.), Metropolitan Museum of Art, New York, USA

Caravaggio painted this subject in the 16th century, and Georges de La Tour produced an even more theatrical version years later. In the Bible, Mary Magdalene renounced her sinful ways for a life of contemplation. La Tour portrays her with a mirror, a symbol of vanity, and a skull, representing mortality. The candle denotes spiritual enlightenment. He produced candlelit subjects in this strong chiaroscuro that were all indebted to Caravaggio.

THE ELEVATION OF THE CROSS

PETER PAUL RUBENS

1610–11

oil on canvas
462 x 341 cm (182 x 134 ½ in.)
Cathedral of Our Lady, Antwerp, Belgium

CULTURED, INTELLIGENT AND CHARISMATIC, Peter Paul Rubens (1577–1640) was one of the most prolific, innovative, versatile and sought-after painters of the Baroque period, and the leading artist of 17th-century Flanders (roughly equivalent to present-day Belgium). A classically educated humanist scholar with a huge workshop, he produced a vast amount of paintings, prints and book illustrations. He was also a respected diplomat, and an avid art and antiques collector. As a student, he studied under Tobias Verhaecht (1561–1631), Adam van Noort (1562–1641) and Otto van Veen (c. 1556–1629), although much of his training involved copying earlier artists' works. On completion of his training, he moved to Italy to study the great Renaissance and classical works that he knew from copies, and was particularly inspired by Raphael, Michelangelo, Titian, Tintoretto and Veronese. For eight years, he travelled and worked in Italy, especially for the Duke of Mantua, Vincenzo Gonzaga.

From 1608, Rubens was back in Antwerp where he was appointed court painter to the rulers of the Netherlands, the Archduke Albert and Archduchess Isabella. Apart from several important diplomatic journeys to Spain, Italy, France and England, where he also undertook painting commissions, he remained in Antwerp. His artistic style was based predominantly on Italian art, characterized by dynamic compositions, bold colours and vigorous brushwork that emphasized movement and sensuality. He worked for important patrons from all over Europe, and was knighted by both King Philip IV of Spain and King Charles I of England. His work includes altarpieces, portraits, landscapes, and history paintings of mythological and allegorical subjects. He became very successful and respect for his work has never diminished.

In 1610, Rubens was commissioned to paint this altarpiece of the Church of St Walburga in Antwerp. Cornelis van der Geest, a wealthy local merchant, dean of the Haberdashers' Guild, warden of the church of St Walburga and art collector, arranged for him to receive the commission. The monumental triptych represents the raising of the cross. The dynamic central panel illustrates men lifting the cross to which Christ has been nailed.

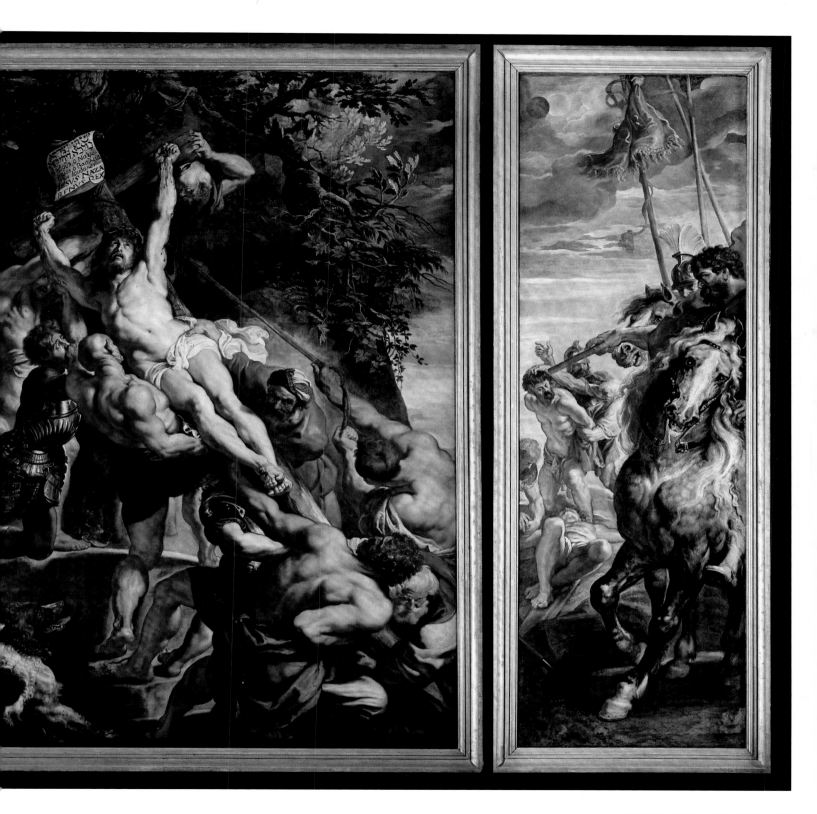

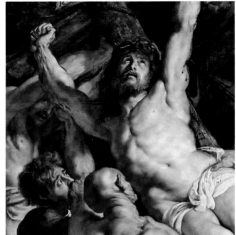

2 CHRIST

In agony, Christ is being hoisted up on his cross. His skin already shows a blue-grey pallor as blood flows down his arms from nails in his hands. His lips are blue, and his eyes look heavenwards as he silently pleads for inner strength. A face looks out from under his arm. This is one of the strong men who are pushing up the cross. He looks guilty, but is simply doing his job.

3 MAN IN RED

Some of the men lifting the cross are stripped to the waist, while others seem to come from various occupations. This man in a black and white turban and red garments appears to be Egyptian rather than Roman, and like most of the men, does not look at Jesus but concentrates on the job in hand.

1 INSCRIPTION

Rubens received a classical education and probably learnt Aramaic, Greek and Latin. With great attention to biblical accuracy, he painted this scroll at the top of the cross in those three languages. As stated in the Gospel of John, the inscription reads 'Jesus of Nazareth, King of the Jews'. Rubens was following instructions of the Council of Trent, which called for historical accuracy in the representation of sacred events.

4 SOLDIER

In a shining suit of armour, a Roman soldier helps pull the cross into position. He looks at Jesus, recognizing his suffering. He is one of the few individuals around Jesus who looks at him, most are concentrating on erecting the cross. As with all Rubens's figures, this man is drawn from life and his expressive face is a study in horror. He contrasts with the burly man next to him, who exerts his strength while ignoring the agony that is occurring.

In contrast with most religious triptychs, all the panels of this work tell one story. The dramatic central panel shows influences of Michelangelo. The left panel features spectators and mourners, and the right panel includes Roman soldiers and the two thieves who were crucified alongside Jesus.

⑤ COMPOSITION

This is an adaptation of the traditional Renaissance X-shaped composition. By placing the base of the cross at one corner and the top in the upper corner, Christ's body becomes the focal point. The strong diagonal creates a sense of dynamism and reinforces the notion that this event is occurring directly in front of viewers.

⑥ PALETTE

The richness of the colouration and the painterly technique is built on Titian's ideas, while the dramatic composition and chiaroscuro follow Caravaggio. After priming, Rubens sketched the outlines directly onto the canvas in fluid paint. His palette included lapis lazuli or ultramarine, azurite, smalt, vermilion, red lead, burnt sienna, yellow lake, verdigris, lead white and ivory black.

⑦ METHOD

Working rapidly, Rubens produced several detailed and accurate preparatory sketches. He produced this before he was famous and rich, so he worked mainly by himself. He used various models and particularly emphasized rippling muscles, energetic poses and foreshortening. He worked extremely quickly, applying bold brushstrokes with oil paint thinned with turpentine.

Detail from *Deposition from the Cross*, Caravaggio, *c*. 1600–04, oil on canvas, 300 x 203 cm (118 ⅛ x 79 ⅞ in.), Pinacoteca Vaticana, Vatican City

When Rubens was in Rome, Caravaggio was working there and became a great influence on him. One of the most important goals of the Counter-Reformation was to involve viewers. This work features a diagonal composition, as Christ's body is lowered into his tomb. Rather than the usual wasted, thin body, this Christ is muscular and strong. Also not idealized but ordinary looking, John the Evangelist and Nicodemus hold him, John under his arms, Nicodemus around his knees. Behind them, the Virgin Mary, Mary Magdalene and Mary of Clopas mourn. Devoid of detail, the dark background forces viewers to focus on the figures, whereas the foreshortened stone ledge of the tomb projects into viewers' space. The image affected Rubens strongly.

JUDITH SLAYING HOLOFERNES

ARTEMISIA GENTILESCHI

c. 1620

oil on canvas
199 x 162.5 cm (78 ⅜ x 64 in.)
Uffizi, Florence, Italy

ARTEMISIA GENTILESCHI (1593–*c.* 1652) was the
eldest child of the Tuscan painter Orazio Gentileschi (1563–
1639). Her mother died when she was twelve years old and she
was introduced to painting in her father's workshop where, like
him, she became heavily influenced by Caravaggio. Other than
artistic training, she had little schooling and did not learn to
read and write until she was an adult. Her life events cannot be
separated from her art. At the age of eighteen, she was raped
by her father's friend and colleague, the artist Agostino Tassi
(*c.* 1580–1644) and when he did not fulfil his promise to marry
her, Orazio sought legal proceedings. During the seven-month
trial, Artemisia was forced to give evidence under torture. The
court exiled Tassi from Rome, but the order was not enforced.

Artemisia married a Florentine artist and moved to
Florence where, unusually for a woman, she became one of the
leading painters of the period, patronized by the Medici family
and later, King Philip IV of Spain. In Florence, she became
the first woman member of the Accademia dell'Arte del
Disegno (Academy of the Arts of Drawing), and she mixed
with prominent artists, writers and thinkers of the time.
Her highly naturalistic paintings are powerful and expressive,
often of strong and suffering women from myth and the Bible.
Following her father's teaching, which followed the working
methods of Caravaggio (whom Orazio knew), Artemisia
painted directly from life. After her death, she was largely
forgotten and she only came to scholarly attention in the
1970s, when she became a feminist icon.

She painted this theme of Judith slaying Holofernes several
times. This version was probably commissioned by Cosimo
de' Medici. The biblical heroine Judith was a Jewish widow
of noble rank from Bethulia. Judith is beheading Holofernes,
the general of King Nebuchadnezzar – who had laid siege to
Judith's city – as he lies drunk after a banquet. The startling
naturalism, chiaroscuro and Judith's pose owe much to the
influence of Caravaggio, and the painting is viewed as one
of the great works of the Baroque period. Her astonishingly
explicit rendition of the Old Testament story continues to
surprise viewers in modern times.

**Detail from *Susanna and the Elders*, Artemisia
Gentileschi, 1610, oil on canvas, 170 x 121 cm
(67 x 47 ½ in.), Louvre, Paris, France**

Artemisia's earliest signed painting is a remarkably
mature and accomplished work for a seventeen year
old. It portrays the biblical story of Susanna, a virtuous
young woman who is tormented by two older men who
falsely accuse her of adultery after she rejects them. In
the Bible, Susanna is condemned to death for the crime
she did not commit, but is ultimately exonerated when
Daniel intervenes on her behalf. Painted from a female
perspective, here Susanna is repulsed and vulnerable
as the men pester her. When portrayed by male artists,
Susanna is usually shown as flirtatious and coy. The men
here are leering, menacing and ignoring her objections.
Artemisia demonstrates influences of Michelangelo
in the soft colours and rounded contours.

② BRACELET

Judith's bracelet has two images that are partly legible. One is a female holding a bow and the other is raising an arm with an animal at her foot. These represent Diana, or Artemis, the goddess of the hunt, also of the moon and animals, and in art, a precursor to the Virgin Mary. As Artemis, they symbolize Artemisia herself.

① HOLOFERNES

In great detail, Artemisia painted Holofernes as he awakes in his drunken state, unable to completely realize what is happening, nor to fight off the two women. Judith grips his hair with her left hand and saws at his neck with the other. Blood spurts down the white sheets. Traditional depictions of this story show Judith using Holofernes's own sabre, but here, Artemisia kills her victim with a sword in the shape of a cross, recalling Christ's victory over evil and sin.

③ ABRA

Conventionally, Judith's maidservant is an old woman in the background, but here, this young woman helps her mistress hold down the tyrant. This makes the act plausible and creates a story of female complicity. A great general would have been able to overpower one woman, but not two in his drunken state. Holofernes lashes out with his fist, trying to push Abra away, but she pins him down.

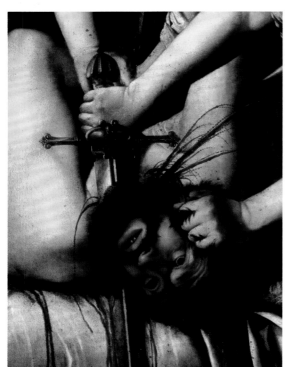

④ JUDITH

After Holofernes attacked her home town, Judith visited his tent, pretending to negotiate with him. She captivated him with her beauty and he asked her to dine with him, intending to seduce her, but after drinking too much wine, he passed out. Seizing her opportunity, Judith decapitated her would-be seducer. Here, her face frowns in concentration, her sleeves are pushed up to her elbows, and blood sprays onto her chest and bodice.

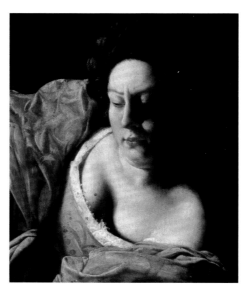

Artemisia painted directly from life and particularly emphasized sharp contrasts of light and dark. Her paintings soon became conspicuous for their theatricality and raw emotional intensity through a few strong figures portrayed from dramatic angles. She did not shirk from representing some of the most graphic elements of her stories in order to make a point.

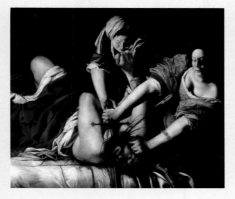

⑤ TEXTURES

Contrasting with the brutality of the scene are the textures both of the elaborate garments worn by Judith and of the hangings in Holofernes's tent. She wears gilded damask and he is covered with a purple-red velvet cover. Crisp white linen creates a strong distinction of texture and colour. The sword glints in gold and silver, while Judith's bracelet dangles on her arm.

⑥ COMPOSITION

Although this painting may seem unconventional, it is quite classical with the sword in the centre of the lower third of the painting. All three of the figures' arms converge by Holofernes's throat, and act like arrows to the point of action. This emphasizes the horror of what is occurring and the blood that is already pouring from the dying man.

⑦ CONFIDENT HANDLING

Using fairly thin paint and a palette that included red lake, vermilion, yellow ochre, ultramarine, azurite, burnt sienna, lead-tin yellow, lead white and ivory black, Artemisia was willing to experiment with psychological dynamics. She found the most sensational aspect of the biblical story and then projected it with bold brushwork and fluid paint.

Judith Beheading Holofernes, Caravaggio, 1598–99, oil on canvas, 145 x 195 cm (57 ⅛ x 76 ¾ in.), Galleria Nazionale d'Arte Antica Palazzo Barberini, Rome, Italy

Although Caravaggio has chosen a dramatic moment as the delicate Judith decapitates the great general, this painting is not as physical as Artemisia's version. Yet there are aspects that she took from this work, including the tenebrism, the black background and Holofernes's expression. However, Caravaggio's Judith looks horrified and recoils as she commits the murder. A book in the Bible is devoted to Judith, because as a woman she embodies the power of the people of Israel to defeat the enemy. Here, Judith enters with her maid from the right. The upturned eyes of Holofernes indicate that he is no longer alive, yet signs of life persist. The realistic precision with which the decapitation is rendered suggests that Caravaggio witnessed contemporary executions.

THE LAUGHING CAVALIER

FRANS HALS

1624

oil on canvas
83 x 67.5 cm (32 ⅝ x 26 ½ in.)
Wallace Collection, London, UK

FRANS HALS (*c.* 1582–1666) was born in Antwerp, but when he was a small child he and his parents fled from the Spanish invasion and settled in Haarlem in 1585, where he remained for the rest of his life. Between 1600 and 1603, he studied under Flemish émigré Karel van Mander (1548–1606) and within a short time he had established a lucrative career. Hals became known for characterful, animated portraits of the citizens of Haarlem, which included individual and group portraits of families, members of the civic guard and regents of Haarlem almshouses. He was exceptionally skilled in creating interaction between his characters.

However, despite his success, Hals also experienced severe financial difficulties at times during his life and he was destitute when he died. He fathered ten children with two wives. Incurring spiralling debts, he worked as a restorer, art dealer and art-taxation expert in order to support his family and his career. His attitude towards life was easy-going and his art is fresh, breaking with convention through his free expression, loose brushwork, use of soft colour and light, and the creation of atmosphere, which redefined the established concept of portraiture.

This exuberant half-length portrait features all the elements that made Hals such a popular portraitist. It seems as if it was painted quickly from life and represents a courtly individual who epitomizes Baroque gallantry. Rakishly leaning back to look at the viewer, the subject projects wealth and confidence in his extravagant clothes, although he is not laughing but smiling, and there is no evidence to suggest that he is a 'cavalier' either. Although not authenticated, it has been proposed that he was a successful Dutch cloth merchant, Tieleman Roosterman, whom Hals also painted two years later. Allusions to gallantry and courtship in the sitter's dazzling costume may indicate that the work was painted as a betrothal portrait, although no companion piece has been identified. Originally simply known as *Portrait of a Man*, in the late 19th century the painting was displayed at an exhibition at the Royal Academy in London with the title *The Laughing Cavalier*, which it has been called ever since.

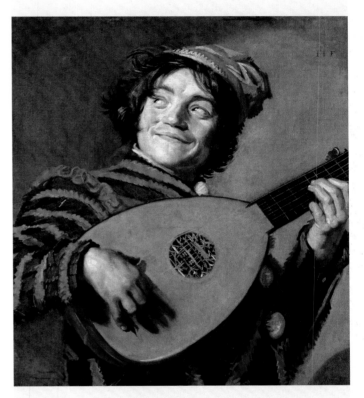

Buffoon with a Lute, Frans Hals, 1624–26, oil on canvas, 70 x 62 cm (27 ½ x 24 ⅜ in.), Louvre, Paris, France

This work is likely of an actor wearing a jester's costume and playing a lute – a tronie rather than a commissioned portrait. It is thought to be an allegory about the vanity of music. Freely handled, the loose brushstrokes and direct composition create a sense of immediacy. With strong illumination from the side, it was created during what became known as Hals's Caravaggist period, even though it is probable that he did not follow Caravaggio, but built on the contemporary vogue for such types of painting.

2 LACE

Weaving and brewing, which had been important trades in Haarlem, were replaced in the 17th century by silk, lace and damask weaving. Here, Hals has taken considerable care over the depiction of the lace ruff and elaborately embroidered sleeve, and even the lace that protrudes through the slashing of the sleeves. The assurance and panache with which the sitter wears it suggests that cloth may have been an important aspect of his life.

3 SLEEVES

Ornate gold, white and red embroidery on the man's sleeves feature intricate patterns – including bees of Cupid, Mercury's winged staff and hat, arrows, flames, hearts and lovers' knots – representing the pleasures and pains of love. Tucked into the crook of his arm is the golden pommel of a rapier, but this does not necessarily indicate that the sitter was in the military, because at the time, skill in swordsmanship was regarded as the mark of a gentleman.

1 FACE

A man looks out at viewers, his eyes knowing and smiling. His jaunty black hat, upward-pointing moustache and tufty beard are examples of high fashion, and his shiny nose, pink cheeks and lips suggest glowing health. His curly hair, white ruff and upright stance imply a proud young gentleman, while the enigmatic smile that plays at the corners of his mouth conveys vivacity and a sense of humour.

Demonstrating Hals's virtuosity in the lively characterization of his sitters and his accomplished, bravura style, this painting is one of his best-known portraits.

4 COMPOSITION

Hals placed the figure in close proximity to the picture plane and depicted him from a low viewpoint. This creates an intimate picture, and forces viewers to look up at him. The man appears to protrude from the empty background.

5 BRUSHWORK

At a time when brushstrokes were meant to be invisible, Hals made his obvious, from fine blended marks in the face to longer marks in the clothing, which create a sense of spontaneity. This freely handled application was unusual then, but in the 19th century was seen as a precursor to Realism and Impressionism.

6 PALETTE

Like his contemporary, the Spanish painter Diego Velázquez, Hals used colour to construct forms and shapes rather than tones. His cool grey background and black and white costume effectively throws the vivid yellow, red and orange forward, creating a brilliant and sparkling effect.

7 LAYERS

Hals often worked *alla prima*, which means 'at the first' in Italian, and is the term used to describe quick, decisive paintstrokes. He also worked 'wet-in-wet', layering wet paint, rather than waiting for previous layers to dry.

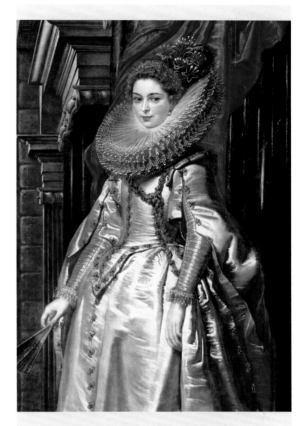

Detail from *Marchesa Brigida Spinola Doria*, Peter Paul Rubens, 1606, oil on canvas, 152.5 x 99 cm (60 x 39 in.), National Gallery of Art, Washington, DC, USA

Hals's style and approach was unique, but he was inspired by his Flemish contemporary, Rubens. Although he never saw this particular portrait, there are several similarities in the two artists' work. Rubens painted this in Genoa in Italy. The Genoese aristocrat Marchesa Brigida Spinola Doria had married the year previously and as Hals's *Cavalier*, Rubens creates a powerful presence through her perceptive gaze directed at viewers, a secret smile playing on her lips. The virtuosity of the marks and translucent glazes describe her sumptuous clothes, and light illuminates her face. Her gaze suggests the painting was meant to be seen from below.

THE ADORATION OF THE GOLDEN CALF

NICOLAS POUSSIN

1633–34

oil on canvas
153.5 x 212 cm (60 ⅜ x 83 ⅜ in.)
National Gallery, London, UK

A FRENCH ARTIST WHO spent most of his working life in Rome, Nicolas Poussin (1594–1665) was a sensual and highly intellectual man who researched his subjects intensively. His art is characterized by clarity, order and smooth lines, and he became a major inspiration for many subsequent artists, including Jacques-Louis David, Jean-Auguste-Dominique Ingres and Cézanne.

Born at Les Andelys in Normandy, he trained in Rouen and then in Paris. Drawn to classical and Renaissance art, he travelled to Rome via Venice in 1624. In Italy, he developed a style that features complex compositions and figures from classical stories. He also became a pioneer of landscape painting. He returned to Paris between 1640 and 1642, when he was ordered back by Armand-Jean du Plessis, Cardinal Richelieu to serve as First Painter to the King.

This painting was commissioned by Amadeo dal Pozzo, a cousin of Poussin's Roman patron, Cassiano dal Pozzo. In the Old Testament Book of Exodus, Moses was leading the Israelites out of slavery in Egypt. When he returned to them after climbing Mount Sinai to receive the tablets containing the Ten Commandments, they had returned to their old pagan ways, and built a statue of a golden calf to worship.

Detail from *The Arcadian Shepherds*, **Nicolas Poussin, 1637–38, oil on canvas, 87 x 120 cm (34 ¼ x 47 ¼ in.), Louvre, Paris, France**

Also called *Et in Arcadia Ego*, this painting depicts a classical, pastoral scene with shepherds. The message inscribed on the tomb is: *Et in Arcadia Ego*, translating as 'Even in Arcadia, I, Death, am Always Present.'

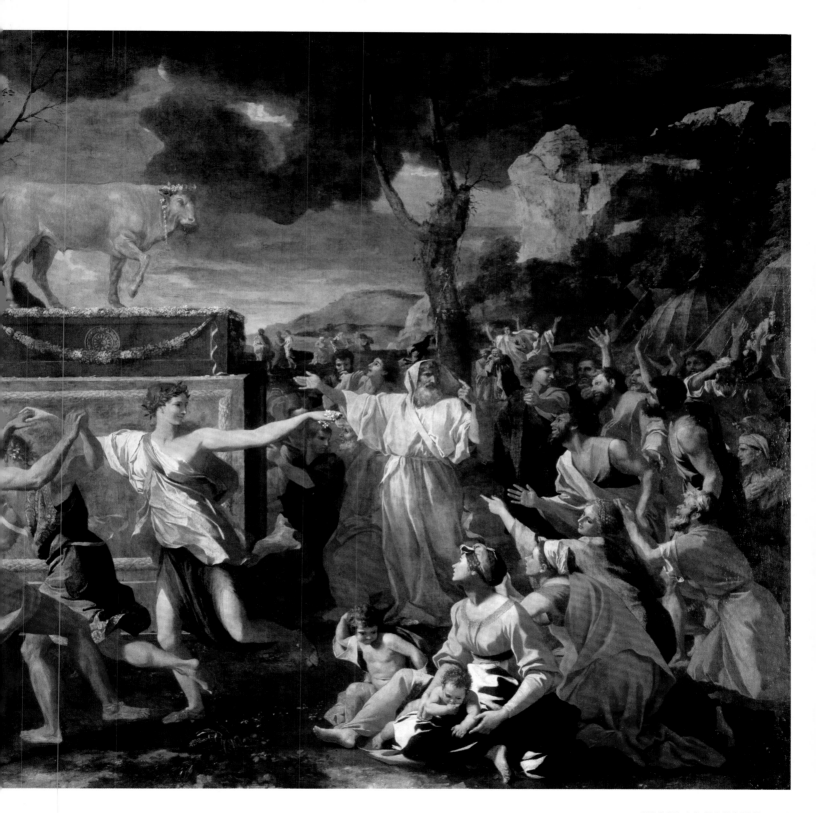

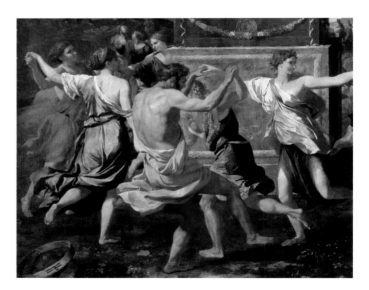

2 MOSES

In the upper left of the painting, the tiny figures of Moses and Joshua are coming down from Mount Sinai carrying the tablets of the Ten Commandments. When Moses heard singing, and saw the calf and the dancing, the Bible says his 'anger waxed hot, and he cast the tablets out of his hands, and brake them beneath the mount'. Furious, he is about to smash the stone tablets while he rages over the idolatry of the Israelites.

1 MAN IN WHITE

The Bible states: 'Moses climbed Mount Sinai to receive the tablets of the Ten Commandments. During his absence the Israelites built an idol with Aaron's help and worshipped it with song and dance.' This figure is Moses' brother Aaron, who was asked by the Israelites to build the statue of the golden calf. He collected all the women's gold earrings, melted them down and made the statue. Poussin painted Moses in white to distinguish him. His gestures draw viewers' eyes towards the golden statue.

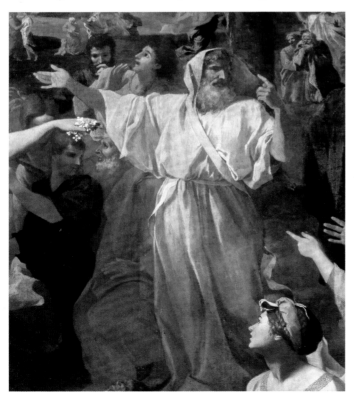

3 DANCING FIGURES

Inspired by Renaissance paintings and classical sculpture, the dancing figures serve to distract viewers when first looking at this painting. Poussin is said to have made little figures of clay to use as models. As on a sculpted relief or painted Greek vase, the figures show individual gestures and movements, but are isolated from each other. He echoed their costumes of blue, red and orange throughout the painting to unify the composition. The extended arm of the girl in white leads viewers' eyes to Aaron and the seated figures in the corner.

4 THE STATUE

High on its altar above the worshipping figures, the statue of the golden calf shimmers in a warm light. Holding up one leg, it is an extremely realistic statue, clearly drawn by Poussin from direct observation. Around the statue, the skies darken ominously. Clouds gather, obliterating the early morning sun as the statue stands above the horizon line, deliberately forcing viewers to look up at it. The statue is also framed in a V-shape of light, created by the background hills.

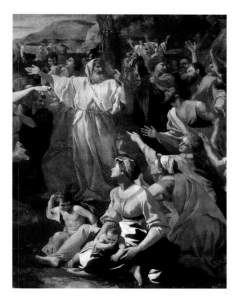

5 THEATRICAL PLACEMENT

Poussin has created a stagelike setting. These figures, sitting on the lower right side of the painting, create a contrast with the energy and frantic dancing of the moving figures on the left. In a triangular arrangement, with babies in the foreground and adult figures in comparable clothes to the dancing figures behind, this group watches in wonder. Individuals raise their arms towards the statue, the diagonal lines made by their arms drawing viewers' eyes towards it.

6 BRUSHWORK

Poussin's brushstrokes are controlled, crisp and smooth, carefully forming the strongly modelled image, emphasizing his belief in the primacy of line, which later members of the French Academy of Arts embraced. His many followers who took this approach became known as 'Poussinistes'. They believed in the primacy of line to depict form as opposed to colour, which they regarded as a decorative element in painting. Poussinistes also admired classical art.

The Death of Socrates, **Jacques-Louis David, 1787, oil on canvas, 129.5 x 196 cm (51 x 77 ¼ in.), Metropolitan Museum of Art, New York, USA**

Poussin's style became highly influential to the Neoclassicists of the 18th century. Jacques-Louis David in particular was inspired by his classical subjects and smooth contours. This portrays the execution of Socrates as described by Plato. Accused by the Athenian government of denying the gods and corrupting the young through his teachings, Socrates was offered the choice of renouncing his beliefs or dying by drinking hemlock. David depicts him just before he drinks the poison, calmly discussing the immortality of the soul with his grief-stricken disciples. With a palette that echoes Poussin's and similarly attired figures, David creates a correspondingly erudite image.

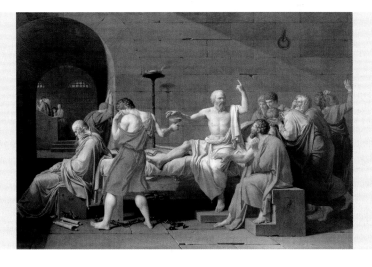

THE NIGHT WATCH

REMBRANDT VAN RIJN

1642

oil on canvas
379.5 x 453.5 cm (149 ½ x 178 ½ in.)
Rijksmuseum, Amsterdam, Netherlands

REMBRANDT HARMENSZOON VAN RIJN (1606–69) was born in Leiden, then the second largest town in the Dutch Republic. Generally considered one of the greatest painters and printmakers in European art and the most important in Dutch history, Rembrandt became best known for his self-portraits, portraits of contemporaries, and his historical and biblical narratives. Rembrandt was the first major artist to work for the open market rather than specific patrons, and his paintings, etchings and drawings sold for high prices across Europe. He was working during a period of great wealth and cultural achievement, often called the Dutch Golden Age. Yet although he achieved youthful success, his later years were marked by personal tragedy and financial hardships, but his reputation as an artist remained high.

The scene in the painting is set during the day. The title, *The Night Watch*, was first used at the end of the 18th century after the image had darkened through the accumulation of layers of dirt and varnish. As a group portrait of a company of civic guardsmen, a more accurate title is *Officers and Men of the Company of Captain Frans Banninck Cocq and Lieutenant Willem van Ruytenburch.*

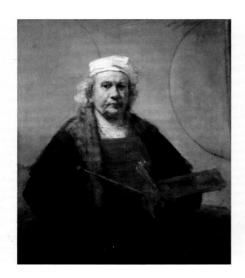

Self-Portrait with Two Circles, **Rembrandt van Rijn, 1659–60, oil on canvas, 114.5 x 94 cm (45 x 37 in.), Kenwood House, London, UK**

At fifty-three years old, Rembrandt has depicted himself at work, holding his palette, brushes and mahlstick. The fragments of the two circles in the background remain a mystery. It has been suggested that they allude to the perfect circles drawn by Giotto in demonstration of his artistic prowess. Rembrandt leaves various unfinished details, such as on his clothes, and he also departs from convention by using the handle of his paintbrush to scratch on a moustache.

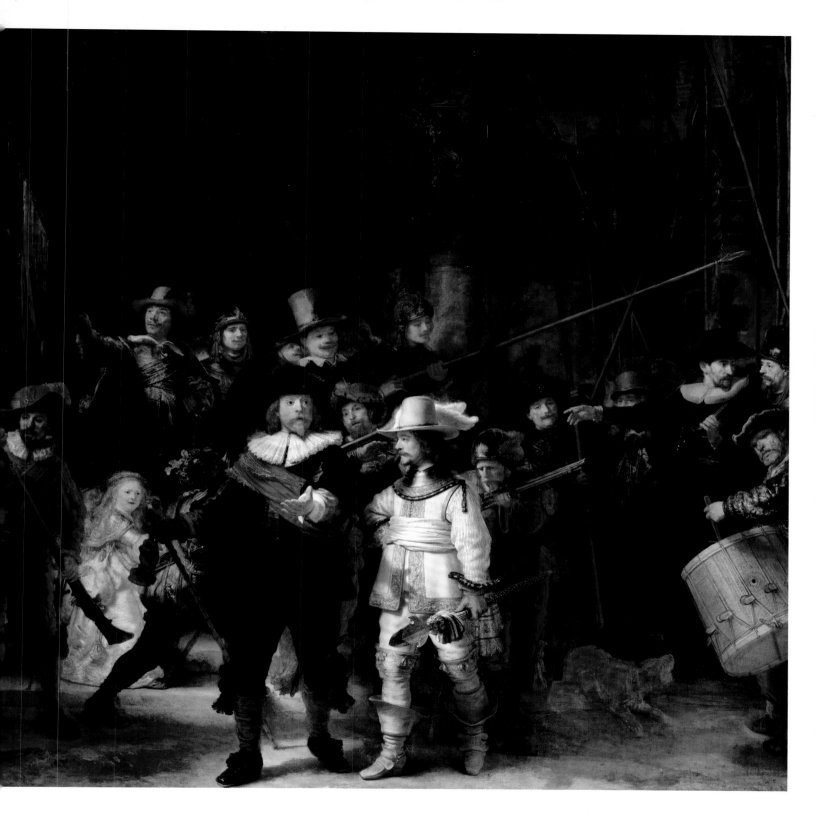

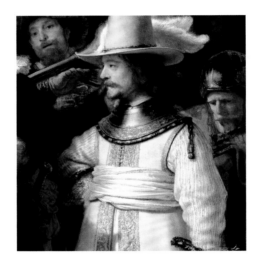

❷ CAPTAIN FRANS BANNINCK COCQ

Dressed in black with a red sash, this is the *burgemeester* (mayor) of Amsterdam, Captain Frans Banninck Cocq who is leading the Militia Company of District II. He symbolizes the Dutch Protestant leadership, and along with seventeen members of his militia, he commissioned the painting from Rembrandt in *c.* 1639.

❶ MYSTERY GIRL

This girl shines out from the darkness. With flowing blonde hair and a gold dress echoing the lieutenant's sumptuous costume, she draws viewers' attention. A large, white chicken hangs upside down from her waistband. Its claws represent the *kloveniers* or arquebusiers, the civic militia guards. Their emblem was a golden claw on a blue ground. She is included as an emblem or mascot for the company.

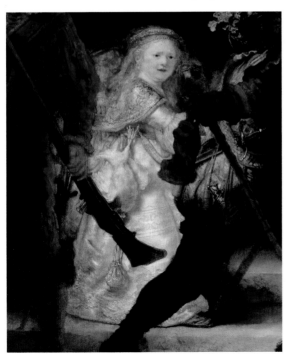

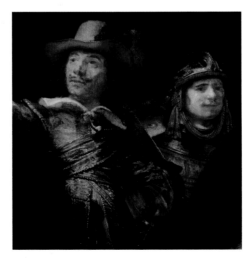

❸ MAN IN YELLOW

Rembrandt's painting illustrates the union between the Dutch Protestants and the Dutch Catholics. This is Captain Banninck's lieutenant, Willem van Ruytenburch, dressed in yellow with a white sash and carrying a ceremonial lance, about to stride out and lead the company with Banninck. The colour yellow represents victory and he represents the Dutch Catholics.

❹ MILITIAMEN

Militia companies were groups of men who could be called upon to defend their city. They met at fixed times and this painting depicts one of those meetings. When Rembrandt painted the militiamen, they no longer had to defend the ramparts of Amsterdam or go out on day or night watches. Behind the helmeted figure, wearing a beret, Rembrandt has painted himself peering out of the picture.

⑤ SENSE OF ACTION

The audacious composition creates a bold sense of action, as the men take their positions, ready to march. Rembrandt's placement of figures creates immense vitality, which is reinforced by the striking use of light and shade. Unusually, he did not follow the advice traditionally given to young painters, namely to travel to Italy to study Italian art first-hand. Instead, he felt that he could learn enough from the art in his country.

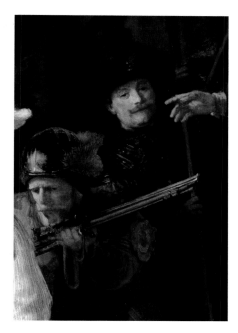

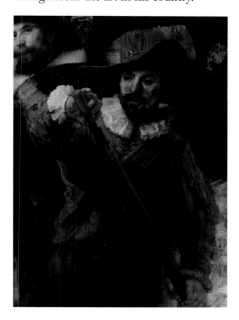

⑥ TECHNIQUE

Rembrandt used several techniques. Here, he worked out some aspects in minute detail, while in some areas he applied thick impasto paint. Chiaroscuro is used to create drama and depth. There are also multiple figures in action. Rather than standing still or making simple, gentle gestures, every portrait here is active, for example, the man poised with his rifle.

⑦ WEAPONS, DRUMMER AND A DOG

With no set uniform or armour, Rembrandt has represented the men wearing various bits of armour and helmets, carrying an array of weapons. Some hold their pikes high, a drummer beats a cadence to encourage them, and a dog barks enthusiastically at his feet. They are marching here, but probably simply to a shooting contest or to take part in a parade.

The Potato Eaters, **Vincent van Gogh, 1885, oil on canvas, 82 x 114 cm (32 ¼ x 44 ⅞ in.), Van Gogh Museum, Amsterdam, Netherlands**

Vincent van Gogh painted this while living among the peasants and labourers in Nuenen in the Netherlands. He strove to depict the people and their lives as truthfully as possible. Since he was a child, he had admired Rembrandt's work and here, using a dark palette traditionally associated with Rembrandt, he depicts the sombre living conditions of the peasants. The effect is heightened by his loose brushstrokes, also taken from Rembrandt's example, while the spiritual depth of the painting as the peasants eat their meagre meal of potatoes can be seen to follow Rembrandt's empathy with others.

ST JOSEPH THE CARPENTER

GEORGES DE LA TOUR

c. 1642

oil on canvas
137 x 102 cm (54 x 40 in.)
Louvre, Paris, France

A FRENCH BAROQUE PAINTER who spent most of his working life in the Duchy of Lorraine, Georges de La Tour (1593–1652) painted mostly religious and genre scenes lit by atmospheric candlelight in strong chiaroscuro.

The second child of a baker, La Tour was born in Vic-sur-Seille in the Diocese of Metz, which was technically part of the Holy Roman Empire but had been ruled by France since 1552. Yet much of his life and educational background is unclear. It is likely that he travelled to Italy and the Netherlands early on. His paintings reflect the naturalism and tenebrism of Caravaggio as well as the Dutch Utrecht School and other Northern European contemporaries, such as the Dutch painter Hendrick Terbrugghen. Alternatively he may have become familiar with art by northern artists through prints and paintings. Lit by crisp daylight, his paintings from this period are characterized by their still atmosphere and meticulous rendering of ornament and textures. Unlike Caravaggio's works however, La Tour's religious paintings lack drama and dynamism. By 1620, after he had married, he lived in the prosperous town of Lunéville where he became a respected painter of religious and genre scenes with some important patrons, including King Louis XIII, Henry II the Duke of Lorraine, and the Duke de La Ferté. Between *c.* 1638 to 1642, he lived in Paris, where he worked as Painter to the King. Increasingly, he painted scenes illuminated by a single candle flame and gradually simplified his forms. After his death, he passed into obscurity until 1915, when a German scholar, Hermann Voss, recognized his style in several pictures that had been variously ascribed to other artists.

This painting is an image of Christ's childhood that La Tour has imagined. There is almost no mention of Jesus' boyhood in the Bible, apart from an episode in the Gospel of Luke when Mary and Joseph lost the twelve-year-old boy: 'After three days they found him in the temple, sitting in the midst of doctors, both hearing them and asking them questions.' This is of a younger boy. La Tour has portrayed what may have happened in Joseph's workshop.

The Concert, **Hendrick Terbrugghen,** *c.* **1626, oil on canvas, 99 x 117 cm (39 x 46 in.), National Gallery, London, UK**

Hendrick Terbrugghen or ter Brugghen (1588–1629), was one of the Dutch followers of Caravaggio, who, along with Gerrit van Honthorst (1592–1656) and Dirck van Baburen (*c.* 1595–1624), became known as the Utrecht Caravaggisti. The influence of Caravaggio was pronounced in their work, which subsequently inspired La Tour. This scene, closely reminiscent of subjects also explored by Caravaggio, features a group of large-scale, half-length, colourfully dressed musicians in candlelight. Shadows play against each other on the wall, the palette is subtle, the grouping is intimate and the musicians are portrayed from a close proximity that gives a sense of immediacy. Many of Terbrugghen's themes included drinkers and musicians like these, which directly influenced La Tour.

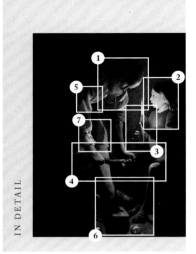

1 JOSEPH

Apocryphal literature about Christ's childhood circulated during the medieval period. One story described how Joseph was asked to make a bed and took Jesus with him to find suitable wood, but when he cut the wood, he realized he had made a mistake in the measurements. The child performed a miracle and the timber was the correct size. Although this is not that exact story, it shows Joseph, the patron of carpenters, in his workshop bending over his work, illuminated by a candle. His brow is furrowed, his beard and moustache grey, showing his age – he was much older than Mary.

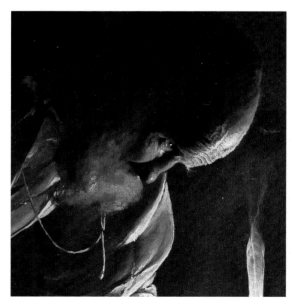

2 JESUS

A pale-skinned, plump-faced eight-year-old boy with long golden hair watches his stepfather, while talking, or asking a question. His face is highlighted as the brightest part of the painting, illuminating the room, ensuring that viewers are aware of his identity. Tiny flecks of white paint in his eye, teeth, nose and hair add realism. His fond gaze towards Joseph upholds the 17th-century emphasis on promoting the importance of family life. However, La Tour's portrayal of emotions is rarely convincing.

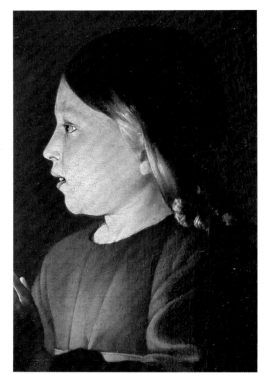

3 HANDS

With dirty fingernails, the little boy's hands are holding the candle for Joseph. La Tour has skilfully painted his right hand with strong chiaroscuro, and created luminescence in his left hand while it shields the flame – symbolically implying that Christ brings light to the lives of others, as explained in the Gospel of John: 'I am the light of the world. Whoever follows me will never walk in darkness, but will have the light of life.' Symbolically, the light from the small candle appears to light the whole room.

4 TOOLS

This is a scene of everyday life that alludes to a divine presence. Joseph's hands are holding an auger as he drills a piece of wood. It is subtle, but the arrangement of the piece of wood and the auger is roughly in the shape of a cross, hinting at Christ's future sacrifice at the Crucifixion. Involved in the Franciscan revival in Lorraine at the time, La Tour has focused on three of the main areas of worship that the Franciscans encouraged: St Joseph, Jesus and the cross.

Initially, La Tour painted brightly coloured scenes, often featuring miscreants. Later he began painting his dark, atmospheric candle-lit scenes, often of religious subjects. His skills of rendering flesh, textures and light, and his scene-setting are calculated to create intrigue and theatricality.

5 TENEBRISM

La Tour uses tenebrism and chiaroscuro. The techniques involve the use of contrasting areas of light and dark and they are often used together. Chiaroscuro involves the use of smaller amounts of shadow and tonal gradations to increase the suggestion of depth and is more about modelling of forms. Tenebrism is used exclusively for dramatic effect, as seen in the folds of Joseph's shirt.

6 REALISM

Despite various simplifications of forms, La Tour's painting exhibits a high degree of realism. He paid close attention to drawing from direct observation even small details such as a wood shaving lying on the ground. Like Poussin, his attention is more focused on line than on colour, but like Caravaggio, it emphasizes realism and drama through tonal contrasts.

7 PALETTE

Differing from many of his earlier works, La Tour worked with an original palette of muted but luminous colours, which can be seen as a blend of Italian and Northern European influences. Mainly painting in earthy tones of sienna, umber, black and red, he creates his brightest areas with lead white. He uses colours that reflect the ordinary nature of what is a humble setting.

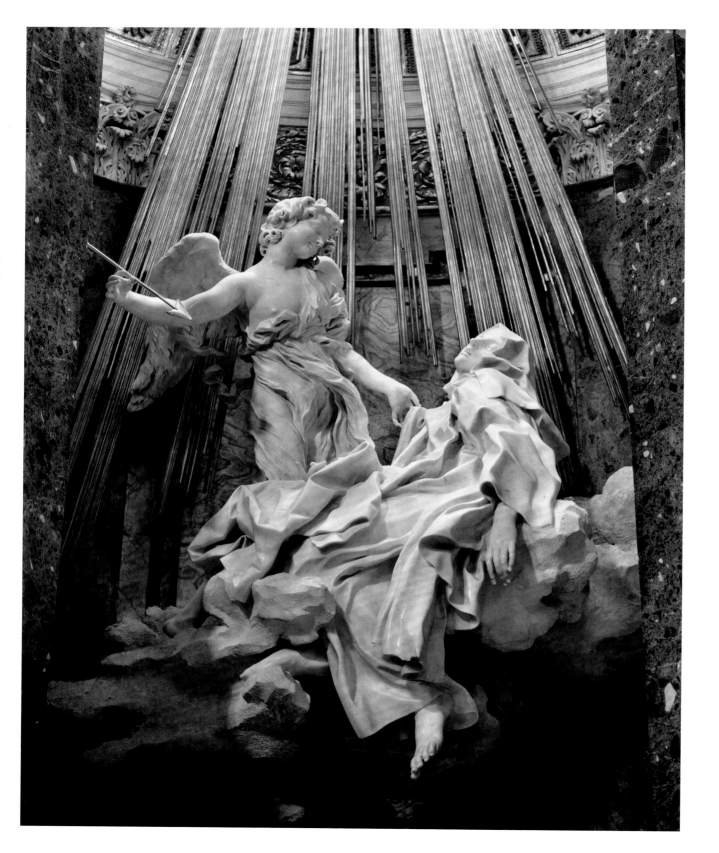

THE ECSTASY OF ST TERESA

GIAN LORENZO BERNINI

1645–52

marble
350 cm (137 ¾ in.) high
Santa Maria della Vittoria, Rome, Italy

GIAN LORENZO BERNINI (1598–1680) was an Italian sculptor, architect, costume and theatre-set designer, and playwright, credited with creating the Baroque style of sculpture. As an architect and city planner, he designed both secular and religious buildings, and huge works that combined architecture and sculpture, such as public fountains and funerary monuments. In fierce competition with his contemporaries, especially the architect Francesco Borromini and the painter and architect Pietro da Cortona (1596–1669), he particularly flourished under the patronage of Pope Urban VIII and Pope Alexander VII. A devout Roman Catholic, he expressed the grandeur of the Baroque with extravagant theatricality, challenging contemporary artistic traditions with innovative interpretations. His dynamic figures express palpable emotions and acute realism, and his skill in manipulating marble included the unique facility to make it appear as soft flesh where necessary. His ability to synthesize sculpture, painting and architecture meant that he secured the most important commissions in Rome, including embellishments to the then newly built St Peter's Basilica. He designed the momentous Piazza San Pietro in front of it and inside the Basilica he created numerous structures.

The Ecstasy of St Teresa is a sculpture set high in an edicule in the Cornaro Chapel of the Church of Santa Maria della Vittoria in Rome. It represents St Teresa of Avila, swooning with the love of God while an angel holds a spear over her. The statue derives from an episode the 16th-century Spanish saint described in her autobiography, *The Life of the Mother Teresa of Jesus* (1611): 'I saw in his hand a long spear of gold, and at the iron's point there seemed to be a little fire. He appeared to me to be thrusting it at times into my heart, and to pierce my very entrails; when he drew it out, he seemed to draw them out also, and to leave me all on fire with a great love of God. The pain was so great that it made me moan; and yet so surpassing was the sweetness of this excessive pain, that I could not wish to be rid of it.' In his right hand, the angel holds a spear of divine love and looks down at Teresa as he prepares to pierce her heart, completing her mystical union with God.

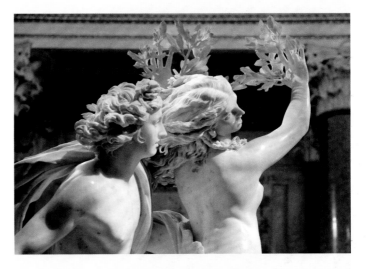

Detail from *Apollo and Daphne*, Gian Lorenzo Bernini, 1622–25, marble, 243 cm (96 in.) high, Galleria Borghese, Rome, Italy

From Ovid's *Metamorphoses*, this depicts the story of Daphne and Apollo. When Apollo, the god of light, is pierced by Cupid's love arrow, and then sees the daughter of Peneus, a river god, he is consumed by desire. But Daphne has been struck by Cupid's love-repelling arrow and runs from Apollo as he chases her. She prays to her father: 'Destroy the beauty that has injured me, or change the body that destroys my life.' She is pinned to the spot, as her feet become rooted to the ground, bark covers her skin, her arms turn into branches and her hair becomes leaves. Cardinal Scipione Borghese commissioned Bernini to produce the work, and to instil the pagan subject with appropriate Christian morality, the base was engraved with a Latin couplet: 'Those who love to pursue fleeting forms of pleasure in the end find only leaves and bitter berries in their hands.'

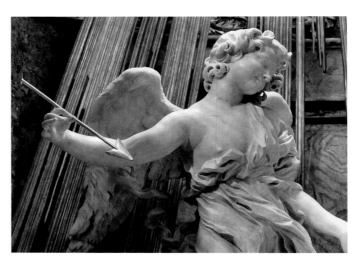

② ANGEL

Teresa described the angel that appeared before her with a golden spear: 'He was not tall, but short, marvellously beautiful, with a face which shone as though he were one of the highest of the angels, who seem to be all of fire. . . . He appeared to me to be thrusting it at times into my heart, and. . .to leave me all on fire with a great love of God.' The angel's garment hangs on one shoulder, exposing his arms and part of his upper torso. Bernini's attention to detail is visible in his meticulous carving.

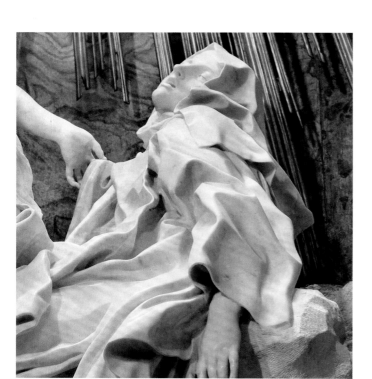

① ST TERESA

St Teresa of Avila was a Spanish nun, mystic and writer during the Counter-Reformation. When she was older, she experienced the first of the episodes that reoccurred throughout her life. She wrote of them, describing how she felt the bodily presence of Christ or of angels, and was transported to an exalted state of ecstasy. Here, Bernini portrays her lying on a cloud swooning in near-erotic rapture, her eyes closed and mouth open. The expanse of crumpled fabric contrasts with the smooth purity of her face.

③ CLOTHING

Clothed from head to foot in a loose-hooded garment, Teresa's feet are bare, her left one prominently displayed. Both her visible limbs hang limp, but the creased and heavy drapery of her clothing adds to the drama of the scene.

④ GOLDEN RAYS

Illuminated by beams of light from a hidden window above the work, Bernini created gilt bronze shafts as a backdrop, intended to resemble the sun's rays to add theatricality and to enhance the divine feeling portrayed.

Bernini designed the entire chapel around this sculpture. Set on its elevated edicule, it is usually described as a 'gesamtkunstwerk'–a German word meaning 'total work of art', because it amalgamates architecture, sculpture, painting and lighting effects in a theatrical setting.

5 COMPOSITION

Drawing from the influences of Mannerist artists, Bernini's dynamic composition was different from anything else being produced at the time. It seems to reach out and include the viewer, while also being a private moment between the nun and the angel – as if the convex niche containing the work has opened to reveal the vision.

6 MOVEMENT

The crumpled fabrics and flowing forms create a sense of movement and sensuality. The twisting folds energize the spectacle. The sculpture portrays the most poignant moment in the story, suggesting exuberance and emotion. It conveys the sense of being a captured moment in time.

7 TEXTURE, IDEALISM AND REALISM

Billowing swirls, drapery and crumpled fabrics, luxuriously curling locks of hair and the supple softness of skin are all depicted here from hard, cold marble. Although the figures are idealized, their individual features and expressions seem natural and believable.

Pietà, Michelangelo, 1498–99, marble, 174 cm (68 ½ in.) high, St Peter's Basilica, Vatican City

Above all sculptors, Bernini admired Michelangelo the most. Made for a cardinal's funeral monument, this is the only work that Michelangelo ever signed. Depicting Christ's body on his mother's lap after the Crucifixion on the rock of Golgotha, it was made from one block of Carrara marble and forms a pyramid shape. Several aspects of proportion are unnatural; for example, Mary is huge in comparison to her son. However, Michelangelo understood perception and if Mary had been the correct size, Jesus would have swamped her. Additionally, she appears extremely young to have a son aged thirty-three and it has been suggested that her youth symbolizes her incorruptible purity. Yet all these elements appear natural through Michelangelo's prowess in depicting elements such as flesh, drapery, gesture and emotion.

SEAPORT WITH THE EMBARKATION OF THE QUEEN OF SHEBA

CLAUDE LORRAIN

1648

oil on canvas
149 x 196.5 cm (58 ¾ x 77 ½ in.)
National Gallery, London, UK

DURING HIS LIFETIME AND for generations afterwards, Claude Gellée (*c.* 1604–82), known as Lorrain, was considered the supreme exponent of landscape painting. One of Poussin's few friends, also born in the Duchy of Lorraine and also spending most of his life in Italy, he painted classical visions of nature and idealized landscapes with sublime effects of light.

Born to poor parents, Claude left Lorraine for Rome at the age of thirteen, but little else is known of this period of his life. Ten years later, he returned to Lorraine and was apprenticed to Claude Deruet (1588–1660) a Baroque painter from Nancy. After a year, he returned to Rome and settled there permanently. He sketched around the countryside, and from his detailed drawings, he created finished landscape paintings in the studio. From 1635, he began keeping records of every picture he painted in his book *Liber Veritatis* (*The Book of Truth*). Although he influenced many, his originality was limited; his landscape type and range of tones were constrained and did not develop much, but as powerful patrons favoured his work he had no reason to change. This depicts the Queen of Sheba about to depart to visit King Solomon in Jerusalem as described in the biblical Book of Kings.

Detail from *Seaport with the Embarkation of St Ursula*, Claude Lorrain, 1641, oil on canvas, 113 x 149 cm (44 ½ x 58 ¾ in.), National Gallery, London, UK

Painted before the *Embarkation of the Queen of Sheba*, this depicts a scene from the life of St Ursula. Claude's evolution can be seen, as he began to simplify his portrayal of classical seaports.

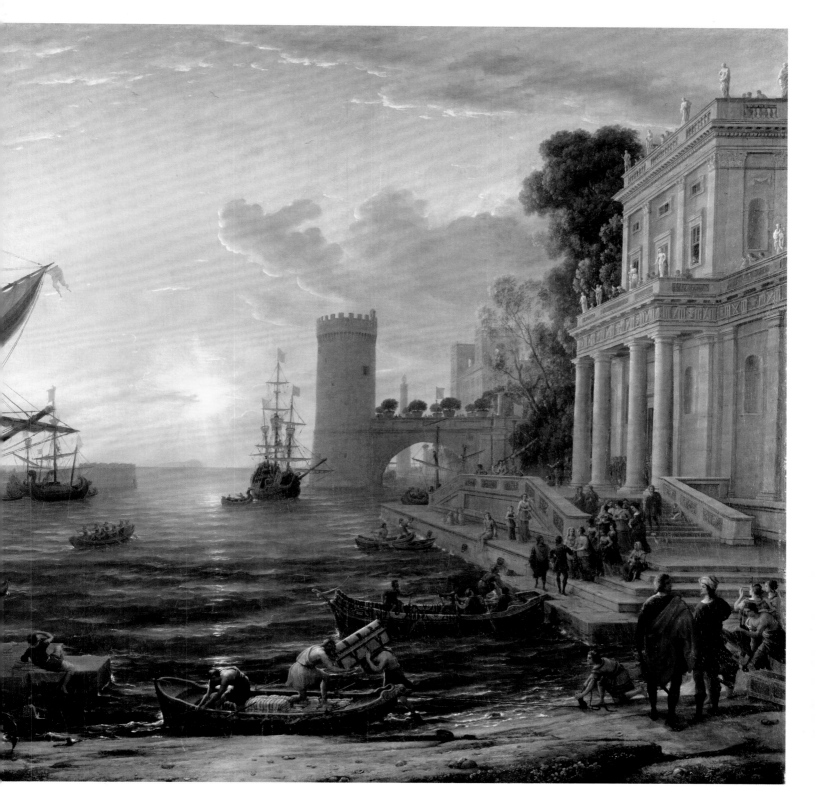

2 NATURALISTIC

At the base of a Roman Corinthian column, a boy on the quayside shields his eyes from the sun's dazzle. Nearby, a sailor in the same ultramarine as the Queen of Sheba pulls his boat into land. Drawn from life, both the figures and the architecture are captured in painstaking detail, to convey a moment in time. This was painted over a white ground, which shines through subsequent colours, helping create a luminous picture.

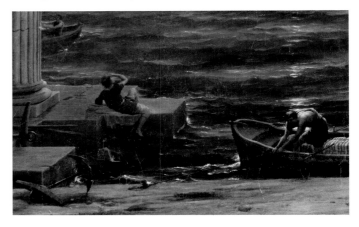

3 THE SUN

Light is always the most important element in any of Claude's paintings, and this is illuminated by the misty glow of dawn. One of his early innovations was painting the sun rising or setting over the sea, directly facing viewers. Here, the delicate sun is rising, its dazzling rays radiating with subtle, sophisticated effects, and sparkling on the sea below. Placed almost at the centre of the work, it creates a soft light.

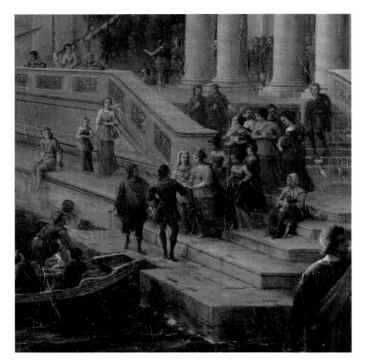

1 THE QUEEN OF SHEBA

In a pink tunic, royal blue cloak and golden crown, the blonde queen is descending some stone steps. A launch is waiting to take her to her ship. Maids hold the queen and her lady-in-waiting's trains, and a man takes the queen's hand to help her into the launch. It was unusual to depict the queen with blonde hair as Sheba was believed to have been in Africa, but Claude has likened her to the Virgin Mary, even painting her cloak blue.

4 THE SHIP

There is much activity on the ship that will take the queen and her ladies to Jerusalem. Seen through the monumental Roman columns, seamen are preparing for departure; a boy climbs up to the bird's nest, another climbs on the bowsprit, some pull ropes and others are communicating with a rower below. Claude's attention to such details, his miniature figures and the inclusion of action helps make the scene come alive.

5 VANISHING POINT

The ship on the horizon is at the centre of the painting and marks the vanishing point, at which all orthogonals, or receding lines, converge. This effectively makes this a classical X-shaped composition. Claude uses perspective to make the left and right sides of the painting balance each other with a pronounced symmetry.

6 ROMAN VILLA

With meticulous detail, Claude represented a beautifully proportioned Roman villa also full of activity as many citizens have come out to watch the queen sail to Jerusalem. Unlike future landscapists that were usually more objective, Claude's landscapes are unfolding stories, populated by busy figures. Nevertheless, their realism and atmospheric and light effects exerted a considerable influence on later landscape painters.

7 FOREGROUND

The Queen of Sheba's luggage is being loaded onto a launch to be taken out to the ship. Wealthy viewers would have empathized with this mode of transport and the notion of trunks full of luggage accompanying them on long journeys. Claude was an expert in creating a sense of depth, not only with perspective, but with the details he painted in the foreground.

Dido Building Carthage, J. M. W. Turner, 1815, oil on canvas, 155.5 x 230 cm (61 ¼ x 90 ½ in.), National Gallery, London, UK

In open imitation of Claude's paintings, the English artist Joseph Mallord William Turner painted this depiction of Virgil's epic Latin poem, the *Aeneid* (c. 30–19 BC). It shows the building of Carthage, founded by Dido. The figure in blue is Dido, on the right is the tomb erected for her dead husband, Sichaeus, and in front of her is probably Aeneas. Inspired by Claude's luminous landscapes, Turner requested in his will that this and another of his paintings be displayed in London's National Gallery between Claude's *Seaport with the Embarkation of the Queen of Sheba* and its companion work, *Landscape with the Marriage of Isaac and Rebecca* (1648).

LAS MENINAS

DIEGO VELÁZQUEZ

1656

oil on canvas
320 x 276 cm (126 x 108 ½ in.)
Museo Nacional del Prado, Madrid, Spain

THE GREATEST PAINTER OF the Spanish School, and considered by many to be the greatest European painter ever, Diego Rodríguez de Silva y Velázquez (1599–1660) was a Baroque artist who had a massive influence on the development of Western art. Born in Seville, he was exceptionally precocious and briefly studied with Francisco Herrera the Elder (c. 1590–1654) and then with Francisco Pacheco (1564–1644). He began his career specializing in a Spanish type of still-life painting called *bodegón*, but in 1623 he was appointed court painter to King Philip IV of Spain. The king declared that only Velázquez should paint his portrait and, for the rest of Velázquez's life, he remained the king's favourite painter.

Velázquez was soon promoted to various roles, including marshal of the royal household and planner of ceremonies. With free access to the royal collection, he studied and learnt from works by Italian artists. Although he also painted historical, mythological and religious works, he became primarily a portraitist – producing fresh, lively and natural images of the royal family, members of the court and European leaders. When Rubens arrived in Madrid on a diplomatic mission, the two artists became friends and following Rubens's advice, Velázquez made two trips to Italy, studying the art at close hand. His style developed as a unique expression of life, showing his remarkable powers of observation, diversity of brushstrokes and subtle harmonies of colour. His depictions of form, texture, space, light and atmosphere contributed to the development of Impressionism in the 19th century.

Las Meninas is one of the greatest masterpieces of European art. Conveying an astonishing sense of reality with a freshness unheard of in 17th-century royal and particularly Spanish circles, it has sometimes been interpreted as Velázquez's personal manifesto because he paints himself at work. An enigmatic portrait of royalty and members of the court, it captures an instant in time within his studio in the Alcázar royal palace in Seville. The relaxed poses of all the figures, the chiaroscuro and mysterious quality of the incident appear to penetrate the stiff etiquette of the Spanish court.

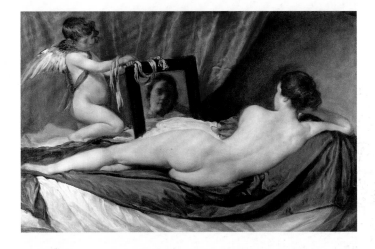

The Toilet of Venus, or *The Rokeby Venus*, **Diego Velázquez, 1648–51, oil on canvas, 122.5 x 177 cm (48 ¼ x 69 ¾ in.), National Gallery, London, UK**

The Spanish Inquisition disapproved of paintings of female nudes, so they were rare in Spain. This is the only known nude by Velázquez. Painted for a private patron and probably while the artist was staying in Rome, it depicts Venus, the Roman goddess of love and the embodiment of ideal beauty. Her son Cupid holds up a mirror so she can see herself and viewers can see her, but judging by the angle of the mirror, the reflection of her face is purely symbolic. Using finely ground pigments mixed with plenty of oil, Velázquez elongated the curve of Venus's back with soft, fluid brushstrokes. Because the painting was housed at Rokeby Hall in northern England in the 19th century, it is also known as *The Rokeby Venus*. In 1914, a suffragette, Mary Richardson, entered the National Gallery in London where the canvas was on display and slashed it seven times. She was arrested, although the painting was soon fully restored.

SELF-PORTRAIT

This is the only known self-portrait of Velázquez. He is wearing courtly attire and looking out from behind his canvas. From his belt hang the symbolic keys of his court offices. On his chest is the red cross of the Order of Santiago, which he did not receive until 1659, three years after the painting was done. Allegedly, the king ordered the cross to be added to the painting after Velázquez's death.

1 THE INFANTA

The Infanta Margarita was the daughter of Philip IV of Spain and his second wife and niece, Mariana of Austria. At this point, she was their only surviving child. At just five years old, she is shown as a golden child, with light shining on her hair. In the artist's studio, she is attended by her ladies-in-waiting, or *meninas*. She is being offered a drink–probably perfumed water–from a jug on a golden tray.

3 THE QUEEN'S CHAMBERLAIN

Don José Nieto, the queen's chamberlain and head of the royal tapestry works, is pausing on steps at a door at the back of the room. Almost in silhouette, he appears to hold open a curtain revealing light and space behind it. He is at the vanishing point of the picture. The lady-in-waiting Doña Isabel de Velasco is on the Infanta' right side, bending forward as if about to curtsey.

4 DWARF, JESTER AND DOG

Many European monarchs employed dwarfs. Velázquez befriended those at the Spanish court and painted several of their portraits. Here, he depicts two dwarfs from the king's entourage: the German, Maribarbola or Maria Barbola, and the Italian, Nicolás Pertusato or Nicolasito, the court jester, who tries to rouse the sleepy mastiff with his foot.

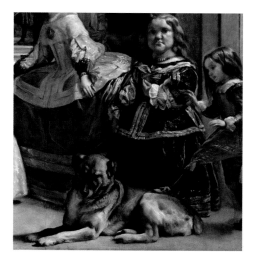

Setting his royal models in natural poses, Velázquez imbues them with life and character. As well as a surprising family portrait, this is an ingenious artistic puzzle, featuring skilful rendering of different textures and surfaces, strong chiaroscuro and supple brushwork.

⑤ REFLECTION

This mirror reflects the images of the king and queen. They appear to be placed outside the picture space alongside viewers, facing the Infanta and her entourage. It is likely inspired by Jan van Eyck's *Arnolfini Portrait* (1434; see pp. 18–21) that hung in Philip IV's palace at the time. Velázquez has made the royal reflection slightly blurred, which was somewhat irreverent for the time.

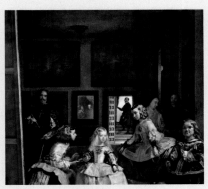

⑥ COMPOSITION

Nine complete figures are in the painting, with the king and queen's reflections making eleven characters, yet all occupy only the lower half of the canvas. There are three focal points: the Infanta, Velázquez's self-portrait and the reflected images of the monarchs.

⑦ LIGHT

Two light sources illuminate the picture. One is an unseen window on the right side, the other is the doorway at the back. Strong chiaroscuro throws the main figures into bright light, the background into obscurity. The light also creates a sense of volume and definition.

The Daughters of Edward Darley Boit, John Singer Sargent, 1882, oil on canvas, 222 × 222.5 cm (87 ⅜ × 87 ⅝ in.), Museum of Fine Arts, Boston, USA

Many subsequent artists have paid tribute to Velázquez. Among them, John Singer Sargent (1856–1925) absorbed aspects of his technique. Sargent was known for his virtuoso handling of paint that derived from Old Masters. He visited Madrid in 1879 to make copies after Velázquez at the Museo Nacional del Prado and among the paintings he studied was *Las Meninas.* This painting, for example, shows a direct connection with *Las Meninas.* Sargent was a friend of the girls' parents, Edward Darley Boit and Mary Louisa Cushing Boit. The four young girls are shown in the entrance hall of their family's Parisian apartment in a painting that is partly a portrait and partly an interior scene. The deep space rendered by chiaroscuro and strong linear perspective, and the ambiguity of the girls' positions and expressions are comparable to *Las Meninas.* Only the youngest girl, the four-year-old Julia, engages viewers; her siblings recede into the shadows against the backdrop of the half-lit drawing room with mirrors and reflections.

THE GUITAR PLAYER

JAN VERMEER

c. 1670–72

oil on canvas
53 x 46.5 cm (20 ⅞ x 18 ¼ in.)
Kenwood House, London, UK

DESPITE HIS BRIEF CAREER, the fact that he never left his native Delft and his relatively few works, Jan (or Johannes) Vermeer (1632–75) is perceived as one of the greatest masters of Dutch 17th-century art – also often referred to as the Dutch Golden Age. With only thirty-six known works left by him, during his lifetime, he was not wealthy, and on his death at just forty-three, he left his wife and eleven surviving children in debt. He worked slowly, with great care and frequently used the most expensive pigments available. He is particularly renowned for his spectacular treatment of light.

Little is known about Vermeer's life and education. Intermittently, he worked as an art dealer, having assumed the family business after his father died in 1652. He may have been apprenticed to Leonaert Bramer (1596–1674) or Carel Fabritius (1622–54). At the age of twenty-seven he was admitted to the Guild of St Luke, a trade association for painters, which meant that he had trained with a recognized master for the obligatory six years. In 1662, 1663, 1670 and 1671, he was elected head of the guild. Inspired by Caravaggio and Pieter de Hooch, he became successful locally. Some of the paintings by the Utrecht Caravaggisti are depicted in the backgrounds of some of his own works. From 1657, a local art collector, Pieter van Ruijven is thought to have become his regular patron.

Vermeer's first works were large-scale biblical and mythological scenes, but his later paintings – for which he is most famous – primarily represent scenes of daily life in middle-class interiors, remarkable for their purity of light and form, and a serene sense of dignity. He also painted some cityscapes and allegorical scenes. Yet after his death he fell into obscurity until his rediscovery in the 19th century; he has since remained revered as one of the greatest artists in history.

With its crisp contours and radiant light effects, *The Guitar Player* is an example of Vermeer's later and most popular style. No longer concerned as he had been previously with describing specific, intricate details, he uses freer brushstrokes to emphasize patterns of colour over details, subtle modulations of tone over sharp contrasts, and an open expression rather than his earlier, more brooding depictions.

Detail from *View of Delft*, Jan Vermeer, *c.* 1660–61, oil on canvas, 96.5 x 115.5 cm (38 x 45 ½ in.), Mauritshuis, The Hague, Netherlands

At a time when cityscapes were uncommon in art, Vermeer captured this view of his birthplace, in great detail, bathed with early morning light. With lifelike details, it is also quite idealistic as the sun glitters on the water and the figures in traditional clothing step out in the bright dawn. It is one of three known paintings of Delft by Vermeer executed out of doors, portraying a sense of depth and distance through clear linear perspective, enhanced by delicate clouds diminishing in size. Viewers are drawn into and around the composition through the reflections on the water and the subtle V-shape of the buildings in the centre. With layering, smoothly painted areas and sand mixed into the paint in places, he also conveys a powerful sense of texture.

② A 'MASTERPIECE OF NATURE'

On the back wall is a painting in the style of the Dutch Golden Age landscapist Jan Hackaert (1628–85). Directly behind the girl, the foliage echoes the shape of her hair, suggesting that she is the ideal woman, described in numerous 17th-century poems as either a 'masterpiece (or miracle) of nature'.

③ THE GUITAR

The guitar was just coming into vogue in the late 17th century as a popular solo instrument to accompany the voice. Bolder than the lute, its chords produced a pleasing resonance, and the inclusion of a Baroque guitar here made the painting appear especially modern to contemporary viewers.

① THE FACE

It has been suggested that the young woman might have been posed by Vermeer's eldest daughter Maria. Yet this is not a personal portrait, nor a reflection of Vermeer's domestic environment. The sitter's expression is outward and not self-contained. With luminescent pearls around her neck, she is smiling, apparently at someone beyond the painting. Her personality is not evident; she is more of a pattern than a person – for example in her silhouetted ringlets against the wall.

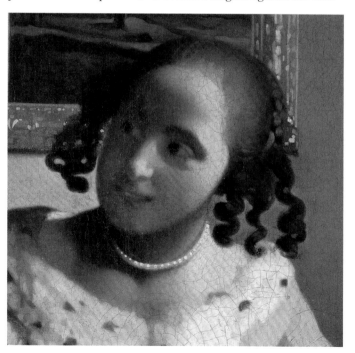

This painting is a clear example of Vermeer's late style, featuring smooth contours, calligraphic brushwork and thinly applied paint. Accents of colour and almost abstract marks describe shapes and patterns, while still expressing naturalism and vitality.

4 BUILDING THE PICTURE

Before beginning, Vermeer sized the canvas to seal it and then applied coats of a grey-brown ground (chalk, lead white, umber and charcoal in an oil and glue emulsion). Afterwards he applied thin brown underpainting, building the picture with glazes.

5 COLOURS

Radiant colours in this painting create a warm glow. Vermeer modelled areas with sharply defined planes of colour but overall he worked with a surprisingly limited palette. Vermilion was applied sparingly on the girl's cheeks and on the leaves of the book behind her.

6 BRUSHSTROKES

Vermeer emphasized patterns and created subtle modulations and contours. Consciously varying his paint consistency, impasto marks provide light-catching texture, such as on the tip of the girl's thumb, while thinner, fluid paint implies more refined textures.

7 PATTERNS

Overall, this painting is a collection of intricate patterns. For example, the girl's pearl necklace is built up with a band of pale greenish white, followed by pinkish-white, finished with dots of pinkish-white impasto for highlights on individual pearls.

The Bedroom, **Pieter de Hooch, 1658–60, oil on canvas, 51 x 60 cm (20 x 23 ⅝ in.), National Gallery of Art, Washington, DC, USA**

Pieter de Hooch (1629–84) skilfully depicts light, colour and accurate perspective. He was born in Rotterdam, studied in Haarlem and spent the last twenty years of his life in Amsterdam. Yet he is particularly associated with Delft, having lived in the city from *c.* 1655 to *c.* 1661. There, he created paintings of tranquil interiors distinguished for their delicate observation. He was very influential on Vermeer. Despite the stiff clothing and careful paint application, this painting is an intimate scene of a mother and child. Here, De Hooch created two light sources: the window on the left and the full-length glass doors. The child could be a girl or boy as all children of this age wore skirts and did not have their hair cut until they were older. It has been suggested that the models could be De Hooch's wife, Jannetje, and either his son Pieter, born in 1655, or his daughter Anna, born in 1656. It presents an idealized view of Dutch domesticity.

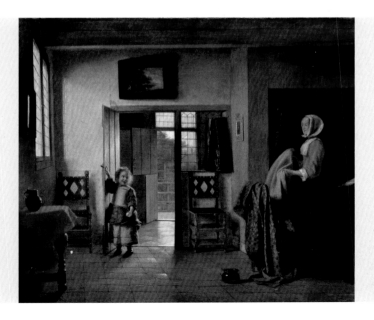

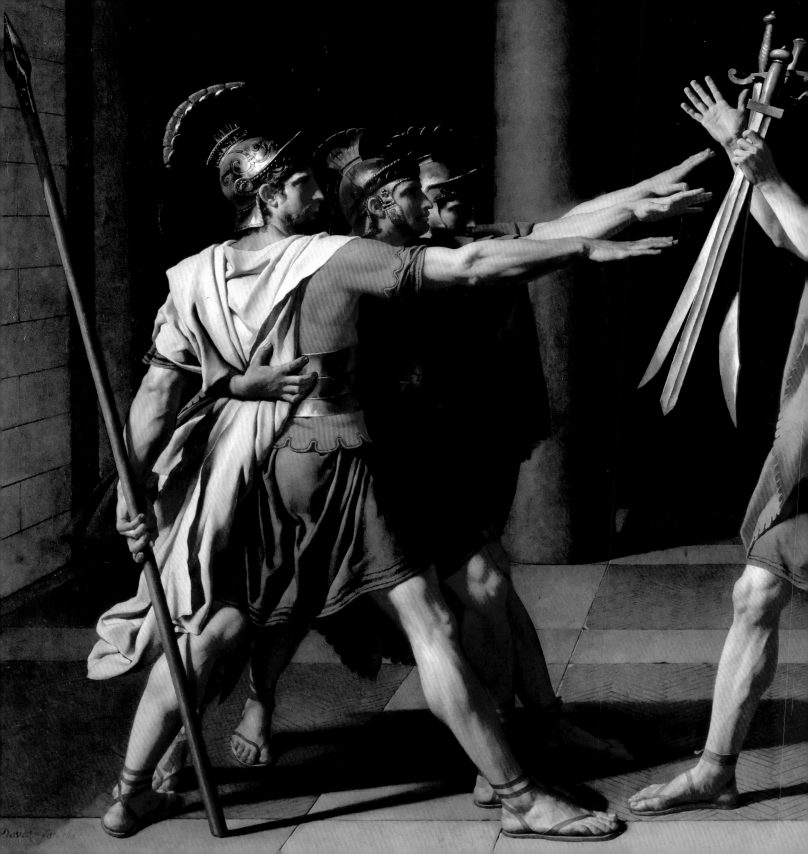

18TH CENTURY

EARLY IN THE 18TH century, both as a development from and a reaction to Baroque, the ornamental, elegant Rococo style emerged. Appearing in Europe and parts of the United States, Rococo celebrated new ideas about personal freedom and democracy. It was the visual representation of the positivity felt by those who could afford to consider these concepts. The term 'Rococo' began to be used at the end of the century. It derived from the French word *rocaille*, meaning 'rock work' or 'shell work', referring to carvings in grottoes and on fountains. Rococo was decorative in nature and characterized by flowing, shell-like curves and shapes. It was initially expressed in interior decoration and then architecture, painting and sculpture. In contrast, at the end of the century, Neoclassicism developed, which aimed to revive styles of ancient Greek and Roman art and architecture. Neoclassicism exemplified the Age of Enlightenment in its embrace of order and restraint.

FÊTES VÉNITIENNES

ANTOINE WATTEAU

1718–19

oil on canvas
56 x 46 cm (22 x 18 ⅛ in.)
National Gallery of Scotland, Edinburgh, UK

THE BRIEF CAREER OF Jean-Antoine, or Antoine, Watteau (1684–1721) inspired a new interest in colour and movement in painting, reviving interests in Correggio (*c.* 1490–1534) and Rubens, and shaping the Rococo style beyond architecture, design and sculpture. A brilliant and innovative draughtsman, Watteau had an extensive influence on the art world. His invention of *fêtes galantes* – theatrical, pastoral, idyllic scenes – became a part of the Rococo style.

Watteau was born in the town of Valenciennes, which had recently passed from the Spanish Netherlands to France. Although little is known about his education, he was possibly apprenticed to Jacques-Albert Gérin (*c.* 1640–1702). He moved to Paris in *c.* 1702 where he secured a job in a workshop painting reproductions of popular Dutch art. In 1704, he became the assistant of Claude Gillot (1673–1722), who was also a set designer. Gillot acquainted Watteau with the Commedia dell'Arte – the characters of traditional Italian theatre – and Watteau's fascination with them lasted throughout his career. He was next apprenticed to Claude Audran III (1658–1734), a painter and interior decorator who was also the curator of the Palais du Luxembourg. There, Watteau saw the Rococo interior design and the vast canvases painted by Rubens for Queen Marie de Medici. In 1709, he entered the Prix de Rome (a scholarship for art students offered by the prestigious Académie des Beaux-Arts in Paris). Although unsuccessful, a few years later he was invited to submit work for the Académie with a view to becoming a student there. He was accepted, but as his style of painting did not correspond with any pre-existing categories, officials introduced the category of '*fête galantes*' for him. His light-hearted paintings of bucolic scenes were extremely popular, but at the age of only thirty-six, he died of tuberculosis. Within a few years, the Rococo style of painting fell from favour and his work was not appreciated again until the mid 19th century.

The Rococo style of light curves and natural patterns that developed first in the decorative arts and interior design became perfectly translated in Watteau's painting, as can be seen in the colourful *Fêtes Vénitiennes*.

Detail from *Pilgrimage to Cythera*, Antoine Watteau, 1717, oil on canvas, 129 x 194 cm (50 ¾ x 76 ⅜ in.), Louvre, Paris, France

A blithe scene of people in harmony with nature, this is the work that Watteau submitted to the Académie des Beaux-Arts and was given the name *fête galante* to describe it. It took him five years to paint because he was working on numerous other private commissions. It is an allegory of courtship, flirtation and falling in love. The couples are wearing contemporary dress, but they are in a fantasy world, going on a journey to Cythera, the island sacred to Aphrodite, the goddess of love. The painting resembles a theatre set. The gentle colours and soft brushwork create a mainly happy atmosphere, echoed by playful putti flying between the couples. A statue of Venus Aphrodite rises up in the landscape, while in the background, the Ship of Love looms in the mist, ready to transport the lovers to Cythera.

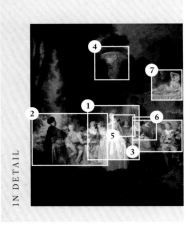

THE DANCING PARTNER

Desmares's dancing partner is Nicolas Vleughels (1668–1737), who was an artist, Watteau's friend and also his landlord. Although Vleughels was born and raised in Paris, his father was a native of Antwerp, so he had close affinities with the Franco-Flemish community in Paris. While he was painting this, Watteau was living in the same house as Vleughels and the two artists often worked side by side, copying drawings by Rubens and Van Dyck.

LADY IN SILVER

The central dancer is thought to be the leading actress Charlotte Desmares, whose stage name was 'Colette'. Noted for her beauty, she was the mistress of Philip II, Duke of Orléans, who served as Regent of France from 1715 to 1723. Watteau has painted her from a low viewpoint, emphasizing her shimmering gown that is described with light, sketchy brushstrokes and soft shades of cool grey and white.

SEATED MUSICIAN

A rather miserable-looking musician in a colourful gold and blue shepherd's costume plays a musette – a small bagpipe – to the courtly ladies and gentlemen who are gathered in the park at dusk. This musician is a self-portrait of Watteau just four years before his untimely death. The musician's mood may reflect the artist's own inner turmoil after discovering that he had a serious illness.

Watteau's attraction to the curving lines of Rococo in interior design and architecture became central to his paintings. Here, he has combined his love for the theatre and his fascination with the Rococo designs in his unique style of painting with ornate elegance that gained him critical attention.

④ RHYTHM

Watteau intentionally created lines, waves and curving shapes in the painting's composition, such as within the form of the urn, to enable viewers to see a rhythm through the sinuous lines. The textures, soft colours and flow between the figures are included to create a sense of harmony in keeping with the musical subject of the work.

⑤ SENSE OF MELANCHOLY

Along with the dreamlike, light-hearted atmosphere, Watteau has incorporated a sense of wistfulness. This may reflect his concerns about life in general. Although wealthy characters flirt and dance in beautiful natural surroundings that suggest simple pleasures, the realities of life are never far away.

⑥ COLOUR AND BRUSHWORK

Watteau revived earlier palettes, including those preferred by Venetian Renaissance artists and those used by Rubens, but lightened them, creating silvery blues, dusty pinks and soft greens. His fine brushwork featured small dabs and streaks that enhance the liveliness in his paintings.

⑦ CREATION OF ATMOSPHERE

The hazy atmosphere surrounding these figures introduces a sense of mystery and suggests the influence of Rubens and Leonardo. Amid the playfulness of the scene, the mistiness of the gathering dusk joins with sensual elements in the paintings, such as this reclining nude sculpture.

The Pastoral Concert, Titian, c. 1509, oil on canvas, 105 x 137 cm (41 ⅜ x 54 in.), Louvre, Paris, France

This painting was titled *Fête Champêtre* when it was acquired by the Louvre museum. A *fête champêtre* was a popular form of garden party during the 18th century that was particularly enjoyed at the French court. *The Pastoral Concert* was originally believed to have been painted by Giorgione but is now thought to be by Titian. From *c.* 1509, the two artists worked in close collaboration, making it difficult to distinguish their styles. It depicts the meeting of the Venetian aristocracy with nymphs and shepherds. Interpreted as an allegory of nature and of poetry, the artwork was bought by King Louis XIV and seems to have influenced Watteau considerably. The female figures represent the ancient muses of poetry, whereas the harmony of the colours and forms suggests concord between humans and nature.

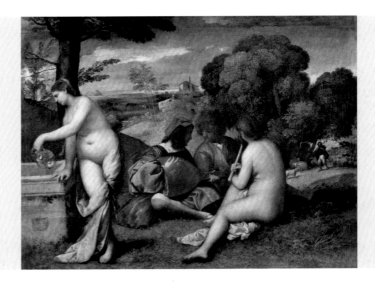

ARRIVAL OF THE FRENCH AMBASSADOR IN VENICE

CANALETTO

c. 1727–45

oil on canvas
181 x 260 cm (71 ¼ x 102 ⅜ in.)
State Hermitage Museum, St Petersburg, Russia

FOR SOME TWENTY YEARS, Giovanni Antonio Canal, known as Canaletto (1697–1768), was one of the most successful artists in Europe. His spectacular views of Venice were extremely popular and marketable, mainly sought after by the wealthy Europeans who undertook Grand Tours. His clarity of light, precise perspective and eloquent tonal details projected colourful images of locations, reminding those who had visited and encouraging those who had not.

Born in Venice, the son of a theatrical-scene painter, Canaletto visited Rome when he was twenty-two year old, which inspired him considerably. On his return to Venice he began producing carefully composed, evocative views that were not symbolic or religious, and were characterized by precise finishes, clear light and a bustling sense of life. As a perfectionist, he used a camera obscura light box to make sure that his basic outlines were accurate and he made numerous meticulous preparatory drawings for every painting.

This is the heart of Venice, the Piazzetta in front of the Doge's Palace, overlooking the Grand Canal. It is painted from an imaginary viewpoint, as if Canaletto was hovering above the water and looking back towards land.

Detail from *Venice, the Upper Reaches of the Grand Canal with San Simeone Piccolo,* Canaletto, *c.* 1740, oil on canvas, 124.5 x 204.5 cm (49 x 80 ½ in.), National Gallery, London, UK

In his soft palette, Canaletto has individualized and idealized a view of Venice long after the city was at its most prosperous. A sense of light sparkling on the water is created through tiny touches of thin white paint.

② THE DOGE'S PALACE

The seat of Venetian Government, the Doge's Palace is designed in the decorative Venetian Gothic style and features pink Verona marble. The palace was the residence of the Doge of Venice, the supreme authority of the former Republic of Venice, but by Canaletto's time he was no longer important. This magnificent facade hides sumptuous spaces – and formidable dungeons.

③ THE PIAZZETTA

The area between the Piazza San Marco and the waterfront by the Doge's Palace is called the Piazzetta. Then as now, it was teeming with activity, predominantly tourists and other visitors. People gather and chat, a man sits on the steps and a dog runs down them, some people are strolling by and others are about to embark on gondolas or barges.

① SANTA MARIA DELLA SALUTE

A grand example of Baroque architecture, built by the architect Baldassare Longhena and one of the most important churches in Venice, the Santa Maria della Salute was built to celebrate Venice's deliverance from the plague in 1630. Standing on a narrow strip of land between the Grand Canal and the Giudecca Canal at the Bacino di San Marco, its dome is particularly recognizable and can be seen clearly when entering the Piazza San Marco from the water.

4 BALCONY

Canaletto uses crowds and bustle in his paintings to create interest. In this work, groups of figures constitute small scenes within the larger whole. Busy with life, throngs of people observe the activity on the waterfront as other travel in gondolas or barges. He also painstakingly includes tiny figures crowding onto the balconies of the Doge's Palace.

6 AMBASSADOR

Amid all the activity, the French ambassador, Jacques Vincent Languet, Count of Gergy, arrives with his entourage, richly clad in dazzling red and gold. Although the ambassador arrived in Venice in 1726, Canaletto made this record of the event later. The exact date of the painting is unknown but it serves to show the Venetian love of pageantry and elaborate finery.

5 THE LIBRARY

Venice's architecture is a fusion of ideas. In Piazza San Marco, the sculptor and architect Jacopo d'Antonio Sansovino (1486–1570) produced High Renaissance buildings such as his library, the Biblioteca Marciana. In front of it is a column topped with the winged lion of St Mark, while the further column has a statue of St Theodore at the top, the first patron saint of Venice.

7 LIGHT

After a grey underpainting, Canaletto applied paint from a carefully chosen palette. For Venice's open skies and sparkling water, he generally used combinations of Prussian blue with lead white. Here, where the sky is growing ominously dark, he added touches of grey made with black and white. His palette also comprised ochres, umbers, Naples yellow, green earth, red lake and vermilion.

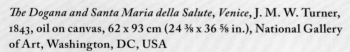

The Dogana and Santa Maria della Salute, Venice, **J. M. W. Turner, 1843, oil on canvas, 62 x 93 cm (24 ⅜ x 36 ⅝ in.), National Gallery of Art, Washington, DC, USA**

The Grand Tour of Europe by wealthy travellers ceased during the Napoleonic Wars of 1793 to 1815, but after that, travel became possible once more. From that time, J. M. W. Turner visited Venice three times, in 1819, 1833 and in 1840. However, his approach to painting the city, although inspired by Canaletto, was completely different. This shows the Dogana, or Customs House, with the domes of the Church of Santa Maria della Salute behind against a luminous sky. Turner's almost abstract images were quickly appreciated by some for their ethereal qualities of light and colour – and caused controversy among others for their lack of finish.

THE FINDING OF MOSES

GIOVANNI BATTISTA TIEPOLO

c. 1730–35

oil on canvas
202 x 342 cm (79 ½ x 134 ⅝ in.)
National Gallery of Scotland, Edinburgh, UK

A PROLIFIC PAINTER AND printmaker from a noble
Venetian family, Giovanni Battista Tiepolo (1696–1770)
brought fresco painting to new heights of technical virtuosity
and dramatic effect. His frescoes feature dynamic images of
gods and saints in mythological and religious stories, and his
use of colour inspired his contemporaries to nickname him
'Veronese Redivio'– a new Veronese. Even though his style
was based on the High Renaissance, he has become accepted
as the greatest Italian Rococo painter.

Tiepolo was successful from the start of his career. He spent
most of his life in Venice, but he also worked in Würzburg,
Germany and lived for the last eight years of his life in
Madrid, Spain. Exceptionally energetic and with a lively
imagination, he initially studied with the Italian painter
Gregorio Lazzarini (1657–1730). In 1755, he was elected director
of the Accademia in Venice.

The Finding of Moses is a story from the Book of Exodus. It
tells how a Hebrew woman saved her baby son from Pharaoh's
massacre of Hebrew children by putting him in a basket on the
River Nile. While bathing, Pharaoh's daughter found the baby,
adopted him and named him Moses.

**Detail from *The Finding of Moses*,
Paolo Veronese, *c.* 1580, oil on canvas,
50 x 30 cm (19 ⅝ x 11 ¾ in.), Museo
Nacional del Prado, Madrid, Spain**

Paolo Veronese was Tiepolo's greatest
influence. This small painting is one
of Veronese's earliest biblical images,
set in 16th-century surroundings.
Standing by a riverbank, Pharaoh's
beautifully dressed daughter finds
the baby boy in a basket. The bridge
and city are reminiscent of the Italian
city of Verona.

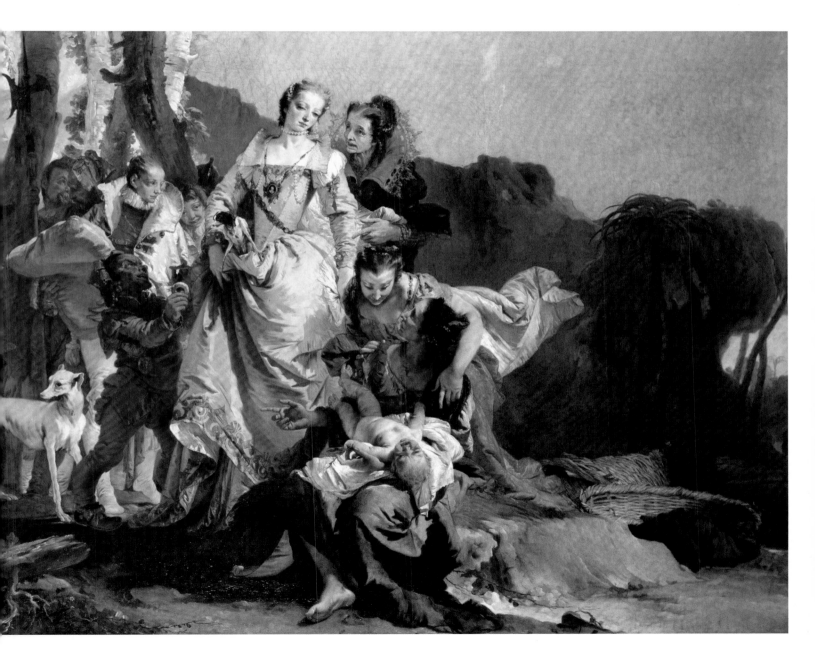

② MOSES AND HIS NURSE

The fair-haired baby is naked and lying on the lap of one of the princess's attendants. Drawn from life, the wriggling baby is presented upside down, squirming in a lifelike, natural manner. Light shines on his pale skin, highlighted by the white cloth beneath him. In the Bible, Pharaoh's daughter gives the baby to the care of a nurse – who happens to be Moses's birth mother: 'And Pharaoh's daughter said unto her, Take this child away, and nurse it for me. . . . And the woman took the child, and nursed it.'

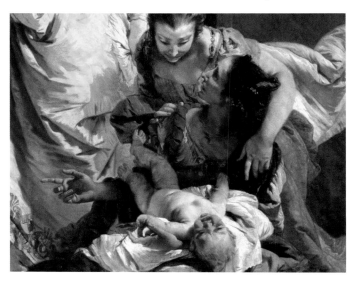

③ PALETTE

Tiepolo adhered to the palettes of the Venetian Renaissance artists he so admired. This work therefore includes lead white, vermilion, carmine, realgar, ultramarine, azurite, Egyptian blue, indigo, verdigris, green earth, malachite, gamboge resin, orpiment, lead-tin yellow, umber, sienna and carbon black.

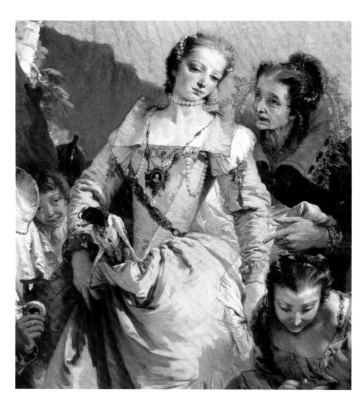

① COSTLY FINERY

In the Book of Exodus, Pharaoh's daughter is not given a name, which in some ways gave artists an open licence to portray her as freely as they preferred. Here, Tiepolo has depicted her as an aristocratic young blonde European woman of the 18th century. Dressed in golden yellow-orange, she is slightly off-centre in the composition. Her formal dress consists of a stiff-bodiced gown with full gathered skirt. Her sleeves are the height of fashion, puffed at the shoulders, loose to the elbow, then tight to the cuffs.

④ COMPOSITION

Although the infant Moses appears to the right of the picture he was originally more central, in keeping with the narrative and viewers' focus of attention. This large work was once bigger; a section that featured a halberdier and a dog in a river landscape was cut from the right side, possibly in the 19th century. Part of the top of the painting was also removed. It is believed that the canvas was cut to fit a new owner's wall. The halberdier and dog section is in a private collection.

⑤ BACKGROUND

Tiepolo invented this mountainous landscape rather than painting it from direct observation as he did with his figures. He learnt how to paint natural objects including clouds and rock formations, not by looking at the things themselves, but by studying the work of other artists he admired, such as Veronese, Michelangelo and Sebastiano Ricci (1659–1734). This method of learning from example was the traditional way of acquiring painting skills.

⑥ LADY IN BLUE

In a brilliant ultramarine costume, this figure of a tawny-skinned young woman steps forward to speak to the princess. Tiepolo was telling the story in stages. The young woman is being ignored because she is appearing at a different point in time. She is probably Miriam, the sister of Moses, who alerted the Pharaoh's daughter to the presence of the baby in the bulrushes. Her smaller scale serves to show viewers that she is part of the story but not of the same moment.

The Parasol, **Francisco de Goya, 1777, oil on linen, 104 x 152 cm (41 x 59 ⅞ in.), Museo Nacional del Prado, Madrid, Spain**

During his career, Francisco de Goya drew on several influences, including at different times, Tiepolo. This painting was executed as part of a decorative series of ten cartoons for tapestries depicting countryside subjects for the Spanish monarchy. Goya has applied the same colours, pyramidal composition, figures in the foreground and sense of movement as Tiepolo. The young woman is dressed in French fashions of the time, holding a fan with a little dog in her lap. The young man holds a parasol to shade her face from the sun. Goya was a young artist when he created this work and was eager to be accepted by the royal court. He therefore built on the kind of art that was admired, adding ideas of his own. The bright colour and bold brushwork are drawn directly from Tiepolo's example, while showing off his own mastery of creating light and shadow.

SOAP BUBBLES

JEAN-BAPTISTE-SIMÉON CHARDIN

c. 1733–34

oil on canvas
93 x 74.5 cm (36 ⅝ x 29 ⅜ in.)
National Gallery of Art, Washington, DC, USA

FRENCH ARTIST JEAN-BAPTISTE-SIMÉON CHARDIN (1699–1779) painted still-life and genre pictures of domestic activities that contrast with many of the more frivolous and flamboyant paintings of the Rococo period. His skill at recording textures complemented his carefully balanced compositions, subdued colours and light effects, tranquil atmospheres and coarse impasto paint.

A carpenter's son from Paris, Chardin was apprenticed for a short time to the history painter Pierre-Jacques Cazes (1676–1754), and then briefly with Noël-Nicolas Coypel (1690–1734). In 1724, he was admitted to the Académie de Saint Luc and in 1728, he became a member of the Royal Academy, described on entrance as a 'painter of animals and fruit'. Most of his paintings at that time were still lifes in the 17th-century Dutch and Flemish tradition, even though it was considered an inferior genre. From the early 1730s until the 1750s, he produced scenes of everyday life – pictures of ordinary individuals in humble surroundings, known as genre paintings. By the 1730s, he was successful and affluent, and he reached the height of his fame in the 1740s, when he was commissioned by the aristocracy and King Louis XV of France. Yet Chardin's last years were troubled. His only son, Pierre-Jean committed suicide in 1767, and the powerful new director of the Academy encouraged more history paintings, and reduced Chardin's pension and his duties at the Academy. As his eyesight failed, he began producing portraits in pastels but they were not popular and he lived the rest of his life in quiet obscurity. In the mid 19th century, however, he was rediscovered by some critics and collectors, and his art influenced numerous subsequent artists including Gustave Courbet and Manet.

Chardin painted this young man blowing bubbles while his wife Marguerite was seriously ill. She was only thirty-eight years old and the mother of his two young children. She died the following year, in 1735. Even without knowing the artist's personal circumstances, contemporary viewers would have recognized his allusions to the transience of life symbolized by the bubble. Chardin made at least three, and probably four, versions of this painting.

The Young Schoolmistress, Jean-Baptiste-Siméon Chardin, 1735–36, oil on canvas, 61.5 x 66.5 cm (24 ¼ x 26 ¼ in.), National Gallery, London, UK

A young child is being taught by her elder sister. Chardin painted this subject several times. Leaning on a cabinet, with a long metal pointer, the 'little schoolmistress' points to a letter in an open book. The pursing of her lips suggests that she is teaching her sister phonetically, by enunciating the sound of each letter. The smaller child tries to follow, pointing with her chubby finger at the letters. The key in the lock of the cabinet symbolizes the many things that she will be able to store in her mind if she applies herself to her learning from this early age. In appealing to all social classes, Chardin's paintings were unique at the time they were painted.

2 BUBBLE-BLOWER

The momentary bubble is a symbol of life's fragility and the vanity of worldly pursuits; it is only a matter of seconds before it will burst. A boy leans forward over a window ledge, concentrating on blowing the bubble. His hair is fashionably curled and tied back in a jaunty ribbon, even though his jacket is torn. Highlights and shadows create the illusion that his face is emerging from the picture plane.

1 THE BUBBLE

The subject of this painting, the bubble, is placed low in the composition, almost invisible in its delicacy. Soft, round and transparent, it is in front of the hard, heavy stone ledge, which gives weight to the entire composition, while the bubble-blower's left hand holds the ledge to steady himself; the contrast of his hand's flesh next to the transient bubble is intentional. The bubble has reached huge proportions.

3 BUBBLE-WATCHER

Next to the older boy blowing the bubble, his eyes wide in wonder, is a smaller boy, watching with rapt attention. Perhaps this is the bubble-blower's brother. His small nose barely reaches above the parapet and he is painted in soft focus, showing that he is in the dark interior. The feather in his cap is there to balance the ivy leaves on the other side of the painting.

4 SOAPY WATER

A master of still-life painting, Chardin's early works include mostly inanimate objects: vegetables and fruit, dead game and kitchenware. Here, his depiction of the opaque soapy water in a glass – swirled with a straw, light glinting on the rim – stands out against the warm brown tones of the canvas. His style influenced the work of later artists, including Cézanne.

The triangular composition draws viewers into the activity. With the broad stone window ledge as a solid base, the soft leaves create a decorative border. Chardin considered every aspect to make his pictures harmonious, from the composition to the mood, and from the colours to his unusual paint application.

The Lacemaker, Jan Vermeer, 1669–70, oil on canvas, 24 x 21 cm (9 ½ x 8 ¼ in.), Louvre, Paris, France

This carefully planned painting is of a young woman in a yellow garment holding a pair of bobbins in her left hand as she carefully places a pin in the pillow on which she is making her bobbin lace. Vermeer directs viewers' attention to the centre of the picture and the lacemaker's work, which he depicts in meticulous detail and in sharp focus, especially the fine white thread that stretches between the young woman's fingers. Other forms in the painting are less distinct, including the red and white threads in the cushion shown in the darker, shadowy foreground. Although the light is coming from the other side and the subject is different, Vermeer's intently contemplative image has clear similarities with Chardin's, including the blank background, effects of light and still-life elements, and of course—the hairstyle.

⑤ LIGHT

Chardin was celebrated by his contemporaries for his great attention to detail, which he built up in varied layers to create luminous glazes. Here, light comes from the left, throwing shadows to the right. Bright spots of dazzling light fall on the glass and the boy's head, collar and shirt cuffs.

⑥ COLOUR

Individual surfaces are enlivened with tiny, almost imperceptible touches of bright red or blue, but overall the painting is created with a restrained and subtle harmony of only three colours: grey, brown and green. The cool grey background contrasts with the warm brown of the boy's jacket.

⑦ BRUSHWORK

Contrasting with other 18th-century painters who used thin paint and imperceptible marks, Chardin applied his paint in lively, heavy layers. This impasto creates a texture of its own, giving the paint a tactile quality that is almost sculptural. It is visible in the hardness of the stone and the soft texture of the cloth.

MARRIAGE À-LA-MODE: I, THE MARRIAGE SETTLEMENT

WILLIAM HOGARTH

c. 1743

oil on canvas
70 x 91 cm (27 ½ x 35 ¾ in.)
National Gallery, London, UK

AN INNOVATIVE PAINTER AND engraver, William Hogarth (1697–1764) was also a social critic and cartoonist. His art ranged from realistic portraiture to satirical images.

Hogarth was born in London and was mainly self-taught as an artist. At first, he apprenticed to a goldsmith and from *c.* 1710, he began to produce his own engraved designs. In 1720, he set up a business in London while studying painting at the free academy run by James Thornhill (*c.* 1675–1734). Hogarth soon took up oil painting, starting with informal group portraits for wealthy families. He went on to create his satirical, moralizing paintings, which were new ideas for fine art. Issued as prints as well as paintings, they generated a good income and great publicity for him but they became so plagiarized that he lobbied for legal protection, which led to the Engravers' Copyright Act of 1735. He also painted life-sized portraits and history paintings in the grand manner. In 1757, he was appointed Serjeant Painter to the King.

Marriage À-la-Mode is a series of six pictures, telling the story of a young couple married in a deal between their fathers. The series satirizes the upper classes, excesses of wealth and arranged marriages. This is the first painting in the series and it relays notions of greed and stupidity.

Marriage À-la-Mode: II, The Tête-à-Tête, **William Hogarth, *c.* 1743, oil on canvas, 70 x 91 cm (27 ½ x 35 ¾ in.), National Gallery, London, UK**

This is the second episode in the *Marriage À-la-Mode* series. Here, the newly-weds are seen in their home on the morning after their wedding. Both are worn out from their individual pursuits the night before.

② THE ALDERMAN

In a red coat and frilled shirt, the wealthy, grey-wigged alderman sits with his back to his daughter, proving that she matters little to him; he merely wants a prospective grandson to inherit a venerable title. He studies the marriage contract through his pince-nez.

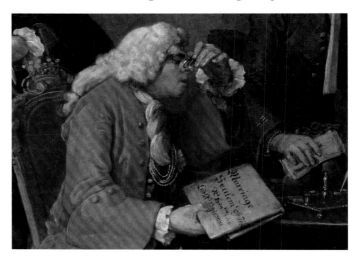

③ BRIDE, GROOM AND LAWYER

The alderman's daughter, dressed in plain white lace with gold trim, leans forward as she listens to lawyer Silvertongue who whispers in her ear as he sharpens his quill. She listlessly dangles her wedding ring on her handkerchief. The fashionably attired earl's son, the viscount, is indifferent to the proceedings. Wearing an ostentatious ring, he takes snuff from his gold snuffbox, his back towards his future wife, while he admires his own reflection in a mirror.

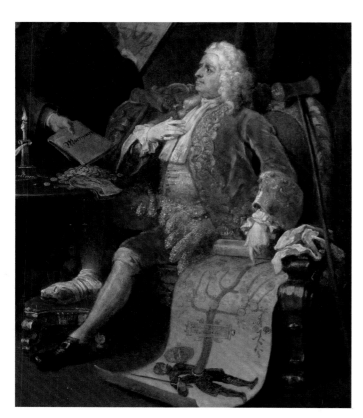

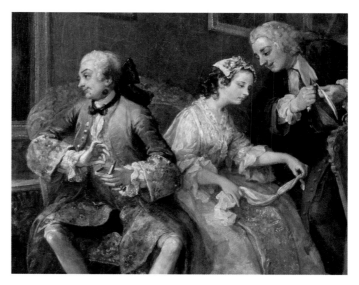

① EARL SQUANDER

Arranging to marry his son to the daughter of a wealthy but parsimonious alderman, the arrogant-looking, over-dressed Earl Squander sits under a canopy, clutching his family tree that shows he is a descendant of William the Conqueror. The earl's right foot is bandaged and propped on a stool, and crutches are leaning nearby; they are all indications of gout and suggest his overindulgence of too much alcohol and rich food.

4 THE DOGS

Two dogs at the viscount's feet are chained together, symbolizing the unhappy, ill-matched, enforced marriage. Traditionally, dogs represent fidelity. These two dogs neither look nor engage with each other, they look out of the painting to the world beyond, with a wistful air of resignation regarding the life yet to come.

6 PAINTINGS

Many of the paintings on the walls reflect the miserable future in store for the main characters. On the wall between the bride and groom are images of death and martyrdom, including, bottom left, a copy of *The Martyrdom of St Laurence* by the school of Eustache Le Sueur (1616–55) and in the centre, *Medusa* after Caravaggio.

5 THE ARCHITECT AND THE CLERK

Contemplating the Neo-Palladian-style building out of the window with scaffolding against it, is the architect who has designed the earl's mansion. Construction has been halted for lack of funds. Behind the architect, the moneylender's clerk shows the earl a mortgage document that explains how much he owes.

7 STYLE

Hogarth used warm hues, often browns and subdued greens, enlivened with bright areas, including silver-white, pale blue and bright red. He layered dark colours over white to create texture. His paint is applied with smooth, loose, brushstrokes and heavy, rich consistencies of paint. For detailed areas, such as ruffles, he pressed the brush firmly onto the canvas.

Detail from *The Betrothal: Lessons: The Shipwreck, after 'Marriage À-la-Mode' by Hogarth*, Paula Rego, 1999, pastel on paper mounted on aluminium, 165 x 500 cm (65 x 196 ⅞ in.), Tate Britain, London, UK

Paula Rego (b.1935) followed Hogarth's *Marriage À-la-Mode* series by interpreting his 18th-century scenes in her own contemporary native Portugal, creating similarly moralistic imagery for the time. This is the first panel of a triptych based on the first painting in Hogarth's series, *The Marriage Settlement*. Called *The Betrothal*, Rego reverses the gender of the parents making the contract and shows a marriage being arranged for two children by their mothers. Rego also changes the financial situations of the families. In her narrative, the girl's family is upper-middle class but has fallen on hard times, while the boy's nouveau-riche mother is the former maid of the girl's family. Like Hogarth's young couple, the children are detached from the agreement, the daughter is even asleep.

THE MUSICAL CONTEST

JEAN-HONORÉ FRAGONARD

c. 1754–55

oil on canvas
62 x 74 cm (24 ⅜ x 29 ⅛ in.)
Wallace Collection, London, UK

A PROLIFIC ROCOCO PAINTER and printmaker, Jean-Honoré Fragonard (1732–1806), was distinguished by his light-hearted paintings full of ebullience and sensuality.

Born at Grasse in the south of France, Fragonard trained as an artist in Paris from the age of eighteen, under the apprenticeships of Chardin and François Boucher (1703–70). In 1752, he won the prestigious Prix de Rome and then entered the École des Élèves Protégés under Charles-André van Loo (1705–65). The École des Élèves Protégés was set up as a separate school within the official Academy, to give three years' specialist training to Prix de Rome winners, so that they might make better use of their time in Rome. He worked at the French Academy in Rome from 1756 to 1761. While in Rome, in 1760, he and fellow painter, Hubert Robert (1733–1808) toured Italy together, sketching the local scenery. It was this experience – of romantic gardens filled with fountains, grottoes, temples and terraces – that inspired the dreamlike gardens and surroundings Fragonard subsequently rendered in his art. He also studied Dutch and Flemish masters, including Rubens, Hals, Rembrandt and Jacob van Ruisdael (*c.* 1628–82). Before he returned to Paris in 1761, he visited Venice, where he also became inspired by Tiepolo. In 1765, he was admitted to the Royal Academy in Paris. Soon, he became renowned among the aristocracy for his portraits, and imaginary scenes and landscape paintings based on his Italian landscape drawings. He paid a second visit to Italy in 1773 for a year, and on his return, continued to paint landscapes, portraits and scenes of everyday life, as well as working as a book illustrator. His work exemplified the blithe and decadent Rococo style, with carefree, sensual imagery, soft colours, rapid brushstrokes and silvery highlights. In 1789, however, his main patrons were annihilated during the French Revolution. He carried on working but his style began changing and by the mid 1780s he employed a more Neoclassical style.

During his career, Fragonard produced more than 550 paintings, plus drawings and etchings. This lush garden is the setting for an elegantly dressed young lady holding a parasol, at the point she is choosing between two prospective suitors.

The Swing, Jean-Honoré Fragonard, 1767, oil on canvas, 81 x 64 cm (31 ⅞ x 25 ¼ in.), Wallace Collection, London, UK

Fragonard's best-known painting blends eroticism with frivolity. This shows a young lady on a swing in a frothy pink silk dress, being pushed by an elderly man and watched by a young one. Both men are hidden in bushes, neither are aware of each other. The young man takes a furtive glance under her dress, while she flicks off her shoe flirtatiously in the direction of a statue of a Greek god. Behind her, cherubic statues look up imploringly at her coquetry.

② IMPLORING SUITOR

Both young men aim to attract the young lady's attention through their musical skills. The young man on her left, however, has become desperate. While holding a flute in his hand, he tries to attract her attention more physically, by grasping her around the waist. Proving that she will not be bullied, she looks in the opposite direction.

① YOUNG WOMAN

Following his admiration of Rubens, Fragonard preferred his females to be plump and pale-skinned. This girl has white skin with rosy accents, slim hands and a casual hairstyle, piled on her head. With her stiff bodice, her bold red dress is full-skirted, revealing ample underskirts. The red bow at her neck picks up the rich hue and a soft voile shawl softens the look.

③ MUSETTE PLAYER

To the girl's right, a second suitor gazes at her adoringly while playing on his musette, or musette de cour (of the heart)–a type of bagpipe popular among the French aristocracy in the 18th century. It appears that this young man is the girl's choice and that she is about to crown him with the pink floral circlet in her right hand.

④ FOUNTAIN

Although Fragonard was later to make detailed sketches of Italian gardens, this fountain with exotic statues was executed before he travelled to Italy. With fluid strokes, he has portrayed a sense of water rushing down the side of this stone waterfall, which features carved putti. Dark leaves hang over it, creating a cool area of shade for this idyllic scene. The falling water serves as a musical accompaniment.

From his lessons with Chardin and Boucher, Fragonard was inspired by Rubens with his plump female figures and loose, sketchy brushwork. A fast painter, Fragonard was able to capture ephemeral frivolity that suited the period with its uncomfortably shifting politics and social climate.

⑤ BRUSHWORK

Emphasizing the free and easy nature of the theme, Fragonard's confident, fluid brushstrokes create soft edges and diffused light. Yet in some areas, he picks out fine details, such as here in the clothing – and in the foliage. His attention to detail helps give the painting a three-dimensional quality.

⑥ LIGHT

For this outdoor scene, Fragonard paints clear sunlight filtering through the trees and backlights them, infusing the scene with a soft, seductive glow. The light lands on the young lady's breasts, highlighting her fair skin and the faces of her suitors. A silvery tone in the highlights creates a mysterious air.

⑦ COLOUR

Although Fragonard uses delicate pastel colours, including soft blues, creams, yellows and greens, he also includes fresh, expressive reds and golds that add brilliance to the scene. His use of gold, red and orange focuses attention on the figures, which are framed by the darker tones behind.

Resting Girl (Marie-Louise O'Murphy), **François Boucher, 1751, oil on canvas, 59.5 x 73.5 cm (23 ⅜ x 28 ⅞ in.), Wallraf-Richartz Museum, Cologne, Germany**

Epitomizing the Rococo style, François Boucher was popular with Louis XV's chief mistress, Jeanne Antoinette Poisson, Marquise de Pompadour, known as Madame de Pompadour. He taught Fragonard twice in Paris – first when Fragonard began his training and again after he had spent time with Chardin. This sensual image is of a young girl who was working as a seamstress in Paris and became one of the king's mistresses. Sprawling naked on a sofa, she reclines on her stomach, relaxing on creased silks and an expensive chaise longue. At this point, she was just fourteen years old and Boucher has presented her charms subtly on purpose. To many, this painting was shocking, whereas to others, it exemplified the hedonistic Rococo style.

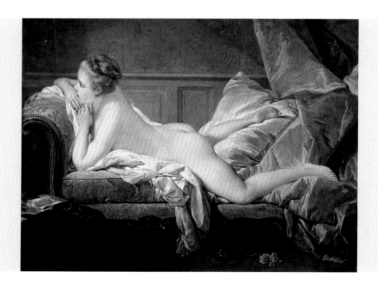

THE OATH OF THE HORATII

JACQUES-LOUIS DAVID

1784

oil on canvas
330 x 425 cm (129 ⅞ x 167 ⅜ in.)
Louvre, Paris, France

THE LEADING NEOCLASSICAL ARTIST, Jacques-Louis David (1748–1825) rejected the light-heartedness of Rococo in favour of smooth contours and classical themes. Neoclassicism became established after the excavations of the ancient Roman cities of Herculaneum and Pompeii in the mid 18th century. It was also a reaction against the hedonism of the French court.

David was born in Paris and trained by Marie-Joseph Vien (1716–1809). In 1774, he won the coveted Prix de Rome and then went to Italy until 1780, where he became inspired by classical antiquity and the Neoclassical doctrines circulated by German artist Anton Raphael Mengs (1728–79). On his return to Paris, his reputation quickly became established. With the French Revolution of 1789, as a deputy in the new parliament, he was instrumental in the abolition of the Royal Academy of Painting and Sculpture. In 1804, he became First Painter to Napoleon Bonaparte. After the fall of the Republic, the new king, Louis XVIII, granted him amnesty and offered him the position of court painter, but he chose exile in Brussels instead.

This painting was exhibited first in Rome in 1785, then at the Paris Salon later that year. An immediate success, it was seen as the embodiment of Neoclassicism.

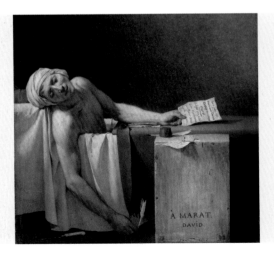

Detail from *The Death of Marat*, Jacques-Louis David, 1793, oil on canvas, 165 x 128 cm (65 x 50 ⅜ in.), Royal Museums of Fine Arts of Belgium, Brussels, Belgium

This is David's idealized image of his friend, the French revolutionary leader, physicist and journalist Jean-Paul Marat, lying dead in his bath after his assassination. Marat suffered from a painful skin disease and had to sit in medicinal baths while he wrote articles supporting the revolution. David depicts Marat still holding his quill and paper.

IN DETAIL

❷ THE BROTHERS

With determined faces and Roman profiles, strong arms and
shining helmets, the three Horatii brothers salute their father,
pledging that they are willing to sacrifice their lives for Rome.
This attitude was pertinent in the run-up to the French Revolution.
Of the three brothers, only one will survive and he will kill his
sister for mourning the death of her lover – one of the Curiatii.

❸ MOTHER AND CHILDREN

The group of brave, patriotic men cast a shadow over their
mother who huddles under a blue cloak with her two grandsons.
Yet the elder boy cannot refrain from peeping out in awe at
the men and their glittering swords – demonstrating that to lay
down one's life for one's country is honourable and something
for which all men should be prepared, even from a young age.

❶ PUBLIUS HORATIUS

Emphasizing the importance of patriotism and self-sacrifice,
the painting represents a scene from a 7th-century BC story
of the triplet sons of Publius Horatius and a war between two
cities, Rome and Alba Longa. This is the Roman Horatii father,
Publius, who is sending his sons to fight the Curiatii brothers
from Alba Longa. His heroic pose, looking upwards at the
swords that he is about to bestow on his sons, shows his nobility.

182 THE OATH OF THE HORATII

4 TWO WOMEN

The Curiatii and the Horatii are related via marriage. The woman in white with a blue turban is Sabina, sister of the Curiatii and wife of one of the Horatii brothers – mother to the two boys under the blue cloak. She leans on her sister-in-law, Camilla, who is betrothed to one of the Curiatii. The women are the manifestation of tragedy, facing the prospect that they will lose loved ones.

5 ARCHITECTURE

Each of the three elements of the picture – the three brothers, the father and the grieving women – is framed by a section of a Doric arcade. The austere Roman Doric style was perceived as masculine and indomitable, therefore highly suitable for this noble image. David paid close attention to accuracy in every aspect of the image, from the armour to the clothing and the architecture.

6 FOCAL POINT

The focal point of the painting is the swords that Publius is holding and about to give to each of his sons. Light glints on the swords as the brothers' hands converge and point at them while they take the oath. Two brothers swear with their left hands and one extends his right. This may have been to indicate which two died and which survived, or it may have simply been David's way of organizing the composition.

7 TECHNIQUE

Clean lines, intricate details, fine tonal gradations and a warm palette contrast with the silvery hues and soft edges of many Rococo paintings. David's paint application is smooth and fine, his figures are deliberately reminiscent of classical statues and his lighting effects are theatrical. This painting initiated Neoclassicism and caused a sensation when it was shown.

Detail from *Madame Moitessier*, Jean-Auguste-Dominique Ingres, 1856, oil on canvas, 120 x 92 cm (47 ¼ x 36 ¼ in.), National Gallery, London, UK

After studying with David for four years, Jean-Auguste-Dominique Ingres succeeded him as the greatest exponent of French Neoclassicism. Ingres became David's most celebrated pupil, and this was painted by him when he was seventy-six years old, by which time he was highly revered and in great demand for his portraits, history paintings and allegorical works. Inès Moitessier's social standing and wealth are proclaimed through her extravagant dress, jewelry, furniture and ornaments, all depicted in detail. Between 1785 and 1814, David's studio was the most important in Europe and after his death, Ingres assumed his role as defender of the French classical style.

CORNELIA, MOTHER OF THE GRACCHI

ANGELICA KAUFFMANN

c. 1785

oil on canvas
101.5 x 127 cm (40 x 50 in.)
Virginia Museum of Fine Arts, Virginia, USA

AS A CHILD, THE Swiss-born artist Angelica Kauffmann (1741–1807) learnt several languages from her mother, read incessantly and showed great ability as a musician, but her greatest talent was in painting, which she learnt from her artist father. By the age of twelve she was painting portraits of important individuals and from the age of thirteen her father took her to study the Old Masters in Italy. In 1762, she became a member of the Accademia di Belle Arti in Florence and in 1763 and 1764 she visited Rome, and then Bologna and Venice. Her art was acclaimed, especially in Rome where she painted portraits of British visitors. This convinced her to visit London, where she joined the social circle surrounding Joshua Reynolds (1723–92). There she became a founder member of the English Royal Academy in 1768, although being female, she was prohibited from participating in life classes. Instead, she developed her own type of history painting, focusing on female subjects from classical history and mythology.

This painting, fully titled *Cornelia, Mother of the Gracchi, Pointing to Her Children as Her Treasures*, is one of her history paintings. Cornelia lived in the 2nd century BC and was the erudite mother of the ancient Roman reformers Tiberius and Gaius Sempronius Gracchus. Kauffmann created versions of the theme for three different patrons in 1785 and 1788 respectively.

Cornelia, Mother of the Gracchi, Pierre Peyron, 1782, oil on canvas, 24.5 x 32 cm (9 ⅝ x 12 ⅝ in.), Musée des Augustins, Toulouse, France

Cornelia was presented by artists as the embodiment of virtue and this work was painted three years before Kauffmann's painting on the same subject. French artist Pierre Peyron (1744–1814) was one of the first since Poussin to apply classical compositions to paintings during the Rococo era. In 1773, he won the prestigious Prix de Rome before his rival Jacques-Louis David.

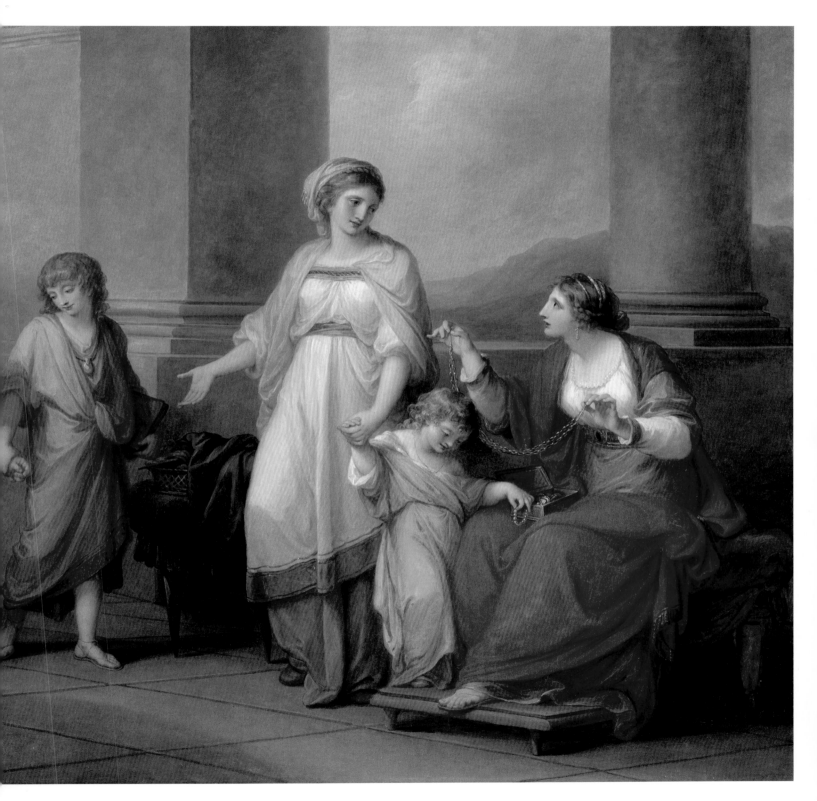

② THE WIDOW

This moralizing image shows the importance of value over luxury. In comparison with her bejewelled guest, Cornelia is modestly dressed with no jewels. After her visitor has proudly exhibited her jewels, Cornelia points to her children. The message is clear: the most precious treasures of any woman are not material but the children she bears for the continuation of humanity. The plain walls of Cornelia's home emphasize she is not materialistic.

③ THE DAUGHTER

Clutching her mother's hand, Cornelia's daughter Sempronia is wearing a simple necklace and pink robe. Fascinated by the jewelry on the guest's lap, she is holding some beads. Her little head, covered in golden curls, is bent over the sparkling jewels. Even in this cool, detached Neoclassical style, Kauffmann's inclusion of some sentimentality invites viewers to empathize with the lifelike portrayal.

① THE VISITOR

Replacing the prevailing vogue for portraying contemporary settings and clothing on historical figures, Kauffmann clothed her figures in ancient Roman attire and posed them in Roman interiors. This lavishly dressed visitor has arrived in Cornelia's home and shows off her magnificent collection of jewelry and precious gems – her treasures. On her lap is her box of jewels and between her fingers is a long golden necklace.

④ THE BROTHERS

The young brothers, Tiberius and Gaius Gracchus, grew up to be political leaders; they sought social reform and ordinary Roman citizens regarded them as friends. This painting serves to show where they learnt their exemplary ethics. Tiberius is nine years older than his younger brother Gaius. Gentle and deliberate in his ways, Tiberius clutches his sibling's wrist.

⑤ PALETTE

Kauffmann used the same basic colour palette of the Renaissance era. It included vermilion, realgar, Venetian red, ultramarine, azurite, smalt, indigo, verdigris, green earth, Naples yellow, lead-tin yellow, orpiment, raw and burnt umber, lead white and carbon black. The relatively new colour, Prussian blue – a deep, greenish blue – has been used in small amounts.

⑥ COMPOSITION

This is a comfortable, shallow triangular-shaped composition, with the figures in a line resembling an ancient Greek or Roman frieze in keeping with the classical theme. Set against two colours – the yellow ochre of the building and the blue-grey of the sky and distant mountains – this effectively throws forward the warm oranges, golds and white of the figures' clothing.

⑦ TECHNIQUE

Geometric symmetry and simplicity of ancient architecture and artefacts inspired Kauffmann and other Neoclassical artists. The clean, clear style with smooth contours and strong tonal contrasts – using cool and warm greys, was perceived by Kauffmann as a way of eradicating the frills of the Rococo style, and allowing viewers to become more rational and reflective.

Detail from *Amo Te Ama Me*, Laurence Alma-Tadema, 1881, oil paint on board, 17.5 x 38 cm (6 ⅞ x 15 in.), Fries Museum, Leeuwarden, Netherlands

Laurence Alma-Tadema (1836–1912) presents an imaginary ancient Roman scene of a young boy and girl on a marble seat overlooking the sea. It is a simple tale of young love – the title translates as 'I love you, so love me too.' Scenes such as this set in ancient Greece, Rome and Egypt were popular among 19th-century artists whose style became called Academic as they worked under the formal training of the official art academies in Europe.

19TH CENTURY

EARLY IN THE 19TH century, Romanticism appeared in art, music and literature. Romanticism was the antithesis of Neoclassicism and its swirling shapes, dramatic compositions and bold colours encapsulated the contemporary revolutionary spirit of the Americas and France. Academic art adhered to the conservative opinions of the art academies of Europe. Realism was a revolt against Academic art and emotionalism, and featured ordinary people and avoided exaggeration. The Pre-Raphaelite Brotherhood was a group of painters who determined to paint 'only truth to nature' rather than follow the styles that originated with Raphael and were favoured by European academies. By the 1870s, Impressionism arrived, closely followed by Post-Impressionism. They were two movements that rejected traditionalism and were inspired by new technologies, Romanticism, English and Dutch landscape painting and Realism. Impressionist artists applied bold brushmarks and colours, and often focused on the effects of light.

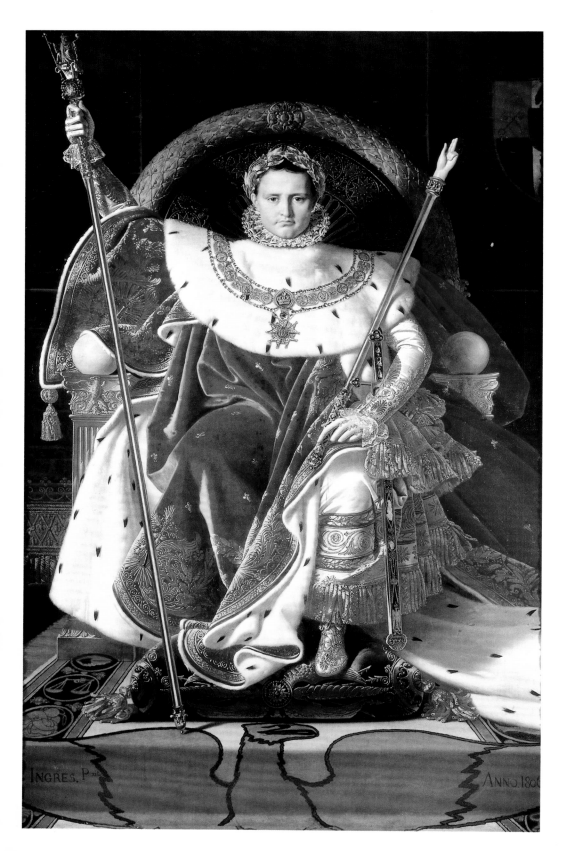

NAPOLEON I ON HIS IMPERIAL THRONE

JEAN-AUGUSTE-DOMINIQUE INGRES

1806

oil on canvas
260 x 163 cm (102 ⅜ x 64 ⅛ in.)
Musée de l'Armée, Paris, France

BELIEVING FIRMLY IN THE supremacy of line over colour, Jean-Auguste-Dominique Ingres (1780–1867) was considered revolutionary in his lifetime because his ideas conflicted with those of his tutor David. Yet he became revered for his cool, structured interpretation of Neoclassicism and his meticulous style, which was the antithesis of the spirited, colourful approach of the Romantic painters, in particular of his rival, Eugène Delacroix.

Ingres was born in south-western France, and received his earliest training in music and art from his father, a painter and miniaturist. Because of his artistic precocity, at the age of eleven he entered the Académie Royale de Peinture, Sculpture et Architecture in Toulouse. Six years later, he went to Paris to study with David for four years, and in 1801, he won the coveted Prix de Rome, but due to the French government's lack of funds, he remained in Paris until 1806. His smooth, detailed style emerged from a blend of influences, including his early education and his Italian experiences, but most of all from David and his own methodical, obsessive and honest character. He became the last champion of the French classical style that had started with Poussin two centuries earlier. At first however, his work was not well received in Paris, so he remained in Italy. He found success at the Paris Salon of 1824 and returned to France. He took up the directorship of the French Academy in Rome from 1835 to 1840 then returned to Paris. Although his life spanned the French Revolution, the rise and fall of Napoleon Bonaparte, the restoration of the monarchy and the *coup d'état* of Louis Napoleon, he never refrained from his traditional methods of lifelike detail, precise drawing and smooth application of paint.

It is not clear whether this painting of Napoleon Bonaparte in his coronation costume was commissioned or painted on speculation but it was bought by the French government before being shown in the 1806 Paris Salon, when it received negative reviews even from Ingres's former tutor David. The painting was criticized for not looking like Napoleon, which is unsurprising given Ingres did not work from life. Set on a high neck ruff, Napoleon's face is almost detached from his body but his features are unblinking, revealing nothing of his thoughts. The aloof expression was disliked; the French wanted a man of the people.

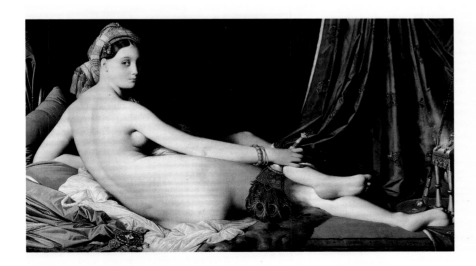

La Grande Odalisque, Jean-Auguste-Dominique Ingres, 1814, oil on canvas, 91 x 162 cm (35 ⅞ x 63 ¾ in.), Louvre, Paris, France

Commissioned by Napoleon's sister, Queen Caroline of Naples, and exhibited at the Salon of 1819, this exotic Turkish harem mistress is portrayed in the tradition of reclining goddesses, but here there is no mythological reference for her. Seen from behind, her languid sensuality and pale limbs demonstrate a cool, sculptural Mannerist influence. Ingres planned every detail, even extending her spine to create a more elegant line.

② CORONATION ROBES

Napoleon is almost swamped by the folds of his ermine-trimmed coronation robes and the gold and jewel-encrusted chain of the Legion of Honour medal around his shoulders. The rods in his silk-gloved hands associate him with the Holy Roman Emperors Charlemagne and Charles V. A jewel-encrusted coronation sword in its scabbard hangs from his left hip, held by a silk scarf.

① NAPOLEON'S LAUREL

In 1799, Napoleon Bonaparte was named First Consul of the French Republic and in 1804 he crowned himself Emperor of the French in an elaborate ceremony. Ingres sought to present him as omnipotent to French citizens who had only recently overthrown their monarchy, so he recalled images of deities. On his head is a golden laurel wreath of victory, similar to one worn by Julius Caesar.

③ FEET AND RUG

Gold-embroidered white shoes rest on a cushion on a rug beneath the throne. This rug displays an imperial eagle, its wings spread wide. Two cartouches can be seen, one represents the scales of justice or the zodiac sign for Libra and the other is a representation of Raphael's *Madonna of the Chair* (1514; see p. 76), an artist and painting that Ingres particularly admired.

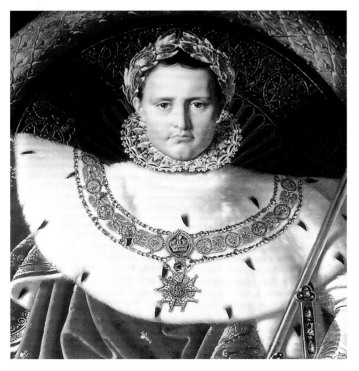

Reacting against the sombre red earth and brown grounds employed in Rococo paintings, Ingres adhered to Neoclassical ideals of painting on pale surfaces to ensure luminosity. However, this strong, coarse canvas breaks with Neoclassical traditions.

④ COLOUR

Although often cited as only being interested in line, Ingres used bright colour in many areas of his work. In 1840, he declared: 'Colour adds adornment and renders the tone perfections of art…more amiable.' In the main, he used earth colours, heightened by brighter hues as needed. His palette here included flake white, Naples yellow, yellow ochre, raw umber, vermilion and Prussian blue.

⑤ LINE AND PATTERN

The firm contours and flowing lines demonstrate how Ingres became nicknamed 'the master of line'. This painting is idealized, but lifelike, with extreme attention to detail. Many patterns compete for attention on the various embroidered materials, the lace, the wreath, the rug, cushion and throne, while even the sumptuous folds and draping elements form ornate patterns.

⑥ TEXTURE

Ingres's brushstrokes varied, depending on whether he was painting smooth, shiny, velvety, soft or hard textures. While he remained loyal to David's classical teaching in his emphasis on line and drawing, he also enjoyed depicting textures. The texture of Napoleon's skin for instance, directly contrasts with the soft fur, the warm red velvet cloak and the hard throne.

Detail from *God the Father, Ghent Altarpiece*, Jan van Eyck, 1425–32, oil and tempera on panel, 350.5 x 461 cm (138 x 181 ½ in.) Cathedral of St Bavo, Ghent, Belgium

The *God the Father, Ghent Altarpiece* by Jan van Eyck was in the Louvre at the time Ingres was executing his painting of Napoleon, and it was no secret that he greatly admired the Flemish master (who was known at the time as Jean de Bruges). The work is remarkable in its realism. With his hand raised in blessing, *God the Father* features incredible painted details that make it astonishingly realistic. The altarpiece was one of many artworks looted by Napoleon's army and taken to Paris where it was exhibited at the Louvre. It was returned to Ghent in 1815 after the French defeat at the Battle of Waterloo.

THE THIRD OF MAY, 1808

FRANCISCO DE GOYA

1814

oil on canvas
268 x 347 cm (105 x 136 in.)
Museo Nacional del Prado, Madrid, Spain

BORN IN HUMBLE CIRCUMSTANCES in Fuendetodos in Aragon, Spain, the son of a master gilder, the art of Francisco de Goya y Lucientes (1746–1828) broke decisively with the past. When the average lifespan was fifty years, Goya's career spanned sixty. His work both commented on and chronicled contemporary events, and he influenced generations of artists who followed him.

At the age of thirteen, Goya was apprenticed to José Luzán y Martinez (1710–85), from whom he learnt to paint in both Rococo and Baroque styles. However, his main influence was the art of Velázquez, whose free brushwork he emulated. From 1786, he became a court painter in Madrid. In 1792, a severe illness made him permanently deaf and he soon produced a series of disturbing satirical etchings that depict atrocities dispensed by both sides during the French occupation of Spain. In later life, he painted some murals on his walls, known as the 'Black Paintings' (1819–23). After the French left, he was mistrusted by the new Spanish king and he moved to France.

This painting represents a real event. When Napoleon Bonaparte's armies marched into Madrid on 2 May 1808, the citizens rose up against them. The next day, French soldiers rounded up hundreds of Spaniards and shot them.

The Family of Charles IV, Francisco de Goya, 1800, oil on canvas, 280 x 336 cm (110 ¼ x 132 ¼ in.), Museo Nacional del Prado, Madrid, Spain

Featuring life-sized depictions of King Charles IV of Spain and his family, Goya modelled this after Velázquez's *Las Meninas* (1656; see pp. 146–49), by setting his subjects in a room in the palace. Like Velázquez, Goya has included himself: he is at the back on the left, looking out of the image.

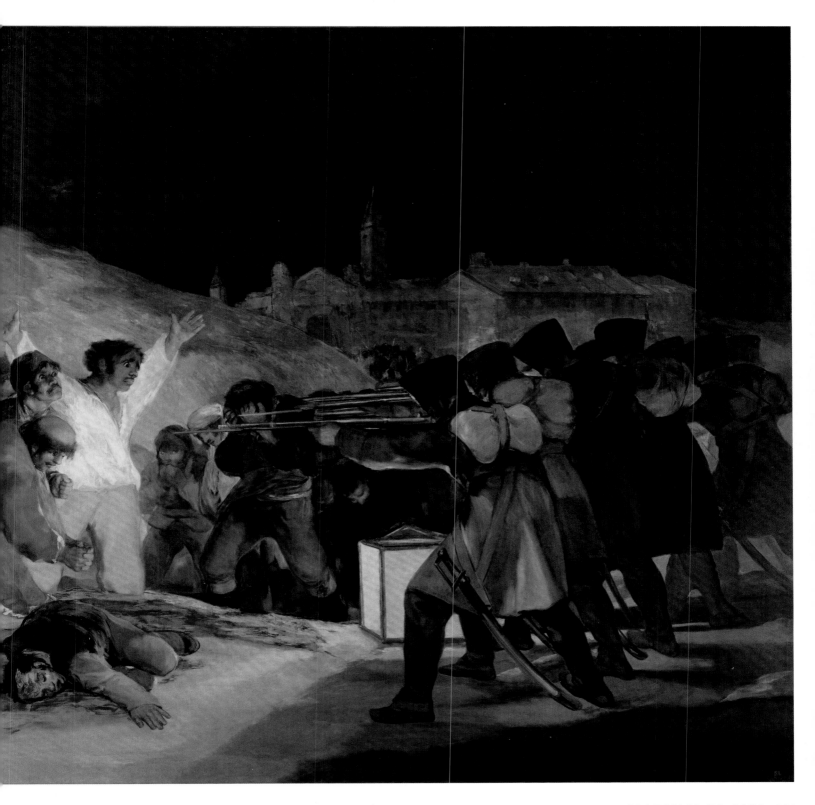

② THE LANTERN

The lantern on the ground between the main victim and the firing squad is the only source of light, and dazzlingly illuminates him, bathing him in a strong, powerful light. The lamp enables the soldiers to see their victims and allows viewers to witness the violence. The lantern casts long, dark shadows elsewhere in the painting, thus suggesting that further abominations will follow.

① THE VICTIM

With no precedent, comparing the horrors of war with biblical notions, this has been called the world's first modern painting. The central figure is one of the Spanish citizens, a simply clad, sunburnt labourer, rounded up by the French soldiers. Brilliantly lit, he kneels on the ground and flings out his arms, in submission both to the men and to his fate. Echoing the stance of Christ on the cross, he is sacrificing himself for his nation.

③ THE MASSACRE

A pile of dead bodies in their own blood represent the men who fought for their city and failed. Even though Goya had shown French sympathies in the past, the slaughter of his countrymen and the horrors of war profoundly affected him. The dead man in the foreground echoes the main figure's upright pose, and the pose of the crucified Christ.

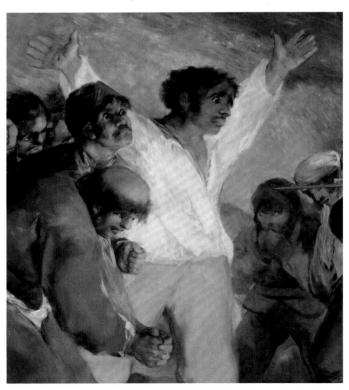

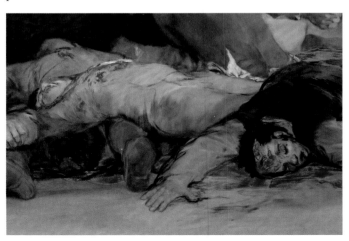

4 THE MONK

The kneeling figure in grey, bent over and with his hands clasped in prayer, is a Franciscan friar. The tension of the monk's clenched hands suggest his fervour. Although a tonsured monk, he has been arrested with the other Spaniards. He is unlikely to have been part of the previous day's insurrection and his presence illustrates the arbitrary nature of the French soldiers' revenge.

5 BUILDINGS

In the background, a town and church tower is visible against the dark sky. None of the buildings can be identified; they simply represent Madrid. The shadowy backdrop of the conquered city is in contrast to the illuminated scene of terror in the foreground that shows its helpless citizens.

6 FIRING SQUAD

Under the guise of reinforcing Spanish armies, in November 1807, some 23,000 French troops had entered Spain. However, Napoleon Bonaparte's real intentions became clear the next year when he put his brother Joseph on the Spanish throne. Two months later, the citizens of Madrid retaliated. Seen from behind, this row of French soldiers in greatcoats, shako hats, sabres and backpacks are anonymous and inhuman as they aim their rifles at their victims.

7 DARK TONES

Dominated by browns, greys and black, Goya's palette emphasizes his nightmarish vision. His loose brushwork developed from his admiration of Velázquez, but his became more sketchy, dynamic and obvious. In some areas, he moved paint on the canvas with a palette knife or even his fingers. As he said: 'I see no lines or details. . .there is no reason why my brush should see more than I do.'

The Execution of Maximilian, Édouard Manet, 1868–69, oil on canvas, 252 x 305 cm (99 ¼ x 120 ⅛ in.), Kunsthalle Mannheim, Baden-Württemberg, Germany

Inspired by Goya's painting of *The Third of May, 1808*, which he possibly saw in the Prado in 1865, this work by Édouard Manet is one of three large oil paintings, a smaller oil sketch and a lithograph of the same subject. It shows in close detail the execution of the Austrian Archduke Ferdinand Maximilian, who had been installed in Mexico as a puppet emperor by Napoleon III in 1864 in an attempt to recover unpaid debts and establish a European presence there. Within three years, however, the deposed president of Mexico, Benito Juárez, took back his position and ordered Maximilian's execution.

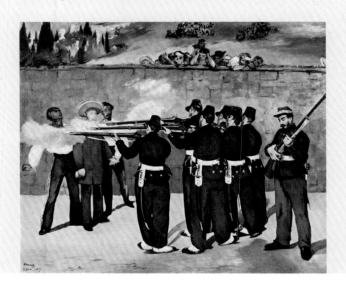

THE RAFT OF THE MEDUSA

THÉODORE GÉRICAULT

1818–19

oil on canvas
491 x 716 cm (193 ¼ x 281 ⅞ in.)
Louvre, Paris, France

A PIONEER OF ROMANTICISM, Théodore Géricault (1791–1824) was an influential painter and lithographer. His passionate temperament and disregard for convention turned him into a legend during his tragically short career of only twelve years.

Born in Rouen to wealthy parents, Géricault studied art initially with Carle Vernet (1758–1836) in Paris from 1808. Two years later, he transferred to the studio of Pierre-Narcisse Guérin (1774–1833). He also spent time in the Louvre, copying paintings by artists he particularly admired, including Rembrandt, Rubens, Titian and Velázquez. After a trip to Italy in 1816, he began to integrate elements he had taken from Caravaggio and Michelangelo's work, which included drama, chiaroscuro and fluidity – all contrasting with the fashionable Neoclassical approach. Along with these influences and his vivid imagination, his passionate style came to be admired even by the conservative Academy officials.

In 1819, Géricault's *The Raft of the Medusa* provoked a furore at the Paris Salon and won him a gold medal. Over life-sized, with strongly contrasting effects of light and vivid realism, the painting conveys energy and emotional intensity. It depicts the survivors of a wreck that occurred partly because of the recently restored French monarchy's incompetence. The *Medusa* was a French navy frigate launched in 1810. In 1816, it was used to ferry French officials to Saint-Louis in Senegal. However, the captain was incompetent and the ship was wrecked. The 400 passengers had to evacuate. There was not enough room on the frigate's launches and many escaped on an improvised raft towed by the launches. The crew of the launches began to worry that the desperate people on the raft would try to climb on board their lifeboats, which were not large enough, so they cut the ropes, leaving the raft and its occupants to their fate. Although 150 men and one woman had clung to the hastily constructed raft, only fifteen people survived. Géricault questioned and sketched the survivors, considering which aspects would encapsulate the events in the most dramatic way. He travelled to Le Havre to study the coast and, while crossing the English Channel to visit English artists, he made further sketches of the elements.

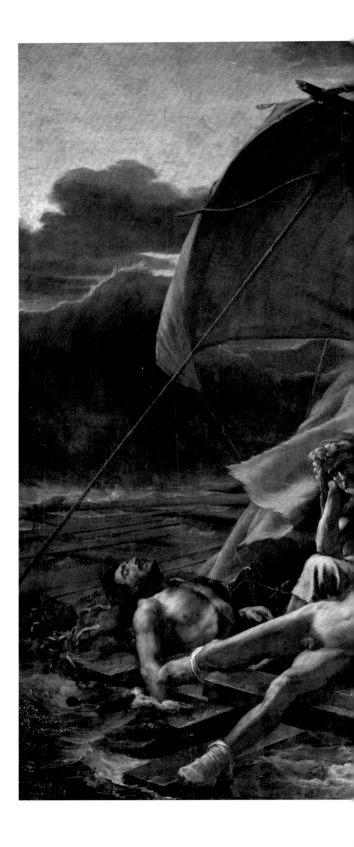

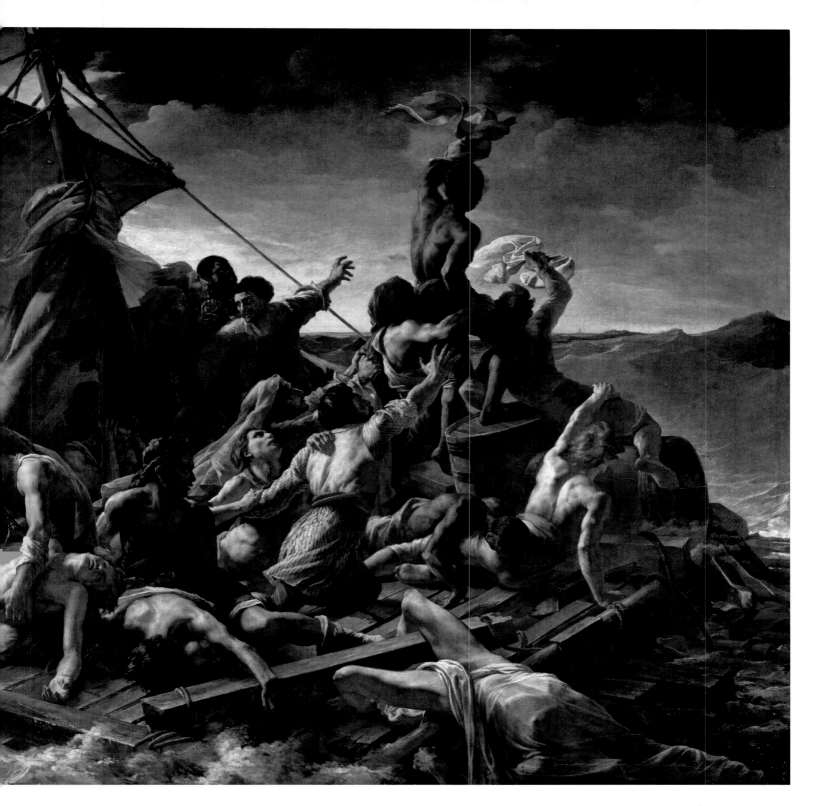

② AXE

On the first night adrift, twenty men were killed or committed suicide. With only the centre of the raft secure, many were washed away or pushed off the edges. By the fourth day, there were only sixty-seven still alive and some resorted to cannibalism. Géricault has indicated this with a bloodstained axe. The scandal became known through the accounts of the few survivors.

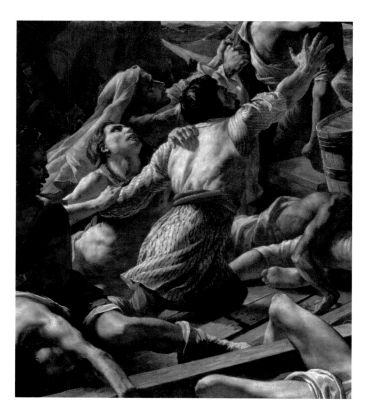

① THE RAFT

After the *Medusa* wrecked, many of the ship's passengers were herded onto an improvised raft. At 20 metres (66 feet) long and 7 metres (23 feet) wide, the raft had few supplies, no means of steering and much of it dipped under water; the situation deteriorated rapidly. Géricault had a full-sized raft reconstructed in his studio.

③ WAVING FOR HELP

This is Jean Charles, one of the crew members. The liveliest person on the raft, he stands on an empty barrel, above the other desperate men, waving his handkerchief at a boat on the distant horizon. Under the arm of the penultimate figure on the right, a tiny, misty shape can be seen in the distance: it is the *Argus*, the ship that rescued the survivors.

④ DEATH

Hanging off the edge of the sinking raft, the dead bodies are about to be swept away by the waves. Géricault researched his subject intensively, collecting documents about the event. To achieve a realistic rendering of the pallor of flesh tones, Géricault made sketches of corpses in the morgue of the Hospital Beaujon in Paris, studied the faces of dying patients, brought severed limbs into his studio to study their decay and borrowed a severed head from a lunatic asylum. His eighteen-year-old assistant, Louis-Alexis Jamar (1800–65) posed for a few of the figures, including this dead youth who is about to slide into the sea.

⑤ EUGÈNE DELACROIX

One of Géricault's good friends, this is Eugène Delacroix. Lying face down, arms outstretched, he is next to the rather biblical-looking grey-haired man with a red cloth on his head, who holds his dead son's body. The deathly colourings are exaggerated by Géricault's powerful chiaroscuro. Géricault drew and painted many preparatory works while deciding which moments of the disaster he would depict in the final work. He drew an outline of the composition onto the canvas and then posed his models one at a time. The lighting has been described as 'Caravaggesque' because of the violent contrasts of tone.

Liberty Leading the People, **Eugène Delacroix, 1830, oil on canvas, 260 x 325 cm (102 ¼ x 128 in.), Louvre, Paris, France**

Directly influenced by his friend Géricault, Eugène Delacroix painted this image of events he witnessed during the Parisian uprising of July 1830 that replaced the Bourbon king, Charles X, with Louis-Philippe, Duke of Orléans. Delacroix posed as one of the figures in *The Raft of the Medusa* and he was influenced by the painting, especially its pyramidal composition and its imaginative combination of fact and fantasy. He developed his plan for the painting using preliminary sketches for every element and at every stage, and completed the work in three months. Focusing on the dramatic and visual impact of the scene, this is the crowd breaking through the barricades to make a final assault on the enemy camp on 28 July. Delacroix also emulated Géricault's vigorous brushwork and chiaroscuro.

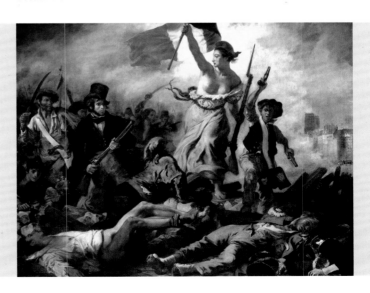

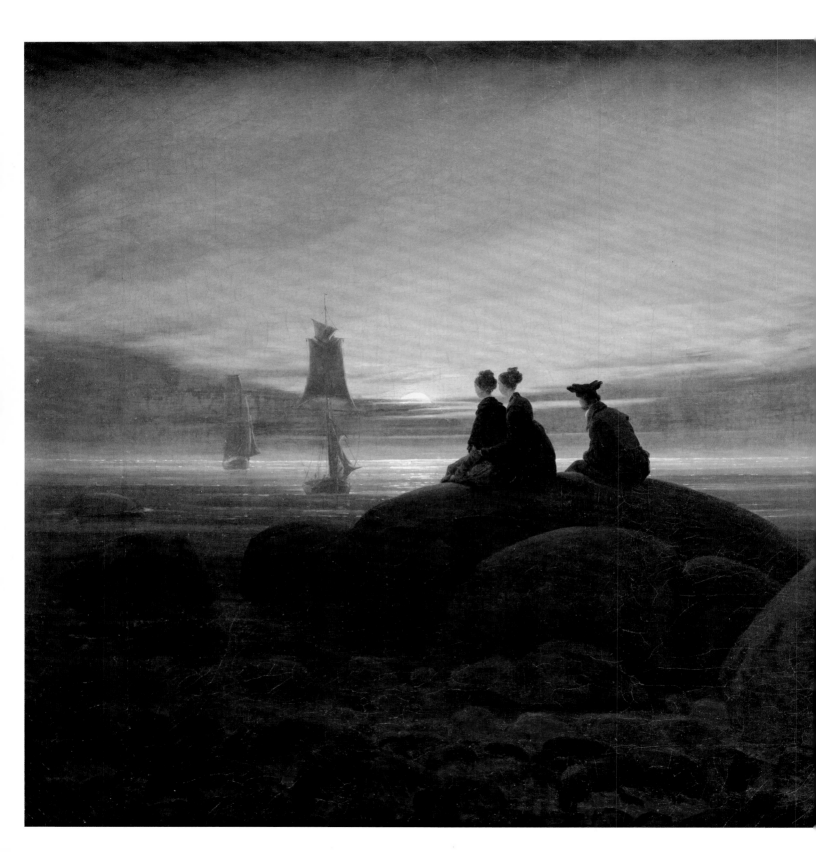

MOONRISE OVER THE SEA

CASPAR DAVID FRIEDRICH

1822

oil on canvas
55 x 71 cm (21 ⅝ x 28 in.)
Alte Nationalgalerie, Berlin, Germany

THE MAIN EXPONENT OF German Romantic painting, Caspar David Friedrich (1774–1840) is best known for his allegorical landscapes featuring meditative figures in atmospheric scenery. Although born in Pomerania on the Baltic coast, he spent most of his life in Dresden. His childhood was unhappy; by the time he was thirteen years old, his mother, sister and favourite brother had died. Brought up by his strict Protestant father, he grew up to be a melancholy man.

Friedrich studied art at Copenhagen Academy, returning to Germany in 1798, where he remained for the rest of his life. After producing topographical drawings in pencil and sepia, he took up painting in his thirties. Intensely introspective, he focused on contemplating nature; he was interested in depicting the effects of light and created haunting, ethereal visions, usually with some human presence. Initially, his work was appreciated, but then it was perceived as outdated and he died in obscurity. He was later rediscovered by the Symbolists, Expressionists and Surrealists.

This work was commissioned by the banker and art collector Joachim Heinrich Wilhelm Wagener. With its symbolism, strange light effects and semi-silhouetted figures, it helped alter the concepts of landscape painting.

The Stages of Life, **Caspar David Friedrich, *c.* 1835, oil on canvas, 72.5 x 94 cm (28 ½ x 37 in.), Museum der Bildenden Künste, Leipzig, Germany**

Although an imaginary view of a harbour, this is based on a real view of Greifswald, where Friedrich was born. Similar to *Moonrise over the Sea*, here, the ships symbolize the figures in the foreground. They are at different points in their journeys, just as the individuals are at different stages of life.

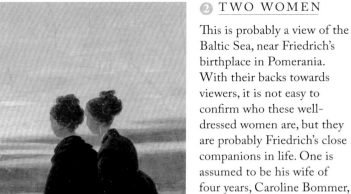

② TWO WOMEN

This is probably a view of the Baltic Sea, near Friedrich's birthplace in Pomerania. With their backs towards viewers, it is not easy to confirm who these well-dressed women are, but they are probably Friedrich's close companions in life. One is assumed to be his wife of four years, Caroline Bommer, who also served as a model for him in other paintings. The other young woman is more than likely the recently widowed Marie Helene Kügelgen, whose painter husband, Franz Gerhard von Kügelgen (1772–1820) was Friedrich's closest friend and had been murdered two years previously.

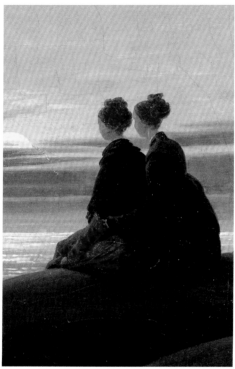

① SELF-PORTRAIT

The figure on the foreground promontory is a self-portrait of Friedrich resting, perhaps after a walk. Elegantly attired, he sits contemplating the ships on the calm water in front of him. Most of all, he is watching the glowing light of the rising moon that seems to suggest a moment of revelation as God's light emerges to send him a message.

③ SHIPS

The ethereal light seems to move over the sky towards the figures, creating a sense of a personal message from God. Two ships, appearing to sail in silent, ghostly fashion across the water symbolize the voyage of life. The stages of Friedrich's life are being reflected back to him through the celestial light and the two ships. He has passed through childhood and youth and is now an adult. Painted in detail, the furthest ship is in full sail, representing youth, while the closest ship is dropping sail to reveal the cross of the mast. This represents maturity and suggests Christ's sacrifice at the Crucifixion.

④ SKY AND WATER

As the moon rises, the surface of the water begins to glow, as if taking up the light of heaven. Clouds have gathered, partially hiding the round shape of the full moon close to the horizon, forcing the light to fall below on various elements. This celestial light seems to move across the water, creating a sense of the vastness of the universe. In this way, the moon is a symbol of hope.

⑥ COLOURS

During this middle part of Friedrich's career he was at his most optimistic and his palette was at its brightest. While keeping to a limited number of colours, he contrasted the cool hues of the sea and sky with the warm browns of the foreground. His palette here included lead white, red earth, iron oxide red, smalt, Prussian blue, Naples yellow, yellow ochre and bone black.

⑤ APPROACH

Friedrich painted everything in a meticulous style, using small brushes and diluted fluid paint. Here he applied oil paint in thin, transparent washes over a delicate underdrawing, using a range of marks including short, hatched strokes, delicate stippling to create the dissolving textures of light. In some areas such as the rocks, he used impasto to convey textures.

⑦ LIGHT

Friedrich conveyed moonlight as a moment of transformation to evoke thoughts about life and mortality. In using nature to express the spiritual, he was continuing the ideas expounded by contemporary Romantic poets. He explained his philosophy: 'Close your bodily eye in order that you may see your picture first with the eye of your inner spirit.'

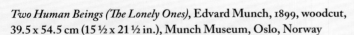

Two Human Beings (The Lonely Ones), **Edvard Munch, 1899, woodcut, 39.5 x 54.5 cm (15 ½ x 21 ½ in.), Munch Museum, Oslo, Norway**

The backs of these two figures dominate the composition, as they stand on a shore, facing the sea. This woodcut was directly inspired by Friedrich's work that Edvard Munch saw on a trip to Berlin in 1892. Yet, unlike Friedrich's mood of contemplation and acceptance, Munch's work exerts a feeling of emptiness, loneliness and even anxiety. Munch's childhood was comparable to Friedrich's. Like Friedrich, Munch frequently painted figures presenting their backs to viewers to express uncomfortable, often unmentioned, disquieting feelings. Many of Friedrich's themes of the inevitability of time, notions about mortality and the power of the universe became essential concepts to Munch and the Symbolists in the late 19th century.

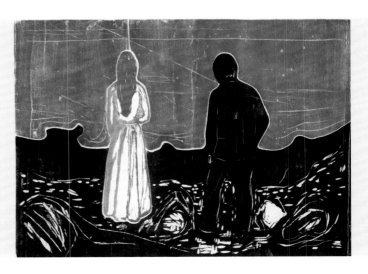

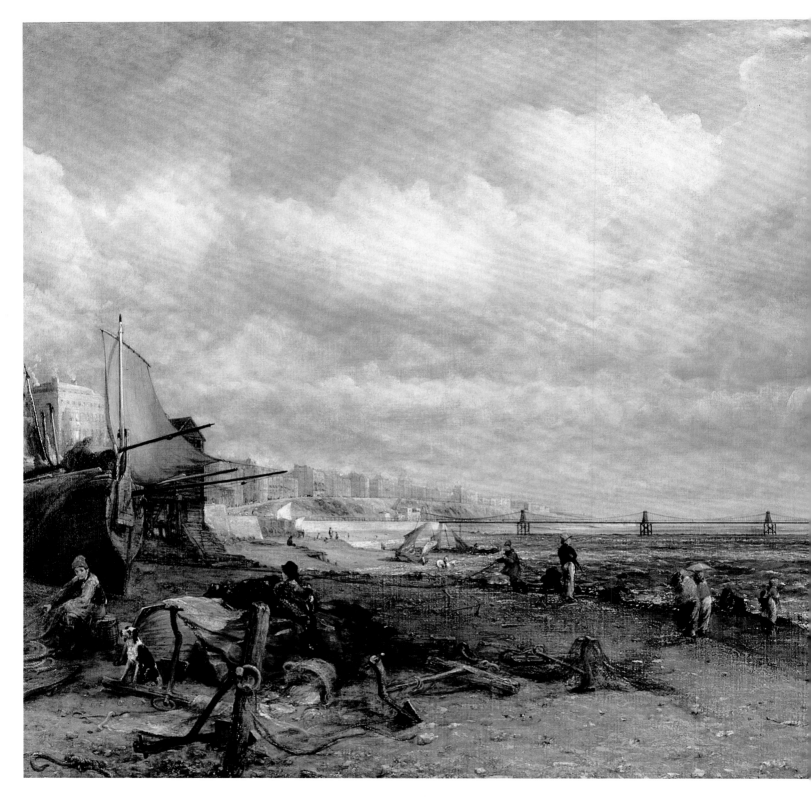

206 CHAIN PIER, BRIGHTON

CHAIN PIER, BRIGHTON

JOHN CONSTABLE

1826–27

oil on canvas
127 x 183 cm (50 x 72 in.)
Tate Britain, London, UK

BEST KNOWN FOR HIS paintings of the English countryside, John Constable (1776–1837) brought a new energy and direction to landscape painting. By producing works in the open air and completing them in the studio, he began a trend that was adopted across Europe and the United States, and contributed to the development of Impressionism.

Born in Suffolk to a prosperous family of mill owners, Constable never travelled beyond England, although he had a strong following in Paris. He was largely self-taught, mainly learning to paint by copying works of art he admired by Claude, Rubens, Thomas Gainsborough (1727–88) and Dutch landscapists such as Ruisdael. However, he did study for a while at the newly established Royal Academy School in London. He strongly believed that the study of nature was essential and that familiarity with locations was also important. He produced hundreds of sketchbooks filled with detailed drawings from direct observation and several large canvases that he called 'six-footers'.

With its free and vigorous brushwork, *Chain Pier, Brighton* conveys energy and atmosphere. Constable saw himself as a conventional artist, but expressive paintings such as this one reveal his daring originality as an artist who took landscape painting in a new direction.

The Windmill at Wijk bij Duurstede, Jacob van Ruisdael, *c.* 1670, oil on canvas, 83 x 101 cm (32 ⅝ x 39 ¾ in.), Rijksmuseum, Amsterdam, Netherlands

Here Jacob van Ruisdael (*c.* 1628–82) creates a feeling of infinity, of the continuation of the landscape even beyond the picture. He is regarded as an influence on Constable.

IN DETAIL

① CLOUD FORMATION

Constable never treated clouds as a mere backdrop in his paintings. Determined to become more scientific in his recording of atmospheric conditions, he studied them intensely. He produced many detailed observational sketches, drawings and oil studies of skies – especially clouds – before including them in his final works. To these studies he added notes, often on the back of the sketches, of the prevailing weather conditions, direction of light and time of day. To portray patchy light filtering through the clouds and the movement of the wind, he used broken brushstrokes, often in small touches, which he has scumbled over lighter passages. Dark strokes capture the atmosphere on a dull, windy day.

② THE PIER

The Chain Pier in Brighton opened in 1823 and was the second seaside pleasure pier to be built in England. It was designed in a mock ancient Egyptian style, which became an influential design for other pleasure piers; it was also one of only three suspension piers built in Britain. Constable made a pencil underdrawing on a pink primed canvas and lengthened his depiction of the pier after first painting it, which meant that he had to obliterate a small boat.

③ FIGURES BY THE SEA

Buffeted against the wind, the figures on the beach include fishermen pulling in their nets and other individuals waiting for a boat, one looking out to sea. Constable lived in Brighton between 1824 and 1828, while his wife Maria was ill. He witnessed Brighton's rapid growth from fishing village to seaside resort because it had acquired fashionable status during the Regency period (1811–20). The Chain Pier was one of the new buildings.

4 BUILDINGS

In the background, several grand buildings extend along the seafront. These were the new mansions and hotels recently constructed by wealthy visitors, mainly from London, who followed King George IV to his favourite resort. Built in what became known as Regency style in Britain, or generally Neoclassicism, they are elegant and symmetrical. The vast sky and fishing boats contrast with the stabilizing buildings, but also convey the dichotomy of old and new.

5 THE SEA

Constable clearly had a deep understanding of nature, and he brought a new vivacity to the genre of landscape, capturing the effervescent sensations of light and atmosphere. His depiction of the sea here displays his boldness in the handling of paint. As a great innovator, he blended ideas of artists such as Claude and Ruisdael, and constantly juxtaposed their interpretations of the natural world against his own experience of it.

6 BRUSHWORK

Constable used a mixture of brushwork here, with fine marks that contrast with delicate and free flicks and controlled dashes of colour laid on with a knife in the foreground. He applied his colours to match atmospheric effects of the changing light in the open air. Off-white flecks applied with a knife gave the impression of reflective light and sparkling waves. Earth colours with transparent glazes dominated his palette and approach.

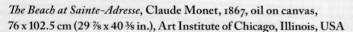

The Beach at Sainte-Adresse, **Claude Monet, 1867, oil on canvas, 76 x 102.5 cm (29 ⅞ x 40 ⅜ in.), Art Institute of Chicago, Illinois, USA**

During the 19th century, Constable inspired several artists, especially in France, beginning with the painters who became known as the Barbizon School. They appreciated the freedom with which Constable painted and the fact that he produced so much of his work in the open air, in front of his motifs. Additionally, they admired the objectivity with which he worked, or appeared to work. Claude Monet was one of the French Impressionists who was influenced by Constable and his approach, including the depiction of light through touches of colour and the impressions of natural phenomena such as clouds and weather. Like Brighton, Sainte-Adresse in Normandy was once a fishing village that became a beach resort.

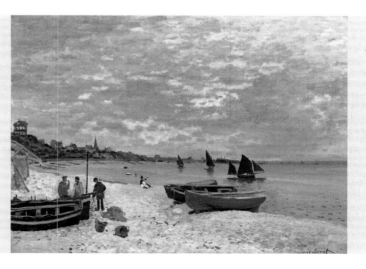

ENTRY OF THE CRUSADERS INTO CONSTANTINOPLE

EUGÈNE DELACROIX

1840

oil on canvas
410 x 498 cm (161 ½ x 196 in.)
Louvre, Paris, France

PAINTER, MURALIST AND LITHOGRAPHER
Eugène Delacroix (1798–1863) was the leading exponent
of Romanticism in French painting. In contrast with the
vogue for clear outlines and carefully modelled forms in
Neoclassicism, Delacroix's style emphasized colour and
movement. Rather than classical models of Greek and Roman
art, North African exoticism became one of his enduring
inspirations. His study of the optical effects of colour
profoundly inspired the Impressionists.

Like Géricault, Delacroix was trained by the Neoclassical
painter Pierre Guérin from 1816 to about 1823. Inspired by
Michelangelo, Rubens, Venetian Renaissance artists, Géricault
and English landscape painters including Constable and
Turner, he first exhibited at the Salon in 1822. In 1825, he visited
England and in 1832, he travelled to Spain, Morocco and
Algeria. From 1833, he painted works for the Palais Bourbon
and received many royal commissions.

This energetic painting was exhibited at the 1841 Salon.
It depicts an episode of the Fourth Crusade in 1204, in
which the Crusaders abandoned their plan to invade Muslim
Egypt and Jerusalem, instead sacking the Christian city
of Constantinople, the capital of the Byzantine Empire.

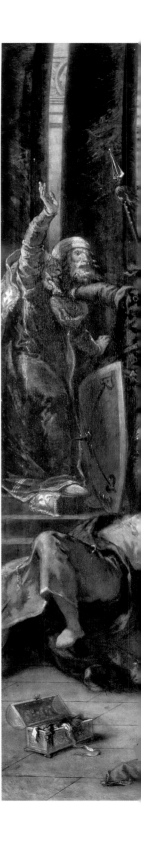

The Death of Decius Mus, Peter Paul
Rubens, 1616–17, oil on canvas,
289 x 518 cm (113 ¾ x 204 in.),
Liechtenstein Museum, Vienna, Austria

A dense mass of horses and men in
the middle of a battle, this dynamic
image by Rubens depicts the ancient
Romans' battle against the Latins.
Rubens's rich palette and paintings
of the Roman classics profoundly
influenced Delacroix who often
painted similar subject matter.

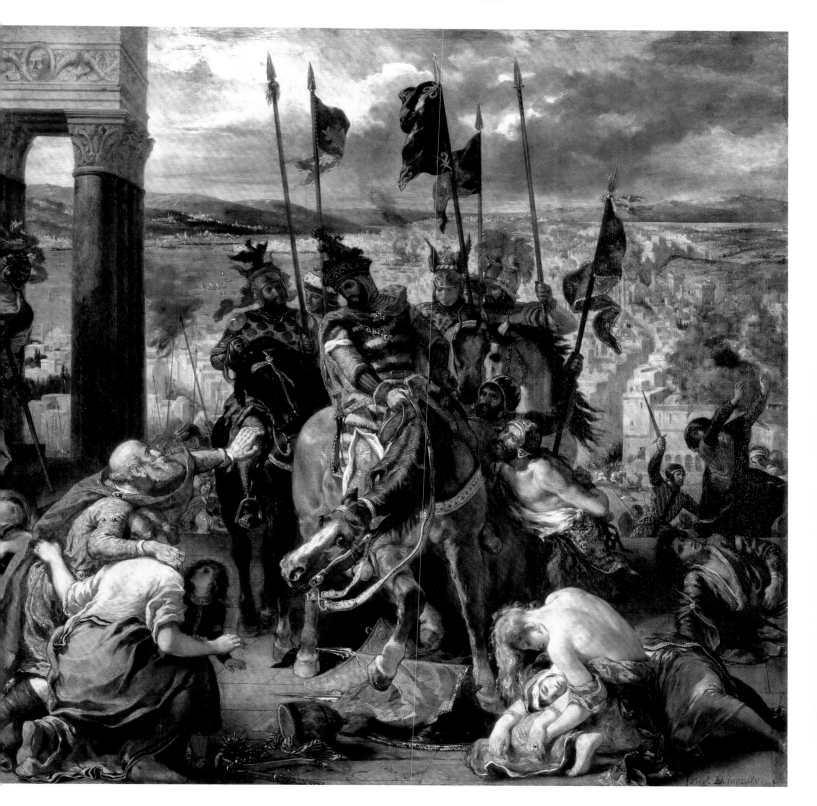

② THREE FIGURES

Three figures form a triangular shape as they huddle together to plead with the crusaders for mercy. An old man, his arm round a young woman's shoulders, implores Baldwin to pity them. Epitomizing innocence, a little girl looks up at him. The crusade was primarily a French undertaking, yet Delacroix presents an empathetic view of the Byzantine citizens who have suffered.

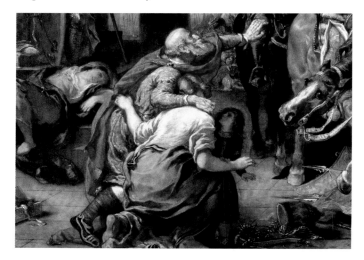

③ FLAGS

The Crusaders came from all over Europe. Fluttering high above them as they ride through the vanquished city, are several pennants announcing their origins. Behind, tumultuous clouds gather and beneath those, in the distance, is the city of Constantinople. The energy with which Delacroix has portrayed the flags creates a strong impression of wind blowing.

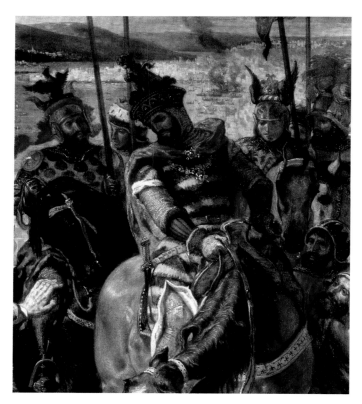

① BALDWIN I

The Crusaders' attack of Constantinople in 1204 during the Fourth Crusade caused the collapse of Eastern Christendom. The territory was broken up and divided among the crusade leaders, becoming a Latin Empire until 1261. On a chestnut steed, in an orange cloak, the leader of the Crusaders, Baldwin IX Count of Flanders, leads the triumphant procession through the streets. He was later crowned Emperor Baldwin I of Latin Constantinople.

4 TWO WOMEN

Perilously close to the horses' hooves are two women. With her dress ripped and back exposed, the blonde woman cradles a dead woman with dark hair. The impression is one of voluptuousness, but also of sadness. In his energetic expression, Delacroix has painted both women – dead and alive – in dynamic, flamboyant poses. His vigorously descriptive brushwork creates solidity.

5 PRISONER

The Crusaders had attacked Constantinople at the request of the Byzantine Emperor, Isaac II Angelus, who had been dethroned by his brother, Alexios III Angelus. Tied to the side of Baldwin's horse is Alexios as prisoner, while behind him, fighting continues in the distance. It was an ignominious fight in which precious relics and treasures were looted or lost from the Byzantine capital.

6 COLOUR

The painting's luminosity and use of colour owes much to Delacroix's study of other artists, such as Veronese. Touches of complementary colours in the shadows and the rendering of reflected colour show his astute observation of natural effects and a break with past ideas. He replaced the darks of traditional chiaroscuro, using colour to create expression.

7 METHOD

Delacroix built up forms working from dark to light, reworking shadows later in the painting process as needed. He applied contrasting individual strokes of orange and green over dry paint to enliven the appearance of flesh. Details of texture, such as the armour and the horse's mane, were added loosely and thickly. Finally, before varnishing, he added glazes.

RAIN, STEAM AND SPEED

J. M. W. TURNER

1844

oil on canvas
91 x 122 cm (35 ⅞ x 48 in.)
National Gallery, London, UK

OVER HIS LONG CAREER, Joseph Mallord William Turner (1775–1851) became one of the most important landscape painters of the 19th century. Frequently called 'the painter of light'–because of his methods of painting luminous colours and atmosphere – he produced oils, watercolours and engravings. Born in London, he entered the Royal Academy Schools in 1789, exhibiting watercolours there from the age of fifteen in 1790, and oils from 1796. In 1799, he was elected an Associate of the Royal Academy at the youngest permitted age, and in 1802, he became the second youngest person ever to be elected full Academician. He travelled widely, producing a vast amount of work. Over the years, his style varied considerably, from accurate, topographical landscapes and to classical works inspired by Claude, to his expressive, almost abstract paintings that explored the effects of colour and light.

During the early 19th century, images of trains or any form of modern machinery was not perceived as picturesque enough for the subject of paintings but, as usual, Turner defied convention. *Rain, Steam and Speed–The Great Western Railway* represents a train hurtling across a bridge and caused a sensation when it was exhibited in 1844.

Fishermen at Sea, J. M. W. Turner, 1796, oil on canvas, 91.5 x 122.5 cm (36 x 48 ⅛ in.), Tate Britain, London, UK

This moonlit scene is the first oil painting that Turner exhibited at the Royal Academy. Despite the title, its subject is the overwhelming power of nature. The small boats are buffeted on the ocean's waves and bathed in the cool, clear light of the moon.

① THE TRAIN

In the early 19th century, the Great Western Railway was one of several private British railway companies established to develop the new means of transport. Trains were represented in engravings, topographical views and cartoons, but they were not customarily featured in paintings. They were too modern, too black, too loud, cumbersome and smoky. Yet Turner embraces the steam power of the future, depicting an early morning train travelling westwards from London.

② THE BRIDGE

This is probably Maidenhead Railway Bridge, across the River Thames near London. The view is looking east towards London. The bridge was designed in 1837 by Isambard Kingdom Brunel to carry his Great Western Railway between London and Bristol. Like the train, such industrial bridges were not conceived as suitable for paintings, but this represents Turner's embrace of the Industrial Revolution and its transformation of the countryside.

③ THE HARE

As if to symbolize speed itself, a hare races along the track, ahead of the rushing train. Some scholars have suggested that this is Turner's symbol of nature about to be destroyed by industry, while others believe that it is simply a way of indicating how slowly the train was moving in comparison with nature.

④ COMPOSITION

Deliberately intersecting two visions of tranquillity – the dark diagonal of the railway bridge and train as it crosses the river – the work presents an image of speed. The bold diagonal of the railway thrusts across the canvas, cutting directly through a horizontal line formed by the upper edge of the trees and foliage on either side of the railway bridge and the line of the old road bridge. The horizontal line represents stability, while the diagonal line embodies energy, purpose and power. The focal point is the front of the train.

⑤ METHOD

Turner explored the sensations of speed and progress and the qualities of light. It appears to be the early evening because a lamp glows on the front of the train and the carriages behind have their gas lamps lit. To convey the effects of a rainstorm sweeping through the valley and a train emerging thunderously through it, he applied thin layers of semitransparent white and yellow oil paint over darker areas to create blurred, atmospheric effects. His characteristically loose brushwork adds to the impression.

⑥ PALETTE

Above all, the surface of this painting is a swirling haze of white, gold and blue, out of which the dark shape of the train erupts. Turner's colours comprised organic, mineral and industrially made pigments, including white lead, chalk white, chrome yellow, gamboge, safflower, quercitron (these are three different yellows), yellow ochre, raw sienna, vermilion, iodine scarlet, Indian red, Venetian red, carmine, madder, cobalt blue, blue verditer, French ultramarine and lamp black.

Train Tracks at the Saint-Lazare Station, **Claude Monet, 1877, oil on canvas, 60.5 x 81 cm (23 ¾ x 32 in.), Pola Museum of Art, Kanagawa, Japan**

The Impressionists, particularly Claude Monet and Camille Pissarro, were inspired by Turner's free handling, rapid brushwork, effects of light, visions of modernity, original compositions and capturing of impressions or sensations. As the painter of light, Turner's recordings of sights around Europe, bathed in the glow of light that dissolve into coloured atmospherics can be seen as a precursor to many of their ideas. With his loose, fluent brushstrokes, here Monet has presented another image of the railway where the train is indistinct and smoke swirls into the air. In the third Impressionist exhibition, which opened in April of that year, he showed seven canvases of the railway station.

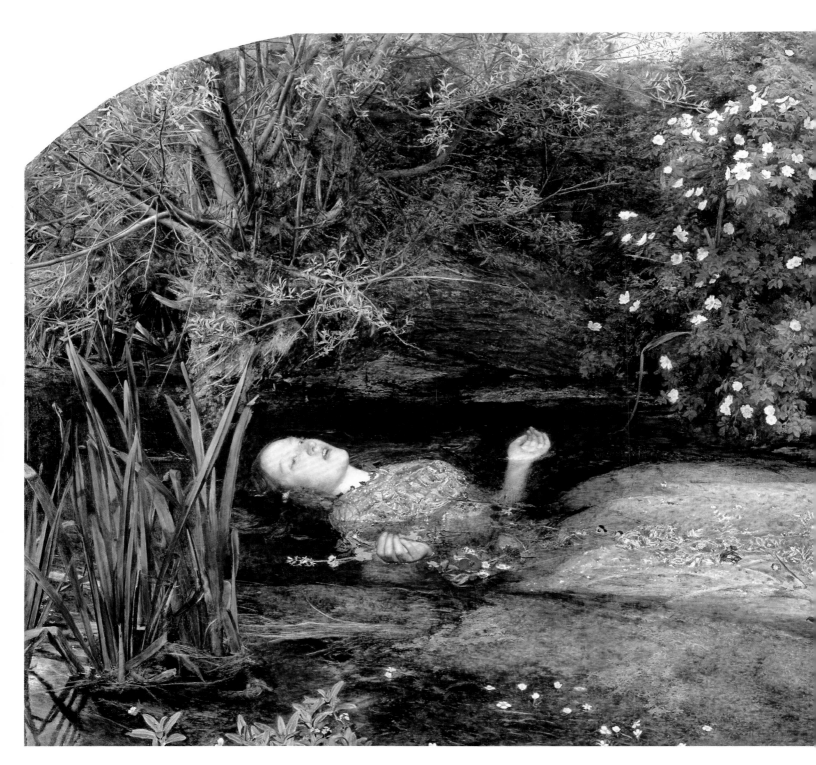

OPHELIA

JOHN EVERETT MILLAIS

1851–52

oil on canvas
76 x 112 cm (30 x 44 in.)
Tate Britain, London, UK

BORN IN SOUTHAMPTON TO wealthy parents, John Everett Millais (1829–96) was a child prodigy. He went to London at the age of nine where he attended Sass's Art School, and won a silver medal at the Royal Society of Arts. By the age of eleven, he was admitted to the Royal Academy Schools as their youngest ever student. At the Royal Academy, he forged friendships with Dante Gabriel Rossetti and William Holman Hunt. In 1848, in efforts to counteract the narrow approach of academic painting, with its brown underpainting and idealized subjects, the three artists helped form the Pre-Raphaelite Brotherhood. The PRB, as they signed themselves, determined to be faithful to nature and to exploit the luminosity of colour. Millais was elected a member of the Royal Academy in 1863 and served as president in 1896. By the mid 1850s, he moved away from the Pre-Raphaelite style and developed a new approach to realism. He became one of the wealthiest artists of his day.

In the summer of 1851, Millais began painting *Ophelia*, William Shakespeare's heroine from *Hamlet* (1603), and he exhibited it the following year at the Royal Academy. It encapsulates the Pre-Raphaelite aims of truth to nature and poetic storytelling.

Detail from *Proserpine*, Dante Gabriel Rossetti, 1874, oil on canvas, 125 x 61 cm (49 ¼ x 24 in.), Tate Britain, London, UK

Even after the Pre-Raphaelite Brotherhood was over, Dante Gabriel Rossetti's (1828–82) style remained the same. This depicts Proserpine from Roman mythology. The model was Jane Morris, the wife of William Morris (1834–96), with whom Rossetti had an affair. Proserpine was lured to the underworld and then doomed to spend six months a year there because she ate six pomegranate seeds.

② BACKGROUND

In July 1851, Millais began painting the background to the work by the Hogsmill River in Ewell, Surrey. Working on a small three-legged easel, he painted for up to eleven hours a day, six days a week, over a five-month period. By November, the weather had turned windy and snowy, so Millais painted from a hut he made from four hurdles covered with straw.

③ DRESS

After Millais completed the background of the painting, he painted the figure of Ophelia. He undertook the intricate work on the dress in his London studio. For four months, Lizzie wore the heavy dress, lying in a bath filled with water, heated underneath by oil lamps. During one sitting, Millais did not notice that the lamps went out. Lizzie became ill and her father sent Millais a letter demanding he pay for medical expenses.

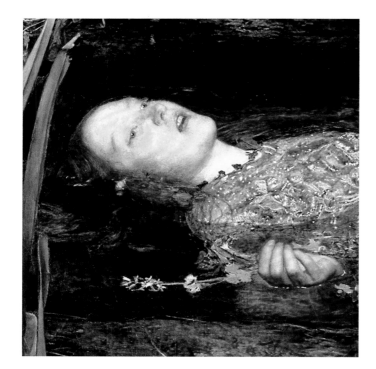

① OPHELIA

This depicts Ophelia from Act IV, Scene VII of *Hamlet*, in which she is driven mad after her lover Hamlet murdered her father. The model is Lizzie Siddal, Rossetti's future wife. Flame-haired and pale-skinned, she sings quietly to herself and floats downstream before she drowns. The pink rose near her cheek alludes to her brother Laertes calling her 'rose of May'. The necklace of violets around her neck represents chastity.

4 FLOWERS

In *Hamlet*, Ophelia falls into the river while picking flowers. Millais chose to depict particular flowers for their symbolism. Many of them bloom at different times of the year, but all are painted in painstaking botanical detail. Daisies are associated with forsaken love, pain and innocence. Pansies symbolize love in vain. Poppies signify death and sleep. Forget-me-nots imply remembrance.

5 ROBIN

On the far left of the painting, a robin sits on a willow branch, distinctive because of its red breast. The willow tree is a symbol of forsaken love and the nettles growing around its branches represent pain. As well as adding a dash of colour, the robin probably refers to the line, 'For bonny sweet Robin is all my joy', which Ophelia sings when she loses her mind.

6 LONG PURPLES

This purple loosestrife alludes to 'long purples' mentioned by Shakespeare, although he really meant purple orchid. The meadowsweet flowers to the left of the loosestrife signify the pointlessness of Ophelia's death. For the first time in history, artists could buy tubes of ready-mixed paint, and Millais's palette included cobalt blue, ultramarine, Prussian blue and emerald green.

7 METHOD

One of the Pre-Raphaelite techniques that Millais used was to coat the canvas in white paint and then, with small brushes and brilliant colours, he painted while the white ground was still wet. Similar to a fresco technique, the white ground was laid freshly for each day's work. Onto this, Millais painted transparent, thin glazes, intensifying the effect of light falling on the scene.

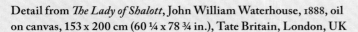

Detail from *The Lady of Shalott*, John William Waterhouse, 1888, oil on canvas, 153 x 200 cm (60 ¼ x 78 ¾ in.), Tate Britain, London, UK

John William Waterhouse (1849–1917) continued to follow the Pre-Raphaelite style years after the group's members ceased working together, and he became known as 'the modern Pre-Raphaelite'. This is a scene from the poem 'The Lady of Shalott' written by Alfred, Lord Tennyson in 1832 and based on a medieval Arthurian legend. Of the three candles at the prow of the boat, two have been extinguished by the wind – an indication that the woman is nearing both the end of her journey and her life. The beautiful and tragic woman, the dark woods behind, the plants and the river beneath the boat all echo elements of Millais's painting. Millais influenced many other artists, including John Singer Sargent and Van Gogh.

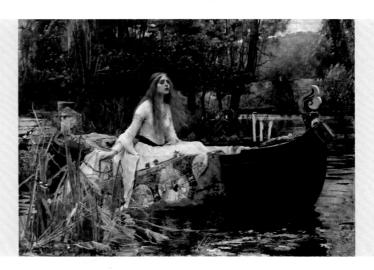

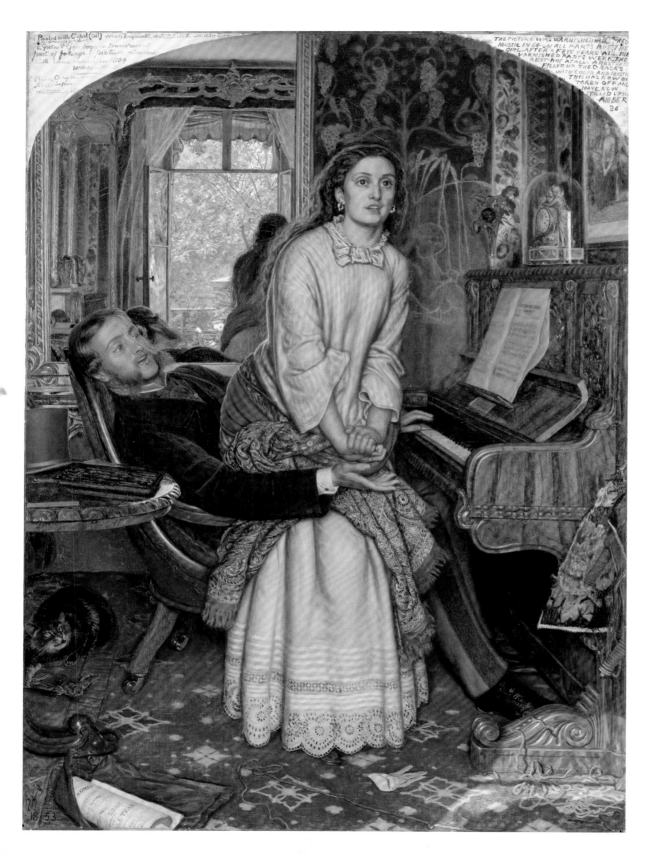

THE AWAKENING CONSCIENCE

WILLIAM HOLMAN HUNT

1853

oil on canvas
76 x 56 cm (30 x 22 in.)
Tate Britain, London, UK

IN 1848, ALONG WITH the artists Millais and Rossetti, William Holman Hunt (1827–1910) founded the Pre-Raphaelite Brotherhood. Although the group disbanded within five years, Hunt adhered to its ideals for the rest of his life.

The son of a warehouse manager, Hunt was born in London, left school early and began working as a clerk at the age of twelve. Five years later, he entered the Royal Academy Schools where he became disillusioned by the rigid conventions of contemporary British art and the influence of the school's founder, Joshua Reynolds (1723–92), in particular. Hunt began exhibiting from 1845 and, after reading the second volume of John Ruskin's *Modern Painters* (1846), he became inspired by the notion that artists should return to the style of late medieval and Early Renaissance painters. With Millais and Rossetti, he formed the Pre-Raphaelite Brotherhood, which aimed to: 'express genuine ideas, to study nature closely, to sympathize with what is direct, serious and heartfelt in previous art, to the exclusion of what is conventional and self-parading and learnt by rote; and to produce thoroughly good art'. By emphasizing painstaking observation of the natural world, they sought to resurrect the spiritual qualities of medieval art, which they saw as opposing the more rational art of Raphael. Hunt's paintings show great attention to detail, vivid colour and elaborate symbolism.

In 1850, the printer and publisher Thomas Combe became Hunt's main patron, friend and business advisor. Combe purchased several of Hunt's works, including *The Light of the World* (right). Three years later, the industrialist and art collector Thomas Fairbain commissioned Hunt to complete *The Awakening Conscience* as a secular version of *The Light of the World*. The two paintings are linked by their religious and moralistic ideals. *The Awakening Conscience* shows a young woman starting up from her lover's lap, struck by the sudden realization of her sin. The model was Annie Miller, an uneducated barmaid who often modelled for the Pre-Raphaelites and whom Hunt nearly married. In his customary fashion, he has depicted every detail, including her shining hoop earrings, the soft bow and lace around her neck, and her abundant auburn hair.

Detail from *The Light of the World*, **William Holman Hunt, 1851–53, oil on canvas, 50 x 26 cm (19 ⅝ x 10 ¼ in.), Manchester City Art Gallery, Manchester, UK**

Christ prepares to knock on a door that has not been opened for a long time. Symbolizing Jesus attempting to enter a sinner's soul, this painting directly illustrates the biblical message: 'Behold, I stand at the door and knock; if any man hear my voice and open the door, I will come to him.' The lantern he holds represents the biblical comment that Christ is the 'light of the world', and provides hope in the darkness. Pertinently, the door has no handle, so it can only be opened from the inside, which symbolizes a mind closed against Christianity.

① THE AWAKENING

Starting up from her lover's lap, this woman has seen the light streaming in the window in front of her. Her conscience has been awakened; she is mistress to a married man. Her face is illuminated by the light of God. Her flowing hair and loose garments reveal to viewers that she is in a state of undress: a respectable woman would not have been in the drawing room insufficiently attired.

② GENTLEMAN

This well-dressed young man was a typical wealthy Victorian gent who kept his mistress in a comfortable, modern house. His hat and book on the table indicate that he is only visiting, his expression suggests that he is oblivious to the epiphany his mistress is experiencing. His reflection can be seen in the mirror, alongside the light reflecting from the window. The book references Hunt's efforts to educate Annie, who was his girlfriend at the time.

③ CAT AND BIRD

Under the table, a cat plays with a bird. The cat represents the man and the bird his mistress. Startled by the young woman's sudden movement, the cat allows the bird to escape. In front of them, a song sheet unfurls from a velvet case. It is a musical arrangement by Edward Lear of the poem 'Tears, Idle Tears' (1847) by Alfred, Lord Tennyson.

④ ON THE PIANO

The clock on the piano is decorated with a gilt carving of Chastity binding Cupid. This suggests that abstinence will prevail and the woman will escape. A painting behind the clock depicts a biblical story of an adulterous woman. The flowers next to it are convolvulus, which characteristically entwine with other plants, therefore symbolizing the trap of deceit.

Hunt's efforts to attain authenticity were obsessive: he travelled to observe closely the elements for his paintings and he also researched the painting methods of Early Renaissance painters. Using small brushes and fluid paint, he worked over a wet white ground.

⑤ PALETTE

Intent on permanency, Hunt chose his colours with care, undertaking tests on paint ageing, brilliance and durability. His palette for this work included lead white, Naples yellow, yellow ochre, raw sienna, Chinese vermilion, Venetian red, Indian red, crimson madder, Indian lake, burnt sienna, raw and burnt umber, Cologne earth, Antwerp blue, cobalt blue, blue black and ivory black.

⑥ INTRICATE DETAILS

With his usual close attention, Hunt hired a room in a house in London, where gentlemen often installed their mistresses. The room is cluttered and the furniture pristine, undamaged by family life. The man's discarded glove on the floor is a warning about prostitution, the common fate of cast-off mistresses. The tangled wool on the floor symbolizes the web woven through deceit.

⑦ REALISTIC EFFECTS

Using his tiny, careful brushmarks, Hunt built up realistic details, such as the hands and textures of the fabrics. He applied paint in translucent layers, building up the effects of soft textiles, warm skin and hard, shiny surfaces. The man's open hand in supplication to the woman contrasts with her tightly clasped hands that reveal a ring on every finger except her wedding finger.

The Birth of Venus, **Sandro Botticelli**, *c.* 1486, tempera on canvas, 172.5 x 278.5 cm (67 ⅞ x 109 ⅝ in.), Uffizi, Florence, Italy

Inspired by the perceived honesty and spirituality of art before Raphael, Hunt and the other Pre-Raphaelites were impressed with Botticelli's clear, elegant style. Here he depicts the goddess Venus emerging from the sea as an adult woman. The smooth paint, concept of beauty and considered details are all elements that appealed to the Pre-Raphaelites, and were regarded as genuine and pure. Millias's *Ophelia* (1851–52; see pp. 218–21), is said to have been inspired by the flowers Botticelli depicted in *Primavera* (*c.* 1481–82; see pp. 50–3).

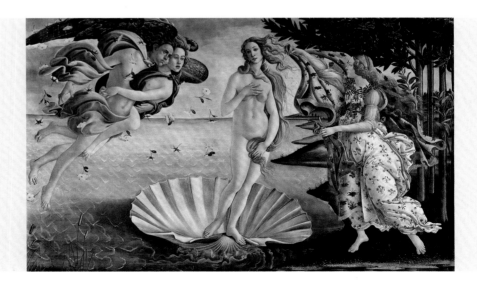

THE ARTIST'S STUDIO

GUSTAVE COURBET

1854–55

OFTEN CATEGORIZED AS THE father of the Realist movement, Gustave Courbet (1819–77) was committed to painting only what he could see. A committed Republican who saw his Realism as a means to champion the working classes, he became a tremendous influence on later art movements, especially Impressionism.

Courbet was born at Ornans in eastern France. After persuasion by his father, he moved to Paris at the age of twenty and entered law school, but soon left in order to pursue a career in art. Avoiding recognized academic studios, he studied with lesser-known artists and mostly taught himself by copying paintings by Caravaggio, Rubens and Velázquez, as well as painting directly from nature. Although he renounced accepted academic treatments, he still submitted his work to the official annual Salons, yet only three of his twenty-five submissions were accepted. When visiting the Netherlands and Belgium he became inspired by Dutch art. During the Paris Commune of 1871, he briefly abandoned painting for a role in the revolutionary government and was imprisoned for six months after it was crushed.

He painted *The Artist's Studio* for the 1855 Paris Exposition Universelle. It is an allegory of his life as a painter.

A Burial at Ornans, Gustave Courbet, 1849–50, oil on canvas, 315 x 668 cm (124 x 263 in.), Musée d'Orsay, Paris, France

Taking his inspiration from group portraits of Dutch civic guards in the 17th century, Courbet shocked visitors at the Paris Salon of 1850 by using a huge canvas – usually reserved for history painting – for a mundane subject – the funeral of his great-uncle in Ornans. The ordinariness of the scene was perceived as derogatory to the tradition of history painting.

oil on canvas
361 x 598 cm (141 ⅛ x 235 ⅜ in.)
Musée d'Orsay, Paris, France

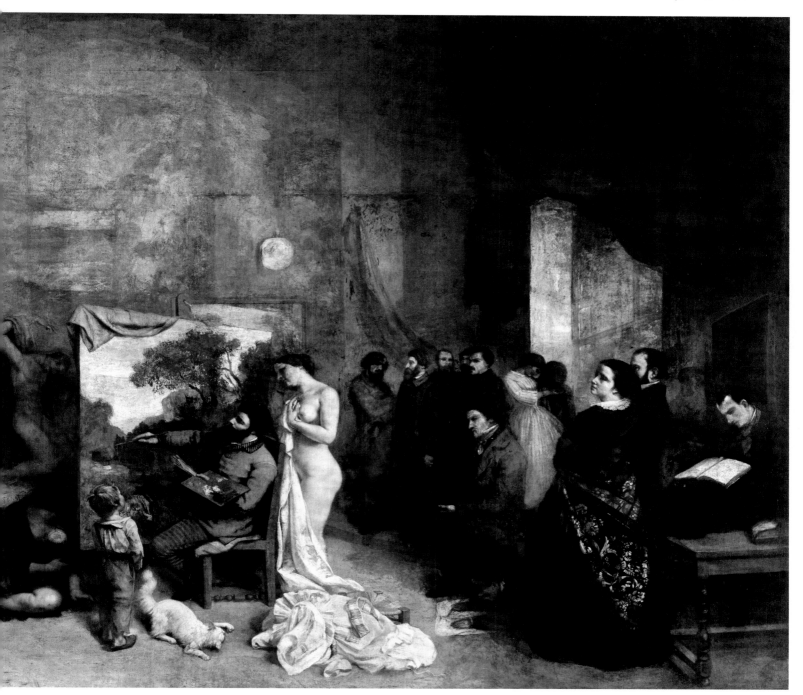

② CHARLES BAUDELAIRE

At the edge of the canvas, shown sitting absorbed in a book, is the poet Charles Baudelaire, who had been a friend of Courbet's since 1848. Next to him, painted out but becoming apparent as the paint thins with age, is Baudelaire's mistress and muse, the Haitian-born actress and dancer Jeanne Duval. In front of Baudelaire and Duval are two art lovers, who have not been identified.

① COURBET

The subheading of this painting, *A Real Allegory Summing Up Seven Years of My Artistic and Moral Life*, poses questions because the words 'real' and 'allegory' mean opposite things. Courbet is flanked by two examples of truth in art: a landscape he is painting – the countryside of his birth – and a nude model. As a traditional element of art, the woman is the embodiment of truth.

③ FIVE FRIENDS

Towards the back of the studio are five of Courbet's friends. Shown standing are: the art collector Alfred Bruyas; in glasses, the socialist Pierre-Joseph Proudhon; Courbet's close friend Urbain Cuenot; and his childhood friend, the poet and novelist Max Buchon. Seated on a stool in front of them is the art critic, novelist and supporter of the Realist movement Jules François Felix Fleury-Husson, known as Champfleury.

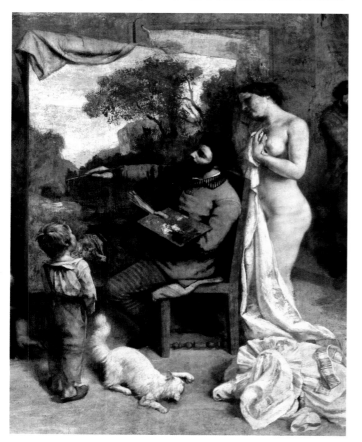

④ DEATH

The skull that rests on a copy of the *Journal des Débats* (*Journal of Debates*) newspaper symbolizes the death of academic art. Next to the skull sits a young man in a top hat, commonly known at the time as an undertaker's mute. This group's authority presents the regimes that Courbet opposed, namely the official Academy and Napoleon III's government.

⑤ NAPOLEON III

This figure surrounded by his dogs is a poacher, but he represents Napoleon III, who assumed the title of emperor in 1852. Courbet was vehemently opposed to his regime and intimates that it uses the resources of France illicitly, as a poacher catches game. The still life in front of him, comprising a guitar, dagger, cloak, buckled shoe and large black hat with a feather – like the skull and journal nearby – suggests the death of Romanticism and academic art.

⑥ TECHNIQUE

Courbet applied thick impasto paint marks using vigorous brushstrokes, palette-knife strokes and sometimes even a cloth or his thumb. Previously, painters only used palette knives to mix pigments on their palettes. On the back wall of the studio, Courbet planned to paint replications of some of his other works but he ran out of time, so he covered up what he had started with a reddish-brown paint, leaving the partially finished paintings vaguely visible.

Diana, **Pierre-Auguste Renoir, 1867, oil on canvas, 199.5 x 129.5 cm (78 ½ x 51 in.), National Gallery of Art, Washington, DC, USA**

A study of a nude, probably in the Forest of Fontainebleau, this is an early painting by Pierre-Auguste Renoir, reflecting the influence of Courbet, Manet, Corot, Ingres and Delacroix. The model is Renoir's mistress, Lise Tréhot. He called the painting *Diana* after the ancient goddess of the hunt in order to make the painting acceptable for the jury of the 1867 Salon. Even so, it was rejected because the nude's voluptuous flesh was considered improper. Following Courbet's methods, Renoir painted a non-idealized image from direct observation and also used a fairly dark palette, applying his paint with a palette knife.

THE GLEANERS

JEAN-FRANÇOIS MILLET

1857

oil on canvas
83.5 x 110 cm (33 x 43 ¼ in.)
Musée d'Orsay, Paris, France

INSPIRED BY LIFE AROUND him in his native Normandy, by 17th-century Dutch painting and by Constable and Chardin, Jean-François Millet (1814–75) became one of the founders of the Barbizon School. He is also classed as a Realist and is often described as instigating the change from traditional to modern painting.

Noted for his rural scenes of peasant farmers, Millet's empathy for their difficult lives came from his own farming background. Yet he was trained in Cherbourg and the École des Beaux-Arts in Paris, and he spent his early career as a historical and portrait painter. After the French Revolution of 1848, he moved to the village of Barbizon in the Forest of Fontainebleau and began painting rural life. In portraying the gravity, hardship and dignity of common agricultural labourers, many critics labelled him a social revolutionary, while others admired his bold stance. When he showed *The Gleaners* at the 1857 Salon, it drew negative criticism from the middle and upper classes, who declared that he was glorifying peasants. At the time, the poor drastically outnumbered the rich and there was a nervousness in the revolutionary climate.

Detail from *Landscape of La Ferté-Milon*, Jean-Baptiste-Camille Corot, 1855–65, oil on canvas, 23.5 x 39.5 cm (9 ¼ x 15 ½ in.), Ohara Museum of Art, Kurashiki, Japan

Jean-Baptiste-Camille Corot (1796–1875) grew up in Paris. After travelling around Europe, where he painted in the open air, he returned to France and worked often in the Forest of Fontainebleau with other artists who captured the light and atmosphere from direct observation. Along with Millet and other pioneering painters who defied academic art expectations, Corot captured the landscape directly in fresh, well-lit, atmospheric images. The artists became known as the Barbizon School.

② TWO BENDING WOMEN

These two women are bending down, reaching for as many stray grains of wheat as they can collect. Tied around their waists are calico aprons with deep pockets made for the task; their hair is out of the way under soft bonnets. The painting is known for featuring the lowest ranks of rural society sympathetically; the women are not in rags and Millet presents them as proud and dignified.

① HALF-BENDING WOMAN

Since ancient times, gleaning had been common practice among the poor. It was the gathering of leftover crops from fields that had just been harvested commercially. *The Gleaners* is famous for its representation of contemporary working-class women. This woman appears to have paused in her arduous task and is either standing up or about to bend down once more.

③ LADEN WAGON

Contrasting with the women in the foreground, the commercial aspect of the harvest is being conducted in the distance. Farmworkers are loading a wagon with harvested wheat. One worker passes up a bale to another. By the cart are huge haystacks – a marked contrast to the meagre ears of wheat that the women are gleaning in order to feed their families.

④ DISTANT HARVESTERS

Far away from the silence of the three women is a large and busy crowd of harvesters. This is the main enterprise of harvesting. Although they too are poor, they appear to be chatting companionably as they work, unlike the weary women. Even in the distance, the workers, farm and haystacks are bathed in a powdery golden haze, almost in direct contrast with the large shadowy figures in the foreground. Millet was not idealizing their harsh lives but celebrating their unflagging endeavours.

⑤ HORSE AND RIDER

This lone rider oversees the farmworkers. He is the steward or landlord, supervising the work on the estate. While the women do not seem to be of any concern to him, his duty was also to make sure that the gleaners respected the rules – that is, of going into the field just before sunset, when most of the work had been done, and only picking up stray ears of wheat from the ground. The steward's presence adds further social distance to the women; he is an authoritative figure, working directly for the rich.

⑥ SUBJECT

At this time, especially in France, the only way an artist could become known was to be accepted by the jury of the annual Paris Salon. They insisted upon a painting style that was a blend of Neoclassicism's smooth contours and Romanticism's fiery colours. A hierarchy was imposed on subjects. Grand, historical and religious themes were the most important, while scenes of everyday life were among the least valued. Images of the poor were considered unsuitable. Because of this, some viewed Millet as scorning convention, while others saw him as an innovator.

The Weeders, **Vincent van Gogh, 1890, oil on paper, 49.5 x 64 cm (19 ¾ x 25 ¼ in.), Foundation E. G. Bürhle, Zurich, Switzerland**

Millet had a huge impact on Vincent van Gogh and here Van Gogh uses the women from *The Gleaners* as women digging in the snow. He painted this while in the asylum at Saint-Rémy-de-Provence in France, from 1889 to 1890, where he had no models and often had to remain in his barred cell. His brother Theo sent him reproductions of Millet's paintings and he used them as inspiration. Millet's late summer landscape has here become a winter one in the south of France; Van Gogh's bending peasant women work in a snow-covered field in front of thatched hovels. Van Gogh's cool colours are offset by a golden setting sun and golden streaks in the sky. The painting has been seen as expressing his nostalgia for the north.

LE DÉJEUNER SUR L'HERBE

ÉDOUARD MANET

1862–63

oil on canvas
208 x 264.5 cm (81 ⅞ x 104 ⅛ in.)
Musée d'Orsay, Paris, France

BORN INTO A BOURGEOIS family, Édouard Manet
(1832–83) defied artistic conventions, scandalizing the
public and art critics with his impressions of modern life.
His innovative method of capturing what the eye perceives in
seconds, rather than deliberate and precise likenesses, was viewed
as outrageous, but his subsequent influence was immense.

Although Manet's parents opposed his decision to become
an artist, his determination prevailed. After a period in the
merchant marines, he studied with Thomas Couture (1815–79)
for five years. In 1856, he travelled to study art in the galleries
of the Netherlands, Germany, Austria and Italy, and ten
years later in Spain. His intelligence and curiosity led
him to interpret Courbet's Realism in Parisian scenes of
contemporary life. He was also inspired by the great Spanish
painters, especially Velázquez. Courbet's loose handling of
paint, simplified rendering of volumes and flattening of forms
were some of the elements of his art that separated him from
accepted contemporary painters. However, although he strove
to achieve something new in his art, he also sought acceptance.

This painting was rejected by the 1863 Salon jury, so he
exhibited it at that year's Salon des Refusés under the title
Le Bain (*The Bath*). Generating both derision and scandal,
it became the principal attraction.

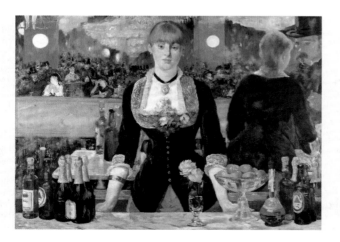

A Bar at the Folies-Bergère,
Édouard Manet, 1882,
oil on canvas, 96 x 130 cm
(37 ¾ x 51 ⅛ in.), Courtauld
Institute of Art, London, UK

Manet's last major painting
shows a bar in Paris. In its
detailed representation of a
contemporary scene, the work
demonstrates his fidelity to the
principles of Realism.

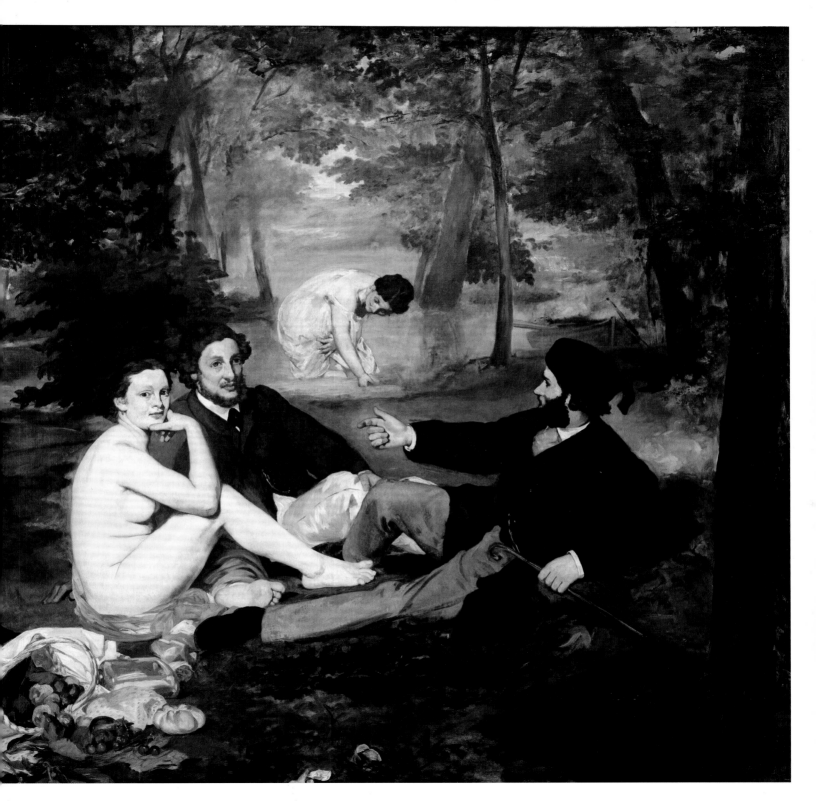

2 RECLINING MAN

The painting pays tribute to Europe's artistic heritage. Echoing a figure in an engraving by Marcantonio Raimondi (*c.* 1480–*c.* 1534) after Raphael's *Judgment of Paris* (*c.* 1510–20), this man leaning on his elbow dangles an elegant cane. He wears a flat hat with a tassel that was usually worn indoors. His silk coat and grey trousers indicate his interest in fashion. He ignores the nude woman as he carries on a conversation with the man next to him.

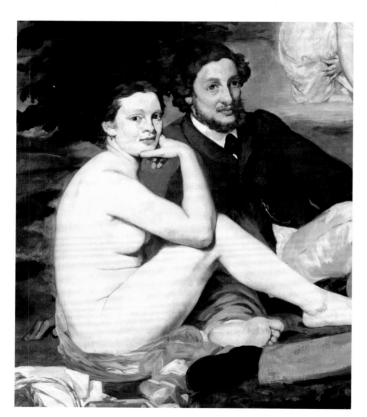

1 NUDE WOMAN

This nude woman is not idealized. Sitting on her clothes, she is not engaging with her companions, but looks directly out of the canvas at viewers. Her pose is relatively modest, but – mainly because she is sitting with fully clothed men – the painting scandalized the public. This was an apparently contemporary situation with no allegorical allusions, which made it unseemly.

3 STILL LIFE

This richly painted, brightly coloured still life comprises some clothes, a basket of fruit, a round loaf of bread and a bottle of alcohol. They are the luncheon items referred to in the title of the work, which means *Luncheon on the Grass*. Rather than build up his colours in layers, Manet used the *alla prima* (at the first) method of laying down paint quickly without blending.

④ THE BATHER

In the background, a woman appears to be bathing in a stream. Too large in comparison with the figures in the foreground, she seems to float above them. This woman is as much of an enigma as the other woman in the painting. It has been suggested that she could represent the same woman at a different point in time.

⑤ LIGHT

Another conundrum in the work is the effects of light, which seem contradictory. The painting appears rather flat and photographic because the light casts almost no shadows. The nude woman is lit directly from the front (as if light is coming from the viewers) and the bather is lit from above.

⑥ FLATNESS

Manet did not try to hide his brushstrokes and left some areas unfinished. This loose handling of paint created the flatness in the painting that appeared to viewers to show a lack of skill.

⑦ BRUSHMARKS

One of the criticisms of the painting when it was shown at the Salon des Refusés was that the background was so roughly painted. With flat brushmarks, it appears to lack depth and detail. It did not convince viewers that the scene was taking place outdoors.

Detail from *Le Déjeuner sur l'Herbe*, Claude Monet, 1865–66, oil on canvas, 248 x 217 cm (97 ⅝ x 85 ⅜ in.), Musée d'Orsay, Paris, France

Inspired directly by and as a tribute to Manet, Claude Monet painted this monumental work with the same title two years later. However, he never completed the work and later he cut the canvas into fragments. This is one of the remaining sections. Unlike the majority of critics who derided Manet's work in 1863, Monet immediately appreciated and admired what he was attempting.

AUTUMN EFFECT AT ARGENTEUIL

CLAUDE MONET

1873

oil on canvas
55 x 74.5 cm (21 ½ x 29 in.)
Courtauld Institute of Art, London, UK

OVER HIS LONG CAREER, Oscar-Claude Monet (1840–1926) remained the most constant of the Impressionists in capturing fleeting moments and using colour to depict light effects. In 1874, when the group first exhibited together, his painting *Impression, Sunrise* (below) inspired their initially derogatory label.

Monet was born in Paris, but grew up in Le Havre, where he learnt to paint en plein air (in the open air) with Eugène Boudin (1824–98). He also received some instruction from the landscape painter Johan Barthold Jongkind (1819–91). In 1862, he entered the Parisian studio of Charles Gleyre (1806–74), where he met Pierre-Auguste Renoir, Alfred Sisley (1839–99) and Frédéric Bazille (1841–70). Also inspired by the Barbizon School painters and Manet, he painted in and around Paris. He exhibited at the Salons of 1865 and 1866, but afterwards, his work was rejected. During the Franco-Prussian War (1870–71), he moved to England where he became influenced by the work of Constable and Turner. One of the instigators of Impressionism, Monet exhibited with the group from 1874 to 1879 and in 1882. He painted prolifically and rapidly, using vivid colours. In 1883, he bought a house in Giverny, north-west of Paris, where he developed a garden that became his main motif.

Depicting the small town of Argenteuil seen from a branch of the River Seine, this is one of his earliest Impressionist paintings. It tells no tale and suggests no moral lesson, but simply captures sensations of light.

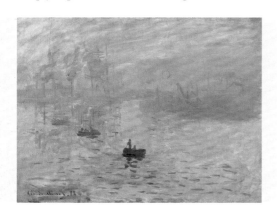

Impression, Sunrise, **Claude Monet, 1872, oil on canvas, 48 x 63 cm (18 ⅞ x 24 ¾ in.), Musée Marmottan Monet, Paris, France**

A morning view of Le Havre harbour, Monet painted this quickly, using the complementary colour contrasts of orange and blue. Monet said it was his 'impression' of a fleeting moment.

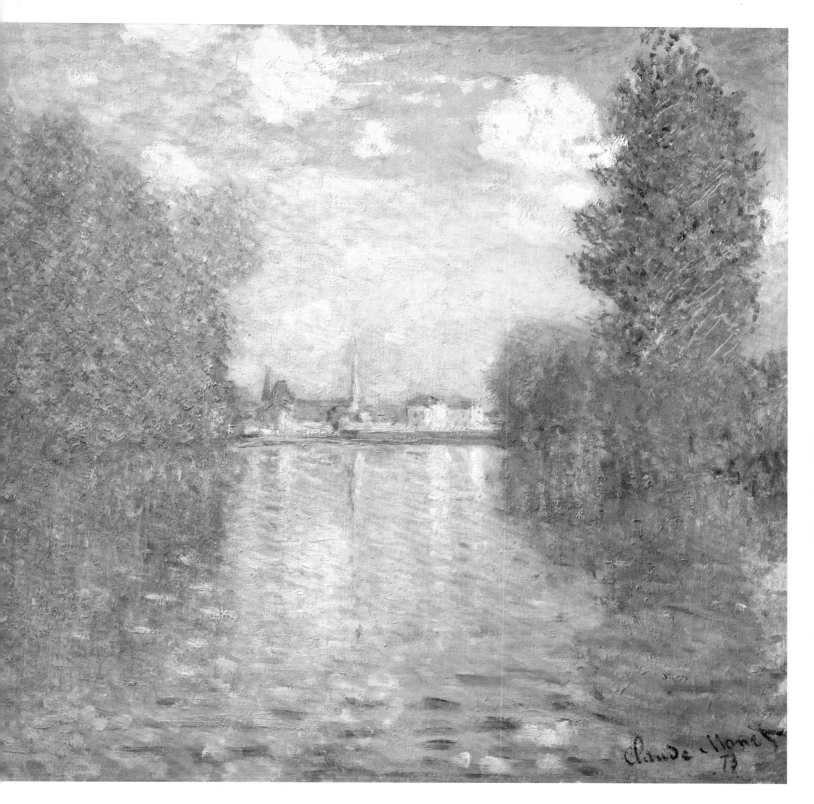

② PAINT APPLICATION

Monet began the picture with initial thin consistencies of paint that became thicker. Rough, impasto strokes depict the foliage, while longer, horizontal marks have been used to build up the reflections of the sky on the water. Clouds are created with stiff dabs of white paint. On the trees on the right of the painting, he used the end of his brush handle to scratch diagonal lines into the paint, revealing the light grey priming beneath.

③ ARGENTEUIL

Painting from his *bateau atelier,* or studio boat, Monet captured the sunlight glinting on the small town of Argenteuil in the distance. When he returned to France from England in 1871, he settled in Argenteuil until 1878. Often he was criticized for painting the aspects of modern life perceived as ugly. Argenteuil was a modern town, and some of the buildings shown here are factories, but Monet's presentation of them is ambiguous; they could be churches.

① PALETTE

After applying a pale grey ground, Monet worked with a limited palette. Abandoning black, he created all he needed with ultramarine, cobalt, chrome yellow, vermilion, alizarin crimson and lead white. He also used small amounts of viridian and emerald green. He began the painting with dilute opaque colours, and pure pigments applied directly, interspersed with white. He focused on the complementary colour contrasts of blue and orange.

④ SPONTANEITY

Conveying a sense of spontaneity – of capturing what he saw in a brief moment – was one of Monet's priorities. Once he had prepared his light grey ground, he blocked in broad areas of local colour – that is, blue for the sky and orange for the leaves – using thin, opaque scumbled paint. He next painted more details either wet-in-wet or wet over dry, and then dragged stiff, dryish paint over the surface to create a mesh of colour.

⑤ LEADING THE EYE

The deep blue of the water at the bottom of the canvas leads the eye into the painting. As it becomes paler, the effect of distance is created with the minimum of detail, while a thick blue stripe between the water and the buildings marks the horizon line.

⑥ AUTUMN LIGHT

On the left side of the painting, the trees are created with directional brushstrokes in orange, amber, gold, yellow, green and pink. Viewed from a distance, the rich network of textures and colours creates the impression of warm autumn sunlight on the leaves, but when viewed in close proximity, the effects are lost; they merely become patches of paint. This unfinished appearance was one of the early criticisms of Impressionism.

⑦ REFLECTIONS

In general, this is a balanced, X-shaped composition. The trees correspond with each other on either side of the river and the blue water is counterbalanced by the blue sky above. Similarly, the town in the distance gains equilibrium through its reflections on the water below the blue horizon line.

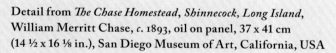

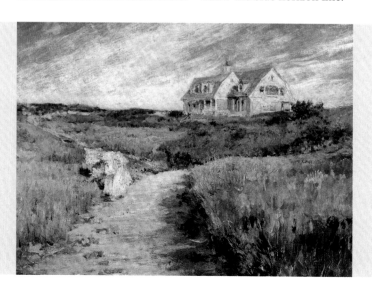

Detail from *The Chase Homestead, Shinnecock, Long Island*, William Merritt Chase, *c.* 1893, oil on panel, 37 x 41 cm (14 ½ x 16 ⅛ in.), San Diego Museum of Art, California, USA

Born in Indiana, William Merritt Chase (1849–1916) studied under local artists before enrolling in the National Academy of Design in New York. While living in Europe from 1872, his style became influenced by the Impressionists and on his return to the United States, he saw an exhibition of French Impressionism in New York in 1886 that confirmed his approach. From then on, he began painting *en plein air* landscapes in his own adapted Impressionistic style. The Shinnecock Hills on New York's Long Island, where his family had a summer residence, became an endless source of inspiration to him. From 1891 to 1902 he ran a summer school there, the first important open-air school of painting in the United States.

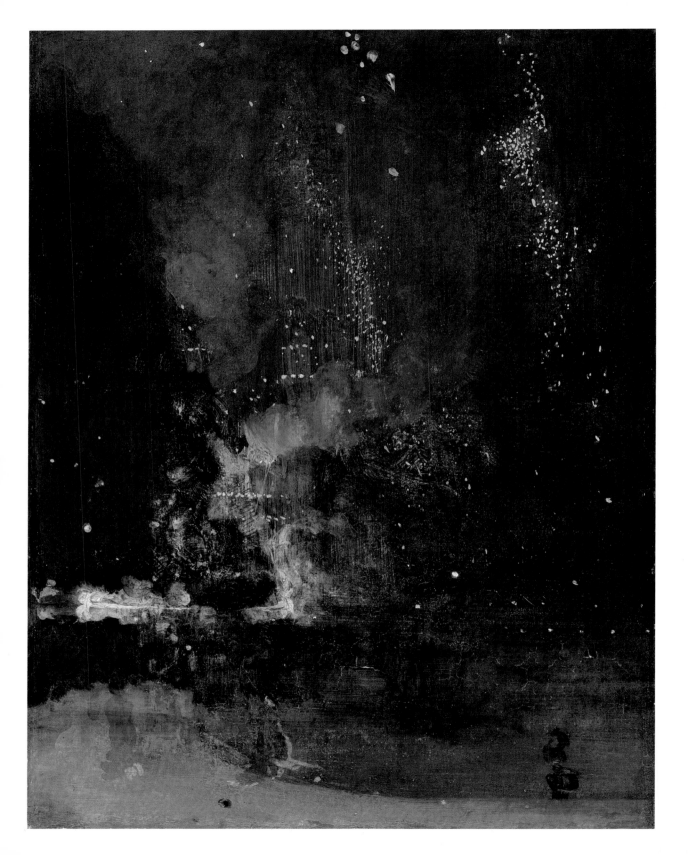

NOCTURNE IN BLACK AND GOLD, THE FALLING ROCKET

JAMES ABBOTT MCNEILL WHISTLER

1875

oil on canvas
60.5 x 46.5 cm (23 ¾ x 18 ⅜ in.)
Detroit Institute of Arts, Michigan, USA

A TRULY INTERNATIONAL ARTIST, James Abbott McNeill Whistler (1834–1903) was of Scottish-Irish ancestry, born in the United States. He spent much of his childhood in Russia, most of his life in England and studied art in France. An admirer of Japanese art and design, he was also a printmaker, and interior and book designer. He was a leading proponent of the Aesthetic movement, with its belief in 'art for art's sake'.

Although born in Massachusetts, Whistler grew up in Russia while his father designed the St Petersburg–Moscow railway for Tsar Nicholas I. At the age of eleven, he enrolled at the Imperial Academy of Fine Arts in St Petersburg, but after his father's death in 1849, he and his mother returned to the United States. Two years later, he entered West Point Military Academy, but was expelled within three years for failing an exam. In 1855, after a brief period working for a cartographer, he travelled to Paris. There he studied for a while at the École Impériale et Spéciale de Dessin and in 1856 he entered Gleyre's studio, six years before Monet. He also copied paintings in the Louvre and socialized with Delacroix, Courbet, Manet and Edgar Degas. In 1859, he moved to London, although he often returned to Paris. His flamboyant personality, dandified dress and quick-witted remarks attracted attention and he became friends with, among others, Oscar Wilde and Rossetti.

With sinuous contours, minimal design, elegance, reduced palette and musical titles, (he called many paintings harmonies, nocturnes or arrangements), Whistler's art broke new ground. His stylized butterfly monogram signature added to the exotic look of his paintings while his popular interior designs that included furniture, ceramics, wallpaper, glass and textiles also exuded an oriental appeal.

Although much of his art was received favourably, in 1878, he sued Ruskin and won after the English critic had accused him of 'flinging a pot of paint in the public's face' with this painting when it was exhibited at London's Grosvenor Gallery in 1877. Unfortunately, it was a pyrrhic victory: Whistler received damages of only a farthing (the least valuable coin of the realm), while the costs incurred bankrupted him.

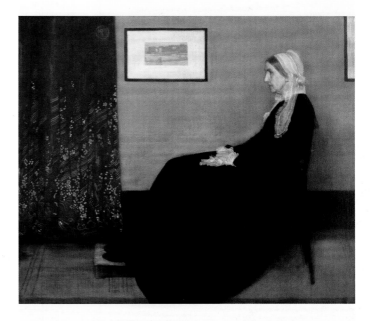

Arrangement in Grey and Black, No. 1 or *The Artist's Mother*, **James Abbott McNeill Whistler, 1871, oil on canvas, 144.5 x 163 cm (56 ⅞ x 64 ⅛ in.), Musée d'Orsay, Paris, France**

In a rigidly formal pose, her hands clasped on a lace handkerchief on her lap, this is Whistler's mother, Anna. Her grey hair and black clothing appear puritanical and her expression ambiguous, but the general impression is calm and dignified rather than severe. Whistler continues the monochromatic scheme throughout the work, emphasizing vertical and horizontal lines, and minimizing decoration. Rather than a sentimental portrait of his mother, this is more about shapes, lines and contours, as he commented: 'To me it is interesting as a picture of my mother, but what can or ought the public to care about the identity of the portrait?'

Before Whistler moved to London, he had collected Japanese prints in Paris. Although some artists and designers had already taken up the French craze for Japonism, it was not until he began exhibiting his paintings that show an Eastern influence that the vogue for all things Japanese seized British artists' imaginations. The main elements adopted were the abandonment of illusions of depth and simplified compositions.

① CREMORNE GARDENS

During the 19th century, Cremorne Gardens was well known. By the side of the River Thames in Chelsea, London, it was where the fashionable gathered to watch firework displays. During the 1870s, Whistler painted several nocturnal views there, including this firework display. He sought to evoke the atmosphere, not to paint a view, yet the outline of trees, a lake and the rocket-launching platform are just visible.

③ EXPLOSION

The 'falling rocket' of the title is a firework exploding in the night sky over the river. Whistler has carefully created a shower of yellow, orange and white sparks falling through the foggy night. This central explosion draws viewers' eyes upwardly to the large drops of paint at the top of the canvas, while tiny specks float silently down behind them.

④ ORIENTAL
CALLIGRAPHY

This is not Whistler's usual monogram of a stylized butterfly but it is still a reference to the East, in that it is a deliberately placed compositional element. Using the tip of his brush, he has painted thick, straight strokes that resemble the seals on the Oriental prints and porcelain that he collected.

Although many of Whistler's paintings, and especially this one, appear to have been worked rapidly and spontaneously, he painted slowly, changing and adjusting marks, reconsidering and replacing elements.

5 BRUSHWORK

Influenced in particular by Velázquez and Courbet, Whistler's brushstrokes appear calligraphic and are often simple flicks of paint. This is what his critics denounced as reckless and lacking in artistic merit. The sky here was painted with great sweeps of the brush, then wiped and painted again. The figures in the foreground were also painted and then wiped, so they appear as mere suggestions of people in the fog. He captures a sense that they are briefly illuminated by a sulphurous light.

6 PALETTE

Whistler told one of his students that 'the palette is the instrument on which the painter plays his harmony, it must be kept in condition worthy of his music.' To this end, he always placed his paints on his palette in a harmonious arrangement. At the top, he put pure colours, with a generous quantity of white at the centre. To create this muted, harmonious image, his restricted palette included yellow ochre, raw sienna, raw umber, cobalt blue, vermilion, Venetian red, Indian red and ivory black.

Fireworks at Ryogoku (Ryogoku Hanabi), No. 98 from *One Hundred Famous Views of Edo,* **Utagawa Hiroshige, 1858, woodblock print, 36 x 23.5 cm (14 ¼ x 9 ¼ in.), Brooklyn Museum, New York, USA**

Whistler owned several prints by Utagawa (also Andō) Hiroshige (1797–1858) especially from his series *One Hundred Famous Views of Edo* (1856–59), which he admired for the use of colour, perspective and spatial structure. This is Hiroshige's representation of fireworks over Ryogoku Bridge, a popular entertainment in Japan at the time. Directly inspired by this print in his *Nocturne in Black and Gold*, Whistler has nonetheless used his own free and delicate approach with dissolving colours and no outlines.

STUDY: TORSO, SUNLIGHT EFFECT

PIERRE-AUGUSTE RENOIR

1875–76

oil on canvas
81 x 65 cm (31 ⅞ x 25 ⅝ in.)
Musée d'Orsay, Paris, France

ONE OF THE FOUNDING members of the Impressionist movement and one of the most prolific, Pierre-Auguste Renoir (1841–1919) is best known for his exuberant scenes of flowers, children and curvy women, using broken brushstrokes and bright colour.

Although he was born in Limoges in south-west France, Renoir grew up in Paris, and from the age of thirteen was apprenticed as a porcelain painter. He also began spending time in the Louvre, studying paintings by Watteau, Fragonard, Boucher and Delacroix. He painted fans and banners, and then joined Gleyre's studio where he met Monet, Sisley and Bazille. From 1864, he was occasionally successful with submissions to the Salon, but this was erratic and he struggled to make a living. He and Monet went on painting expeditions together where they painted *en plein air* and he began using pure unblended colours and broad brushstrokes, capturing brief moments with a sketchlike looseness that formed the basis of the Impressionist style. He exhibited at four of the Impressionist exhibitions and became successful in the late 1870s as a portraitist. During the 1880s, he travelled to Italy, England, the Netherlands, Spain, Germany and North Africa, where he became inspired by the light, scenery and in particular, the art of Raphael, Velázquez and Rubens. From 1881, the art dealer Durand-Ruel began buying his work.

Although sometimes criticized for the 'sweetness' of his work, which developed from his employment, and his admiration of Rococo artists, unlike many of his contemporaries Renoir embraced the modern sights of Paris. In the late 1880s, he abandoned his soft Impressionist brushstrokes for smoother contours, which has since been called his 'dry' or 'sour' style. Working carefully and meticulously, his colours also became cooler, but after scathing condemnation, he returned to vibrant, rich colours and free brushwork. This painting was executed at the height of his Impressionist phase; he focused purely on the effects of sunlight dappling through the trees onto the woman's skin. This was the consummation of Renoir's studies of light playing on surfaces in the open air.

The Umbrellas, Pierre-Auguste Renoir, 1881–86, oil on canvas, 180.5 x 115 cm (71 x 45 ¼ in.), National Gallery, London, UK

Renoir was the first to introduce an underlying structure into Impressionism as this work demonstrates. He painted some of the canvas in 1881 and reworked it in 1886 after studying Renaissance paintings in Italy. The completed canvas shows both his Impressionist experiments with colour and light and his later firmer contours. It depicts a moment in the rain on a busy Parisian street as a gentleman offers a young woman shelter beneath his umbrella.

② VENUS

Although this semi-nude is voluptuous in the traditions of Rubens, Rembrandt and Titian, Renoir was also following Realist ideas and presenting a real woman rather than a goddess. He was tackling his own extremely difficult technical problem, too, in attempting to portray reflective effects on the skin.

③ BACKGROUND

First displayed in the Second Impressionist Exhibition of 1876, this painting followed the Impressionist aim of capturing the effects of light seen in brief glances. The tangle of leaves and branches in the upper right-hand corner help to anchor the image, as does the water behind the model's right elbow. The branches are simply long brown brushstrokes, while leaves are implied with dashes and dabs of yellows, greens and blues.

① THE WOMAN

'The only thing I require of a model is that her skin captures the light' declared Renoir. His model is his mistress, Alma-Henriette Leboeuf. Apart from her brown hair and facial features, he has ignored local colour in favour of reflected light effects. Although nude bathing was a traditional theme, his handling was badly received by critics. *Le Figaro* newspaper described it as 'a heap of decomposing flesh covered with green and purple patches'.

Renoir's youthful experience as a portrait painter had a lasting influence on his art, contributing to a love of fluid, transparent paint and introducing him to the 18th-century Rococo artists, although he also greatly admired Delacroix, Manet, Courbet and Corot.

④ METHOD

During the 1870s, Renoir used light-coloured grounds. Over this he laid down thin scumbles of diluted local colours. He worked the background quickly, wet-in-wet. Then he built up the figure slowly. Finally, he made subtle adjustments, here enlarging her right shoulder by adding bluish paint above the patch of sunlight.

⑤ PALETTE

Renoir was a celebrated colourist with a keen eye for capturing light effects. His images embrace pleasure, happiness and his perception of beauty. He used a restricted palette, which he often varied. For this painting, he used flake white, Naples yellow, chrome yellow, cobalt, ultramarine, alizarin, vermilion and emerald green.

⑥ DEFINITION

Across the figure, flesh hues exploit subtle warm-cool modulations with pastel blues on the chest depicting the cool reflections of sky and foliage. Cobalt blue at the model's elbows defines the difference between her body and the background. Wet reds and yellows were then applied over the dry, brown marks in her hair.

⑦ LIGHT

The luminosity derives from the pale grey ground, and despite the effects of dappled sunlight, the figure never loses its impression of solidity. Renoir was the first artist of his generation to exploit the effects of warm-cool colour contrasts, which created his brightly illuminated images. Dabs of white paint create the impression of dancing sunlight.

Detail from *Venus of Urbino*, Titian, 1538, oil on canvas, 119 x 165.5 cm (46 ⅞ x 65 ⅛ in.), Uffizi, Florence, Italy

Reclining on her couch in a luxurious Renaissance palace, this female nude was called the goddess Venus by Titian to make her acceptable, but with no allegorical symbols or allusions to ancient mythology, she is clearly a sensuous woman of the 16th century. Renoir blended elements of the nudes of both Titian and Rubens with his own modern ideas. Even though Courbet and Manet had already challenged the doctrine of the Academies, Renoir still faced hostility for his ideas and unusual handling of a traditional theme.

THE TEA

MARY STEVENSON CASSATT

c. 1880

oil on canvas
65 x 92 cm (25 ½ x 36 ¼ in.)
Museum of Fine Arts Boston, Massachusetts, USA

WHEN AT THE AGE of twenty-one, Pennsylvanian-born Mary Stevenson Cassatt (1844–1926) told her prosperous parents that she intended to become an artist, they were horrified. She had been studying art at the prestigious Pennsylvania Academy of the Fine Arts for four years, but while it was respectable for young ladies to learn to draw and paint, to make a career of it was different. The Cassatts had already lived in France and Germany from 1851 to 1855, which gave Mary exposure to European arts and culture, but in 1866, she returned to Paris for her artistic training and remained there for most of her life. She studied first with painter and printmaker Charles Chaplin (1825–91) and then with history painter Thomas Couture (1815–79). Initially, the Paris Salon accepted her work, but she became disenchanted with the official Academy's oppression. In the early 1870s, she travelled to Spain, Italy and the Netherlands, and studied artists including Velázquez and Rubens. In 1877, her parents and sister Lydia joined her in Paris, and she accepted Edgar Degas's invitation to join the independent Impressionist exhibitions that flouted the official Salon. Skilled in oils, pastels and printmaking, she created sensitive images of women and children, as here in *The Tea*, using soft colours and loose brushwork.

The Cup of Tea, **Mary Stevenson Cassatt,** *c.* **1880–81, oil on canvas, 92.5 x 65.5 cm (36 ⅜ x 25 ¾ in.), Metropolitan Museum of Art, New York, USA**

Cassatt made a career of painting young, middle-class women at everyday activities. Taking afternoon tea was a social ritual for such women and she painted the theme several times. The sketchlike expressive brushwork and contrastingly luminous colours are evidence of her embrace of the Impressionist ideals.

② THE GUEST

Although the identity of this model has not been verified, she was probably a family friend. Cassatt has obscured her face with the teacup as she tilts it to drink, like a frozen moment. However, this is not merely a snapshot image; there are several creative layers. One is Cassatt's focus on pattern, as here in the rounded shapes of the woman's hat, cup and saucer.

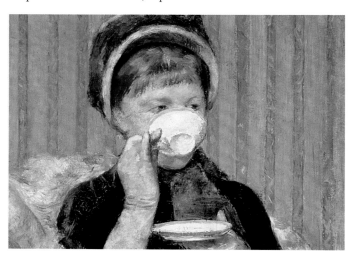

① LYDIA

This is Cassatt's elder sister, Lydia Simpson, who appears in several of her paintings. She holds her hand to her chin and her lace cuff dangles down. She stares into the middle distance, in relaxed contemplation, or looking at someone or something beyond the picture. Dressed in a simple brown day dress with brown hair neatly styled, Cassatt has set her against two contrasting patterns: striped wallpaper and floral sofa cushions.

③ TEA SERVICE

Shining and elegant, this silver tea service on a silver tray implies a distinguished family history (it was a Cassatt family heirloom, made in Philadelphia, c. 1813). Dark contour lines define the objects, while the metallic qualities of the silver have been enhanced with strong highlights and reflections, making it as much a focus in the painting as the women themselves.

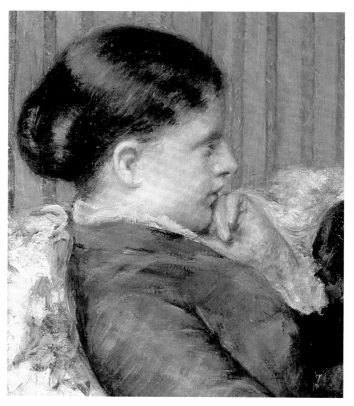

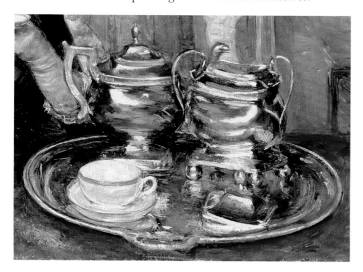

4 PAINTING AND FIREPLACE

In sketchy, lightly applied marks, this carved marble fireplace is topped with an elaborately framed painting featuring a porcelain jar. This is typical of the period for an upper-middle-class Parisian interior, and would have been recognized as such by viewers. The horizontal line of the mantelpiece also draws viewers' eyes into the human aspect of the painting.

5 LINE

Cassatt's variation of line creates interest and defines the space: the vertical lines of the wallpaper draw the eye towards the tea service in the foreground, while the horizontal line of the mantelpiece acts like an arrow, pointing towards the two women, and is echoed by the saucer in the guest's hand. The diagonal line of the table leads viewers towards the tea service.

6 PATTERN

Cassatt's focus on surface arrangements of pattern emerged from her fascination with Degas's work and with Japanese woodblock prints, especially *ukiyo-e* (pictures of the floating world) that flourished from the 17th to 19th centuries. Not interested in depicting movement, Cassatt focused on these patterns, such as in the striped wallpaper and the flowered chintz covering the sofa.

7 IMPRESSIONIST STYLE

Cassatt's airy brushmarks, soft colours and focus on the effects of light emerged from the influence of Pissarro, while the asymmetrical composition and cropped edges were inspired by Degas and Japanese artists. Like Degas and unlike the other Impressionists, she rarely painted outdoors, but captured natural moments as if seen through a camera lens.

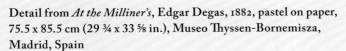

Detail from *At the Milliner's*, Edgar Degas, 1882, pastel on paper, 75.5 x 85.5 cm (29 ¾ x 33 ⅝ in.), Museo Thyssen-Bornemisza, Madrid, Spain

The cross-influence between Edgar Degas and Cassatt is apparent in their work. They were friends in a period when most men did not regard women as being able to think logically, yet through Cassatt, he learnt about women's interests – their suffrage, aims for dress reform and for social equality. He also accompanied her to fashion boutiques, which led him to paint several images exploring Paris from a viewpoint rarely seen by men. Here, in a situation that was normally strictly female, as in Cassatt's painting *The Tea*, the diagonal composition draws attention to the table and hats, minimizing the importance of the two women.

BATHERS AT ASNIÈRES
GEORGES-PIERRE SEURAT
1884

oil on canvas
201 x 300 cm (79 ⅛ x 118 ⅛ in.)
National Gallery, London, UK

SEVERAL ARTISTS THAT FOLLOWED the Impressionists expanded upon the achievements of that movement. After their deaths, they were labelled the Post-Impressionists, but they were never a group and had individual ideas. With his scientific approach to painting and colour that altered the direction of art, Georges-Pierre Seurat (1859–91) is one of the most important Post-Impressionist painters.

A Parisian, Seurat's artistic education was traditional. He studied at the École Municipale de Sculpture et Dessin under the sculptor Justin Lequien (1826–82) and then he was taught by history and portrait painter Henri Lehmann (1814–82) at the École des Beaux-Arts. He also took instruction from Pierre Puvis de Chavannes (1824–98) who painted large-scale classical, allegorical scenes, and he studied in the Louvre. He began producing drawings in Conté crayon and read books on colour theory. He was influenced by the juxtaposing of complementary colours to create brighter effects, which became the basis of his method of Divisionism or pointillism, in which he rendered paintings with small dots or strokes of colour. A monumental painting, *Bathers at Asnières* captures the light and atmosphere of summer on a group of workers relaxing by the Seine and was created using a criss-cross brushstroke technique known as *balayé*.

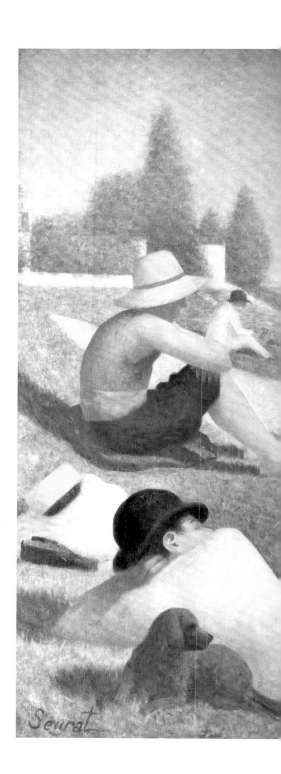

A Sunday on La Grande Jatte – 1884, Georges-Pierre Seurat, 1884–86, oil on canvas, 207.5 x 308 cm (81 ¾ x 121 ¼ in.), Art Institute of Chicago, Illinois, USA

This monumental work is Seurat's first full-scale pointillist painting and the painstaking procedure took him two years to complete.

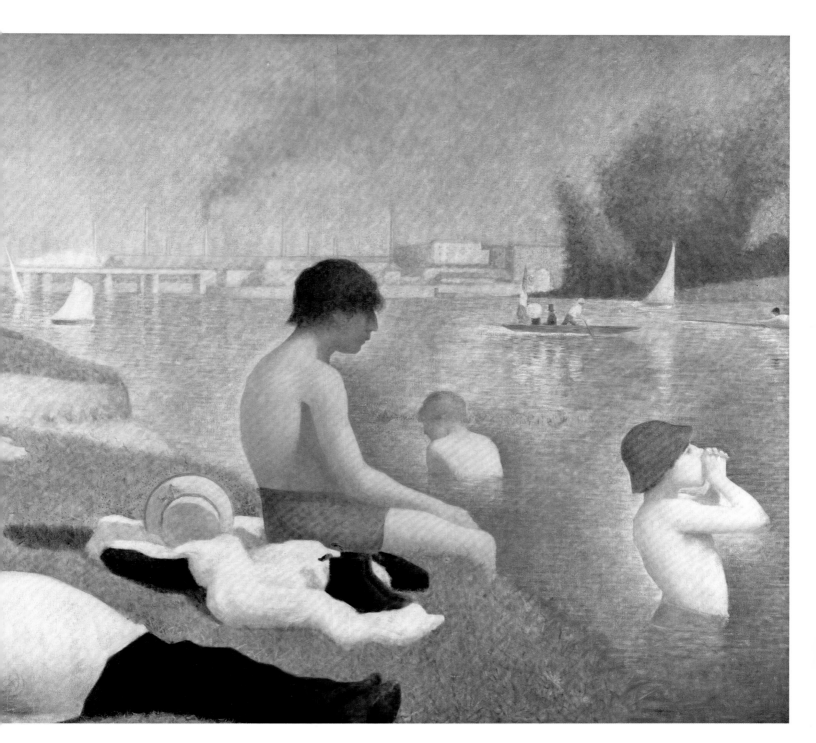

② SILENT WHISTLE

Further rounded shapes are featured with this pale-skinned figure who stands waist high in the still water and cups his hands to his mouth to whistle or call, perhaps to a passing boat. Calmness pervades the image, which makes this boy's whistle or call seem to be silent. Nothing was left to chance: he was also drawn by Seurat in Conté crayon from life studies in his studio.

③ SITTING FIGURE

These men and boys have just left their workplace. Their brown and white clothing implies that they work in the same place, but they do not appear to be communicating, which could be part of Seurat's commentary: life for industrial workers can be isolating and lonely. This figure forms a triangular shape as he sits in a patch of shade looking across the river, his face obscured by his hat.

① CENTRAL FIGURE

Seurat produced at least fourteen oil sketches and ten drawings in preparation for this work. One of these is a careful, tonal Conté crayon drawing of this youth. The stillness of the pose and its soft, rounded forms became an important element of the painting, with the curves repeated in all the figures contrasting with straight lines in the background. This boy's round head and rounded shoulders are echoed in his straw hat, which lies on its side with his discarded clothes and boots behind him.

④ THE FOREMAN

This reclining man wears the long linen jacket and bowler hat of a foreman. Like the other foreground figures, he has been heavily worked in opaque layers of paint. By cutting off his feet at the bottom of the painting, Seurat suggests that the image continues.

⑥ COMPOSITION

Seurat painted this on the scale of a traditional history painting, but going against convention, featured the working class within the composition. The composition is divided with a clear diagonal axis, differentiating the land from the water and sky.

⑤ RICH AND POOR

In the distance the factories and smoking chimneys of Clichy are visible. A green boat crosses the river as a man punts two passengers; an upper-class man in a top hat and a lady with a parasol. They are going to La Grande Jatte island opposite this working-class area.

⑦ COLOUR

Seurat began by blocking in local colour, then created colour contrasts in a wet-over-dry method. Complementary contrasts can be seen across this canvas; for example, in the green grass there are adjacent strokes of pinkish-red.

Notre-Dame-de-la-Garde (La Bonne-Mère), Marseilles,
Paul Signac, 1905–06, oil on canvas, 89 x 116 cm (35 x 45 ¾ in.),
Metropolitan Museum of Art, New York, USA

Seurat submitted *Bathers at Asnières* to the Salon in 1883 but the jury rejected it. Subsequently, he and several other artists founded the Société des Artistes Indépendants, enabling him to exhibit it in 1884. There, he met and befriended Paul Signac (1863–1935). Luminous and vibrant, this painting by Signac demonstrates Seurat's influence as well as that of Henri-Edmond Cross (1856–1910) and of Matisse with whom Signac spent the previous summer at Saint-Tropez. The rectangular strokes of unmixed pigment are Signac's interpretation of Seurat's Divisionism. Even though he died aged only thirty-one, Seurat's innovations were highly influential.

VISION AFTER THE SERMON

PAUL GAUGUIN

1888

oil on canvas
72 x 91 cm (28 ⅜ x 35 ⅞ in.)
National Gallery of Scotland, Edinburgh, UK

ONE OF THE MOST remarkable artists of the late 19th century, Eugène Henri Paul Gauguin (1848–1903) had a profound influence on the development of 20th-century art. Initially a stockbroker, he left his job when he was in his late thirties, and abandoned his wife and five children in order to pursue his artistic dreams.

As an artist, Gauguin struggled because he worked against popular opinion. After mastering Impressionist methods of depicting light and fleeting moments, he studied religious groups in rural Brittany and, later, landscapes and communities in the Caribbean, while also exploring the latest scientific colour theories. After spending two months with Van Gogh in the south of France, his new kind of 'synthetic' painting, featuring symbolism blended with colour theories, developed even more strongly. He labelled his style Synthetism, but it was also called Cloisonnism, to describe the bold, flat areas of colour separated by black lines. Additionally, his style is often defined as Primitivist, which reflects his admiration of the art of earlier cultures from Africa, Asia, French Polynesia and Europe. He subsequently inspired Les Nabis, which means 'prophet' in Hebrew and Arabic, a group of younger artists who followed his approach.

This painting was executed while he was staying in Pont-Aven in Brittany. It depicts a biblical story imagined by pious Breton women in response to a sermon they have just heard. To make clear that this was not a realistic account but a mystical vision, Gauguin made the two wrestlers of the story like figures from a child's book or a stained-glass window, and placed the image on a flat background of brilliant vermilion. It was his first Synthetist or Cloisonnist painting, with bold, non-naturalistic colours that appear like a *cloisonné* enamel or stained glass. The subject demonstrates his determination to paint not only what he saw, but also what he imagined. After showing it to other artists in Pont-Aven, including Jacob Meyer de Haan (1852–95), Charles Laval (1862–94), Louis Anquetin (1861–1932), Paul Sérusier (1864–1927), Émile Bernard (1868–1941) and Armand Séguin (1869–1903), Gauguin became the leader of what would be known as the Pont-Aven School.

IN DETAIL

② JAPANESE WOODBLOCK STYLE

Inspired by the Japanese woodblock prints by Hiroshige and Katsushika Hokusai (1760–1849) that he owned, Gauguin developed the idea of non-naturalistic landscapes with large areas of flat colour. The large diagonal tree trunk cutting the composition in two is an arrangement taken from Japanese woodcuts. The red ground departs from conventional representations of landscape, and the figures are distorted and flattened, with exaggerated features and strong contour lines. The tree trunk cuts the composition diagonally, creating a visual separation between the Breton women and their vision.

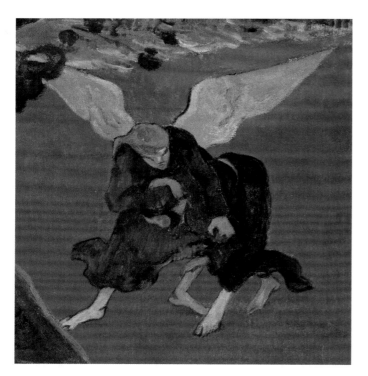

① JACOB WRESTLING THE ANGEL

The vision seen by the women in the painting is inspired by a church sermon taken from Genesis 32:22–31. In this passage from the Old Testament of the Bible, Jacob, after wading across the Jabbok River with his family, spent a whole night wrestling with a mysterious angel. Gauguin suggests that the faith of these pious women enables them to see miraculous events of the past as vividly as if they were occurring before them.

③ CLOISONNISM

With Émile Bernard, Gauguin developed Cloisonnism, a style of painting that resembles enamelling. The name refers to the compartments (*cloisons*) separated by metal wires used in the creation of enamel objects. Thin, dark, contour lines, strong colours, and an abandonment of perspective characterized the style, which diverged from traditional painting of the time, and emphasized the discontinuity that became a feature of modernism.

Gauguin's new way of painting, involving firm outlines and areas of relatively unmodulated colour, was intended to convey emotions and ideas more directly than other contemporary painting styles using small brushstrokes, patches of colour and tonal contrasts.

4 BRUSHWORK

Rather crudely worked, the paint on some parts of the background was applied lightly with a palette knife, and then overlaid with thin, translucent paint applied with a brush. The broad areas of colour are relatively flat but contain subtle variations of hue. The thin paint is thinner at the edges of the figures.

6 COMPOSITION

The figures are distributed unconventionally, cut off and framing the canvas edge at the left and in the foreground. No identifiable source of light is used. The women are the focus, taking up about half of the painting, and larger than the wrestlers. Their white coiffes are a strong sign of their perceived primitivism.

5 BOLD COLOUR

Against the vermilion background, the simplified figures of Jacob and the angel are created with ultramarine, emerald green, chrome yellow. Gauguin was competing with photography, but the new technique had not yet perfected colour representations, so he deliberately exaggerated colour to be different.

7 WET ON DRY

Gauguin applied thin paint, wet over dry, dragging his brush across dry layers beneath, so some show through. His palette for this painting included Prussian blue, ultramarine, vermilion, viridian, yellow ochre, emerald green, Naples yellow, lead or zinc white, chrome yellow, red ochre and cobalt violet.

Detail from *Dancers in Blue*, **Edgar Degas**, *c.* 1890, oil on canvas, 85.5 x 75.5 cm (33 ⅝ x 29 ⅝ in.), Musée d'Orsay, Paris, France

This image of dancers by Edgar Degas shows the essence of the figures, rather than a photographically lifelike scene. In bright, pure colour they portray rhythmic movement. From 1884, Degas started to simplify his compositions, reducing the depth of his pictorial space, and concentrating on single characters or small groups of figures. Here the figures touch and overlap, and the light is reflected off their pale skin and blue tutus, emphasizing the shapes, and their gestures are simplified, but nevertheless appear natural. Virtually untaught, Gauguin was quick to absorb ideas from artists he admired. He perceived these elements in Degas's work and used them in his own.

CHAIR WITH PIPE

VINCENT VAN GOGH

1888

oil on canvas
92 x 73 cm (36 ⅛ x 28 ¾ in.)
National Gallery, London, UK

ONE OF THE BEST-KNOWN artists in the world, Vincent Willem van Gogh (1853–90) only painted for ten years of his life but during that time he produced more than 2,000 works of art, including paintings and drawings. Although he experienced almost no success, he helped to lay the foundations of modern art.

A troubled man, Van Gogh experienced many rejections, was plagued by mental illness and attempted several careers before deciding to be an artist at the age of twenty-seven. The eldest surviving child of six, he grew up in North Brabant in the southern Netherlands. His father was a Protestant minister. At the age of sixteen, he was apprenticed to the art dealers Goupil & Cie in The Hague, London and Paris, but after being dismissed, he taught in England for a while and then worked as a missionary in the Borinage mining district of Belgium. In 1881, he took art lessons with Anton Mauve, and studied the work of artists, especially 17th-century Dutch painters and Millet. In 1885, he visited Antwerp where he discovered Rubens and began collecting Japanese *ukiyo-e* prints. The following year, he joined his brother Theo in Paris, where he studied with the painter Fernand Cormon (1845–1924) and met the Impressionists, and through their example, he lightened his palette and shortened his brushstrokes. In 1888, he moved to Arles in the south of France, hoping to found an artists' colony. Using Impressionist and Japanese art as influences, his work brightened as he used colour and symbolism to express his feelings. Gauguin was the only artist to join him at Arles, but they argued frequently and Van Gogh's mental illness worsened. After one blazing row, Van Gogh cut off part of his left earlobe and was temporarily hospitalized, but his work became even more striking and dynamic. In May 1890, he moved to Auvers-sur-Oise, where the sympathetic Dr Paul Gachet treated him, but two months later, he shot himself and died in the arms of his beloved brother Theo.

Van Gogh painted this when Gauguin was staying with him at Arles. Although simple and plain, the chair represents his hope for the future.

Van Gogh's Bedroom in Arles, **Vincent van Gogh, 1889, oil on canvas, 57.5 x 73.5 cm (22 ½ x 28 ⅞ in.), Musée d'Orsay, Paris, France**

This painting is the third version of Van Gogh's bedroom in Arles that he painted between 1888 and 1889. Each painting is almost identical. Writing to his brother Theo, he explained the appeal: 'the pale, lilac walls, the uneven, faded red of the floor, the chrome-yellow chairs and bed, the pillows and sheet in very pale lime green, the blood-red blanket, the orange-coloured wash stand, the blue wash basin, and the green window. I wanted to express absolute repose with these different colours.' Much has been made of there being two of everything, possibly indicating Van Gogh's anticipation of Gauguin's companionship. However, the sparseness of the room and its colour scheme also shows his admiration for Japan and the simplicity with which 'great artists have lived in that country'.

2 THE PIPE

Placed on the rush seating, Van Gogh's pipe and tobacco, like the chair itself, represents himself – and happiness. A religious man, he had few possessions, but his pipe and tobacco were – like paint – things he felt he needed. Therefore, along with the chair, these objects comprise a self-portrait. The pipe and bulbs were painted last of all, over dry paint.

1 THE CHAIR

Yellow was Van Gogh's favourite colour. As the colour of the sun, this simple wooden chair represents optimism and happiness. He painted it in Arles when Gauguin had come to stay. As the chair Van Gogh used, it also symbolizes him. He found Gauguin's insistence on painting from the imagination difficult, and explained that he had to work from direct observation, even though he might make alterations or exaggerations.

3 SPROUTING BULBS

Included partly for their colour and shape, and partly for their implications of new life, these sprouting bulbs add to the sense of hope for the future implied across the work. At this point, Van Gogh truly believed that he was starting something positive in Arles, where many artists would work together in harmony in a buzzing artists' colony. He used the flat yellow surface of the box to write his usual signature, a simple and bold 'Vincent'.

While in Paris, Van Gogh lightened his palette, abandoning the sombre colours of his Dutch period, while his expressive markmaking became even more graphic. Although he experimented with painting directly onto unprimed canvases, he preferred medium canvases with light-coloured grounds.

④ COLOUR

Although the local colour of the chair is yellow, the contrasting outline colours throw the object forward from the background. Contrasts of red and green are placed together on the floor while orange and blue, and violet and yellow are used in the chair.

⑤ METHOD

First, Van Gogh applied opaque paint on his unprimed canvas, allowing it to show through in places. He added more paint with the wet-in-wet technique. Some paint is very thick, especially in the middle of the chair. Outlines were added with long, sweeping strokes.

⑥ DARK OUTLINES

The image's bold outline, distorted perspective and asymmetrical composition show an influence of Japanese prints. Dark outlines became a feature of Van Gogh's paintings. They help to delineate areas and here, on the chair, the blue and orange outlines suggest shadows.

⑦ IMPASTO

Unlike the smoothness of the Japanese prints he admired, Van Gogh applied thick, impasto brushstrokes across most of this painting. Rather than squeezing it onto his palette, he often used paint straight from the tube and pushed it across his canvas with stiff brushes.

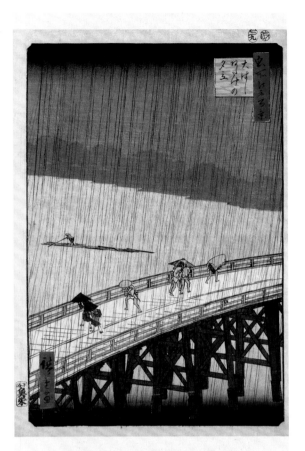

Sudden Shower Over Shin-Ohashi Bridge and Atake, No. 52 from *One Hundred Famous Views of Edo*, **Utagawa Hiroshige, 1857, woodblock print, 36 x 23 cm (14 ¼ x 9 ⅛ in.), Brooklyn Museum, New York, USA**

The Japanese *ukiyo-e* artist Hiroshige produced several series of prints featuring landscapes, figures, birds and flowers. He became exceptionally influential to Western artists and Van Gogh was one of the first to collect Japanese prints. Van Gogh owned a copy of this example, which depicts people walking across the great bridge at Atake during a rainstorm. Van Gogh made an oil painting copy of the print, and his subsequent style and subject matter show how he assimilated the influences, including the flat-looking areas of colour, distorted perspectives and minimization of shadows.

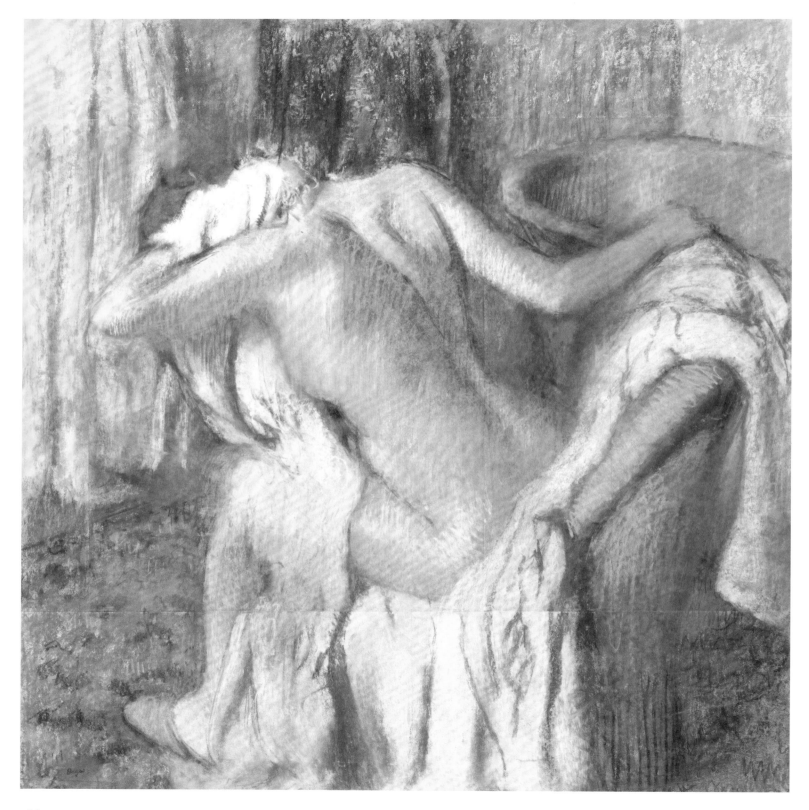

266 AFTER THE BATH, WOMAN DRYING HERSELF

AFTER THE BATH, WOMAN DRYING HERSELF

EDGAR DEGAS

1890–95

pastel on wove paper laid on millboard
103.5 x 98.5 cm (40 ¾ x 38 ¾ in.)
National Gallery, London, UK

AMONG THE MOST IMPORTANT artists of the 19th century, Hilaire-Germain-Edgar Degas (1834–1917) was central to the development of Impressionism, although he differed in many ways with their beliefs. Similarities included his interest in the effects of light and contemporary life and an understanding of colour. Contrastingly, he painted only indoors and not *en plein air*, and he paid great attention to detail. He was a sensitive portraitist and excelled in the depiction of movement. Rejecting the label 'Impressionist', he preferred to describe himself as an independent and became famous for his painting, sculpture, printmaking and drawing, with a style that was a mixture of Realism, Impressionism and Neoclassicism.

From a wealthy Parisian family, Degas briefly studied law, but then studied art with Louis Lamothe (1822–69), a former pupil of Ingres. He registered at the Louvre as a copyist, and was captivated by Courbet's Pavilion of Realism at the Exposition Universelle of 1855. In 1856, he went to Italy for three years where he studied the work of artists including Michelangelo, Raphael and Titian. His fascination with the human figure was shaped by his academic training, but he approached it innovatively, usually capturing figures from unusual angles under artificial light. Rather than following an academic approach, he presented contemporary figures in modern, everyday situations, inspired by Realism. In 1865, he exhibited at the Salon for the first time.

Drawing inspiration from the boulevards, cafés, shops, dance studios, drawing rooms and theatres of Paris, his close observations contrasted dramatically with the Impressionist method. Building on his interests in photography and Japanese art, he created compositions from unconventional angles, often cutting figures off at the edges and featuring bold linearity. With deteriorating eyesight, he eventually abandoned oil painting, but continued working with a variety of media, including pastels, photography, clay and bronze.

One of his series of controversial pastels of women at their ablutions, this shows a seated woman rubbing her neck with a towel. It initiated harsh criticism and fuelled controversy about his assumed misogyny.

The Tub, **Edgar Degas, 1886, pastel on card, 60 x 83 cm (23 ⅝ x 32 ⅝ in.), Musée d'Orsay, Paris, France**

One of a series of images of women at their toilette – washing, bathing, wiping and drying themselves – this was shown at the last Impressionist exhibition in 1886. Although it was a subject that many of the time found too personal and unsuitable for art, Degas also explored the subject in monotypes and bronze sculpture. He used classical art as his basis for the pose and elegant contours, and Japanese ideas in the distorted perspective, bird's-eye view and unusual composition, with his own innovative and delicate use of pastel. He used a variety of strokes, some with the tip of the pastel and some with the flat side, while soft strokes create blurred effects. So, some of his marks define the forms and others diffuse them. The reactions of contemporary critics varied. Some suggested that images of real women were modern and honest, whereas others criticized the ugliness of the models and the disrespect he showed to women considering the private nature of the activities.

② RIGHT SHOULDER AND SPINE

The cream-coloured paper can be seen through the charcoal grey contour of the shoulder blade. Charcoal shadows act as muted flesh tints. The woman's back is arched and slightly twisted, creating a tension accentuated by the line of her backbone. The strength of the dark grey line that delineates her back from her right arm shows that a photographic reference has been used. Degas was fascinated with the new medium; he often spent the day painting and the evenings preparing photographic prints.

① LEFT SHOULDER AND HEAD

From the 1870s, Degas produced several series of women washing, usually in pastel, later in bronze. This is all the viewer sees of the flame-haired woman's head as she dries her neck with a towel using her left hand. Adjustments to the image are visible. Degas shortened the projecting elbow correspondingly.

③ ELBOW, BATH AND CHAIR

This section of the almost square painting consists of various shapes and angles. Cut off at the edge of the composition is the tin bath in the background. The woman sits on white towels spread over a wicker chair in front of it, while her right arm reaches out to hold the chair for support.

Unlike other Impressionists, Degas did not paint quickly from nature, as he said: 'No art was ever less spontaneous than mine.' His initial outlines and underlying shadows were created with charcoal – decidedly different from the coloured shadows of the Impressionists.

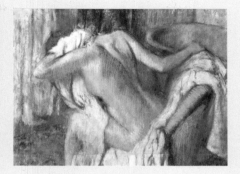

❹ FIRST STAGES

Pastels enabled Degas to combine colour and line. By layering his colours, he built up a mesh of overlapping lines. After he had applied his first light pastel marks, he steamed the surface of the paper, dissolving the colours into a blur. He then worked it as a paste using a stiff brush or his fingers.

❺ COMPOSITION

The drawing was made on several pieces of paper mounted on cardboard. The composition is dominated by the vertical and diagonal lines of the floor and walls meeting and the cross-diagonal of the woman's back. Straight vertical and diagonal lines contrast with the curve of her limbs, the bath and the chair.

❻ GENERAL METHOD

Using photographs and preliminary sketches, and focusing on the light, Degas worked his pastels across the picture simultaneously. He used a variety of strokes, some vertical, some smooth. The layered method creates deep textures and blurred contours that emphasize the woman's vigorous movements.

❼ COLOURS AND MARKS

Degas used commercially available pastels. The main pigments used in this painting are Prussian blue, ultramarine, cadmium yellow, white, orange, yellow ochre, pale blue and cream. He varied his marks across the work, creating decorative and textural effects. He put zigzags in the carpet, with longer sweeping lines on top.

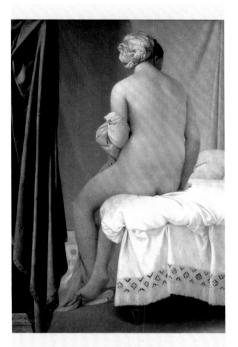

The Valpinçon Bather, Jean-Auguste-Dominique Ingres, 1808, oil on canvas, 146 x 97 cm (57 ½ x 38 ¼ in.), Louvre, Paris, France

Painted while Ingres was studying at the French Academy in Rome, this work was unusual in presenting the nude's back. Ingres accentuates the smooth flesh with draperies, while the depiction of her discarded red sandal shows her to be a real woman, not a mythological goddess. Years later, the Realists and the Impressionists still fought this concept, and Degas was directly inspired by it. He studied the great masters. Following Ingres, he emphasized the importance of classical draughtsmanship, of creating harmony through contrasts, clear contours and delicate effects of light.

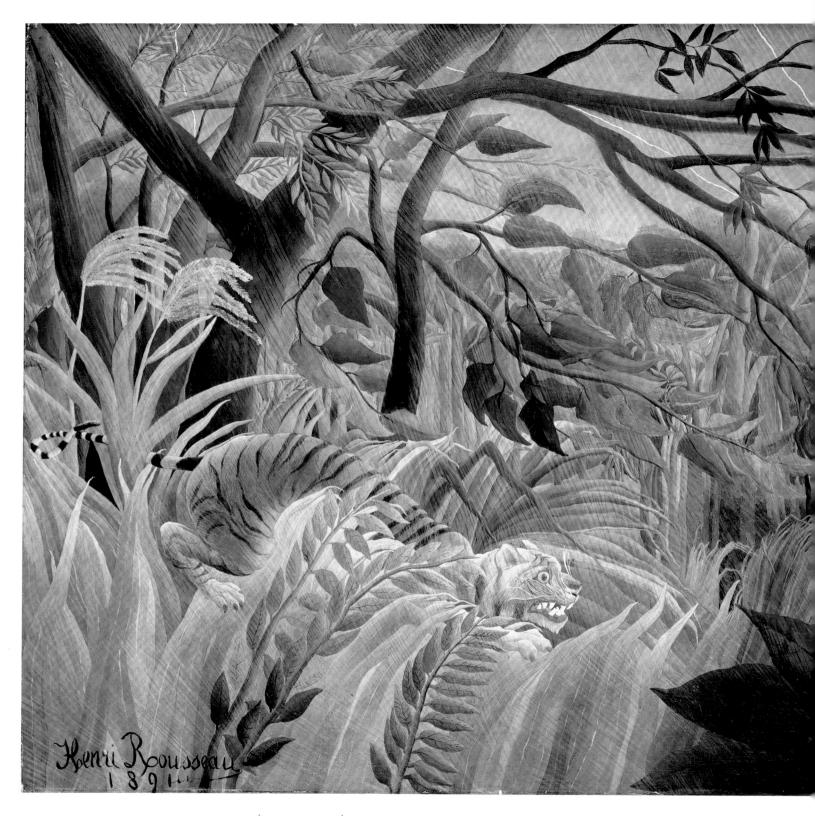

270 TIGER IN A TROPICAL STORM (SURPRISED!)

TIGER IN A TROPICAL STORM (SURPRISED!)

HENRI ROUSSEAU

1891

oil on canvas
130 x 162 cm (51 ⅛ x 63 ¾ in.)
National Gallery, London, UK

HENRI ROUSSEAU (1844–1910) WAS an untutored 'Sunday painter', ridiculed about his art during his life. Yet he inspired artists including Picasso and Wassily Kandinsky, who recognized an innocence and directness in his work.

In his late teens, Rousseau enlisted in the army and after four years, he left and moved to Paris, where he worked as a tax collector at tollgates. He began to paint at the age of forty, making copies of paintings at the Louvre, and he became influenced by a range of sources, from sculpture to postcards and newspaper illustrations, while his greatest admiration was for academic painters such as Jean-Léon Gérôme and William-Adolphe Bouguereau (1825–1905). Although he strove for recognition from the Académie des Beaux-Arts, he was never accepted and from 1886, he exhibited regularly at the Salon des Indépendants. Even at the open-minded Salon des Indépendants, however, his paintings were ridiculed as 'naive'; an expression that was not yet used to describe the ingenuous approach that many artists later adopted.

Rousseau claimed to have drawn this jungle scene from direct experience. However, with its incorrect proportions, odd-looking animals and plants, unnatural colours and simplified perspective, it is more likely that his references came from secondary sources.

The Snake Charmer, Henri Rousseau, 1907, oil on canvas, 167 x 189.5 cm (65 ¾ x 74 ⅝ in.), Musée d'Orsay, Paris, France

With a bold composition and rich colours, this dreamlike image was developed from sketches made in the Natural History Museum and the botanical gardens of Paris. The foliage seems lush, but the snake charmer, snake and bird look like cardboard cut-outs. The bright, backlit colours had not been seen in paintings before.

② FOLIAGE

Exotic vegetation – painted from domestic pot plants – creates patterns across the canvas and leaves only glimpses of the sky beyond. The trees and plants were painted from examples in the hothouses of the Jardin des Plantes. One of the plants is mother-in-law's tongue, or *Sansevieria trifasciata*, and each leaf is carefully depicted, suggesting it was copied from botanical drawings.

③ THE SKY

Glimpsed between the defined, carefully shaded leaves, the stormy sky is rendered in a subtle white and grey glaze. Growing darker as it reaches the top of the canvas, two fine streaks of white represent fork lightning, while diagonal slashes depict the pouring rain. Rousseau's paintings were later celebrated by the Surrealists who valued his dreamlike imagery.

① THE TIGER

Constantly rejected by the Salon jury, Rousseau exhibited *Tiger in a Tropical Storm* at the Salon des Indépendants in 1891 under the title *Surprised!* He later said that the tiger was about to pounce on a group of explorers, although this is not clear in the picture. Whatever its prey, the tiger is illuminated by a flash of lightning from a tropical storm. With sharp white teeth, red gums and wild eyes, it looks beyond the picture. Rousseau claimed that he had experienced life in the jungle during his time in the army, but in actuality he never left France. Instead, his inspiration came from the Jardin des Plantes in Paris, the Natural History Museum and illustrated books.

Two other inspirations for this work came from Persian miniatures and medieval tapestries. Accordingly, dense patterns and intricate details have been contrasted with looser, diagonal stripes that indicate the slashing rain.

④ COLOUR

Due to his lack of money, Rousseau used student-grade paints. For this painting his palette included white lead, ultramarine, cobalt blue, yellow ochre, ivory black, Pozzuoli red (a natural earth red), raw sienna, Italian earth, emerald green, vermilion, Prussian blue, Naples and chrome yellow. From these thirteen colours, he created his abundance of greens and browns, plus the golden tones of the tiger and the splash of red in the foliage. Hues of green, yellow, orange, brown and red predominate, camouflaging the tiger in the undergrowth.

⑤ COMPOSITION

Rousseau was inspired by Gauguin's paintings, as can be seen in this lush jungle scene. Although criticized for his childlike compositions, this nevertheless conveys the idea of dense vegetation, with the storm adding a subtle, diagonal dimension. Angled and overlapping, stripes govern the composition.

⑥ PAINT APPLICATION

Rousseau's childlike simplicity inspired the use of the term Primitivism. Despite the apparent simplicity, this painting was constructed in meticulous layers. Rousseau started with a graduated wash for the sky, then built up the leaves and plants and finally painted the tiger. Using innumerable varieties of green, he worked on this for a considerable length of time, painstakingly working on each leaf, frond, branch and stripe.

The Snake Charmer, **Jean-Léon Gérôme,** *c.* **1879, oil on canvas, 82 × 121 cm (32 ⅜ × 47 ⅝ in.), Sterling and Francine Clark Art Institute, Massachusetts, USA**

After leaving the army, Rousseau studied briefly with Jean-Léon Gérôme (1824–1904) in Paris. He maintained that Gérôme told him to retain the naivety of his style. Gérôme was an exalted academic painter, and this painting was admired. A naked boy standing in the centre of a room holds a python that coils around his waist and over his shoulder, while an older man sits to his right playing a flute. The performance is watched by a group of armed men. Although antithetical to Rousseau's style, this painting was an inspiration to him.

AT THE MOULIN ROUGE

HENRI DE TOULOUSE-LAUTREC

1892–95

oil on canvas
123 x 141 cm (48 ⅜ x 55 ½ in.)
Art Institute of Chicago, Illinois, USA

HENRI DE TOULOUSE-LAUTREC (1864–1901) was the last in line of a noble aristocratic family. He grew up on one of the family estates near Albi in southern France and began sketching at the age of ten. However, through an inherited illness – after breaking his legs as an adolescent – his body grew to adult size but his legs did not. He began studying art with the portrait painter Léon Bonnat (1833–1922), but moved the next year to the historical painter Fernand Cormon (1845–1924). However, he soon left, rented his own studio in the bohemian district of Montmartre and became a well-known figure sketching in the local cafés, cabarets and nightclubs. He also illustrated song sheets and designed posters. To overcome self-consciousness, he drank heavily. Influenced by the Japanese design that was popular in *fin de siècle* Paris, his freely handled line and colour captured the energy, atmosphere and people, conveying a rhythmic sense of movement that presaged the early 20th-century movements of Fauvism and Cubism.

With its simplified, diagonal arrangement that leads viewers' eyes into the image, this painting – like his others – is brutally frank. The fluidity and sense of design had a strong impact on Art Nouveau and poster design specifically.

At the Moulin Rouge, The Dance, Henri de Toulouse-Lautrec, 1890, oil on canvas, 115.5 x 150 cm (45 ½ x 59 in.), Philadelphia Museum of Art, Pennsylvania, USA

This is the second of several paintings by Toulouse-Lautrec depicting the Moulin Rouge cabaret in Paris. A man and woman dance the can-can in the middle of a crowded hall. The man is teaching the girl. He is Valentin le Désossé, who was so flexible that he was known as 'Valentine the Boneless'. The background features several familiar figures of the time, including leaning on the bar, the white-bearded Irish poet William Butler Yeats.

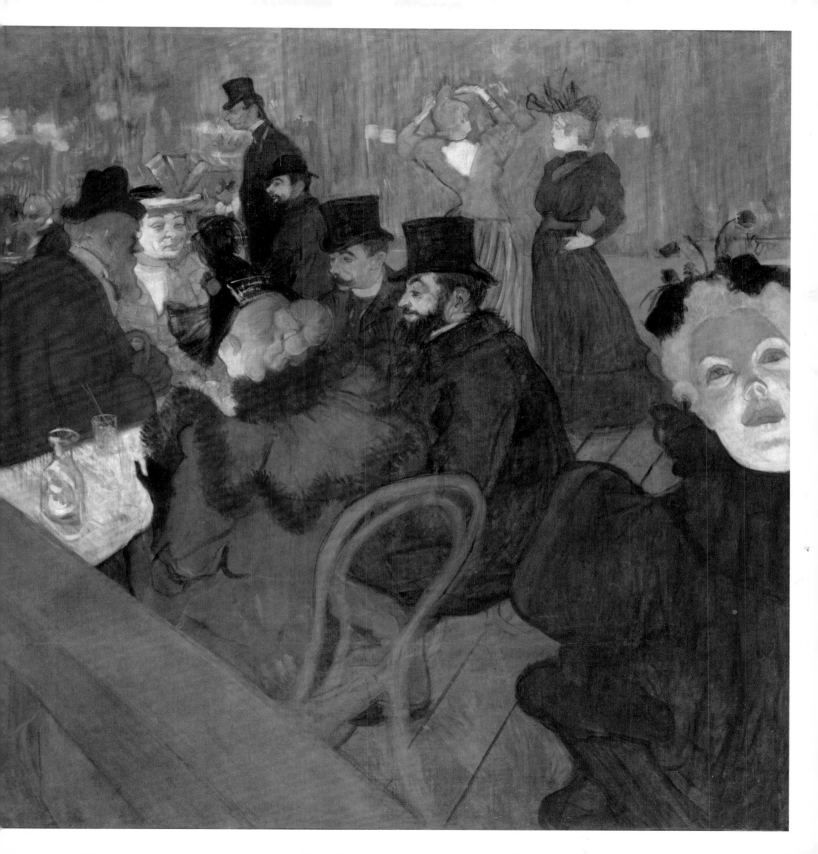

Towards the back of the painting, in profile, this diminutive figure is a self-portrait of Toulouse-Lautrec. Accompanied by his tall, stooped cousin and frequent companion, the physician Gabriel Tapié de Céleyran, both men are in top hat and tails. Nearby, part of the group seated around a table are the author and dandy Édouard Dujardin, with his vibrant orange beard and the dancer Juana la Macarrona still wearing her stage make-up.

③ TABLE OF FRIENDS

Toulouse-Lautrec uses atmospheric perspective to make viewers focus on the conversation. With her complicated hairstyle and her back to viewers, this slender redhead is probably the dancer Jane Avril. In a fur-trimmed coat and black gloves, her little finger is gracefully crooked, silhouetted against the white tablecloth. Next to her is the photographer Maurice Guibert and next to him is another photographer, Paul Sescau.

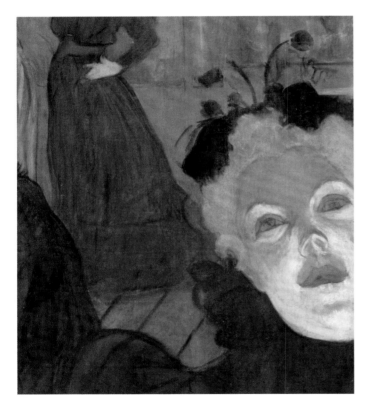

① GREEN FACE

The Moulin Rouge, named for the red windmill on its roof, became known for its exciting, exotic performers who mingled with the patrons when they were not performing. The eerie green light of the interior evokes an unhealthy atmosphere and is emphasized on this woman's face. It is May Milton, one of the Moulin Rouge's regular singers. Angled from below, the artificial illumination creates a ghoulish green and white effect.

4 DANCERS

In the background, La Goulue (The Glutton) another of the Moulin Rouge's dancers, adjusts her red hair. La Goulue was the nickname for Louise Weber, a can-can dancer who was also called the 'Queen of Montmartre'. With her is La Môme Fromage (The Cheese Kid). The Moulin Rouge became known for these lithe, energetic dancers and their exotic, often erotic performances.

6 LIGHT

The Moulin Rouge attracted an adventurous, middle-class clientele and the avant-garde. Electric light was relatively new and Toulouse-Lautrec observed its effects. The eeriness of the greenish illumination inspires feelings of anxiety, distorting the image, almost threateningly. As Toulouse-Lautrec exploited these evocative effects, it became an early example of Expressionism.

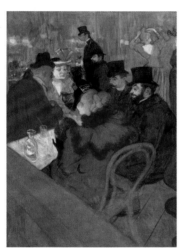

5 COMPOSITION

Inspired by Japanese woodblock prints, Toulouse-Lautrec created a dramatic view of the location, with distorted perspective, tilting the picture plane upwardly. The large diagonal bar seen from above, effectively cuts off viewers from the action – and it reaffirms the mystique of the Moulin Rouge. The large mirror in the background helps to distort the view.

7 PAINT SURFACE

Toulouse-Lautrec's friend, dealer and biographer Maurice Joyant noted that he completed the painting in 1892, but later added an L-shaped piece of canvas to extend the balustrade at Avril's left elbow and include the figure of Milton. His paint application is consistent across the surface and in a bright palette including chrome yellow, vermilion, red madder and ultramarine blue.

Detail from *A Corner of the Moulin de la Galette*, Henri de Toulouse-Lautrec, 1892, oil on cardboard, 100 x 89 cm (39 ⅜ x 35 ⅛ in.), National Gallery, Washington, DC, USA

In another interior scene of the most famous Parisian cabaret, Toulouse-Lautrec drew from a vantage point in a corner. With several figures overlapping, in close proximity to each other and facing different directions, this is a complex composition. None are communicating, each is in his or her alienated world. Their plain clothing shows their poverty; they were individuals on the edges of society, who appear tired. The image also demonstrates Toulouse-Lautrec's innovative use of line and colour that influenced so many subsequent artists and styles, including Picasso, Maurice Utrillo, Art Nouveau, Expressionism and Pop art.

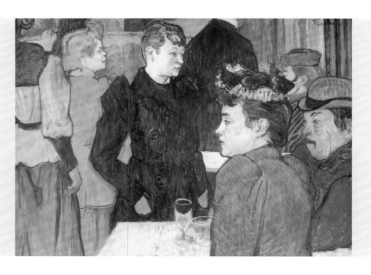

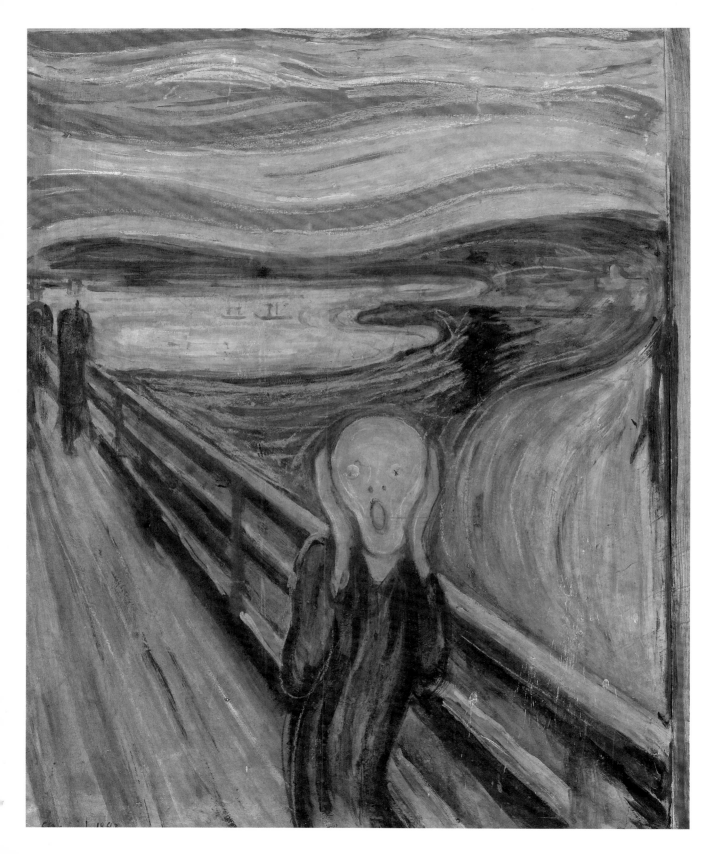

THE SCREAM

EDVARD MUNCH

1893

tempera and crayon on cardboard
91 x 73.5 cm (35 ⅞ x 28 ⅞ in.)
National Museum of Art, Architecture and Design, Oslo, Norway

A PROLIFIC YET PERPETUALLY troubled artist, Edvard Munch (1863–1944) was preoccupied with human mortality, and he expressed these obsessions through intense colour, flowing, distorted forms and enigmatic themes. Unlike the focus on direct observation and light that had been endorsed by the Realists and the Impressionists, Munch concentrated on his imagination and as a result became one of the most controversial artists among a new generation of painters.

Growing up in Norway, when he was five-years-old, Munch's mother died of tuberculosis and nine years later his elder sister Sophie also died of tuberculosis aged fifteen. From that time, his father, a fundamentalist Christian, experienced fits of depression, anger and visions. He instructed his children in history and religion, and read them ghost stories. Munch grew up anxious and morbidly fascinated with death. He was also frequently ill and missed weeks of school. As he convalesced, he drew and painted.

In 1879, he entered Kristiania Technical College (Kristiania was the capital of Norway, later renamed Oslo) but within eighteen months, he left and enrolled at the Royal Drawing School instead. He also began taking lessons with the Realist painter Christian Krohg (1852–1925). In 1885, he first visited Paris, where he saw the work of the Impressionists, Post-Impressionists, Symbolists and emerging Art Nouveau designs. In 1889, he received a two-year state scholarship to study in Paris with the painter Léon Bonnat (who had taught Toulouse-Lautrec). He arrived in Paris during the Exposition Universelle of 1889 and discovered the work of Van Gogh, Gauguin and Toulouse-Lautrec. After that, he experimented with brushstrokes, colours and emotional themes. For the next sixteen years, he spent a lot of time in Paris and Berlin, and he produced a prodigious amount of etchings, lithographs, woodcuts and paintings.

This is one of four versions of a painting originally entitled *The Scream of Nature*. It has been suggested that the unnaturally harsh colours may have been due to volcanic dust from the eruption of Krakatoa in Indonesia in 1883, which produced spectacular sunsets around the world for months.

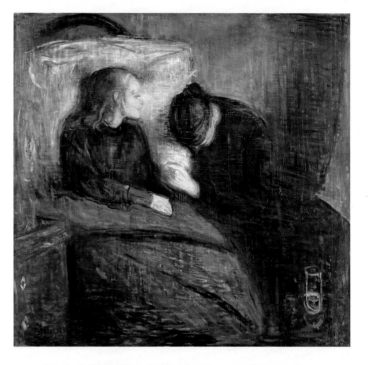

The Sick Child, Edvard Munch, 1885–86, oil on canvas, 120 x 118.5 cm (47 ¼ x 46 ⅝ in.), National Museum of Art, Architecture and Design, Oslo, Norway

A sick girl sits up in bed, her flame-coloured hair contrasting with the white of the pillow and her pale face. The dark-haired woman bent crying over her suggests that the girl is about to die. Often associated with the death of Munch's sister who died of tuberculosis in 1877, this image was described by him as his farewell to Realism. Thickly applied layers of paint draw attention to the picture's physical surface that appears sketchy and unfinished. When he first showed it in 1886, it catapulted him to fame. He painted five further versions of the same image.

② BACKGROUND

Munch later described his inspiration for this image:
'I was walking along the road with two friends – the sun was setting – suddenly the sky turned blood red – I paused, feeling exhausted, and leaned on the fence – there was blood and tongues of fire above the blue-black fjord and the city – my friends walked on, and I stood there trembling with anxiety – and I sensed an infinite scream passing through nature.' The location has been identified as the Kristiania Fjord seen from Ekeberg.

① THE HEAD

With the *Mona Lisa* (*c.* 1503–19; see pp. 60–3), this is probably the most recognizable face in Western art. An androgynous, skull-shaped head, with long, slim hands, wide eyes, flaring nostrils and an open mouth conveys anxiety and fear. The hands are held to the head and the mouth is open in what seems like a silent scream, amplified by the undulating shapes surrounding it. The ambiguity of the figure adds to its sinister implications.

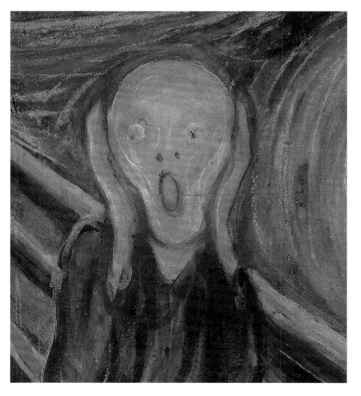

③ TWO FIGURES

Walking along the bridge in the distance are two faceless figures. At first glance, it is not clear if they are walking away or towards the main figure. On reading Munch's explanation, however, it can be understood that they are Munch's two friends who walked on, unaware of the phenomenon he was experiencing.

Initially a naturalistic painter, Munch decided that art should project artists' moods and emotions, conveying strong feelings to evoke empathy. To this end, he loosened his style, stopped aiming for Realism and became generally more expressive.

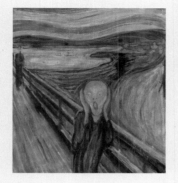

4 LINE

Munch's flowing, tortuous lines have similarities with contemporary Art Nouveau designs, but Munch was focusing on psychological revelations rather than decoration. The swirling lines describe the landscape and figures, while the straight lines form the bridge.

5 COMPOSITION

With its strong diagonal line, this is a classical triangular composition, with the main figure as the focal point. All lines lead to the face, from the straight lines of the bridge, to the undulating waves of the fjord. With the face slightly off-centre it attracts immediate attention.

6 COLOUR

It is unclear whether Munch had the condition known as synesthesia – the union of the senses – but he suggested sound through colours – he 'saw' blood-red as a scream. He associated colours with feelings, such as yellow with sorrow, blue with melancholy and violet with decay.

7 MATERIALS

Munch's painterly effect is created by his use of unusual materials and expressive, loose lines. Working on cardboard, he applied free brushstrokes, leaving certain areas of the cardboard exposed, especially at the edges to give the impression of the work being unfinished.

The Bridge at Trinquetaille, Vincent van Gogh, 1888, oil on canvas, 65 x 81 cm (25 ⅝ x 31 ⅞ in.), private collection

This painting by Van Gogh features all his usual characteristics, including bold colours, dark outlines, undulating contours and expressive paint application. Whether this was a direct influence on *The Scream*, or whether both artists simply had similar outlooks and used colour, line and composition in comparable ways, is not known. Nevertheless, many comparisons can be drawn, from the composition to the strange, unidentified figure in the foreground, as well as the diagonal and serpentine lines, and the dark, sinister-looking figures ignoring the distressed main figure. The two artists never met and Van Gogh never knew of Munch's existence, although Munch – who lived until 1944 – eventually got to know about Van Gogh. The parallels between two iconic artists led to an exhibition 'Munch: Van Gogh' (2015–16) at the Van Gogh Museum in Amsterdam.

STILL LIFE WITH PLASTER CUPID

PAUL CÉZANNE

1895

oil on paper
70 x 57 cm (27 ½ x 22 ½ in.)
Courtauld Institute of Art, London, UK

PERHAPS THE SINGLE MOST influential artist in shaping 20th-century art movements, Paul Cézanne (1839–1906) initially associated with the Impressionists, but aimed to: 'make of Impressionism something solid and durable like the art of museums'. Discovered by the Paris avant-garde during the 1890s, his work was particularly influential to Picasso and Matisse who declared that he was 'the father of us all'.

Although misunderstood and derided for most of his life, Cézanne eventually altered attitudes and approaches to art. He was born into a wealthy family in Aix-en-Provence in the south of France and became close friends with the future writer Émile Zola while at school. Under family pressure, like Manet and Degas, he initially trained as a lawyer although he also attended lessons at the local drawing academy. Under pressure from Zola, he moved to Paris where he was rejected from the École des Beaux-Arts, so he enrolled at the Académie Suisse, where he met Camille Pissarro and his circle of friends. In 1863, he exhibited at the Salon des Refusés and from 1864 to 1869, he submitted work to the Salon but was rejected. At that time, inspired by Delacroix, Courbet and Manet, he painted from his imagination, dark, impasto portraits, often using palette knives.

In 1874 and 1877, he exhibited with the Impressionists. By then, he was dividing his time between Provence and Paris. He also briefly lived in Auvers-sur-Oise, where Van Gogh spent the last months of his life. While there, he went on painting expeditions with Pissarro. Under Pissarro's influence, he lightened his palette and used smaller brushstrokes. Almost a decade later, he painted in the countryside with Renoir and Monet. However, whereas most of the Impressionists sought to capture the effects of light, Cézanne was always more interested in exploring underlying structures. To this end, his mature paintings display distinctly sculptural dimensions, examining everything from several angles at once. It was this analytical approach that led the future Cubists to regard him as their mentor. This is one of his last paintings, which is often seen as one of the most radical compositions that he produced due to its abstract, analytical approach that provoked Cubism.

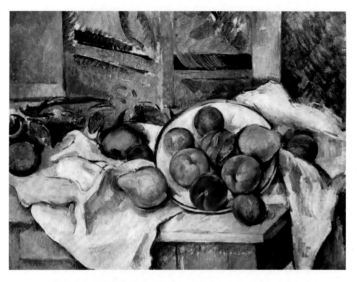

A Table Corner, **Paul Cézanne, c. 1895, oil on canvas, 47 x 56 cm (18 ½ x 22 ⅛ in.), Barnes Foundation, Pennsylvania, USA**

Aiming to blend the freshness of Impressionism with the grandeur of the Old Masters, Cézanne formulated a sculptural approach to painting, creating a style that is challenging and original, while indebted to the artists he studied in the Louvre, including Titian, Giorgione, Poussin and Chardin. Pissarro had advised him to paint only with 'the three primary colours and their immediate derivatives' and he adhered to this. Strewn across a tabletop, pears, peaches, a white cloth and dish appear to tumble at different angles, harmonized by oblique, subtle brushwork that helps to create a sense of vibrancy, space and depth. This faceted style seems to create several perspectives at once and balances the entire surface. Cézanne's disciplined approach led the way from naturalism to Cubism and then on to abstract art.

❷ APPLES AND ONIONS

Although from his location in the south of France, Cézanne could have painted exotic fruits and vegetables, he focused on these basic objects because the subject was less important than his method. Three apples in a white dish, one in front of it on the table and an onion behind all repeat the rounded shapes across the image. He was not aiming to paint an illusion of fruit; his focus was to recreate three-dimensional forms on a flat surface, so he emphasized shapes, colours and the spaces between them all.

❶ PLASTER CAST

This plaster cast of Cupid appears twisted as Cézanne painted it from more than one angle – mostly from a high viewpoint – and the foreshortening makes the head seem larger than the feet. He built up the image by moving around it – only slightly – but painted small areas from each angle, which creates this distorted result. It is a plaster cast of a sculpture by Pierre Puget (1620–94).

❸ STILL LIFE WITH PEPPERMINT BOTTLE

On the left side of the work is a painting within it, *Still Life with Peppermint Bottle*, which was painted between 1890 and 1894. Two apples and a glass are on a blue cloth. The colours and subject matter merge the real and painted elements, adding to the disorientation of the image, while the predomination of blue helps to project Cupid forward.

Cézanne said he aimed to depict 'something other than reality'. For him, colours and forms were the most important elements of his compositions and he completely discarded the rigid rules of perspective and paint application promoted by the Academy.

④ COLOURS

Cool colours – blues – were used for the shadowy or receding areas and warm colours – reds, yellows and oranges – for the rounded forms. The juxtaposition of contrasting colours creates complex spatial arrangements. His palette here included black, yellow ochre and red earth.

⑤ BUILDING UP

Cézanne used paper primed with a cream-coloured ground. Then he drew the outlines of the image in graphite and overlaid it with a dilute mixture of ultramarine. Before the outlines were dry, he applied wet-in-wet paint across the canvas. Next, thin opaque paint was applied following contours in contrasting tones.

⑥ BRUSHSTROKES

Cézanne painted in discrete, methodical, directional brushstrokes describing the shapes and forms. He applied thin layers, allowing the cream ground to show through in places to define highlights. He dragged some of his initial wet ultramarine outlines into adjacent colours to create deeper tones.

⑦ SCULPTING

Cézanne's adept handling of his range of greys enabled him to sculpt the image, portraying a sense of depth without using conventional linear perspective. Delicate blended patches of colour create the impression of the diffused light of the studio. His variety of brushmarks enhances the sense of solidity.

Still Life with Apples and Pitcher, Camille Pissarro, 1872, oil on canvas, 46.5 x 56.5 cm (18 ¼ x 22 ¼ in.), Metropolitan Museum of Art, New York, USA

Three years after Pissarro's death in 1903, Cézanne acknowledged his debt to him by describing himself in an exhibition catalogue as 'Paul Cézanne, pupil of Pissarro'. Unlike Monet, Renoir, Cézanne and other artists in his circle, Pissarro painted few still lifes and most were executed late in his career. So this work is unusual for its subject as well as for its clearly delineated forms and the subtle use of light. Pissarro painted it during the period when he was advising Cézanne, particularly showing him how to lighten his palette and use two-dimensional brushstrokes to describe images. It shows how Cézanne built on Pissarro's example, although Pissarro used soft marks to represent light, while overall, Cézanne aimed to express the underlying structures of things.

THE BOULEVARD MONTMARTRE AT NIGHT

CAMILLE PISSARRO

1897

oil on canvas
53.5 x 65 cm (21 x 25 ½ in.)
National Gallery, London, UK

AS HE ADVISED SO many younger artists, Camille Pissarro (1830–1903) is often called the 'father of Impressionism'. He was also the only artist to participate in all eight of the independent Impressionist exhibitions held between 1874 and 1886. Assimilating many ideas, he developed his own style, mainly painting *en plein air*, landscapes and scenes of peasants, creating vibrant effects with small flecks of colour and subtly conveying infinite variations of light.

Born in the West Indies, Pissarro lived and worked mainly in and around Paris. He studied at the École des Beaux-Arts and at the Académie Suisse, where he met Monet and Cézanne, and he became an integral part of the Impressionist group. During the Franco-Prussian War of 1870 to 1871, he moved to London where he met up with Monet and together they studied the work of the English landscapists, especially Turner. He later tried out pointillism with Seurat, but always focused on direct observations of light and atmosphere. As he grew older, eye problems prevented him from working outdoors except in warm weather and he began painting from hotel-room windows. This is one of several images he painted from the window of the Hôtel de Russie in Paris.

The Hermitage at Pontoise, Camille Pissarro, 1874, oil on canvas, 61 × 81 cm (24 × 31⅞ in.), Oskar Reinhart Collection, Winterthur, Switzerland

Pissarro painted this in the open air during the year in which he and the other Impressionists had their first independent exhibition in Paris. The method of applying colour in short vibrant streaks arose from his discussions with them.

② COMPLEMENTARY CONTRASTS

The Boulevard Montmartre was one of the new airy, wide streets designed by Baron Haussmann, with modern streetlights and bright shop windows. Pissarro concentrated on only the essential shapes and colours – here, they are predominantly the complementary contrasts of yellow-orange and violet-blue.

③ PALETTE

In accordance with his emphasis on complementary colour juxtapositions, Pissarro mainly used yellows and blues in his palette for this work, with only one red and white. It comprised lead white, ultramarine, lemon yellow, chrome yellow, alizarin crimson, cobalt blue and yellow ochre. He painted these without blending too much, creating patterns with his brushmarks.

① THE BOULEVARD

The illuminated street lamp has a halo around it through the effects of rain. Like the other Impressionists, Pissarro was fascinated by the effects of light on objects, and here he depicts three sources of artificial light: the orange/burnt yellow of the gas lamps in the shops and cafés, the pale yellow lights of oil lamps from the carriages, and the paler white-toned electric lights from the street lamps. These are surrounded by a faint blue aura, mimicking the effect of rain.

④ THE SKY

Pissarro was a great believer in directional brushmarks. His brushstrokes vary – lengthening, shortening and changing direction. The sky is painted in this way, creating a fan shape with short, angled marks that stress the apparent widening of the boulevard due to perspective as it nears him. Here, the colour of the brushstrokes is uniform and becomes clearer towards the vanishing point.

⑥ VIEWPOINT

Between February and April 1897, Pissarro painted fourteen versions of this view at different times of the day and in varying weather conditions, and two of the Boulevard Italiens to the side. This is the only night scene. The strong central shape of the receding boulevard flanked by rows of trees and buildings creates a composition that is made especially dramatic by the high viewpoint.

⑤ TECHNIQUES

After applying a pale grey priming to his canvas, Pissarro used a soft brush and fluid paint across the image. He explained his outdoor painting technique to a student: 'Paint generously and unhesitatingly, for it is best not to lose the first impression.' He worked both wet-in-wet and wet-over-dry, building up layers of little marks, including hatching and dashes to establish mass and form.

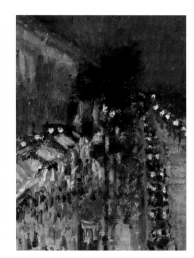

⑦ THE STREET

Sketchily painted figures and carriages appear blurred adding a sense of bustling movement. On the left is a restaurant, on the right are shop fronts on the ground floor of the buildings and, above them, residential apartments. Lights from shops and cafés radiate out onto the wet pavement, and carriages line up, waiting for the show at the Moulin Rouge around the corner to end.

Rue Custine à Montmartre, **Maurice Utrillo, 1909–10, tempera on cardboard, 51 x 73 cm (20 ⅛ x 28 ¾ in.), State Hermitage Museum, St Petersburg, Russia**

Maurice Utrillo (1883–1955) was the illegitimate son of the painter and former artist's model Suzanne Valadon (1865–1938), who never revealed who his father was. From a young age, Utrillo abused alcohol and so his mother encouraged him to paint as a distraction. He was attracted to depicting streets, churches and ordinary houses. His early work, of views such as this around Montmartre, show a clear influence of Pissarro's approach to perspective and composition, if not to his lighter palette and directional brushmarks. With his natural abilities as a teacher, Pissarro was highly influential to many of the other artists he encountered, including Gauguin, Seurat and Signac.

POST–1900

FROM THE EARLY 20TH century, there was an explosion of ideas, technologies and discoveries. As a result, the challenges to accepted artistic conventions became even more frequent and revolutionary. Art movements emerged and changed rapidly as artists sought to express new attitudes. Modernism began in France in the 1870s. It gathered momentum and had spread worldwide by the turn of the century, ending in the 1950s and followed by Post-Modernism. Twentieth-century art movements included Expressionism, Cubism, Futurism, Minimalism, Abstract Expressionism and Pop art. The 21st century has been called the Information Age. When the World Wide Web was launched in the early 1990s, it opened the world for everyone. Artists began using an even wider variety of materials and many mix media and forms. Artistic influences have changed drastically with the impact of globalization. Figurative or abstract, all is embraced as boundaries are erased.

PORTRAIT OF ANDRÉ DERAIN

HENRI MATISSE

1905

oil on canvas
39.5 x 29 cm (15 ½ x 11 ¾ in.)
Tate Modern, London, UK

HENRI MATISSE (1869–1954) IS commonly regarded as one of the most influential artists of the 20th century for his original use of colour and innovative draughtsmanship.

Born in northern France, Matisse initially studied law, but at the age of twenty-one, while recovering from appendicitis, he discovered the exhilaration of painting. He moved to Paris where he studied with Gustave Moreau (1826–98) and then Odilon Redon. His early paintings consisted of fairly traditional landscapes and still lifes, but after seeing the work of the Impressionists and Van Gogh, he began experimenting with brighter colours and freer paint application. Becoming further influenced by a range of other artists including Poussin, Chardin, Manet, Cézanne, Gauguin, Seurat and Signac, and the light of both Corsica and the south of France, his interest in capturing light and colour intensified. He spent the summer of 1905 in the village of Collioure in the south of France with his friend and fellow painter André Derain (1880–1954), where they began painting with brilliant colours and an abstracted, loose style. Later that year, along with Albert Marquet (1875–1947), Maurice de Vlaminck (1876–1958), Georges Rouault (1871–1958) and others, they exhibited at the Salon d'Automne in Paris that had been set up as an alternative to the annual Salon in the spring. The art critic Louis Vauxcelles described their distorted paintings as looking like '*fauves*' (wild beasts) and the name stuck. Matisse became the leader of the movement, and although it did not last long, Fauvism had an extensive influence on the development of art.

In 1906, he visited Algeria and Morocco, where he became inspired by the radiant light, exotic surroundings and Moorish architecture. Writing that he sought to create art that would be 'a soothing, calming influence on the mind, rather like a good armchair', he began dividing his time between Paris and the south of France. As well as painting, he designed stage sets, ballet costumes, stained glass and illustrated books.

This portrait of Derain presents the joyful spirit that is apparent in all of Matisse's work, and his applications of pure, unmodulated and expressive colour continued throughout his career.

Odalisque with Red Trousers, Henri Matisse, c. 1924–25, oil on canvas, 50 x 61 cm (19 ¾ x 24 in.), Musée de l'Orangerie, Paris, France

Heavily influenced by art from other cultures and endorsing the value of decoration, Matisse's use of colour and pattern is often deliberately disorientating and unsettling. After seeing several exhibitions of Asian art and visiting North Africa, he incorporated some of the decorative qualities of Islamic art, the angularity of African sculpture and the flatness of Japanese prints into his style, declaring that he wanted his art to be one 'of balance, of purity and serenity devoid of troubling or depressing subject matter'. During the 1920s and 1930s, he painted several odalisques (reclining women surrounded by elaborate, contrasting patterns and colours, recalling the exoticism of the Orient) as here, with the model in a white tunic and red embroidered trousers.

❷ SUMMARIZED MARKS

While Matisse painted Derain, his friend painted him, each applying non-naturalistic colours and expressive, separate brushstrokes. Matisse started the new style and Derain followed. Matisse painted Derain in his painting smock with relatively sparse, summarized marks. Traces of his long brushstrokes are visible on the yellow area of paint that takes up almost a third of the painting. In some places, the white ground is visible.

❶ COLOUR RELATIONSHIPS

Matisse painted this portrait of his friend during their holiday in the fishing village of Collioure in 1905. Capturing the sensation of sunlight on Derain's face and casting a shadow down one side, colour was always the focus and here he has created a clearly definable series of colour relationships. Warm reds, oranges and yellows are concentrated on the face, while cool blues and greens mark the background as well as the cheek and chin in shadow.

❸ BASIC METHOD

Matisse covered his fine-grained canvas with a ground made of chalk, oil, size (weak glue) and white pigment, applied in a thin, even layer across the whole surface, and then used a small round brush and a dilute mixture of cobalt blue to paint the outlines of the face, moustache, neck and smock. He next painted some of the background using broadly applied brushmarks of blue and green. Overall, he worked *alla prima*.

Synthesizing Post-Impressionist elements, including expressive brushstrokes and flat planes of colour, Matisse's approach contrasted with the smooth finish and photographic realism of academic art that for so long had been considered the aspirational style for all painters.

④ PALETTE

Matisse used saturated, mainly unmixed colours. His palette here included viridian, cobalt blue, scarlet lake, vermilion, cadmium orange, chrome yellow and lead white. He juxtaposed complementaries, from the pinkish-red hair against the green background to the orange face against the blue.

⑤ FAT OVER LEAN

The thinnest application of paint is on the smock, while the thickest marks make up the face so it comes forward. Shadows are created with the most fluid paint, while the white highlights on the face are the thickest. In this, Matisse has complied with academic painting methods of 'fat over lean'.

⑥ COLOUR

Matisse did not use black in this portrait but created intense, dark tones using unmixed viridian or, in some places, mixed viridian with cobalt blue. His understanding of colour and tone meant that he used unusual interpretations, such as cobalt blue and white and viridian and white for shadows.

⑦ SPONTANEITY

Due to his careful consideration of unexpected colour harmonies and contrasts that contradict with his seemingly spontaneous method of freely and rapidly applied paint, Matisse is often regarded as a precursor of Abstract Expressionism, Colour Field painting and Expressionism.

Self-Portrait with Portrait of Émile Bernard (Les Misérables),
Paul Gauguin, 1888, oil on canvas, 44.5 x 50.5 cm (17 ½ x 19 ¾ in.), Van Gogh Museum, Amsterdam, Netherlands

Inspired by Japanese prints, colour theories, medieval art, stained-glass windows and the ancient enamelling technique of *cloisonné*, Gauguin created a unique style of vividly coloured, dark outlined, flat-looking painting. His ideas were only appreciated during his life by a few, but Matisse was one of those. This is one of several self-portraits by Gauguin. He has represented himself as Jean Valjean, the main character in Victor Hugo's novel *Les Misérables* (1862). Gauguin compared the fictional outcast with the misunderstood artists of his time. He wrote: 'By doing him with my features, you have my individual image, as well as a portrait of us all, poor victims of society, taking our revenge on it by doing good'. Gauguin's use of colour was exceptionally inspirational to Matisse.

THE KISS

GUSTAV KLIMT

1907–08

oil and silver and gold leaf on canvas
180 x 180 cm (70 ⅞ x 70 ⅞ in.)
Österreichische Galerie Belvedere, Vienna, Austria

WIDELY RECOGNIZED AS THE greatest painter of the Art Nouveau period and one of the founders of the Vienna Secession, Gustav Klimt (1862–1918) was initially successful as an academic painter of large works inside public buildings. He developed a more ornamental, sensuous style, synthesizing the stylized shapes and unnatural colours of Symbolism with his own concept of beauty, which often featured beautiful women, allegorical scenes and landscapes.

The second son of seven children, Klimt was born in a suburb of Vienna. His father, an engraver and goldsmith, struggled to support his family, particularly after the Viennese Stock Exchange crash of 1873. When he was aged fourteen, Klimt entered the Kunstgewerbeschule, the Viennese School of Arts and Crafts. He was strongly inspired by Titian, Rubens and Hans Makart (1840–84), the most famous Viennese historical painter of the time. Klimt's exceptional ability was soon recognized and he was commissioned to paint large-scale works for major buildings. These theatrical, dramatic paintings with striking light effects were well received. However, his interests began moving towards avant-garde art. He withdrew from the staid official artists' association in 1897 and with some other artists and architects, formed the Vienna Secession. They organized their own exhibitions that welcomed and encouraged painters, architects and decorative artists working in a wide range of styles, and they produced their own progressive journal, *Ver Sacrum* (*Sacred Spring*).

At the time, Vienna was entering a golden age of industry, research and science but as far as the arts were concerned, it remained static and conservative. The new ideas shown at the Secession exhibitions were welcomed by the public and elicited surprisingly little controversy. Klimt produced some of his most celebrated paintings during his time with the Secession, which lasted until 1908. Reflecting his interest in the Byzantine mosaics he had seen in Venice and Ravenna, he used gold and silver leaf, applying coils and spirals reminiscent of Mycenaean decorations. This became known as his 'Golden Phase', with works including *The Kiss*. The period was marked with positive critical reaction and financial success.

The Tree of Life, **Gustav Klimt, 1910–11, mixed media on paper, 200 x 102 cm (78 ¾ x 40 ⅛ in.), Museum of Applied Arts, Vienna, Austria**

Executed during Klimt's Golden Phase, this painting signifies the links between heaven, Earth and the underworld. The coiling branches express life's complexity and physically connect the sky, the Earth and the world below; suggesting the eternal cycle of birth, life and death. Amid the symbolism, ornamentation and stylization, the single black bird draws viewers' attention. Black birds are also symbols of death in many cultures. This mystical, decorative and symbolic unification became an essential part of Klimt's approach during this period.

② THE DRESS AND THE ROBE

The young woman's tight-fitting dress reaches to her calves. It is embellished with paint, gold and silver leaf, and decorated with gold, circular or ovoid forms. The man's cloak or robe is decorated with 'masculine' symbols of plain rectangular shapes in black, white and silver that deliberately contrast with the more curving, rounded shapes of the woman's garment.

③ FEET AND GROUND

On a bed of densely-packed brilliantly coloured flowers that appear to be growing in a meadow, the two figures kneel. This contrasts with the gold areas of the painting, enhancing the sense of exoticism. The woman's feet are bent and her toes are curling at the edge of the flower bed. Golden ivy trails down and around her ankles, blurring the distinction between the figures and the meadow.

① THE KISS

A man with a thick neck and large hands turns to kiss a young woman. Wearing a crown of ivy in his thick, black, curly hair, he could be the ancient Greek god Dionysus. The young woman submissively tilts her head to receive his kiss. Her auburn hair is sprinkled with flowers and encircles her head like a halo. She clutches his hand and thick neck with her small hands. Although the models for this work have not been identified, some believe that they were Klimt himself and his companion Emilie Flöge.

Klimt's gold technique was probably influenced by his father's profession. Using matt paint, shiny gold leaf, silver leaf and silver thread, he created some areas to look lifelike and three-dimensional, and others that deliberately appear flat.

④ INFLUENCES

Klimt's use of gold leaf recalls medieval paintings and tapestries illuminated manuscripts, as well as earlier mosaics, while the curling patterns in the clothes recall Celtic and Bronze Age art. The simplified, unusual composition and flat-looking areas reflect an influence of Japanese prints. His approach met with particular favour among advocates of Art Nouveau styles.

⑤ COMPOSITION

Centrally placed on a square canvas, the two figures have become one in their embrace. Around the top of their heads is a curved golden shape that continues behind the woman. This could be an armchair, a bell, or simply a decorative surround to make them stand out. By portraying them as one complete unit with no space between, Klimt evokes a feeling of complete intimacy.

⑥ PALETTE

Klimt painted the background a warm red umber with a wide, flat brush, which he sprinkled with glittering gold dust to create a flat impression and to complement the figures and meadow. As well as gold dust and gold and silver leaf, he used a wide range of colours here, including flake and zinc white, lemon yellow, alizarin crimson, emerald green, viridian, cerulean blue and ivory black.

Empress Theodora and Her Attendants, **artist unknown, 547, glass and gold, 264 x 365 cm (104 x 143 ¾ in.) Basilica di San Vitale, Ravenna, Italy**

Directly inspired by a trip to Italy in 1903, Klimt began to add gold and silver and more surface ornamentation to his paintings to emulate the Byzantine art he had seen in the Basilica di San Vitale in Ravenna. The church is one of the most important surviving examples of Byzantine architecture and mosaic work; every surface is densely covered with glittering mosaics. The apparent flatness, lack of perspective, rich colours and gold backgrounds of the mosaics and the jewel-encrusted figures became an overriding influence to his style.

BATHERS AT MORITZBURG

ERNST LUDWIG KIRCHNER

1909–26

oil on canvas
151 x 199.5 cm (59 ½ x 78 ⅝ in.)
Tate Modern, London, UK

A LEADING MEMBER OF Die Brücke (The Bridge), Ernst Ludwig Kirchner (1880–1938) has come to be seen as one of Germany's most influential Expressionists. He produced powerful and disturbing paintings, prints and sculpture that were motivated by anxieties about the agitated state of the world.

Born in Bavaria, Kirchner began studying architecture at Dresden Technical High School in 1901, but in 1905, with fellow architecture students, Fritz Bleyl (1880–1966), Karl Schmidt-Rottluff (1884–1976) and Erich Heckel (1883–1970), he founded the Brücke, an art group that renounced traditional academic art and aimed to form a 'bridge' between the art of the past and contemporary ideas. Through unrefined marks, exaggeration and vivid, unnatural colours, the artists of the Brücke expressed extreme emotions. However, after serving in the German army during World War I, Kirchner had a breakdown and moved to Switzerland to recuperate. His work was admired at first, but in 1937 it was labelled 'degenerate' by the Nazis and the following year he committed suicide.

In this painting, Kirchner's Expressionistic approach shows influences of Gauguin, Matisse and Munch, especially in the flat areas of unbroken, unmixed colour and simplified forms.

Berlin Street Scene, **Ernst Ludwig Kirchner, 1913, oil on canvas, 121 x 95 cm (47 ⅝ x 37 ⅜ in.), Neue Galerie, New York, USA**

Jarring colours, jagged contours, masklike faces, roughly applied paint and distorted perspective create a nightmarish vision of prewar Berlin. The two women's confident walk and showy, feathered hats reveal them to be prostitutes, while the men are furtively checking that all's clear before making their approach.

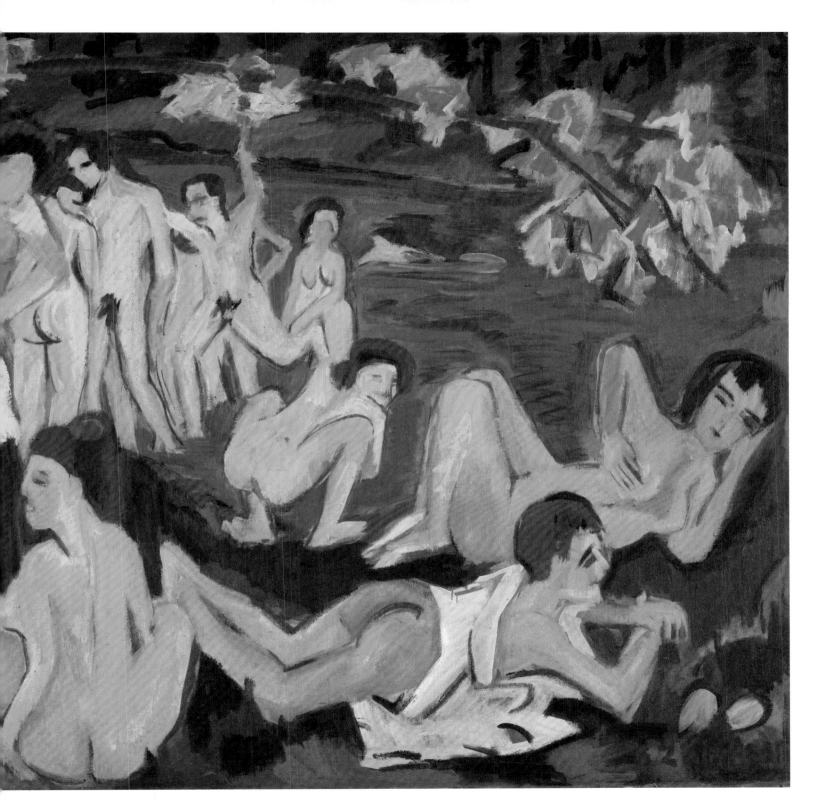

<div style="writing-mode: vertical">IN DETAIL</div>

2 PARADISE

During the summers of 1909 to 1911, Kirchner and other members of the Brücke group took regular expeditions to the Moritzburg Lakes near Dresden. Their relaxed, communal lifestyle included bathing, sunbathing and sketching in the nude, which reflected a cult of nature that was popular in Germany at the time. These trips provided the subject matter for several of Kirchner's paintings and drawings, including this one.

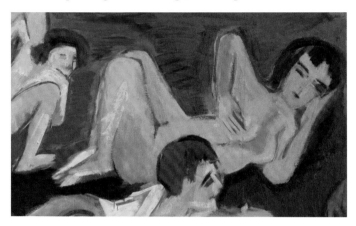

3 SKEWED PERSPECTIVE

This work reflects Kirchner's fascination with Gauguin's idyllic primitive-style paintings of Tahiti. In his rejection of conventional linear perspective, Kirchner has painted his figures in different sizes, overlapping, sometimes appearing level with the picture plane, while in other places they appear to recede. His graphic, agitated lines fill the composition with raw, subjective suggestions of real life, all from distorted perspectives.

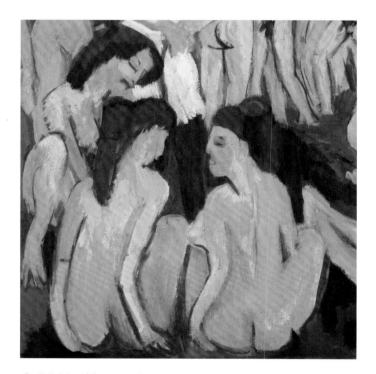

1 PRIMITIVE STYLE

Kirchner believed that powerful forces existed beneath the facade of civilization and that art was a way of exposing them. For this reason, he created a 'primitive' style of simplified forms with masklike faces that he deemed to be more direct than an attempt at realism. Yet while painting in this new way, he saw his work as descending directly from traditions of German art, especially that of Dürer, Grünewald and Lucas Cranach the Elder (1472–1553).

④ MAN BY A TREE

The male figure on the left of the painting with one hand on a tree is observing the people around him as they relax and enjoy their surroundings. Detached from the main activities, he stands where two lines meet. One line is formed from the water to the tree and another lies across the foreground. It is thought that this lone figure is a self-portrait of Kirchner.

⑥ COLOUR

Inspired by Fauvism, Kirchner created flat areas of unbroken, often unmixed colour. His harmonious, lively colours here are chiefly shades of yellow, orange, green, blue and brown, and his palette included flake white, lemon yellow and Prussian blue. Although he had more or less finished the work in 1910, in 1926 he reworked parts of the painting, lightening some of his colours.

⑤ NUDES

Kirchner believed in painting and drawing as instinctively as he could, so he did not deliberate while he painted these nudes. They were not professional models but part of his circle. Although he broke with convention and painted his figures freely, he was following established practice by painting a scene of nudes as artists such as Ingres, Delacroix and Renoir had done before him.

⑦ EXPRESSION

Kirchner's spontaneous brushstrokes, loosely drawn figures and bold colours work together to express a mood and atmosphere. He and the other Brücke artists often set up their easels to paint together. He usually depicted figures in movement, rather than static ones, believing that this expressed the vitality of the human body, which was further enhanced with bold, expressive brushstrokes.

***In the Shade*, Henri-Edmond Cross, 1902, oil on canvas, 113.5 x 146 cm (44 ⅝ x 57 ½ in.), private collection**

Henri-Edmond Cross (1856–1910) took up pointillism after Seurat, and along with his friend Signac became an important artist of the next phase of the style, later recognized as Neo-Impressionism. Although Cross met Seurat in 1884, he did not start using pointillist techniques for several years. Colour to him was exceptionally important and this painting demonstrates his painstaking efforts at juxtaposing certain vivid colours in small marks to create vibrant effects. As well as being a powerful influence to Kirchner – who saw his work at an exhibition in 1904 – Cross was also extremely influential on Matisse and Fauvism. This particular image can be seen to have directly influenced *Bathers at Moritzburg*.

COSSACKS

WASSILY KANDINSKY

1910–11

oil on canvas
94.5 x 130 cm (37 ¼ x 51 ¼ in.)
Tate Modern, London, UK

A PIONEER OF ABSTRACT art, Wassily Kandinsky (1866–1944) was a painter, wood-engraver, lithographer, teacher and theorist. Influenced by the philosophy of theosophy, he sought to express spirituality beyond external appearances, creating relationships between colour and form that corresponded with music.

Kandinsky was born in Moscow. Initially, he studied law and economics then later he studied art in Munich with Anton Azbé (1862–1905) and at the Munich Academy of Fine Arts under Franz von Stuck (1863–1928). In 1901, he became a founding member of the artists' group Phalanx. From 1906 to 1908, he travelled around Europe, making paintings and woodcuts inspired by Russian folk art and fairy tales, plus landscape studies painted directly from nature. On his return to Munich, he began using Fauve-like contrasts of colour and eliminating representational elements from his paintings. In 1910, he wrote *Concerning the Spiritual in Art*, describing how he wanted his art to create emotion in viewers. The following year, he founded the expressive artists' group *Der Blaue Reiter* (The Blue Rider) with Franz Marc. After living in Russia from 1914 to 1921, he returned to Germany and was appointed professor at the Bauhaus in 1922. This painting epitomizes his belief that abstract images can convey spiritual and emotional values merely through arrangements of colours and lines.

Several Circles, Wassily Kandinsky, 1926, oil on canvas, 140.5 x 140.5 cm (55 ⅜ x 55 ⅜ in.), Solomon R. Guggenheim Museum, New York, USA

After meeting Russian Suprematist and Constructivist artists and working at the Bauhaus, Kandinsky began emphasizing geometric forms, with overlapping flat planes and clearly delineated shapes.

② FORTRESS

Over the blue hill in the distance is a fortress, merely suggested by a black outline against white. Above it, a flock of birds flies into the sky, disturbed by the fighting below. Details are not required; this is simply an evocation of events and not meant to be a lifelike representation.

③ CAVALRYMEN

On the left of the painting is a cavalryman. This bearded Cossack wears a tall, red fur hat and wields his sabre as he attacks an opponent. Although he and the sabre are represented with only a few lines, his gesture is emotive and dynamic, the horse beneath him is just a flick of the tip of a brush loaded with black paint. Overlapping is his adversary, also swinging his sabre as their two horses rear up against each other, their front legs interlocking.

① MARCHING COSSACKS

Painted when Kandinsky was living near Munich before World War I, the image shows his transition from a kind of Expressionism towards Abstraction. With some representational elements, it remains vaguely figurative and depicts a battle between Cossacks (Russian soldiers). Here are three marching Cossacks wearing their distinctive tall fur hats. Two hold long black lances aloft while the third leans on his sabre.

❹ RAINBOW

Below the horses, a rainbow bridges a valley, a sign of ultimate or hoped-for peace. To the left of the rainbow is a wall of lances, carried by further infantrymen marching up a hill. The red cloud could be gunfire, or a symbol of bloodshed. Kandinsky's palette here was extremely restricted, comprising only three primary colours and black and white, but he achieved all he wanted.

❺ COLOUR

Kandinsky is believed to have had synesthesia, a condition that combines some senses, so for instance, colours can be heard or sounds seen in the mind as colours. Although far more complex than this, for Kandinsky, yellow sounded like trumpets and high fanfares, light blue like a flute, dark blue like a cello, light red and orange were violins, violet was the English horn and bassoon, black was a dramatic pause, and white was a 'harmony of silence'. Colours also had spiritual connotations. Blue for him was the most spiritual colour; as he said, 'The deeper the blue becomes, the more strongly it calls man towards the infinite.'

❻ OBJECTIVE ABSTRACTION

Distorted and barely recognizable, the painting is nonetheless descriptive and representational. Kandinsky had not yet moved into purely abstract painting. This type of work is known as an 'objective abstraction', in which an expressive arrangement of colours and lines are of primary importance but a representational element still remains. The ambiguity of how far he could go in moving towards a completely non-representational painting is indicated by the various titles it has had – *Improvisation 17*, *Fragment for Composition 4*, *Battle* – and his final title, *Cossacks*.

Blue Horse I, Franz Marc, 1911, 84.5 x 112.5 cm (44 ¼ x 33 ¼ in.), Städtische Galerie im Lenbachhaus, Munich, Germany

Kandinsky and Franz Marc (1880–1916) formed the Blue Rider in 1911 in Munich. It was an informal association of painters who shared an interest in abstracted forms and vibrant colours, which they believed had spiritual values that could counteract the corruption and materialism of their age. Other artists involved were Paul Klee and Auguste Macke. The name 'Blue Rider' refers to a 1903 painting by Kandinsky as well as to the frequent inclusion of horses and riders in his and Marc's work. For them, horses symbolized freedom, power and pleasure, while the colour blue had particular spiritual connotations. The group disintegrated at the onset of World War I, but Expressionist art became widespread in Germany after the conflict.

I AND THE VILLAGE

MARC CHAGALL

1911

oil on canvas
192 x 151.5 cm (75 ½ x 59 ½ in.)
Museum of Modern Art, New York, USA

BASING HIS IMAGES ON emotional and poetic associations rather than reality, Marc Chagall (1887–1985) depicted distant memories in a figurative, colourful style that recalls the folk art of his native Russia. Born Movsha (Moses) Shagal into a poor family living on the fringes of the Russian empire, Chagall lived until the age of ninety-seven, becoming the last surviving member of the School of Paris.

Chagall's Jewish background became an important element of his art, which comprised painting, book illustrations, stained glass, stage sets, ceramic and tapestries. He was born in Vitebsk (now in Belarus) and took his first artistic instruction under a local portraitist Yehuda Pen (1854–1937). From 1907 to 1910, he attended the Imperial School for the Protection of the Fine Arts in St Petersburg and later studied with Léon Bakst, an artist famed for his exotic, richly coloured sets and costumes for the Ballet Russes. Bakst said that Chagall was his favourite student, because when told to do something, he listened carefully, and then did something completely different.

From 1911 to 1914, Chagall lived in Paris, where he created evocative, fantastic paintings and socialized with Apollinaire, Robert Delaunay (1885–1941), Amedeo Modigliani (1884–1920) and André Lhote. He returned to Russia in 1914 and remained there throughout World War I. His marriage in 1915 to Bella Rosenfeld had a profound effect on his art. In 1917, after the October Revolution, he was given a succession of administrative and teaching posts, and some theatre-design work. He returned to Paris in 1923 and met the art dealer Ambroise Vollard who became an important part of his success. In the 1930s, he travelled to Palestine, the Netherlands, Spain, Poland and Italy, and during World War II, fled to the United States. In 1948, he settled permanently in France.

Throughout his career, Chagall experimented with various styles, including Cubism, Fauvism, Suprematism and Surrealism, all interpreted through his own narrative approach. In the 1920s, the emerging Surrealists embraced him, but his dreamlike style differed from their conceptual subject matter. Reminiscent of a child's painting, but with elements of Cubism, this work represents Chagall's childhood memories.

White Crucifixion, Marc Chagall, 1938, oil on canvas, 154.5 x 140 cm (60 ⅞ x 55 ⅛ in.), Art Institute of Chicago, Illinois, USA

This was the first of a series of paintings that feature the image of Christ as a Jewish martyr, to draw attention to the persecution and suffering of European Jews in the 1930s. Chagall has highlighted Christ's Jewishness by replacing the traditional loincloth with a tallith, or Jewish prayer shawl. Similarly, the crown of thorns is a head-cloth. Around the cross, scenarios illustrate contemporary Jews being persecuted by Nazis.

① THE GOATS

Showing both Cubist and Fauvist influences, this work depicts Chagall's memories of his childhood in Russia, particularly visits to his uncle's farm where he knew every animal by name. Here on the cheek of the head of a goat a smaller goat is being milked. Goats are also a biblical symbol for the Jewish day of atonement. In the Old Testament, on that day each year, Jewish people tied a red ribbon around the neck of a goat and sacrificed it by sending it into the wilderness.

② GREEN MAN

This green-faced man in a cap looks across the painting at the goat. Next to him are some houses adjacent to an Orthodox church and an upside-down female violinist in front of a black-clothed man holding a scythe. Chagall said the painting 'shows the relationship between me and my place of birth'.

③ THE TREE

This tree is one of the mystical symbols that Chagall often featured. It represents the tree of life, which holds great significance in many cultures. He explained: '[My] fanciful style is due to my childhood memories becoming shaped and reshaped by my imagination, but not diminishing with the passing of time.'

Combining pioneering elements of modernism from Cubism, Symbolism, Fauvism and early versions of Surrealism, with a colourful individual interpretation of his rich heritage, Chagall developed a new style that had wide appeal.

④ IMAGINATION

While stylistic elements from various contemporary art movements can be detected in his work, Chagall's expressive imagination always dominates. His friend Apollinaire described these images as 'supernatural' and then as 'surreal', which gave the later movement of Surrealism its name. Chagall's imaginative imagery and approach became a major influence on the movement.

⑤ COLOUR

One of the most captivating elements of this painting is the dynamic use of colour to create a fantastic impression. When he painted this, Chagall had recently arrived in Paris, where he befriended Robert Delaunay, who was producing Cubist-type 'pure paintings' of bright, complementary colours. From his example, Chagall began using opposing colours, too. However, he used the colour theories to highlight his own emotional responses and symbolism.

⑥ SHIFTING SCALES

Inspired by the broken planes of Cubism, much of this painting is composed of angled lines and shapes. However, here Chagall has softened and overlapped his shapes to create a nostalgic and allegorical tale that–unlike the analytical elements of Cubism–is a patchwork of shifting scales. He said: 'For the Cubists, a painting was a surface covered with forms in a certain order. For me, a painting is a surface covered with representations of things. . .in which logic and illustration have no importance.'

Detail from *Costume for the Firebird*, Léon Bakst, 1913, metallic paint, gouache, watercolour and pencil on paper on board, 67.5 x 49 cm (26 ½ x 19 ¼ in.), Museum of Modern Art, New York, USA

Born in Russia, Léon Bakst (1866–1924) rebelled against 19th-century stage realism, which had become literal and lacked theatricality. This work is one of his designs for the pioneering Ballet Russes, founded by Serge Diaghilev in 1909. It is for the ballet production of *The Rite of Spring* in 1913. Enchanted by the magical character of the Firebird, Bakst drew inspiration from Russian folk tales, blending his love of symbolism, sinuous lines and opulent eroticism in a flat-looking image that recalls both Russian folk art and Cubism.

MAN WITH A GUITAR

GEORGES BRAQUE

1911–12

oil on canvas
116 x 81 cm (45 ¾ x 31 ⅞ in.)
Museum of Modern Art, New York, USA

THROUGH HIS COLLABORATION WITH Picasso, Georges Braque (1882–1963) was at the forefront of the development of Cubism. He was also one of the first artists to include decorators' techniques in paintings and introduced the idea of using unexpected materials in fine art.

Although born in the Parisian suburb of Argenteuil, Braque grew up in Le Havre. He trained to be a house painter and decorator like his father while also taking evening classes in drawing and painting. In 1902, he moved to Paris and studied at various art schools. After visiting the Salon d'Automne in 1905, he contributed his own Fauvist paintings to the Salon des Indépendants the following year. In 1907, he became fascinated by Cézanne's retrospective exhibition and by Picasso's new painting *Les Demoiselles d'Avignon*, which he saw at Picasso's studio. Abandoning the exuberance of Fauvism, he and Picasso began producing new forms of painting, presenting multiple viewpoints on single canvases. In 1908, the art critic Louis Vauxcelles derisively described Braque's paintings *Houses at L'Estaque* (right) as being composed of 'bizarre cubes', which resulted in the name Cubism.

Braque and Picasso felt that their approach was a more descriptive way of representing the three-dimensional world on two-dimensional surfaces than the established traditions of linear perspective. Yet the resulting images were not always easy to understand, so to assist interpretation, Braque began stencilling letters and numbers onto his works. This phase became known as Analytical Cubism. From 1912, the two artists began experimenting with *papier collé*, a collage technique that Braque took even further by glueing various fragments of other objects and materials onto his canvases. He also mixed paint with sand to create texture, and used *trompe l'oeil* effects of marble and woodgrain that he had learnt while training to be a decorator. This phase became called Synthetic Cubism. Although Picasso moved away from Cubism in 1914, Braque continued experimenting with it throughout his career. In subdued colours, this painting forms part of his Analytical Cubist phase. The similarity of colours, layers and broken planes make it difficult to decipher.

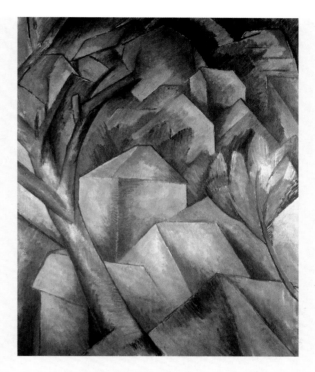

Houses at L'Estaque, Georges Braque, 1908, oil on canvas, 73 x 60 cm (28 ¾ x 23 ½ in.), Kunstmuseum, Bern, Switzerland

This work shows the houses of a fishing village near Marseille. It is one of the paintings by Braque that Vauxcelles mocked for being composed of cubes, which led to the name of the movement. In direct response to Cézanne, Braque reduced what he could see before him to a series of overlapping planes. He painted six versions of the theme that year and presented them all to the jury of the Salon d'Automne, which included Matisse, but all six were rejected. The approach went on to become one of the first truly modern movements in art and one of the most important of the 20th century.

② THE GUITAR

Inspired directly by the lively Parisian café culture of the early 20th century, where artists and writers gathered to discuss ideas and musicians and dancers entertained, Braque has represented a man playing a guitar within the fragmented image. Although difficult to discern, the neck, scroll, body and strings of the guitar can be distinguished. The splintered image conveys the fast rhythm of a flamenco.

① NAIL AND ROPE

As part of his Analytical Cubist phase, Braque experimented with different types of representation to challenge usual methods of portraying space and depth in painting, but this often meant that the images were almost indecipherable. While the intention was to challenge viewers, Braque began including clues, such as this lifelike rendering of a nail and piece of rope at the top left of the canvas, to help viewers realize that it was a traditional painting, what the orientation of the work should be, and that it was light-hearted and not taking itself too seriously.

③ THE MAN

The guitar player is set back in the dark recesses of the café. The image is cryptic because everything is in the same colour scheme and only parts of the figure have been represented. However, the man's finger can be seen pressed against the neck of his guitar.

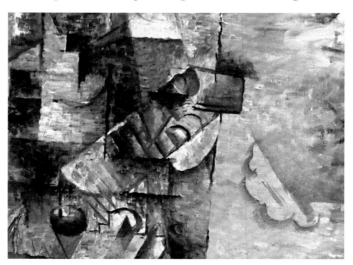

Following Cézanne, Braque concentrated on still lifes. Although his paintings also shared many similarities with Picasso—such as choice of pigments, comparable style and subject matter—Braque stated that unlike Picasso, he was concerned purely with pictorial space and composition.

④ PALETTE

As his fragmented planes became more complex, Braque reduced his palette. Colours became muted to dull greys and browns. The earth tones create an organic impression, and by using the same colours for the figure, guitar and setting, Braque has blended the whole work together, suggesting movement and sound.

⑤ SPACE

Here, Braque freed himself of all the attributes associated with traditional painting, including illusionistic perspective, foreshortening, modelling and colour. In their place, he created a new kind of pictorial space. He sought to depict a convincing illusion of three-dimensional space, while drawing the viewer's eye back to the flat picture surface.

⑥ COMPONENTS

In reducing the subject to geometrical components, Braque shows different aspects of the guitar player at once and challenges viewers to try to understand what they are seeing. By painting from different angles on one canvas, he breaks down all the components into facets, creating an ambiguous yet dynamic image.

⑦ LIGHT

As Braque fractured contours by flattening volumes and reducing them to a geometry of sharp angles and barely perceptible curves, he had to adjust his angles of light accordingly. He managed to do this and unite the surface, which he created using angled, broken brushstrokes, clearly enjoying the textures of his paint.

The Quarry at Bibémus, **Paul Cézanne**, *c.* 1895, oil on canvas, 65 x 81 cm (25 ⅝ x 31 ⅞ in.), Museum Folkwang, Essen, Germany

It was Cézanne's abandonment of conventions of linear perspective to create illusions of space and depth that motivated Braque and initiated Cubism. Cézanne believed that the illusionism of perspective denied the flatness of paintings and aimed to place more emphasis on the surface—to stress the construction and arrangement of colour on two-dimensional surfaces. The Bibémus quarry near Cézanne's home in Aix-en-Provence, France served as a motif for a number of his works in which he explored this highly influential concept. This painting is thought to be his first depiction of the cliffs. He painted the large, vertical cliff walls in orange pastel tones that contrast with the slender strip of purple-blue sky above, while blurred, green treetops form the horizon.

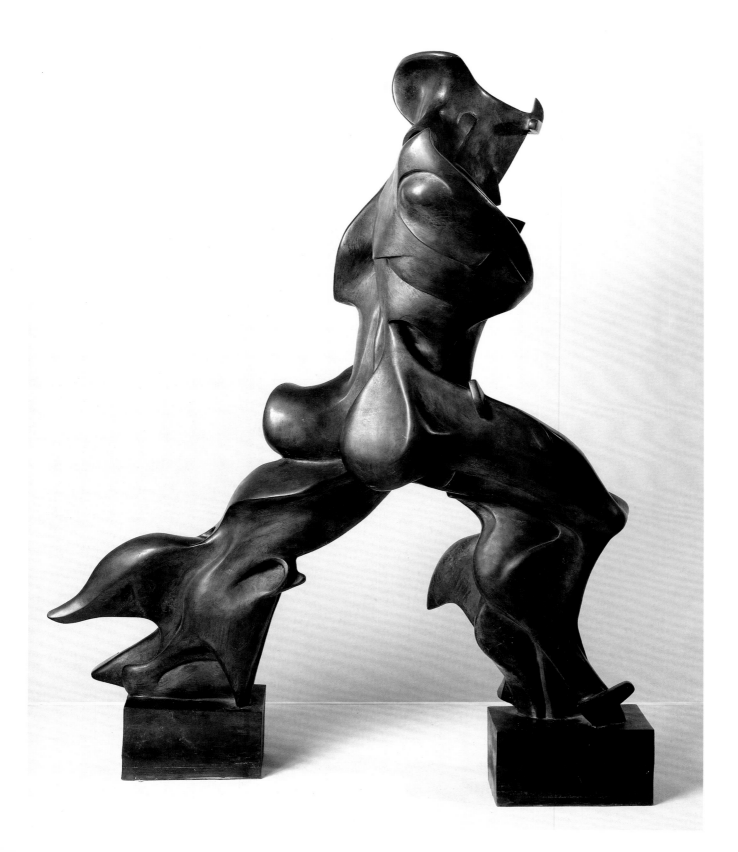

UNIQUE FORMS OF CONTINUITY IN SPACE

UMBERTO BOCCIONI

1913

bronze
111.5 cm (43 ⅞ in.) high
Museo del Novecento, Milan, Italy

IN 1909, A NEW art movement called Futurism was formed in Milan, which involved several artists who were exhilarated by speed, technology, machines, youth and violence. Futurists anticipated a new world of more innovations, perceived institutions such as museums and libraries to be redundant, and considered Italy's classical past to be an impediment to its development as a modern power. One of the most prominent and influential Futurists was Umberto Boccioni (1882–1916), who developed many of the movement's theories and produced energetic, original paintings and sculpture.

From 1898 to 1902, Boccioni learnt to paint in the studio of the painter Giacomo Balla (1871–1958) in Turin. In 1907, he moved to Milan where he met Filippo Tommaso Marinetti, a Symbolist poet and theorist, whose ideas inspired Boccioni. In 1909, Marinetti published the first Futurist manifesto on the front page of the French newspaper *Le Figaro*. Boccioni translated Marinetti's literary theories to the visual arts and in 1910, he and other artists published their 'Manifesto of Futurist Painters' and 'Technical Manifesto of Futurist Painting'. That same year, he painted *The City Rises* (right), a dynamic-looking work that celebrates the developing urban world. After visiting Paris in 1912, he became strongly influenced by Cubism and began working in three dimensions. He published the 'Technical Manifesto of Futurist Sculpture' and by June 1913, he had produced *Unique Forms of Continuity in Space* and a number of other sculptures. Epitomizing advancement and progress, the figure striding through space represents a human aerodynamically deformed by speed and movement. It is one of the movement's most important works.

Intensely nationalistic, from the outset the Futurists admired violence. Their manifesto stated: 'We will glorify war – the world's only hygiene – militarism, patriotism, the destructive gesture of freedom-bringers, beautiful ideas worth dying for.' So when Italy entered World War I in 1915, many of them enlisted. Several were killed in action, including Boccioni who died after a fall from a horse in 1916. These premature deaths, especially that of Boccioni, ultimately brought an end to Futurism.

Detail from *The City Rises*, Umberto Boccioni, 1910, oil on canvas, 199.5 x 301 cm (78 ½ x 118 ½ in.), Museum of Modern Art, New York, USA

Generally perceived as the first Futurist painting, this appeared at the '*Arte Libera*' (Free Art) exhibition in Milan in 1911, where Futurist artists exhibited together for the first time. A semi-abstract work, it depicts the construction of a new city in the background, with a large horse in the foreground appearing to twist and struggle as workers try to control it in a dynamic effort in the foreground. The blurred, swirling effect embraces vigour as well as the elements of modern life and progress that the Futurists loved. The urban environment formed the basis of many of Boccioni's paintings. After completing this painting, he adapted elements of Cubism to create a more distinct Futurist style.

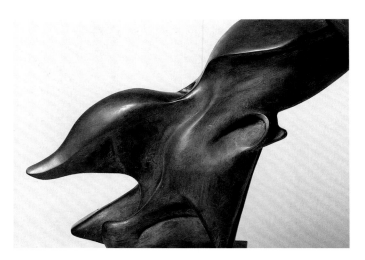

② THE BACK LEG

Flowing shapes generate a sense of rhythmic, muscular energy. Boccioni described what he was aiming to achieve in the phrase 'physical transcendentalism'. Although the impression is one of a weighty individual, the sense of dynamism as this foot leaves the ground is light. The original plaster version in the Museu de Arte Contemporânea in São Paulo, Brazil appears more fluid and ephemeral than the later bronze casts, and is more relevant to Futurism: one of the concepts of Futurism was a desire for later artists to destroy Futurist work rather than preserve it in a museum.

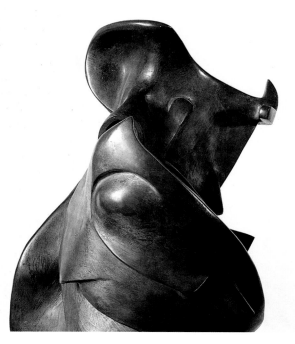

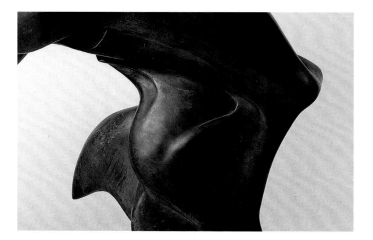

① THE HEAD

Deformed through the effects of fast movement, the face is formed into a cross shape, while the head suggests a helmet, which was highly appropriate for artists who looked towards the impending war with optimism. The suggested movement creates flamelike shapes as air swirls around the active body.

③ FRONT LEG

The legs are free-flowing and wide, and Boccioni deliberately exaggerated the body's dynamism so that it embodies the notion of progress. Originally inspired by the sight of a football player running to pass the ball, Boccioni's goal was to depict a 'synthetic continuity' of motion.

When Boccioni first studied with Balla, he learnt to paint in the pointillist style. After spending time in Paris in 1911 with fellow Futurist Carlo Carrà (1881–1966), and visiting various artists' studios, including those of Braque and sculptors Constantin Brâncuși (1876–1957), Alexander Archipenko (1887–1964) and Raymond Duchamp-Villon (1876–1918), he became obsessed with sculpture.

④ SURFACES

Aiming to break completely from the classical and Renaissance styles still dominant in Italy at the start of the 20th century, Boccioni created a figure striding into the future. Its undulating surfaces seem to move and change as the figure is viewed from different angles.

⑤ CONTOURS

In his 'Technical Manifesto of Futurist Sculpture', Boccioni wrote that Futurist sculpture should be made of straight lines to achieve 'primitive purity'. However, this consists of dynamically curving contours, which suggest the forces of wind or air as the figure advances.

⑥ MATERIAL

Boccioni also declared in his manifesto that sculpture should not be made from a single material or from traditional materials such as marble or bronze. To this end, he produced several mixed-media sculptures. This work was made in plaster but it was cast in bronze after his death.

⑦ ANATOMY

Nudes were taboo for Futurists because they were associated with art of the past. Although Boccioni had learnt how to draw and paint the nude, here he has taken liberties with the figure, discarding its arms and introducing small, winglike protrusions that emerge from the back.

Detail from *Adriana Bisi Fabbri*, Umberto Boccioni, 1907, oil on canvas, 52 x 95 cm (20 ½ x 37 ⅜ in.), private collection

This is a portrait by Boccioni of his cousin, the painter Adriana Bisi Fabbri (1881–1918). Because of his influence, she participated in the '*Arte Libera*' (Free Art) exhibition in 1911 in Milan, where the Futurists exhibited together for the first time. She also painted with a similar, fragmented, colourful approach expressing energy. Despite the inherent misogyny among Futurists, several female artists worked in the style, sharing some views about technology and an interest in emerging ideas about Cubism. In 1912, French artist, writer, choreographer and lecturer Valentine de Saint-Point (1875–1953) published the 'Manifesto of the Futurist Woman' in response to the chauvinism in Marinetti's Futurist manifesto.

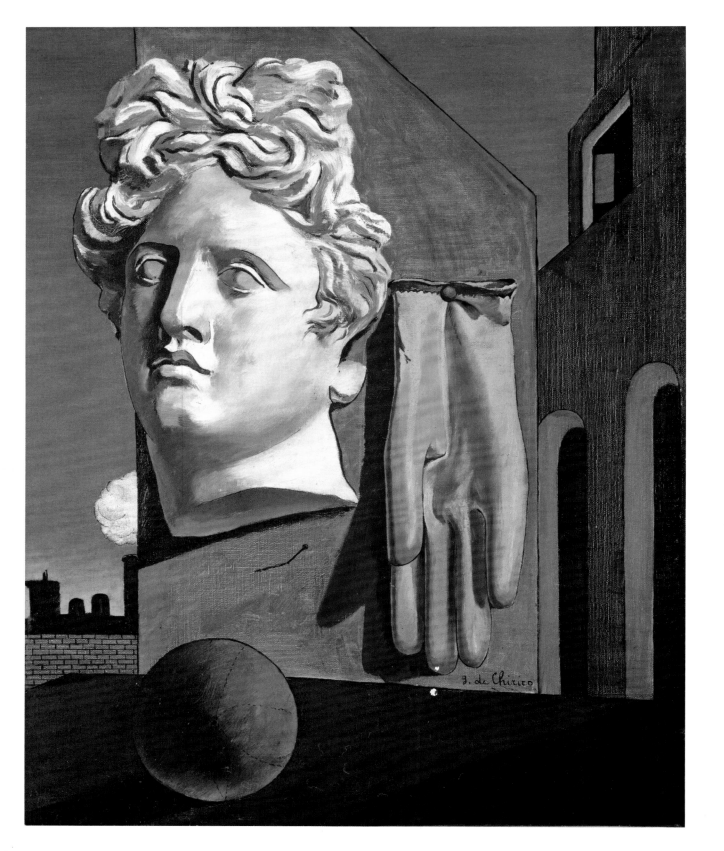

THE SONG OF LOVE

GIORGIO DE CHIRICO

1914

oil on canvas
73 x 59 cm (28 ¾ x 23 ⅜ in.)
Museum of Modern Art, New York, USA

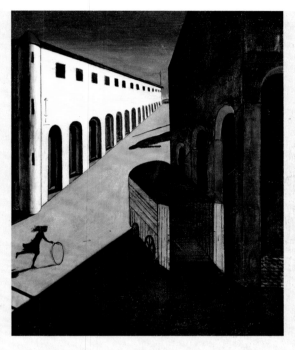

Mystery and Melancholy of a Street, **Giorgio de Chirico, 1914, oil on canvas, 85 x 69 cm (33 ½ x 27 ⅛ in.), private collection**

KNOWN FOR HIS DREAMLIKE images, dramatic perspectives and strange juxtapositions of unrelated objects, Giorgio de Chirico (1888–1978) was a precursor of Surrealism and later, a pioneer in the revival of classicism that developed across Europe in the 1920s. Before World War I, his mysterious-looking paintings of empty streets and town squares with long, eerie shadows formed the *Pittura Metafisica* (Metaphysical Painting) movement.

Growing up in Greece, De Chirico became fascinated by Greek mythology and, inspired by his Italian parents, developed a love of classical art and architecture. From 1903 to 1905, he studied art in Athens and, after his father's death in 1905, he visited Florence with his family before moving to Munich where he enrolled at the Academy of Fine Arts. There he became enthralled by Symbolist artists including Max Klinger (1857–1920) and Arnold Böcklin. Eighteen months later, he rejoined his family in Milan and then moved to Florence, where he began studying German philosophers such as Friedrich Nietzsche, Arthur Schopenhauer and Otto Weininger. He tried to incorporate their theories in his paintings, attempting to uncover the realities that he believed were concealed beneath superficial appearances. In 1911, he went to Paris and participated in various exhibitions, including the Salon des Indépendants and the Salon d'Automne. With the outbreak of World War I, he returned to Italy where he met Carrà and with him developed Metaphysical Painting. These were paintings featuring sinister-looking arcades and piazzas in illogical perspectives, dramatically lit and including incongruous, unsettling elements such as statues and faceless mannequins. He continued producing these melancholic paintings during his military service in World War I and they attracted notice, particularly among Surrealists. However, in the 1920s when he returned to a more conservative style, the Surrealists renounced him.

With its incongruous objects, this painting represents what lies beyond the physical world. Each object forms part of De Chirico's visual language, which became highly influential to the Surrealists.

Long shadows emit a sinister, desolate air. A child is playing and runs towards the shadow cast by an adult or a statue. The atmosphere is oppressive and threatening. The imposing facade of a dark building dominates the foreground, while a long white wall on the left of the painting creates an illusion of depth. The wooden box on wheels parked in the shadows has open doors, suggesting a refuge or the menacing possibility of imprisonment. The light and perspective defy logic, while the flat painting style is crisp and plain, almost naive, which enhances the sense of unease. Overall, the image represents anguish and a sense of impending tragedy.

② THE MARBLE BUST

For De Chirico, the classical marble bust symbolized the beauty of art. This is a bust of Apollo based on the *Apollo Belvedere* (*c.* AD 120–40), which is a Roman copy of a lost bronze original made in ancient Greece. One of the most important mythological deities, Apollo is the sun god, and the god of beauty, music and poetry, but in the writings of Nietzsche he presides over the world of dreams. The same sculpture reappears in at least five more paintings by De Chirico.

① THE GLOVE

This oversized rubber glove has been described as a surgeon's glove, a housewife's glove and a midwife's glove. De Chirico's friend Apollinaire wrote about it in *The Paris Journal* in July 1914: 'If one quizzes him about the terror that this glove might provoke, he immediately switches the subject.' De Chirico made a feature of the glove, depicting it as huge and pinned on a wall, attracting immediate attention. For De Chirico, a glove was associated with destiny, chance and accident – all aspects of fate.

③ THE TRAIN

Like the Futurists, De Chirico loved trains, perceiving them to be symbols of modernity, power and speed. They also reminded him of his childhood because his father had been a railway engineer. Also, for him, to go on a journey was to follow a goal. He believed that following one's goals and falling in love were two essentials in life. Love is often the theme of songs, hence the painting's title. Overall, the painting is a metaphor for life – of aiming for goals and falling in love.

Influenced by the enigmatic work of the Symbolists, De Chirico's seemingly nonsensical juxtapositions evoke personal memories and connections as he sought to unmask mysterious truths behind apparent reality.

④ JUXTAPOSITIONS

Unexpected placements evoke comparisons and make things remarkable that would normally be insignificant. Not everything is clear however. The green ball evokes notions of childhood, but its size and position are odd; it is unclear what it is resting on or why it is there. Visually, it acts as an anchor.

⑥ CONTRASTS

Extremes of light and shade and steep perspective enhance the disturbing appearance of the ordinary objects. The contrasts of light and dark were created smoothly, with simple greys in the shadows, which are exaggerated to evoke a sense of mystery, melancholy and foreboding.

⑤ PAINT

Unlike most artists, De Chirico made his own paints using dry pigments and individual binders. He spent a great deal of time creating mixtures for different paintings, often with oil, wax, vinegar and honey, but his usual palette, which he probably used for this, remained fairly consistent.

⑦ METHOD

De Chirico followed traditional painting methods, applying paint smoothly, building up images with a restrained clarity. This enabled him to present each element clearly. He maintained that his early academic training was essential for his style, which influenced René Magritte.

The Sanctuary of Hercules, Arnold Böcklin, 1884, oil on wood, 114 x 180.5 cm (44 ¾ x 71 in.), National Gallery of Art, Washington, DC, USA

Four soldiers gather around a circular, stone shrine housing a grove of trees. Three of the soldiers kneel reverently on the outer step, while a fourth looks into the distance. At the back of the shrine, silhouetted against the cloudy sky is a statue of Hercules, the ancient Greek hero and protector from danger. Influenced by Romanticism, Arnold Böcklin (1827–1901), a Symbolist, aimed to express his feelings through images that include mythological, fantastical figures in classical settings, and he directly inspired De Chirico.

SUPREMATIST COMPOSITION: AEROPLANE FLYING

KAZIMIR MALEVICH

1915

oil on canvas
58 x 48.5 cm (22 ⅞ x 19 in.)
Museum of Modern Art, New York, USA

IMMEDIATELY AFTER THE RUSSIAN Revolution, the non-objective paintings of Kazimir Malevich (1878–1935) were admired by the Bolshevik regime. His pioneering Suprematist paintings were embraced by the new authorities as a radical art that discarded the past. But in the 1920s, these experimental ideas were suppressed. Elsewhere, however, his rigorous and philosophical ideas about forms and meanings in art influenced innumerable other artists working in a variety of media, and profoundly influenced the evolution of modern art.

Born in Ukraine to parents of Polish origin, as a child, Malevich moved constantly around Russia as his parents searched for work. He studied art at schools in Kiev and Moscow and with painters including Leonid Pasternak (1862–1945). His early work mostly featured scenes of provincial peasant life, influenced by Post-Impressionism, Symbolism and Art Nouveau. From 1907, after becoming acquainted with artists such as Kandinsky and Mikhail Larionov (1881–1964), he began painting in a style that blended elements of Cubism, Futurism and Primitivism.

In 1915, at '0.10: The Last Futurist Exhibition' in Petrograd (now St Petersburg), Malevich unveiled his new type of abstract painting that abandoned all reference to the outside world in favour of coloured geometric shapes floating against white backgrounds. Concentrating on the exploration of pure geometric forms and their relationships to each other, this art demonstrated his belief that art should transcend subject matter; the truth of shape and colour should reign 'supreme' over the image or narrative, and it should express pure sensation and experience devoid of illusion. He called the art and his theories about it Suprematism. That same year, he published his manifesto, 'From Cubism and Futurism to Suprematism: The New Painterly Realism'. The basic units of this visual vocabulary were planes, stretched, rotated and overlapping. The style evolved from his involvement with Russian Futurism, where artists explored the dynamism of trains, planes, cars, moving pictures and other aspects of the modern machine age. This painting was displayed at the '0.10' exhibition along with other similarly radical works.

Black Square on a White Ground, Kazimir Malevich, 1915, oil on linen, 79.5 x 79.5 cm (31 ¼ x 31 ¼ in.), State Tretyakov Gallery, Moscow, Russia

First shown in '0.10: The Last Futurist Exhibition', this painting was Malevich's profound solution to non-objectivity in art. It emerged from the stage and costume designs he had created two years earlier for *Victory Over the Sun*, a futuristic opera. His costumes were comprised of geometric forms and the backdrop was simply a black square. This painting represents the ultimate abstraction, as he said, a zero point from which one could invent art from scratch. It illustrates a meditative philosophy that strongly influenced both 20th-century architecture and Russian Constructivism.

② SPEED

Influenced by Futurism, initially Malevich painted suggestions of the speed and dynamism of contemporary modern life through fragmented forms and stippled brushwork. Then, inspired by Cubism and Kandinsky's theories about abstraction, colour and spirituality, he began trying to depict speed through these pure, geometric shapes.

① THE PLANE

Unusually, Malevich referred to an object in the title of this work, even though no aeroplane can be discerned. He wrote about expressing the 'sensation of flight' and he was also interested in aerial photographs of landscapes. So this can be perceived as a view of a machine flying through the air, taken from above, although it was not meant to be a direct representation. The implied aeroplane symbolizes the awakening of the soul surrounded by the freedom of the infinite.

③ THE MACHINE AGE

The emergence of a wide spectrum of new technologies, including cars, faster trains and electric lighting, excited many artists during the early years of the 20th century. In direct opposition to traditional art, Malevich embraced the inventions and looked forward to experiencing more. The image heralds the coming of the machine age with brightly coloured shapes on a plain background, suggestive of control panels or the streamlined facades of locomotives.

During his early career, Malevich worked in many different styles, from Impressionist paintings using an application of thick paint to build form and volume through colour, to a smoother, more academic technique. Even this work is not as plainly painted as it might first appear.

④ TEXTURE

Malevich was concerned about textural appearances. He wrote: 'Colour and texture in painting are ends in themselves.' He placed one transparent colour over another to create a new colour. Even the flat areas of black have texture and are made up of various hues.

⑤ COLOUR

Breaking with past styles, Malevich reduced his palette to primary colours, as well as black and white, but he used opaque and transparent pigments to differentiate planes of colour. His palette here included zinc and lead white, lamp black, chrome yellow and red lake.

⑥ PREPARATION

Malevich began by coating his canvas in white paint. When this layer was dry, he drew outlines of the shapes in freehand with a pencil. He applied his coloured paint in thin layers on top. In some places his initial pencil marks are visible through the coloured paint.

⑦ METHOD

Malevich learnt how to create a sense of movement through tensions created by the proximity and irregularity of his flat shapes, when they are placed on a diagonal axis. He used cardboard as a guide for his brush as he painted the edges of his shapes.

Linen, **Natalia Goncharova, 1913, oil on canvas, 95.5 x 84 cm (37 ⅝ x 33 in.), Tate Modern, London, UK**

Natalia Goncharova (1881–1962) was a Russian avant-garde artist, painter, costume designer, writer, illustrator and set designer. She met Mikhail Larionov in 1900 and the two artists remained together for the rest of their lives. Goncharova introduced Malevich to Russian folk art and Primitivism, and with him and Larionov, she pioneered Russian Futurism. In 1913, Goncharova and Larionov launched the Rayonism movement in Moscow. Rayonism was a synthesis of the leading contemporary European styles Cubism, Futurism and Orphism. This semi-abstract work was painted the same year. It is a fragmented image depicting laundry and also references the relationship of Goncharova and Larionov. On one side are men's shirts, collars and cuffs, and on the other side are a women's lace collar, blouse and apron. The style of the Russian inscriptions on the painting suggests a sign for a commercial launderette.

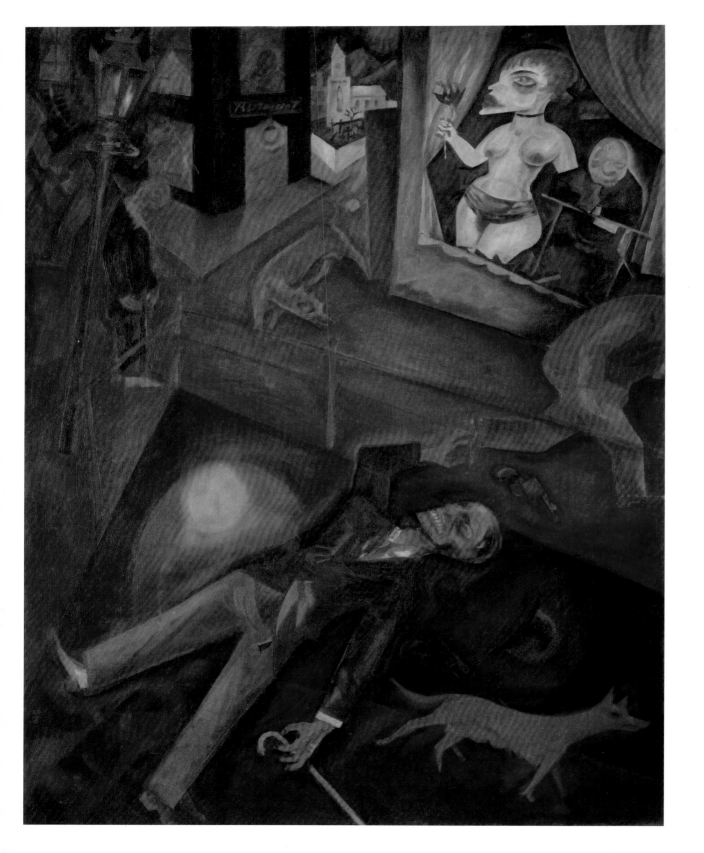

SUICIDE

GEORGE GROSZ

1916

oil on canvas
100 x 77.5 cm (39 ⅜ x 30 ½ in.)
Tate Modern, London, UK

UNLIKE MANY ARTISTS OF his generation, George Grosz (1893–1959) – born Georg Ehrenfried Gross – vehemently opposed rather than welcomed World War I. However, to evade conscription and in the hope of avoiding being sent to the front, he volunteered for military service in November 1914. Six months later, he was discharged on health grounds. While recuperating in Berlin, he met various authors, artists and intellectuals with whom he founded the Berlin branch of Dada. He was conscripted in 1917 but was soon discharged as permanently unfit after a nervous breakdown.

Grosz was born in Berlin but after his father's death in 1901, he and his mother lived alternately in Berlin and Stolp in Pomerania (now Poland). From 1909 to 1911, he studied at the Dresden Academy of Fine Arts, and subsequently took a graphic-art course at the Berlin College of Arts and Crafts. In 1913, he spent several months in Paris at the Académie Colarossi. After his discharge from the army, he remained in Berlin during World War I and worked as a successful illustrator and cartoonist, although he was accused by some of obscenity. During that time, his painting style changed as he became inspired by the political and social satirists Honoré Daumier and William Hogarth. His subsequent images scathingly attacked what he perceived as German corruption in politics, society, the army, religion and commerce. From 1917 to 1920, he played a prominent role in the Berlin Dada group. In 1918, he joined the *Novembergruppe* (November Group) formed by German Expressionist artists and architects. He was also involved with the German Communist Party. In the 1920s, he became one of the principal artists associated with the *Neue Sachlichkeit* (New Objectivity) movement that took its name from an exhibition in Mannheim in 1923. New Objectivity artists produced vivid depictions of what they saw as the corruption, frenzied pleasure-seeking and general debilitation of postwar Germany under the Weimar Republic, which governed until the Nazi Party took control in 1933.

Executed in Berlin during his first discharge from the army, this painting is one of Grosz's vehemently satirical images that he declared 'expressed my despair, hate and disillusionment'.

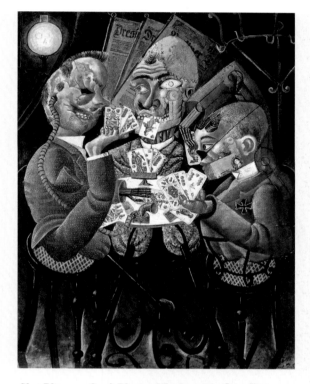

Skat Players – Card-Playing War Invalids, Otto Dix, 1920, oil with photomontage and collage on canvas, 110 x 87 cm (43 ¼ x 34 ¼ in.), Staatliche Museen zu Berlin, Germany

Like Grosz, the German printmaker and painter Otto Dix (1891–1969) was a prominent member of the New Objectivity group, and was known for his searing depictions of Weimar society and the barbarism of war. This painting criticizes the postwar state of Germany with its haunting representation of the physical damage caused by war. Three German military officers play cards. Extremely disfigured, they represent the senselessness of war and the devastation of Germany after the conflict.

❷ THE PROSTITUTE

In the window above the dead man is a prostitute with an ageing client visiting her. They epitomize the depravity in Berlin at the time and represent the decay of the human spirit that Grosz believed had occurred through the war. The bald, fat client represents all those with whom Grosz was angry, including individuals who were responsible for taking Germany into war.

❶ FIGURE ON THE GROUND

In front of an open window, this man has just shot himself in the street. He is not a specific individual, but an allegorical figure representing the predicament of German society during and after World War I. Allegory allowed Grosz to present a piercing appraisal of his society. As if bathed in the man's blood, the painting is tinged blood red. A dog scavenges near the corpse, a figure hurries by, ignoring the dead man, his revolver lies nearby and his head has taken on the characteristics of a skull.

❸ THE CHURCH

In the distance, a church is highlighted even though it is far in the background. An overriding image of morality, it stands prominently as witness to the death – and destruction of war. Its distance suggests a lack of religious observance – or hope.

Grosz amalgamated elements of Futurism, Cubism and German Gothic art with his own expressive graphic style, using thin layers of paint to convey his savage social commentary.

④ PERSPECTIVE

Tilted on a diagonal, and portrayed from an aerial viewpoint, the composition conveys the social upheavals of wartime. Multiple perspectives are integrated to create a disorienting space and confuse the distinctions between elements of the image. The dead man is in a distorted arena or boxing ring.

⑤ PALETTE

The paint is thin and smooth. Created with a reduced palette, the dominant red implies corruption and suffering, conjuring notions of blood and a red-light district. As this is a night scene, all the other colours are muted and dull, mainly Prussian blue and green with black.

⑥ LINEAR STYLE

A skilled draughtsman, Grosz was a successful illustrator from early on. Yet his drawings became expressive as his disillusionment with humanity's barbarism increased. This jarring linear style conveys his disgust. In his autobiography of 1946 he wrote: 'I had utter contempt for mankind in general.'

⑦ METHOD

Following traditional painting styles, Grosz applied thin layers of paint often using contrasting colours on his early layers and finishing with the final, desired colour on the top. Although he painted wet-over-dry here, underlying layers are visible in places through the translucent final layers.

The Third-Class Carriage, Honoré Daumier, c. 1862–64, oil on canvas, 65.5 x 90 cm (25 ¾ x 35 ½ in.), Metropolitan Museum of Art, New York, USA

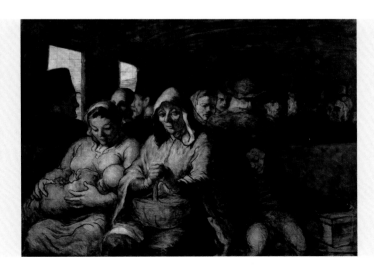

Grosz was fascinated by Hogarth and Honoré Daumier (1808–79), and developed his drawing style partly by studying them closely. As a graphic artist and painter, Daumier chronicled the impact of industrialization on modern urban life in mid-19th-century Paris. In this painting, he illustrates the adversities endured by third-class train travellers. Focusing on the darkness and cramped discomfort of the passengers, he highlights several generations in the shape of a nursing mother, an elderly woman and a sleeping boy. Yet a sense of resolve and patience emanates from their worn faces; they possess an inner fortitude despite the hardships of life.

STILL LIFE WITH A BEER MUG

FERNAND LÉGER

1921–22

oil on canvas
92 x 60 cm (36 ¼ x 23 ⅝ in.)
Tate Modern, London, UK

ALTHOUGH THE FRENCH ARTIST Fernand Léger (1881–1955) was a pioneer of Cubism, his style varied over his career, alternating from figurative to abstract. He also worked in a range of media including painting, ceramics, filmmaking, set design, stained glass and printmaking. His form of Cubism fractured objects into geometric shapes similar to other Cubists, but he retained an interest in depicting unequivocal illusions of three dimensions and in primary colours. Focusing on cylindrical forms that embraced the machine age, he is regarded as a forerunner of Pop art.

Born in Argentan in Normandy, Léger was initially apprenticed to an architect at Caen. After finishing his compulsory military training in 1903, he studied in Paris at the École des Arts Décoratifs and the Académie Julian. During his studies, he made a living doing architectural drawings and retouching photographs. He absorbed a variety of influences, including Impressionism, Neo-Impressionism and Fauvism, but after seeing the Cézanne retrospective at the Salon d'Automne in 1907, his art completely changed. In 1909, he moved to Montparnasse and met artists including Braque, Picasso, Delaunay and Rousseau, and the writers Apollinaire and Blaise Cendrars. At the Salon des Indépendants of 1911, he showed paintings that led to his recognition as a major Cubist. He continued to exhibit at the Indépendants and at the Salon d'Automne until he was drafted into the French army in 1914. He survived a gas attack at the Battle of Verdun in 1916 and was released from the army a year later.

Inspired by machines and other modern industrial objects, Léger created illusions of three-dimensional tubular forms. In 1913, he painted a series of abstract studies he called *Contrast of Forms*, which juxtaposed contrasts of colour, curved and straight lines and solids and flat planes, producing an effect that he felt asserted modern life. In 1920, he met the Swiss architect, designer and painter Charles-Édouard Jeanneret-Gris, known as Le Corbusier (1887–1965), and became involved in a movement called Purism. Léger then began to use flatter colours and bold, black outlines, emphasizing geometric composition and decoration as in this painting.

Quince, Cabbage, Melon and Cucumber, Juan Sánchez Cotán, *c.* 1602, oil on canvas, 69 x 84.5 cm (27 ⅛ x 33 ¼ in.), San Diego Museum of Art, California, USA

As well as following the new ideas of Cubism, Léger was building on a long tradition of painting that had been practised as a regular art form from the earliest eras. Still-life paintings were featured on walls in the ancient Roman cities of Pompeii and Herculaneum. The term 'still life' became used in the 17th century for this already well-established genre of painting that comprised arrangements of ordinary objects. At the beginning of that century, the devoutly Catholic, Spanish artist Juan Sánchez Cotán (1561–1627) produced detailed, lifelike images to portray feelings of harmony and spirituality. His controlled, illusionistic painting style made a powerful impression on many future still-life painters, especially his exploration of light and portrayal of volume and depth. Sánchez Cotán entered a monastery soon after painting this canvas.

① BEER MUG AND FOOD

A simple lunch is on a table. The angled, Cubist picture is dominated by the large German-style beer mug that appears completely flat, like a cut-out, floating in front of the objects surrounding it. Bold patterns and colours help make it stand out, creating strong contrasts with all the elements around it. Surrounding the beer mug are what appear to be two plates of fruit, some small pots of butter and a corkscrew.

② THE TABLE

In the centre of the composition is this small, square table. Painted golden brown to resemble wood, it contrasts with the strong patterns and colours around it. In line with Cubist theories, it is shown from several angles at once to best describe it on a two-dimensional canvas. The top is distorted into a squashed diamond and the legs are portrayed as if viewed from the side. Léger employed Cubist techniques but from 1919, he began working in a more accessible, illustrative style with recognizable fragments of objects.

③ CURTAIN

In the background is what appears to be a kitchen and running down the right side of the canvas is a blue curtain tied back halfway down its length. The curtain suggests a stage set, while also making a connection with art of the past, for instance Titian's *Venus of Urbino* (1538; see p. 249). Léger was keen to emphasize different aspects of each of his elements within the painting, saying: 'I group contrary values together: flat surfaces opposed to modelled surfaces...pure flat tones opposed to grey, modulated tones, or the reverse.'

Léger was fascinated by smooth lines and contrasts. As well as his involvement with Cubism, he shared the Futurists' fascination with technology, machinery and speed, and developed his own style by combining elements of both movements, centring on powerful contrasts of forms.

4 COLOUR

Each colour and tone offsets another: the warm colours of vermilion, cadmium orange and yellow are foils for the cool Prussian blue. These intense areas are relieved by the interaction of washes of pale lemon-yellow and pale blue-green in the diamond shapes below the table.

5 PATTERNS

From the diamond shapes on the floor to the black circles and rectangles that make up the kitchen behind, to the curving, wavy shapes on the beer mug, Léger has portrayed the elements of the composition in flat geometric shapes, using them to create bold decorative effects.

6 CONTRASTS

The painting is constructed around three contrasting elements: the geometric gridlike black and white background; the warm soft tones of the table; and the beer mug in brilliant orange-red, blue and white. Blue and orange are also complementary colours.

7 METHOD

Léger first divided his white primed canvas into twenty-four squares and worked on this ordered grid, carefully structuring the image. He made final adjustments after it was completed. Léger disliked textural effects and he applied his paint in smooth, even layers.

***Still Life with Glass of Red Wine*, Amédée Ozenfant, 1921, oil on canvas, 50.5 x 61 cm (19 ⅞ x 24 ⅛ in.), Kunstmuseum Basel, Switzerland**

Purism was a movement developed by the French painter Amédée Ozenfant (1886–1966) and Le Corbusier, who met in Paris in 1918. They felt that Cubism had degenerated into an art of decoration and Purism aimed to use clear, precise, ordered forms they believed expressed the spirit of the modern machine age. Ozenfant and Le Corbusier set out the theory of Purism in their book *Après le Cubisme* (*After Cubism*) published in 1918. They continued to collaborate and published essays from 1920 to 1925 in their review, *L'Esprit Nouveau* (*The New Spirit*). Coloured with only neutrals of grey, black and white with green, and depicting stripped-down, simple forms, this still life by Ozenfant is a typical Purist painting. Léger admired the orderliness of the Purist approach.

THE HUNTER (CATALAN LANDSCAPE)

JOAN MIRÓ

1923–24

oil on canvas
69 x 100.5 cm (25 ½ x 39 ½ in.)
Museum of Modern Art, New York, USA

WITH THE AIM OF liberating the unconscious mind, Joan Miró (1893–1983) created a vocabulary of biomorphic forms and geometric shapes, and played a crucial role in the development of Surrealism. His influences ranged from folk art and church frescoes of his native Catalonia to 17th-century Dutch realism, Fauvism, Cubism and Dada. Throughout his career, he constantly experimented with styles and different media, from ceramics and engravings to paintings and installations.

Despite wanting to become an artist, in order to please his parents Miró attended the School of Commerce in Barcelona from 1907 to 1910. Then in 1912, he enrolled at the Llotja School of Industrial and Fine Arts. While there, he developed an interest in the bright colours of the Fauves and the fractured compositions of Cubism. In 1919, he moved to Paris, where he was so poor that he later explained: 'At night, I'd go to bed, and sometimes I hadn't had any supper. I saw things, and I jotted them down in a notebook. I saw shapes on the ceiling.' These hallucinations fuelled his 'automatism' or unconscious painting. He believed that these paintings revealed underlying feelings that would otherwise have been suppressed by consciousness, although many were nonetheless planned carefully. This work is an example of that mixture of conscious and unconscious thought. Although little can be distinguished, it represents a hunter in the landscape.

Detail from *Christ Pantocrator from Sant Climent de Taüll*, artist unknown, *c.* 1123, fresco, 620 x 360 cm (244 x 141 ¾ in.), Museu Nacional d'Art de Catalunya, Barcelona, Spain

This fresco is one of the masterpieces of Romanesque art. Miró's radical style took elements from it, including the restricted palette of bright colours, expressive lines and lack of perspective.

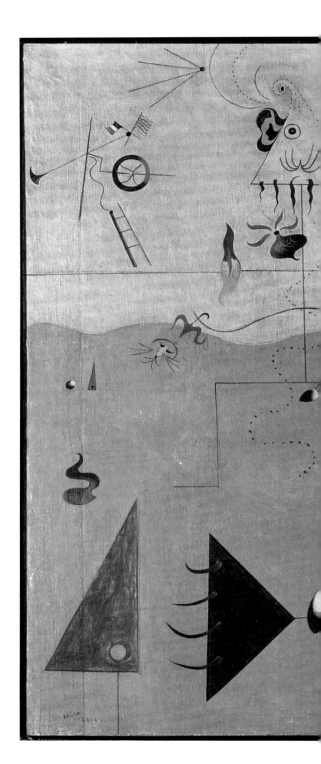

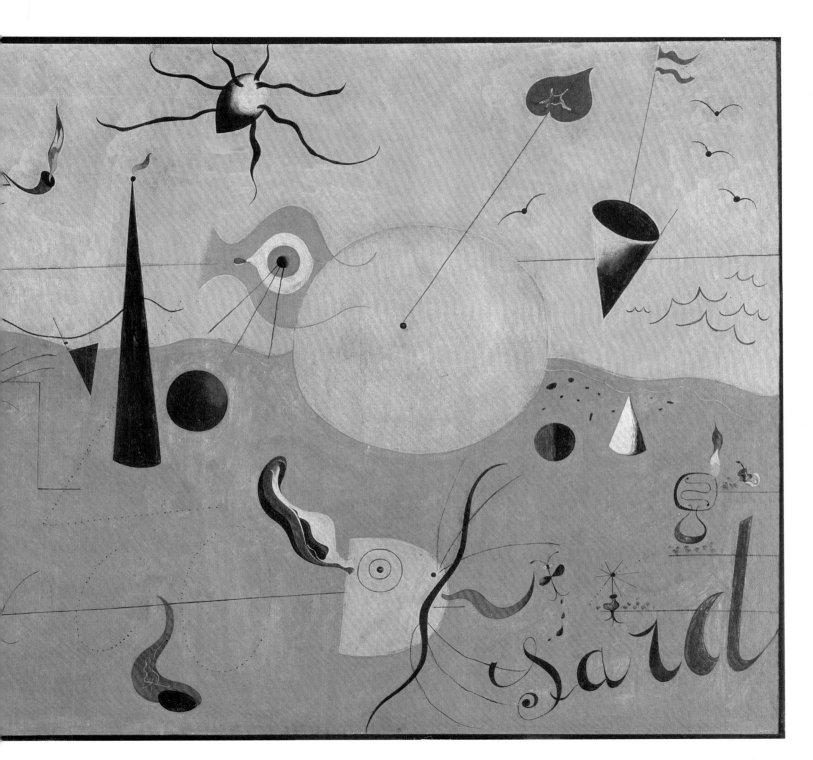

② THE LEAF

The large beige circle is a cross-section of the trunk of a carob tree that sprouts a green leaf. Such organic forms became a common element of Miró's increasing stylization and abstraction at this point in his career. This leaf shows that his art never became fully non-objective. Instead, Miró spent all his career exploring various means by which to disassemble traditional notions of representation.

③ THE HUNTER

This painting may look abstract but it is filled with things from the real world. Here, the hunter is a stick man with a triangle for a head. Black tufts of a beard hang from the bottom line of the triangle. A smoking pipe protrudes from his mouth. He wears a *barretina*, a Spanish peasant headdress. The wavy line represents his arms. He holds a recently killed rabbit in one hand and a smoking, black, conical-shaped rifle in the other.

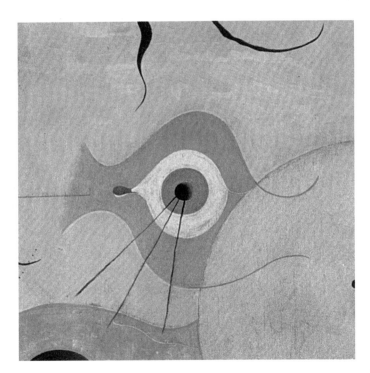

① THE EYE

Complex and puzzling iconography appears in many of Miró's paintings. Overall, this is an abstract depiction of the landscape of Miró's Catalan homeland. This giant, all-seeing eye bisected by the horizon line represents his memory, awareness and imagination, as well as spirituality and power. Yet it is also meant to be whatever viewers perceive it to be; Miró's intention was to release viewers' unconscious minds.

④ LANDSCAPE

The picture may be viewed as a statement on the political upheaval in Europe. It is set in the countryside of Catalonia, a region of Spain that had its own parliament, language, history and culture – and where Miró was born. Waves and seagulls appear on the right. A few years later, he explained: 'I have managed to escape into the absolute nature, and my landscapes have nothing in common anymore with outside reality. . . .'

⑤ SARDINE

This is a sardine: it has an ear, an eye, a tongue and whiskers. This sardine has also been caught by the hunter. Miró explained: 'In the very foreground, a sardine with tail and whiskers gobbling up a fly. A broiler waiting for the rabbit, flames and a pimento on the right.' The word 'sard' in the foreground is short for '*sardana*', the national dance of Catalonia. This truncated word is also a reference to the fragmented words found in Dadaist and Surrealist poetry.

⑥ PLANNING

Miró planned this painting, producing many preparatory drawings, some squared into methodical grids. The planning included his own language of symbols and signs, such as the ladder that symbolizes escape and freedom. He said: 'I've shown the Toulouse–Rabat aeroplane on the left; it used to fly past our house once a week. In the painting I showed it by a propeller, a ladder and the French and Catalan flags.'

⑦ COLOUR AND PERSPECTIVE

Non-naturalistic, Fauvist colour, a rejection of perspective and flattening of the picture plane creates a lively, playful image, dominated by the pinkish-ochre field and bright yellow sea and sky. Miró's limited palette probably included flake white, zinc white, lemon yellow, cadmium yellow, vermilion, raw and burnt umber, raw and burnt sienna, alizarin crimson, Prussian blue, cobalt violet and ivory black.

HOUSE BY THE RAILROAD

EDWARD HOPPER

1925

oil on canvas
61 x 73.5 cm (24 x 29 in.)
Museum of Modern Art, New York, USA

WITH HIS CONTEMPLATIVE PAINTINGS of the urban United States during the early to mid 20th century, Edward Hopper (1882–1967) is renowned for his strange, often desolate-looking depictions of familiar surroundings that strongly influenced Pop art and New Realist painters of the 1960s and 1970s, as well as filmmakers.

Hopper was born near the Hudson River north of New York, one of two children in a middle-class family. For six years, he studied commercial illustration and painting, taught by William Merritt Chase (1849–1916). His early painting style was modelled after Chase, Manet and Degas. From 1905 to the mid 1920s, he produced illustrations for an advertising agency, although between 1906 and 1910, he made three trips to Europe to study art. During that time, he visited Paris, London, Amsterdam, Berlin and Brussels. However, unlike many of his contemporaries, he remained untouched by the experimental work then flourishing in Europe and instead continued to paint in a realistic style, making American life his subject. At first, he made money from prints of his paintings and watercolours, but after his solo show in 1924, he became immensely successful. Acknowledged as his first fully mature painting, this work exemplifies the sense of solitude in urban locations that he became famed for, distinguished by subtle spatial relationships and a dextrous handling of light.

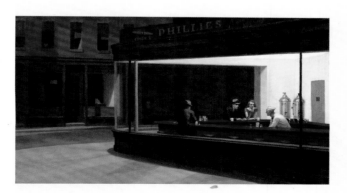

Nighthawks, Edward Hopper, 1942, oil on canvas, 84 x 152.5 cm (33 ⅛ x 60 in.), Art Institute of Chicago, Illinois, USA

Three customers and a waiter inhabit a city diner. The figures appear lost in their own private concerns, their disconnection echoing the feelings of anxiety felt across the United States during World War II.

<div style="text-align:left">IN DETAIL</div>

② THE WINDOWS

With most of the blinds drawn at the many windows, the house seems to be deserted, raising questions such as whether the family has gone away. Was the house left empty, to be demolished? For how long had it been deserted? Why was it empty? The blinds shuttered in broad daylight invite more questions than answers.

③ STRONG SHADOWS

Hopper's method of creating drama with strong chiaroscuro, especially the play of light on architecture, represented his personal vision. The sunlight illuminating the painting is bright enough to cast deep, menacing-looking shadows on the stately mansion, generating an air of desolation and sadness. English film director Alfred Hitchcock acknowledged that the painting was his inspiration for the motel in his thriller *Psycho* (1960).

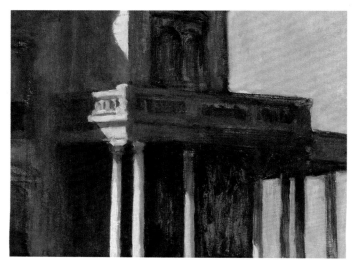

① THE HOUSE

Hopper invented this house based on some he saw in New England and others he had seen on the boulevards of Paris, but it also features elements of a Victorian house on Conger Avenue in Haverstraw, New York. With its double-pitched Mansard roof and dormer windows, this is an imaginary portrait of the French style of architecture that had been fashionable in the United States in the 19th century but had become a relic of the past.

4 RAILWAY LINE

Strong shadows are not the only contrasts in the painting. A modern railway line is set directly against the old house. Trains suggest progress, connecting and enlarging towns and cities, and changing the rural landscape. With its strong horizontal lines, the track actually creates a notion of calm and silence, rather than the thunderous noise, speed and smoke of contemporary life.

6 METHOD

To begin this painting, Hopper outlined the structure of the house with black paint thinned with turpentine. He then painted from dark to light, gradually adding more paint and less turpentine, building up the forms with free, often diagonal brushwork. The highlighted side of the house was formed with transparent dark paints and opaque light colours, especially white.

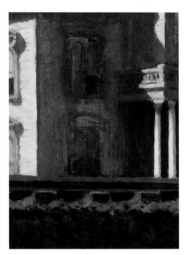

5 VIEWPOINT

The entire image is presented from an exceptionally low viewpoint. It seems to have been observed from the lower side of an embankment next to the railway track, at a distance, rather like a snapshot. This low viewpoint has the effect of making the railway track appear to cut through the lower part of the house. The track also serves to separate viewers from the house, enhancing its isolation.

7 COMPOSITION

Hopper's composition can be broken down into two elements: the verticality of the house and the horizontal foreground of the railway line. This simple geometry of planes, angles and intersecting forms add to the painting's sense of mystery. Sharp lines and large shapes starkly capture the lonely mood. Yet Hopper denied the work representing any deep, underlying meanings.

Dramatic changes

From 1920 to 1930, dramatic social and political changes occurred in the United States. The nation's total wealth more than doubled from 1920 to 1929, which created the new consumer society, although more than 60 per cent of Americans lived just below the poverty line. In addition, Prohibition took place from 1920 to 1933; it was a nationwide constitutional ban on the sale, production, importation and transportation of alcoholic beverages. The strength of the US economy came to a sudden end in October 1929 when the Wall Street stock market crashed (right) and the world economy was subsequently plunged into the Great Depression. Hopper's work reflects and depicts the state of the nation, both in its celebration of modern progress and its sense of alienation.

ORIENTAL POPPIES

GEORGIA O'KEEFFE

1927

oil on canvas
76 x 102 cm (30 x 40 ⅛ in.)
Frederick R. Weisman Art Museum, Minneapolis, Minnesota, USA

SINGLE-MINDED AND ORIGINAL, GEORGIA O'Keeffe (1887–1986) was a significant contributor to American Modernism and is regarded as a pioneer of feminist art. A prolific artist, she produced more than 2,000 works over the course of her long career. Her bold, expressive, figurative art that sometimes borders on abstraction defies classification, although she is often linked with Precisionism.

Born in Wisconsin, O'Keeffe attended the School of the Art Institute of Chicago from 1905 to 1906. In 1907, she moved to New York and studied under William Merritt Chase at the Art Students League. She also visited exhibitions at Gallery 291, which was owned by photographer Alfred Stieglitz (1864–1946) and was one of the few places in the United States where European avant-garde art was displayed. Her art was influenced by a variety of sources, including Rodin, Matisse, Art Nouveau, Arthur Wesley Dow (1857–1922) and Arthur Dove. In 1915, she read Kandinsky's *Concerning the Spiritual in Art* (1910) and she began experimenting with Dow's theory of self-exploration through art. She made some charcoal drawings of simplified natural forms that were brought to the attention of Stieglitz, who recognized her potential and exhibited ten of the drawings at his gallery. Stieglitz helped her financially to leave teaching and they eventually married in 1924.

O'Keeffe created richly coloured large-scale paintings of natural forms at close range and of New York skyscrapers as well as other architectural forms. This vibrant work was one of many large paintings of flowers in close-up that she produced in the early years of her marriage. Confident, fluid lines draw together her dramatic colour palette and innovative composition. She described her reasons for painting flowers in close-up: 'Nobody sees a flower, really, it is so small. We haven't time – and to see takes time. . . . If I could paint the flower exactly as I see it no one would see what I see because I would paint it small. . . . So I said to myself – I'll paint what I see – what the flower is to me but I'll paint it big and they will be surprised into taking time to look at it – I will make even busy New Yorkers take time to see what I see of flowers.'

② COLOUR

O'Keeffe's use of colour emits great emotional power that animates her brilliantly hued poppies. Although it is not clear whether she had the condition, she was fascinated by synesthesia and was particularly sensitive to colour. Here, she applied analogous colours from a small range of the spectrum, predominantly dazzling reds, with touches of orange as well as yellow, and black, violet and blue in the centre of the flowers.

③ JAPANESE INFLUENCE

The curving shapes and lines here reflect O'Keeffe's fascination with Art Nouveau designs. The asymmetrically balanced composition also demonstrates her awareness of Japanese woodblock prints. She has used the negative space around the edges of the petals and centres of the flowers to emphasize their shapes, while the composition's asymmetry is accentuated by the judicious placement of dark and light colour contrasts.

① CLOSE-UP

The flowers are painted on a large canvas and the image resembles a close-up photograph. Denying critics' accusations of underlying themes in her flower paintings, especially as symbols of sexuality, O'Keeffe explained that she was painting the plants as she saw them, merely observing nature in her own way. She exploited photographic devices, such as cropping the edges and distorting relationships between the foreground and background.

④ ABSTRACT FORMS

O'Keeffe simplified the composition, presenting the two flower heads close together in front of a plain red background so that nothing detracts from them. When many artists were experimenting with abstract painting, O'Keeffe was working figuratively. Although this is a directly observed image of two Oriental poppies, her nuances of line and colour, angles of observation and choices of colours, shape and texture create a sense of pattern and abstracted forms.

⑤ PAINT APPLICATION

The painting was started with a white ground that O'Keeffe made with a wash of lead white mixed with plenty of turpentine. Then she built up the image with thin layers of paint. The reds were mainly transparent, while the yellow was translucent and the white and black opaque. Thin, white highlights have been dragged dry over some of the edges of the petals, while the black and violet in the centre have been applied in a fairly thin and dry consistency, but with more layers than the white highlights.

⑥ LINE

O'Keeffe's lines define the petals and outlines of the flowers, while also creating a sense of vitality. The smooth confidence of the lines and their flow around the composition make the image appear deceptively simple. From her early training, O'Keeffe remained committed to the discipline of drawing, and throughout her life, she recorded her acute visual perceptions in sketchbooks. Her expression 'selection, elimination and emphasis' epitomizes her focus on lines to evoke moods and impressions.

Nature Symbolized No. 2, **Arthur Dove**, *c.* 1911, pastel on paper on masonite, 45.8 x 55 cm (18 x 21 ⅝ in.), **Art Institute of Chicago, Illinois, USA**

The US painter Arthur Dove (1880–1946) interpreted the natural world into an abstract vocabulary of colour, shape and line. Also an amateur musician, he was inspired by parallels between the visual arts and music. He is regarded as the first US artist to have created purely non-representational imagery. Works such as *Nature Symbolized No. 2* use Cubist planes and soft, muted colours that suggest the natural, organic forms found in the US landscape. Dove was a member of Stieglitz's avant-garde circle and held his first solo show at the photographer's Gallery 291 in 1912. Dove had a lasting influence on O'Keeffe, particularly with his sense of rhythm conveyed through shape and colour. Following his lead, she often synthesized abstract and realistic elements.

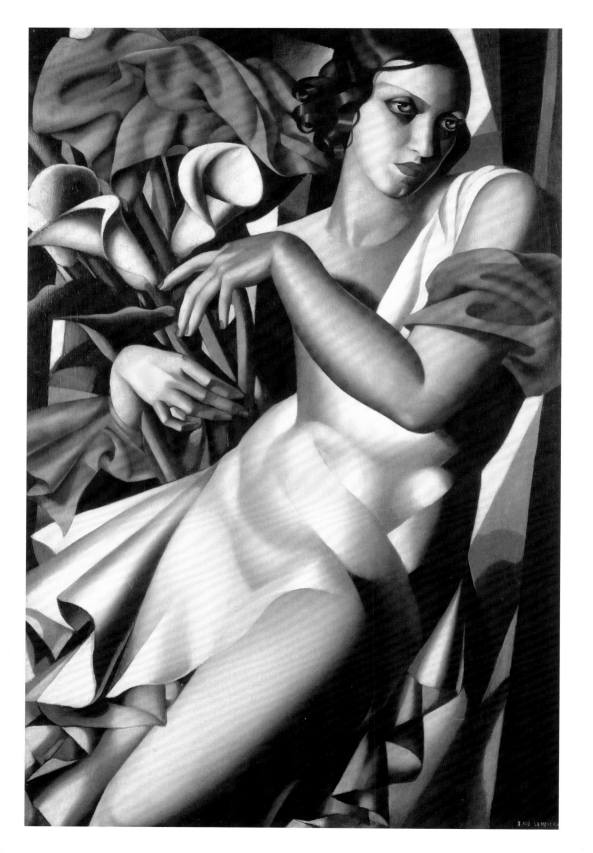

PORTRAIT OF IRA P

TAMARA DE LEMPICKA

1930

oil on panel
99 x 65 cm (39 x 25 ⅝ in.)
private collection

WITH THEIR JUXTAPOSITIONS OF rounded and angular forms and accentuated tonal contrasts, the paintings of Tamara de Lempicka (1898–1980) reflect her glamorous lifestyle and social circle. Influenced in particular by Cubism and Ingres, she became the leading artist of the Art Deco style, nicknamed 'the baroness with a brush'.

De Lempicka was born Maria Gorska into an affluent Polish family in Warsaw. After her parents divorced in 1912, she went to live with an aunt in St Petersburg. At the age of eighteen, she married a lawyer, Tadeusz Lempicki. In 1917, during the Russian Revolution, the couple fled for Paris. There, she continued with the art studies she had started in St Petersburg, enrolling first with painter Maurice Denis (1870–1943) at the Académie Ranson and then at the Académie de la Grande Chaumière, where she met the painter André Lhote who especially influenced her style with his modified Cubist ideas. De Lempicka soon began painting portraits of the aristocracy and other prominent figures in Paris. Fascinated by the Renaissance, she studied the art in Italy and on her return she began incorporating precise details and using more luminous colours. Her astute curiosity about people and her perception of their conceits became the subject of her portraits. Her almost Mannerist-style forms and figures gave her work a sculptural quality, and her amalgamation of classical and modernist elements had instant appeal. By the mid 1920s, during the peak of the Art Deco period, her paintings were exhibited in the prestigious salons of Europe and her popularity soon translated into financial success. She worked exceptionally hard, often for twelve hours a day. Eventually divorcing from Lempicki, she later married one of her wealthiest patrons, the Baron Raoul Kuffner von Diószegh. Her art continued to be as popular as ever; commissioned by the royalty of Europe and bought by prominent museums.

The subject of this portrait, Ira Perrot, was a neighbour of De Lempicka, who became her closest friend, favourite modél and probably her first female lover. This elegant, refined portrait with its clean colours and sensual forms exemplifies De Lempicka's style.

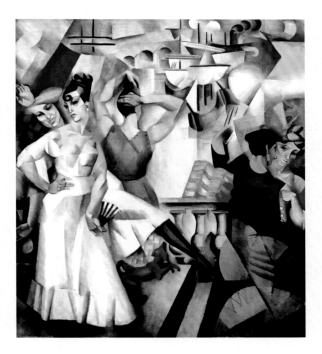

L'Escale, **André Lhote, 1913, oil on canvas, 210 x 185 cm (82 ⅝ x 72 ⅞ in.), Musée d'Art Moderne de la Ville de Paris, France**

After initially working in a Fauvist style, French painter André Lhote (1885–1962) began experimenting with his own version of Cubism that reflected his sculptural skills. This was painted before he was conscripted to the army during World War I. After the war, Lhote taught in various academies and De Lempicka became his student in 1920. Using strong colours, Lhote encouraged a harmonious blending of traditional style painting with Cubist experimentation. De Lempicka effortlessly absorbed the lessons of this Neo-Cubism, creating a synthesis that enabled her to also express her interest in classical culture. Lhote later called her style Soft Cubism.

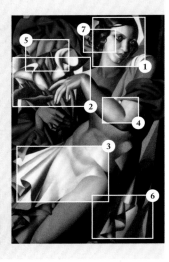

② LILIES

De Lempicka often included arum – or calla – lilies in her paintings, probably for their elegance and streamlined appearance. Here, the smooth flowers complement the silky white dress and emphasize the elongated composition. The strong contrasts make the petals appear rigid. The stems are also stiff and smooth, while Perrot's elegant hands holding them display red nail varnish that matches both her lips and the fluttering drapery above, which is used as a space-filling device.

① FACE

Throughout the 1920s, Perrot was one of De Lempicka's favourite models and they had a close and often fiery relationship. Here, she is recognizable for her long, straight nose and dark auburn hair that enhance the appearance of her large, pale green eyes, while her scarlet lips draw attention to her smooth, tanned skin. Angular shadows and softer highlights do not detract from the femininity of the image, illustrating De Lempicka's skill for imbuing a monumental figure with psychological depth.

③ DRESS

Satin and bias-cut, this white dress flows and clings to Perrot's body. The soft and strong tonal contrasts form a sense of the shining, metallic machine age, and project the sitter as an emancipated, modern woman. One of the criticisms of the official art world and the press was that De Lempicka had a decadent lifestyle and was openly outrageous. She never made a secret of her many love affairs with both men and women, and likely invented some in order to be extra shocking.

Once settled in Paris, from the early 1920s De Lempicka's style developed quickly. With her exceptional technical skill, she blended influences from Lhote, Denis, Ingres and Picasso with those of classical and Renaissance art. She used broad brushstrokes and smoothly applied paint.

4 TONE

With her imperceptible brushmarks, De Lempicka pays great attention to modelling, employing subtle shading on the spherical and cylindrical forms to achieve an impression of monumentality. Using soft cool greys and warm browns, her smooth tonal gradations have come to epitomize the Art Deco movement.

5 COLOUR

De Lempicka used a strict palette of light, bright and strong colours. Starting with a white ground, she built up the darker tones with monochrome fluid paint. Then she painted using a mixture of clear colours, probably including cadmium red, alizarin crimson, lead white and cobalt blue.

6 GEOMETRIC PLANES

While De Lempicka assimilated many different aspects of traditional fine art, much of her technique arose from contemporary art forms, including advertising, photography and film. Her inclusion of small geometric planes for shadows and depictions of form reflect her fascination with Hollywood glamour.

7 LIGHTING

Strong lighting creates an effect of Perrot's skin being lit by moonlight or a spotlight, while her hair glows with a metallic sheen. De Lempicka's effects of light evolved from her love of Italian Renaissance painters that started when she visited Italy with her grandmother at the age of ten.

Art Deco design

Taking its name from the '*Exposition Internationale des Arts Décoratifs et Industriels Modernes*' (International Exposition of Modern Decorative and Industrial Arts) held in Paris in 1925, Art Deco spanned the Roaring Twenties and the Depression-dominated 1930s. It affected all forms of design, from the fine and decorative arts to fashion, film, photography, transport and product design. Luxuriant and exuberant, Art Deco style is characterized by rich colours, bold geometric shapes and gilded, angular ornamentation. The style drew influences from the discovery of ancient Egypt's Tutankhamun in 1922 but also embraced technology and the industrialization of the interwar years with its streamlined machines.

AD PARNASSUM

PAUL KLEE

1932

oil and casein paint on canvas
100 x 126 cm (39 ⅜ x 49 ⅝ in.)
Kunstmuseum, Bern, Switzerland

THE SWISS-BORN GERMAN PAINTER, printmaker and draughtsman Paul Klee (1879–1940) produced a diverse body of work that defies categorization, but was inspirational to many other artists of the 20th century. A transcendentalist, Klee believed that the material world was only one of many other realities, and his use of design, pattern and colour are his attempts to express that philosophy. An accomplished musician, he often played his violin before starting a painting, and like Kandinsky and Whistler he drew comparisons between music and visual art.

In Munich in 1900, Klee studied with the German symbolist Franz von Stuck (1863–1928) with whom Kandinsky had also trained. In 1911, Klee met Kandinsky, Marc and Macke and joined their Expressionist group, *Der Blaue Reiter* (The Blue Rider). Klee studied the work of other avant-garde artists such as Delaunay, Picasso and Braque, and began experimenting with abstraction. During World War I, Klee worked maintaining aircraft – including restoring their camouflage – and he was able to continue painting. By 1917, art critics acclaimed him as the best of the new German artists. He went on to teach at the Bauhaus in Germany, in Weimar from 1921 and in Dessau from 1926. At the Bauhaus he created advertising materials and taught in the bookbinding, stained-glass and mural-painting workshops. He left the Bauhaus in 1931 to teach at the art academy in Düsseldorf. However, when the Nazis came to power in 1933 they derided Klee's work as 'subversive' and 'insane' and he was dismissed from teaching.

From 1923, Klee created a series of imaginative colour constructions featuring symbolic colours that he called 'magic squares'. His last painting of the series was *Ad Parnassum* and it is a blend of reality, memory and fertile imagination. The title of the painting refers to Mount Parnassus near Delphi in Greece. Mount Parnassus was sacred to the ancient Greeks because it was believed to be the home of the god Apollo and the Nine Muses, and the mountain was dedicated to the arts. The title of Klee's painting means 'Towards Parnassus' and it is thought to describe the path that leads through an arched gateway to Mount Parnassus.

IN DETAIL

① PROCESS

This is one of Klee's few large-scale works and the last of his magic-square paintings. His process of painting it was elaborate and complex. On a traditional canvas with a white ground, he painted a grid of large, flat squares in muted casein paints. Then he dabbed on smaller squares, initially with white oil paint; he repeated the process with variegated oil paints diluted with turpentine. Finally, he added the orange circle and the lines.

② COLOUR

The black of the arch and the diagonal lines create a sense of dynamism across the image. Klee evolved a system of colour placement in which all the colours of the spectrum are incorporated but with a focus on the complementary contrasts of orange and blue. The colours vary from light to dark and blue to orange in two distinct layers. The grid of muted colours was laid first and then the layer of shapes, like a mosaic.

③ MEMORY

The glowing orange circle is reminiscent of the sun, while the large point formed by the long diagonal lines can be interpreted as a roof, mountain or pyramid. Klee said that his paintings were abstract but based on memory, so this may be a painting of the Great Pyramid, which he saw in 1928 on a visit to Egypt. Alternatively, the shape recalls Mount Niesen in the Swiss Alps on the shores of Lake Thun, which Klee knew well.

④ POLYPHONY

The title of the painting also suggests the book *Gradus ad Parnassum* (*Steps to Parnassus*, 1725) by composer Johann Joseph Fux. It defines the musical term polyphony, where two or more independent melodies are woven together in a musical arrangement. Klee knew the book and he defined polyphony as 'the simultaneity of several independent themes'. The different colours and shapes can be regarded as an analogy for the polyphonic sound of an orchestra.

⑤ POINTILLISM

Built up with individually dabbed dots, small blocks of shifting colours appear to float across the canvas. This creates an image like a mosaic in Klee's own form of pointillism. However, while it recalls Seurat's developments in Divisionism in the late 19th century, Klee had his own ideas about colour that were not scientific, but based on spirituality and the splendour of the mosaics in the early Christian basilicas of Ravenna. His dabbed marks form a dense, uniform, colourful texture.

⑥ BROKEN LANDSCAPE

When Klee painted *Ad Parnassum* he had recently had to relinquish his teaching position at the Bauhaus. One of the exercises he had given his students involved working with basic geometric shapes and this painting recalls elements of that. He maintained that the subject of the artwork was the world but not the visible world. He wrote that it represented the landscape as a mere memory—fragmented, defined by colours and characterized by an overall harmony, resembling music.

The Bauhaus

The most influential art school of the interwar period, the Bauhaus changed approaches to teaching and design. Founded in 1919 by the German architect Walter Gropius, the Bauhaus was shaped by the Arts and Crafts movement that had sought to demolish distinctions between fine and applied arts, as well as to reunite the creativity of craftsmanship with manufacturing. The Bauhaus focused on amalgamating art with industrial design in particular. The Nazis shut down the Bauhaus in 1933 but the school's impact reverberated around the world long after it closed. Klee enjoyed a friendship with fellow Bauhaus teacher Wassily Kandinsky. When the Bauhaus moved from Weimar to Dessau, Klee, his wife Lily and son Felix lived in one of the Bauhaus-designed masters' houses (right); Kandinsky and his wife Nina were their neighbours.

THE HUMAN CONDITION

RENÉ MAGRITTE

1933

oil on canvas
100 x 81 cm (39 ¼ x 31 ¾ in.)
National Gallery of Art, Washington, DC, USA

THE NATURALISTIC YET IDIOSYNCRATIC style of the Belgian artist René Magritte (1898–1967) attracted great acclaim during his life and has been heavily plagiarized since. A leading exponent of Surrealism, his individual, witty and thought-provoking images that present strange juxtapositions of ordinary objects challenge viewers' preconceptions of reality. To support himself he spent many years working as a commercial artist, which had a lasting influence on advertising as well as Pop, Minimalism and Conceptual art. Apart from a brief digression of style during World War II, he always remained true to Surrealism.

Little is known about Magritte's early life. In 1912, his mother committed suicide by drowning. When her body was retrieved from the river, allegedly, her dress was covering her face and images of people with white cloths obscuring their faces appear in several of Magritte's paintings. He studied art at the Académie Royale des Beaux-Arts in Brussels from 1916 to 1918. He then worked as a wallpaper designer and commercial artist, producing paintings in his spare time that were influenced by Futurism and Cubism. After 1920, Magritte discovered the work of De Chirico and he began working in his Surrealist style, which has an illusionistic, dreamlike quality. In 1925, Magritte helped produce some Dadaist magazines with artists including Jean (or Hans) Arp (1886–1966), Francis Picabia (1879–1953), Kurt Schwitters (1887–1948), Tristan Tzara (1896–1963) and Man Ray (1890–1976). Magritte moved to Paris in 1927, where he became a leading member of the Surrealist movement.

Focusing on the development of thought, Magritte's odd juxtapositions raise questions about the mysteries of existence. His men in bowler hats have been interpreted as self-portraits, while other images suggest that the inexplicable lurks in the most unexpected of places. Here, a canvas on an easel depicts a landscape that looks identical to the landscape seen outside the window. Magritte painted several versions of this theme. The view outside the window is real while the painting on the easel is a representation of reality and so the image raises the question of what is real and what is not.

Tea Time (Woman with a Teaspoon), Jean Metzinger, 1911, oil on cardboard, 76 x 70 cm (29 ⅞ x 27 ⅝ in.), Philadelphia Museum of Art, Pennsylvania, USA

French painter and theorist Jean Metzinger (1883–1956) had a powerful influence on Magritte when he was starting out as an artist. This painting was exhibited at the Salon d'Automne in Paris in 1911. That same year, the image was reproduced in the journal *Paris Medical*. Over the next three years the image appeared in three further magazines and the French art critic André Salmon nicknamed it 'The Mona Lisa of Cubism'. Almost a decade later, Magritte began uniting elements of Metzinger's style with Futurist approaches.

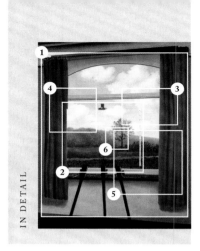

① PARADOX

Magritte explained this painting: 'In front of a window seen from inside a room, I placed a painting representing exactly that portion of the landscape covered by the painting. Thus, the tree in the picture hid the tree behind it, outside the room.' The work was his deliberate investigation of the paradoxical relationship between a painted image and what it conceals.

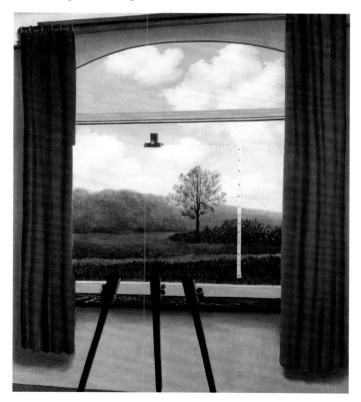

② ON THE EASEL

Viewers are meant to assume that this painting of a landscape is what can be seen in the real landscape outside the window. An intentional optical illusion, the easel with a canvas is the focal point of the image, both physically within the composition and in terms of the main purpose of the painting.

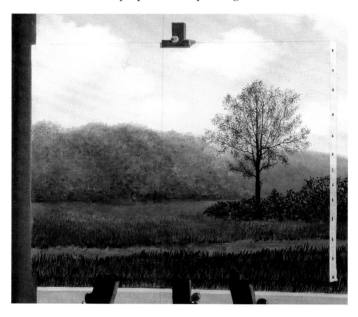

③ PERCEPTION

Magritte believed that reality is a matter of perception – or how people see things. So while viewers are prevented from seeing the actual subject matter being painted, they have to determine what they think is happening. Magritte wrote: 'As with life, time and distance lose relevance as perception moves to the forefront.'

Heavily influenced by the writings of German philosopher Immanuel Kant, who proposed that humans can rationalize situations but cannot comprehend things in themselves, Magritte explored human perception and understanding through smoothly painted, naturalistic images.

4 AMBIGUITY

The landscape on the easel is painted in the same way as the landscape seen through the window. In demonstrating the contradictions between three-dimensional spaces – or reality – and the two-dimensional space of the canvas used to represent it, Magritte creates irreconcilable ambiguities between real space and spatial illusion.

5 COLOUR

Without the wild colours of the Fauves or the earth pigments of Braque's Cubism, Magritte kept to a traditional soft, bright palette throughout his career. As this painting depicts both indoor and outdoor environments, the colours representing the interior are warm, while the colours depicting the view outside the window are bright to portray daylight.

6 COMMERCIAL ART

The straightforward rendition of the unexplained owes a great deal to Magritte's experience working as a commercial artist. The plain, descriptive style and the smooth, restrained handling of paint arise directly from the need for clarity and creating an impact found in advertising. For him, a painting's message was far more important than the method used to create it.

Girl Reading a Letter at an Open Window, Jan Vermeer, *c.* 1659, oil on canvas, 83 x 64.5 cm (32 ⅝ x 25 ⅜ in.), Gemäldegalerie, Dresden, Germany

Magritte admired Vermeer for his precise paint handling, atmospheric clarity, the stillness of his interiors and for his symbolic meanings. Vermeer's observational acuity, and the clarity of his vision was profoundly influential to many artists, and especially to those Surrealists, like Magritte, who aimed to paint perceived realities. This girl in profile by a window reading a letter with a heavy curtain masking a quarter of the room presents an image filled with mystery and symbolism. Like Vermeer, Magritte uses curtains to act as a frame in *The Human Condition*. Magritte employs the brown curtains to draw viewers' eyes into the landscape on the canvas.

METAMORPHOSIS OF NARCISSUS

SALVADOR DALÍ

1937

oil on canvas
51 x 78 cm (20 ⅛ x 30 ¾ in.)
Tate Modern, London, UK

AMONG THE MOST PROLIFIC artists of the 20th century, Salvador Dalí (1904–89) was a skilled draughtsman and a relentless self-promoter. His art included painting, sculpture, printmaking and filmmaking, as well as fashion and advertising design. His work was personal and obsessive, and its hyperrealistic style and weird juxtapositions appealed to the general public. However, he became renowned for his flamboyant personality as much as for his technical ability.

Born near Barcelona to a prosperous family, Dalí's artistic talents emerged early on, and at the age of fifteen, he published articles on the Old Masters in a local magazine. In 1922, he moved to Madrid to attend the San Fernando Academy of Fine Arts. Opposing his teachers' insistence on studying Impressionist and Fauvist art, he studied the art of Raphael, Vermeer and Velázquez instead. Dalí became interested in the psychoanalytic concepts of the Austrian neurologist Sigmund Freud and the art of De Chirico, and he began to draw on his subconscious to generate ideas. In 1929, he joined the Surrealist group in Paris. His vivid imagination and attention to detail resulted in highly lifelike, fantastic visions. During the early 1930s, Dalí's work went through what he described as his 'paranoiac-critical' period, when he produced paintings with double meanings that sprang from his fascination with hallucination and delusion. Through optical illusions evolved from his memories and feelings, the resulting images deconstruct psychological concepts of identity, eroticism, death and decay. Despite his formal expulsion from the Surrealist group in 1934 for his reactionary political views, Dalí became one of the most well-known Surrealists. He lived in the United States from 1940 to 1948, after which he returned to Catalonia. Throughout his life, Dalí continued to depict the landscape of his homeland in many of his paintings.

This painting represents the tale of Narcissus. According to Greek mythology, Narcissus was so proud and self-absorbed that he disdained all others. One day, however, he saw his own reflection in a pool and fell in love with it. Unable to embrace the beautiful watery face, he lost the will to live. The gods immortalized him as a flower they called narcissus.

② FLOWER AND HAND

Echoing the youth's pose is a series of stones, balanced together. They mirror Narcissus, but on closer inspection, can be seen to be a hand holding an egg from which a narcissus flower is growing. Dalí used the egg as a symbol of sexuality in several works. Another symbol he used frequently was ants, which here climb the hand. For Dalí, ants represented decay and death.

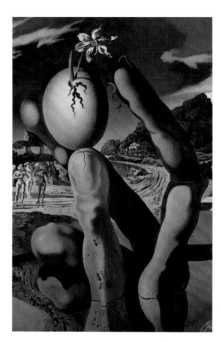

③ FIGURE ON A PEDESTAL

Set apart from everyone else, alone and standing on a pedestal, looking down and admiring his own body, is Narcissus as he was in life. The figure is shown from behind and is deliberately androgynous. The black and white floor tiles similarly suggest male and female. In the distance is an exaggerated landscape that resembles Dalí's home region of Cadaques in Catalonia.

① NARCISSUS

The self-obsessed boy Narcissus is unable to take his eyes from his own image on the still water. Dalí recommended that the painting should be viewed in a state of 'distracted fixation' – in other words, stared at – so that the figure of Narcissus becomes invisible as he dissolves into his surroundings. Dalí's dark shadows contrast directly against the highlighted areas and makes some elements appear to protrude from the flat canvas.

④ GROUP OF FIGURES

This group of small figures surrounding a pond is thought to represent the individuals who have variously loved Narcissus but been shunned by him. Although the figures are tiny, Dalí has imbued each with a detailed appearance and personality as if they represent individuals from different countries and cultures.

⑤ DOG

Gorging on meat, close to some sharp and painful-looking stones, the dog represents the end of something that was once beautiful. Behind the stones is a sinister-looking shadow on the red ground. Although the shadow is only that of Narcissus, its position and shape make it appear threatening.

⑥ LIGHT

Always fascinated by light and the way the eye functions, Dalí has presented this scene as having two strong and disparate effects of light. One is the early morning as the sun rises; a cold light that harshly illuminates the stone hand. The other is the warmth of sunset; a golden light that bathes the figure of Narcissus.

⑦ COLOUR

Predominantly worked in the three primary colours, plus black and white, the painting is organized extremely carefully. The left side is brighter than the right, featuring yellow, red and blues, while the right side is in the shade of the early morning light, so is depicted in cool blues and greys with some reddish-brown.

Meeting Sigmund Freud

Dalí relied on the theories of the neurologist and father of psychoanalysis Sigmund Freud (right) regarding the unconscious. The artist was therefore delighted when he was able to meet Freud in London in 1938, and took his painting *Metamorphosis of Narcissus* with him. Freud, however, was contemptuous of the Surrealists and was not inclined to discuss any of his ideas with the artist. Later, Freud wrote about the meeting in a letter to a friend: 'Up to now I have been inclined to consider Surrealists, who seem to have chosen me as their patron saint, as incurable nutcases. The young Spaniard, however, with his candid, fanatical eyes and unquestionable technical skill has made me reconsider my opinion. In fact, it would be very interesting to investigate the way in which such a painting has been composed.'

GUERNICA

PABLO PICASSO

1937

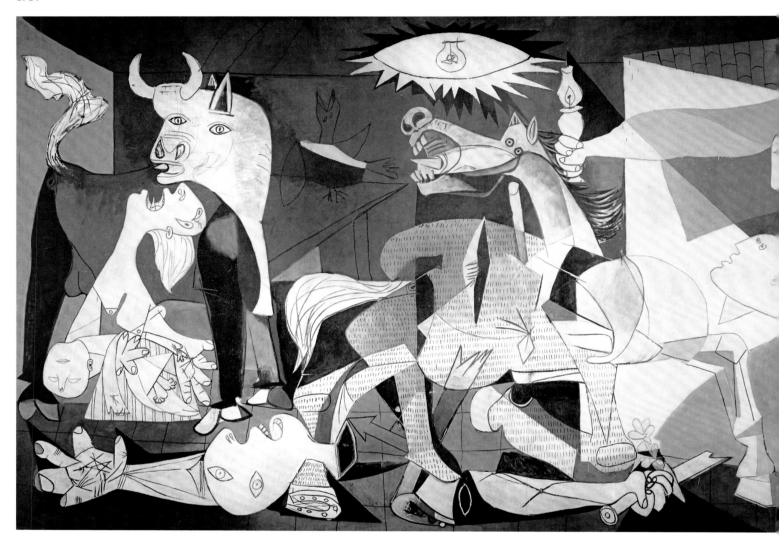

THE MOST FAMOUS ARTIST of the 20th century, Pablo Picasso (1881–1973) was a painter, draughtsman, sculptor and ceramicist. During his long career, he produced more than 20,000 works and changed the course of art. A child prodigy, his originality, versatility and prolific achievement have left an unrivalled legacy. An innovator, he experimented with various media, co-founded Cubism, invented constructed sculpture and introduced collage into fine art.

The Spanish-born Picasso grew up admiring El Greco, Velázquez and Goya. At the age of fourteen he was accepted at the Llotja art academy in Barcelona, where he surpassed all the older students. After moving to Paris in 1900, he became inspired by Manet, Degas, Toulouse-Lautrec and Cézanne, and by African and Oceanic art. Over the next decade, he experimented with numerous theories, techniques and ideas. While many of his later styles have not been labelled, the

oil on canvas
349 x 776 cm (137 ⅜ x 305 ½ in.)
Museo Reina Sofía, Madrid, Spain

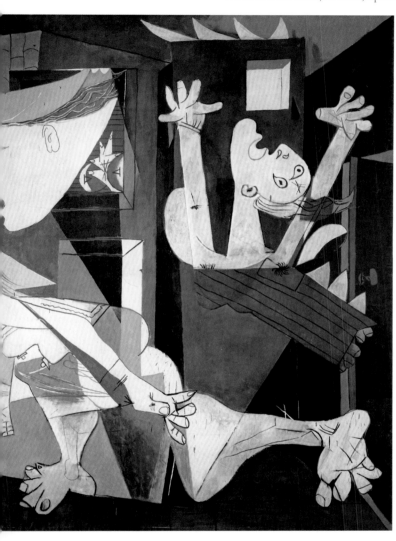

Paths of Glory, C. R. W. Nevinson, 1917, oil on canvas, 45.5 x 61 cm (18 x 24 in.), Imperial War Museum, London, UK

Picasso's *Guernica* followed traditions of war illustrations. British artist Christopher R. W. Nevinson (1889–1946) produced powerful paintings depicting the horrific actuality of World War I. Here, two dead British soldiers lie face down in the mud behind the Western Front. The title of the painting is a quote from the poem 'Elegy Written in a Country Churchyard' published by Thomas Gray in 1751: 'The paths of glory lead but to the grave.' Nevinson's image shows that there is no glory, only horror and death and the painting was censored in 1917 because the authorities believed it would damage morale at this point in the war. Twenty years later, the Spanish Republican government commissioned Picasso to create a large mural for the Spanish display at the World's Fair in Paris. After reading a newspaper account of the bombing of Guernica, Picasso began planning his painting. Famously, a few years later, when a German Gestapo officer visited Picasso's studio in Nazi Occupied Paris and pointed to a photograph of the painting asking him, 'Did you do that?' Picasso replied, 'No, you did.'

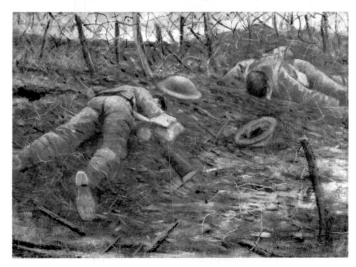

earliest include his Blue Period (1900–04), Rose Period (1904–06), African Period (1907–09), Analytical Cubism (1909–12), Synthetic Cubism (1912–19), Neoclassical Period (1920–30) and Surrealism (1926 onwards).

This moving anti-war painting shows the destruction wrought by the Spanish Civil War (1936–39). It is a response to the bombing of the Basque town of Guernica by German forces at the request of General Francisco Franco in 1937.

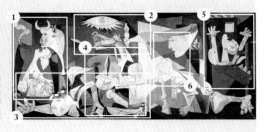

❶ BULL

In Spain, bulls represent strength and power, and Picasso depicted them often. Here, the bull is ambiguous although it appears to suggest brutality. Its swishing tail forms the image of a flame with smoke rising from it, seemingly in a window created by the lighter shade of grey surrounding it. In front of the bull is a woman, her head thrown back in anguish, screaming in pain and despair, as she holds a dead child in her arms. Like the horse and bull, her tongue is pointed to express her agony. Behind the bull, a dove holding an olive branch – a sign of peace – can be distinguished on the wall. Part of its body is a crack in the wall, through which a bright light – of hope – is visible.

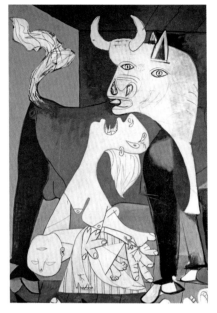

❷ LIGHT BULB

A single light bulb blazes from the ceiling, illuminating the harrowing imagery. The jagged edge suggests an explosion – recalling the bombs that fell on Guernica. The light may also represent an all-seeing eye, or the sun, as a symbol of hope. Although Picasso rarely interpreted his work, he explained that the horse stands for the people, here shrieking with pain, its tongue a sharp, daggerlike shape. Next to the horse's head, a candle is held by a frightened woman floating in the air. In Christian iconography, a flame implies hope or can be a sign of the Holy Spirit.

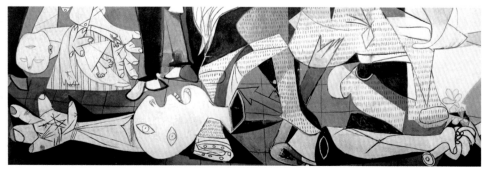

❸ FALLEN SOLDIER

Under the horse is a dead, dismembered soldier with a severed arm that still grasps a shattered sword from which a small flower grows. The flower is another symbol of hope, suggesting the renewal of life. In the soldier's open left palm is a stigmata, a symbol of martyrdom from Christ's Crucifixion. The soldier's arms are flung open as if crucified on a cross.

4 WOUNDED HORSE

The horse's body fills the centre of the painting. It has a large, gaping wound in its side, as if a spear has pierced it. There are two hidden, or subliminal, images in the horse's body. One is a human skull turned sideways, symbolizing death, while below the body is another bull's head contained in the outline of the horse's buckled front leg. The kneecap forms the bull's nose. The bull's horn gores the horse's breast.

5 BURNING FIGURE

With arms thrown up in terror, this figure – it is unclear if it is a man or a woman – is engulfed by flames from the fallen bombs. Helpless, the person appears to be falling or even trapped in a building as the flames rise below. The figure's right hand resembles the shape of a bomber plane. The victim's face is contorted in shock, emphasizing the brutality and chaos of the event.

6 TREATMENT

This huge work is created in a monochrome palette, reflecting the newspaper from which Picasso learnt of the massacre. The lack of colour suggests newspaper print and a journalistic report of horror. Although painted almost twenty years after the artist's Cubist phase, he depicts the faces in a Cubist style. In many ways, this was more powerful, creating a universal warning about the suffering of war.

The bombing of Guernica

In 1937, South African-born British journalist George Steer was sent to Spain to report on the Civil War. His eyewitness account of the bombing of Guernica (right) was published in *The Times* and *The New York Times*. He wrote: 'The bombardment of this open town far behind the lines occupied precisely three hours and a quarter, during which a powerful fleet of aeroplanes. . .did not cease unloading on the town bombs weighing from 1,000 lb downwards and, it is calculated, more than 3,000 two-pounder aluminium incendiary projectiles. The fighters, meanwhile, plunged low from above the centre of the town to machine-gun those of the civilian population who had taken refuge in the fields.'

368 COMPOSITION WITH YELLOW, BLUE AND RED

COMPOSITION WITH YELLOW, BLUE AND RED

PIET MONDRIAN

1937–42

oil on canvas
72.5 x 69 cm (28 ⅝ x 27 ¼ in.)
Tate Modern, London, UK

A **PIONEER OF ABSTRACT** art, Piet Mondrian (1872–1944), started his career painting landscapes until he developed an interest in the mystical principles of theosophy and began radically simplifying his paintings to create non-representational art. He became an important part of the De Stijl group, which means 'The Style', and the group advocated a way of life as well as a style of painting. His influence on art and design of the 20th century came as much from his theoretical writing as from his painting.

Mondrian was born Pieter Cornelis Mondriaan in Amersfoort in the Netherlands; he dropped an 'a' from his surname after 1906. From 1892 to 1897, he studied painting at the Rijksakademie van Beeldende Kunsten (Royal Academy of Fine Arts) in Amsterdam. He painted local landscapes reflecting a variety of styles including Symbolism and Impressionism, as well as the traditional Dutch painting style of The Hague School. In 1908, Mondrian became fascinated with theosophy, a form of religious mysticism based on Buddhist and Brahmin teachings. In 1911, he moved to Paris, where he experimented with a form of Cubism. He returned to the Netherlands for the duration of World War I. There he commenced reducing elements in his paintings until they only contained straight lines and pure, flat colours. In 1915, he met Theo van Doesburg and within two years, they and the architects J. J. P. Oud and Jan Wils were collaborating on a journal they called *De Stijl*. Along with several other artists and designers, they formed a group with the same name. Through De Stijl, Mondrian explored his theories about art, which were based on his philosophical beliefs about the spiritual order inherent in the world. Back in France in 1919, he developed Neo-Plasticism by simplifying the subjects of his paintings to the most basic elements. These paintings consisted of a white ground, upon which he painted a grid of vertical and horizontal black lines and the three primary colours.

Mondrian's *Composition with Yellow, Blue and Red* is an example of his constant modification and refinement of the elements of his paintings. He started painting it in Paris in 1937 and completed it in New York in 1942.

Counter-Composition VI, **Theo van Doesburg, 1925, oil on canvas, 50 x 50 cm (19 ⅝ x 19 ⅝ in.), Tate Modern, London, UK**

Dutch artist Theo van Doesburg (1883–1931) had his first exhibition of paintings in 1908 in The Hague. In an attempt to make a universal art beyond everyday appearances, he reduced his images to essential elements and abandoned subject matter from 1916. Although his work appears to be calculated, he achieved visual balance and harmony through intuition rather than mathematics. In 1917, he established the De Stijl group and periodical. He painted his first *Counter-Composition* in 1924, which uses diagonal grids to create a dynamic tension between the rectilinear format of a canvas and its composition.

② GRID SYSTEM

Between 1911 and 1919, Mondrian's art progressed towards greater reduction and objectivity. For this work and for many of his other paintings, he used a grid system based on eight equal squares like a chessboard. He drew it with charcoal and a ruler. His rigorous use of straight lines were for him an expression of extreme purity.

③ HORIZON LINES

Mondrian used his grid pattern to create a rhythmic sequence of squares and rectangles. Using a ruler and ribbons of transparent paper, he painted the four main horizon lines as the first step of his painting, and based their placement on the eight-square divisions of the grid.

① PREPARING THE CANVAS

Mondrian used iron tacks and tape to stretch a finely woven linen canvas around the frame. Then he painted an even layer of commercially bought size (a glutinous substance based with wax applied to seal a porous surface). This smoothed the canvas ready for his applications of paint.

4 DYNAMIC TENSION

Once his four horizontal lines were dry, Mondrian painted eight vertical lines. At this point, he made adjustments to ensure that the composition was harmonious, and that the lines suggest dynamic tension – something that could not be decided through mathematical calculations but which relied on his instincts and creative ability.

6 COLOUR

Once he was sure that his black grid was balanced, Mondrian brushed a thin mixture of cadmium yellow vertically in the top left corner. He then brushed thicker cadmium red paint onto the square lower down and to the right, and then added the tiny strip of cadmium red on the lower right. Finally, he painted the strip of cobalt blue near the lower left side.

5 PURITY

Mondrian's creation of complete abstraction is outstanding in the history of modern art, while his search for harmony and purity in his painting can be seen to have evolved from the austere, puritan tradition of Dutch Calvinism. His work was also inspired by his theosophical beliefs, as he continually strove for *schoon*: a Dutch word meaning both 'clean' and 'beautiful'.

7 APPLICATION

Mondrian's methodical approach expresses his utopian ideal of universal harmony in all the arts. Although this painting appears flat, there are differences in the textures of various elements. The black stripes are the flattest, while the areas with colour have visible brushstrokes. The white spaces are painted in layers, with brushstrokes painted in different directions.

Morning Ride on the Beach, Anton Mauve, 1876, oil on canvas, 43.5 x 68.5 cm (17 ¼ x 27 in.), Rijksmuseum, Amsterdam, Netherlands

In direct comparison with the French Barbizon School, The Hague School consisted of a group of Dutch Realist painters who worked in The Hague between 1860 and 1900 capturing local landscapes and the activities of local workers. Anton Mauve (1838–88) was a leading member of The Hague School. He was also a great colourist and teacher of his cousin-in-law Van Gogh, whom he encouraged to become a professional artist. Most of Mauve's paintings portray people and animals in outdoor settings. His *Morning Ride on the Beach* shows riders on the seashore on a summer day. Mondrian was particularly inspired by The Hague School artists and his early landscape paintings followed their approach.

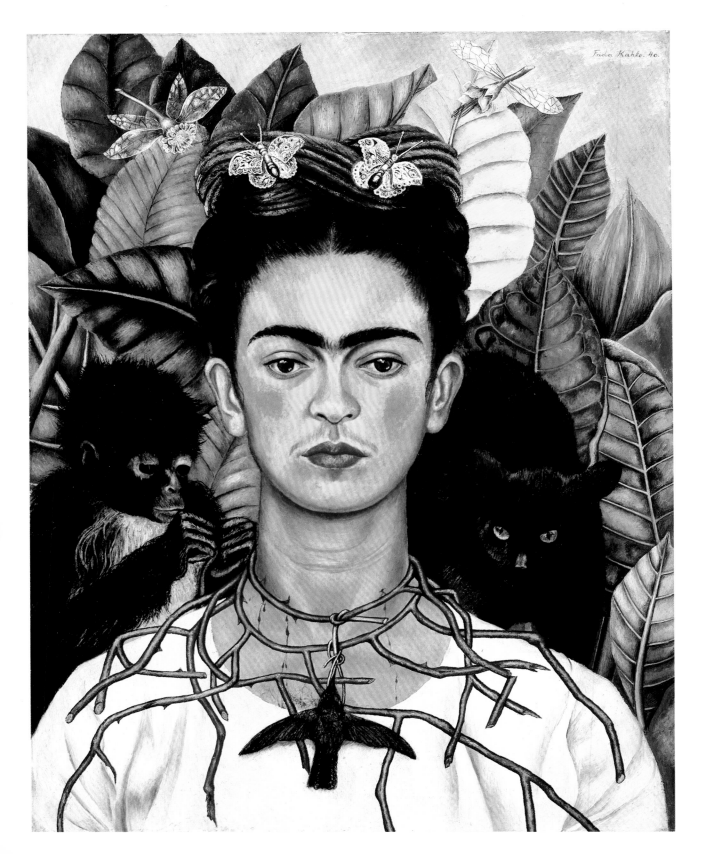

SELF-PORTRAIT WITH THORN NECKLACE AND HUMMINGBIRD

FRIDA KAHLO

1940

oil on canvas
61 x 47 cm (24 ⅛ x 18 ½ in.)
Harry Ransom Center, Austin, Texas, USA

FRIDA KAHLO (1907–54) IS renowned as much for her colourful art as for her tragic life. One of the most famous female painters, her work was influenced by traumatic physical and psychological events, and her own German-Mexican identity. Although she is sometimes called a Surrealist because of her often disquieting themes, her art was always blatantly autobiographical; she was never interested in painting dreams or the subconscious.

Born on the outskirts of Mexico City to a German father and a Spanish-Indian mother, she grew up in a strict household. At the age of six she contracted polio and had to remain in bed for nine months. This damaged her right leg permanently so she walked with a limp. Her father introduced her to painting and the writings of philosophers such as Goethe, Friedrich Schiller and Arthur Schopenhauer. While at school, she watched the Mexican artist Diego Rivera paint a mural. Three years later, at the age of eighteen, she had a near-fatal accident when a tram crashed into the bus she was riding. Sustaining multiple fractures, she never fully recovered and underwent more than thirty operations during her life. She began painting small autobiographical portraits when confined to her bed. She admired Rivera and in 1928 she approached him to ask his advice on pursuing a career as an artist. A year later, they married. She started painting indigenous themes and dressing in a traditional Mexican Tehuana costume. Kahlo's life remained difficult because Rivera had a violent temper and was unfaithful. In 1939, she and Rivera divorced, although they remarried the following year. Kahlo became increasingly ill and her right leg was amputated in 1953. That same year, she had her first solo exhibition in Mexico. However, she was so ill she had to be taken to the show's opening night in an ambulance. There, she joined in the celebrations from her four-poster bed that she had sent ahead to the gallery. She died in 1954, aged only forty-seven.

Kahlo painted this self-portrait while she was divorced from Rivera and after she had an affair with the Hungarian-born US photographer Nickolas Muray (1892–1965), who also bought this painting from her.

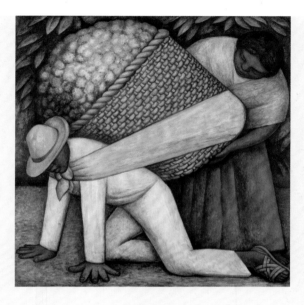

The Flower Carrier, **Diego Rivera, 1935, oil and tempera on masonite, 122 x 121 cm (48 x 47 ¾ in.), San Francisco Museum of Modern Art, California, USA**

Kahlo was twenty years younger than Diego Rivera (1886–1957) and she was his third wife. Their volatile relationship is as well known as his significant contribution to the Mexican Muralism movement. Mexican Muralism began in the 1920s when Rivera and two other Mexican artists, José Clemente Orozco (1883–1949) and David Alfaro Siqueiros (1896–1974), painted murals on public buildings featuring social and political messages in an effort to reunify the country after the Mexican Revolution. This painting of a man struggling with an oversized basket of flowers strapped to his back and a woman loading it, represents the burdens of the working class in the modern, capitalistic world. The man on all fours is unable to see the beauty of the flowers as he tries to carry them to market.

② MONKEY

The little black monkey on Kahlo's right shoulder references her pet monkey. The animal was a gift from Rivera, so it is often perceived as representing him. The monkey is playful in nature and it pulls her necklace so the thorns pierce her skin – it also represents her miscarriages and the child she could not have because of her ill health.

① HUMMINGBIRD NECKLACE

On Kahlo's necklace is a dead, black hummingbird; the shape of its outstretched wings echoes the shape of her eyebrows. In Mexican folk tradition, dead hummingbirds were used as charms to bring good luck, so it suggests hope after her painful divorce. In Aztec culture, which she often also explored, a hummingbird is a symbol associated with the god of war, Huitzilopochtli. The thorns on her necklace dig into her skin, making her bleed; this alludes to her physical pain and recalls Christ's crown of thorns at the Crucifixion.

③ BLACK CAT

The entire work represents Kahlo's pain over her divorce from Rivera. The black cat on her left shoulder is a sign of her depression because in her culture black cats are omens of bad luck and death. This cat is menacing as it appears to be watching the hummingbird and waiting to pounce on it. The cat is pulling the necklace tighter, making her bleed even more.

④ BUTTERFLY

Beneath her characteristically heavy black eyebrows, Kahlo's eyes are emotionless, staring directly at viewers. Behind her are lush green and yellow tropical leaves. The butterflies in her hair represent both Christ's Resurrection and her own personal resurgence, which she hoped for after splitting up with Rivera. She once said: 'I have suffered two grave accidents in my life, one in which a tram knocked me down... The other... is Diego.'

It is impossible to separate Kahlo's life from her work. Her paintings are her autobiography, which is why her art is so different from that of her contemporaries. When asked about her painting methods, she replied: 'I put on the canvas whatever comes into my mind.'

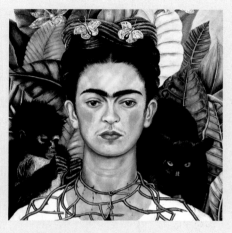

⑤ INFLUENCES

Although Kahlo's work is highly individual, numerous historical, artistic and cultural influences helped to shape it. These include Mexican folk art, Renaissance and pre-Columbian art, as well as her father's profession as a photographer. She was also inspired by several Old Masters, including Velázquez, El Greco, Leonardo and Rembrandt.

⑥ NATURE

Kahlo's distinctive self-portraits, surrounded by exotic animals and vegetation, are reminiscent of Rousseau's paintings. The bright colours and exaggerated textures of the leaves reflect her interest in indigenous Mexican art. The yellow leaf is reminiscent of a halo, as if she is a holy figure. The dragonfly is a Christian symbol of resurrection.

⑦ COMPOSITION

With no set painting method and no boundaries, Kahlo's individualism is a strong part of her work. Yet this is a conventional portrait composition, with her head and shoulders almost in the centre of the canvas, looking directly out at viewers. The central position of the face recalls religious icons and the small devotional paintings known as retablos.

Detail from *Great Goddess of Teotihuacán*, artist unknown, *c.* 100 BC–AD 700, painted stucco, 110 cm (43 ¼ in.) high, Palacio de Tetitla, Teotihuacán, Mexico

Kahlo was profoundly affected by the Mexicanidad movement, which was a form of nationalism that aimed to re-establish Mexican pride and culture, including the revival of indigenous art. As a result, her style became more primitive. Kahlo drew inspiration from various cultures that settled on the central plateau surrounding modern-day Mexico City to form the Teotihuacán civilization, which reached its peak from *c.* 292 BC to AD 900. Teotihuacán city was important to the Aztecs. They considered the city sacred and created colourful, powerful works of art that influenced Kahlo. Their paintings often depict war, symbols, animals and gods.

VOX ANGELICA

MAX ERNST

1943

oil on canvas
152.5 x 203 cm (60 x 79 ⅞ in.)
private collection

ONE OF THE LEADING Dadaists, then Surrealists, who drew imagery from his unconscious by methods involving chance and free expression, Max Ernst (1891–1976) was a prolific painter, sculptor, graphic artist and poet.

Ernst was born near Cologne, Germany, one of nine children. He learnt to paint with his father, who was a strict disciplinarian. On his father's insistence, he entered the University of Bonn to study philosophy. He discovered the theories of Sigmund Freud and Nietzsche, which later greatly affected his art. At the start of World War I, he was conscripted into the German army. He emerged from military service in 1918, deeply traumatized and highly critical of conventional values; he turned to art to express his anxieties and in an attempt to alleviate them. With no training, but influenced by Van Gogh, Macke, De Chirico and Klee, Ernst began painting dreamlike fantastic imagery that ridiculed social and artistic conventions. In 1919, he founded the Cologne Dada group with the artists Arp and Johannes Baargeld (1892–1927). That same year, he produced his first collages, in which he combined irrational elements and humour. In 1922, he moved to Paris, where his friendship with the writer André Breton and the poet Paul Éluard led to his participation in the Surrealist movement. One of the first artists to investigate the psyche in art, Ernst focused on the unconscious mind through Freudian methods of free association, which in art became called automatism. This was writing or drawing without consciousness and Ernst produced streams of words, images and collages directly from his unconscious mind. Through automatism, he developed the techniques of frottage (rubbing) and grattage (scraping). At the outbreak of World War II, he was interned in France. After his release, the Germans occupied France and he was arrested by the Gestapo. He managed to escape and in 1941 went to the United States as a refugee.

The title of this painting refers to Ernst's flight from Nazi persecution in France as well as referencing a 16th-century altarpiece. Closely autobiographical, it reveals his personal traumas, while bringing order and shape to his memories.

② SERPENT

Ernst assembled these canvases to resemble the structure of Grünewald's *Isenheim Altarpiece* (c. 1512–16; see pp. 80–3). The painting's title '*Vox Angelica*' is named after part of the altarpiece: *The Concert of Angels*. Here, Ernst refers to the Bible as a serpent coils around the Tree of Knowledge. Above, at night, the serpent is with a small bird and a female nude.

① EIFFEL TOWER AND EMPIRE STATE BUILDING

Ernst made *Vox Angelica* while he was in New York and it represents a culmination of his pioneering techniques. It is like a diary of his work to date and depicts important moments of his life. He was aged fifty-two when he began the painting, which consists of four canvases divided into fifty-two rectangles. The Eiffel Tower symbolizes Paris, where he lived for nearly twenty years, and the Empire State Building represents New York, where he lived from 1941. Between them is a blue area produced using his oscillation technique that consisted of swinging a perforated tin can filled with paint over the canvas to create a pattern.

③ STRUCTURE

Despite being a record of Ernst's experiences – which included being interned in France in World War II and forced to flee to the United States – this is a hopeful work. Symmetrically structured, it is composed of contrasts of light and dark, and of blue, yellow and brown, with touches of pale green and vivid red. It is a tribute to Mondrian's gridlike paintings, such as *Composition with Yellow, Blue and Red* (1937–42; see pp. 368–71).

④ FOREST SCENE

This gloomy forest scene resembles the forbidding growths, menacing forms and sinister atmosphere of his dramatic forest paintings of the 1920s. The horse leaping over the trees recalls elements of his automatic writing. Although Ernst's art was never completely non-objective, he was moving towards greater abstraction.

Ernst employed a wide range of techniques in this work, including frottage or rubbings of textured surfaces. He also used grattage, which involves applying a layer of oil paint over a surface and then scraping off the paint to create an interesting texture.

⑤ WOODGRAIN

These dividing panels represent woodgrain and recall the summer of 1925, when Ernst stayed in Brittany, France. Woodgrain was on the floor of his hotel there and he invented his frottage technique during his stay. Across the painting, Ernst has pictured geometric instruments including compasses and protractors, which were often used by the Dadaists and contrasted with traditional fine-art practice.

⑥ STRIATIONS

This compartmentalized painting is Ernst's personal retrospective. These red and orange panels imitate the geological striations of the land, while the blue panel beneath suggests the sea and sky he crossed to reach the United States. In-between, Ernst used the grattage technique he invented of scratching into wet paint to suggest the dense German forests he recalled from his youth.

⑦ COLLAGE

The bright yellow and red panel creates equilibrium with the darker, more sombre elements of the painting. It suggests heat, daylight, sun and hope. The elements in the collage recall Germany before World War I as well as emblems of Dadaism and Ernst himself. He said: 'Even though you rarely find a faithful representation of man in my paintings, it can be said that everything there is anthropomorphic.'

Detail from *Woman in a Green Jacket*, August Macke, 1913, oil on canvas, 44 × 43.5 cm (17 ⅜ × 17 ⅛ in.), Museum Ludwig, Cologne, Germany

One of the leading members of German Expressionist group the Blue Rider, August Macke (1887–1914) expressed his feelings through shape and colour. Between 1907 and 1912, he made frequent trips to Paris, where he absorbed various artistic influences, including Fauvism, which persuaded him to use bright, non-naturalistic colours, with broad brushstrokes and strong angularity. Marc and Kandinsky were also important influences, but he was especially inspired by Robert Delaunay. In turn, Macke was highly influential to Ernst. Macke painted *Woman in a Green Jacket* during a stay at Lake Thun, Switzerland in 1913. It is an example of his harmonious arrangement of form and use of luminous colour to express mood.

AUTUMN RHYTHM

JACKSON POLLOCK

1950

enamel on canvas
266.5 x 526 cm (105 x 207 in.)
Museum of Modern Art, New York, USA

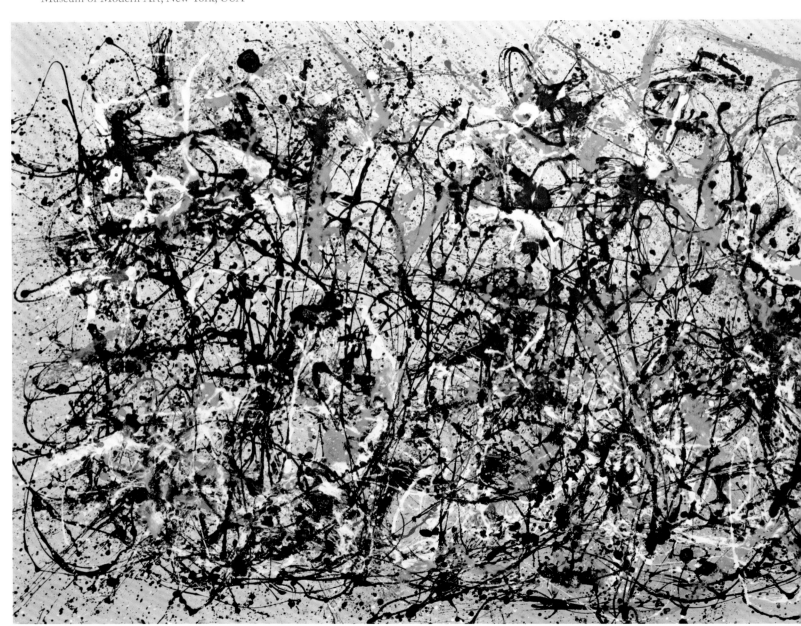

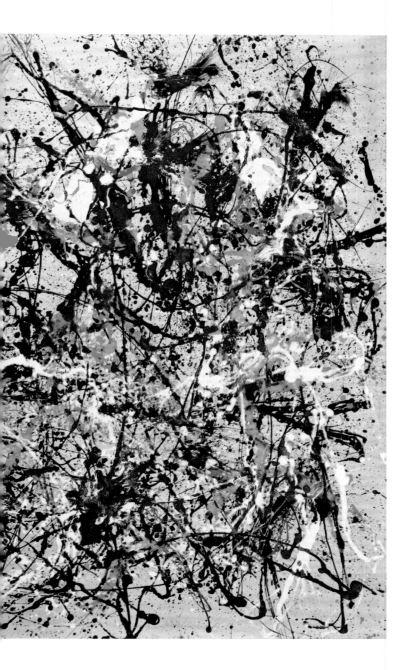

JACKSON POLLOCK (1912–56) WAS a major figure in the Abstract Expressionist movement that emerged in the United States in the 1940s and 1950s, which was characterized by gestural marks and impressions of spontaneity. Although reclusive and an alcoholic, Pollock became celebrated during his lifetime for his drip paintings that were inspired by Surrealist automatism and Ernst's oscillation technique.

Although born in Wyoming, Pollock moved around the south-west of the United States throughout his childhood. At school in Los Angeles, he was introduced to theosophical ideas, which prepared him for his later interests in Surrealism and psychoanalysis. He moved to New York in 1930, where he studied at the Art Students League, and was fascinated by the work of the Mexican muralists Orozco and Rivera. From 1935, he worked for the Works Progress Adminstration's (WPA) Federal Art Project. The next year, he joined an art workshop set up by Siqueiros. Pollock's art at this time reflected numerous influences, including Mexican Muralism and Surrealism. After he finished working for the WPA in 1942, his paintings became totally abstract as he began creating large, intricately interwoven patterns of vivid colours. By the late 1940s, he was throwing, flicking and pouring paint onto huge canvases on the floor.

The Federal Art Project

In the mid 1930s, the United States was in the grip of the Great Depression. The WPA Federal Art Project was set up in 1935 and employed artists to create art for schools, hospitals and libraries. The project sustained some 10,000 artists and ran until 1943.

② CANVAS

Action painting was as much about the process as about the finished product. As Pollock could not afford artists' canvases he bought large rolls of upholsterers' canvas, which was cheaper. To start this work, he laid the vast sheet of raw, unprimed canvas flat on the floor. He began the painting by laying down black enamel in a network of splashes, splatters and dribbles, applying the paint from all directions.

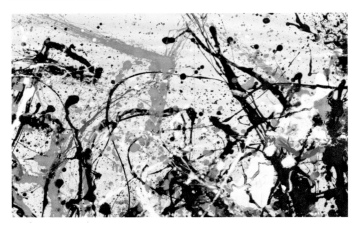

③ UNLIMITED ACCESS

Pollock constantly moved around the unprimed, unstretched canvas on the floor. He found this unlimited access extremely liberating as he walked around it, across it or stood over it, dripping paint from sticks or hardened brushes, or pouring, spattering or throwing it. In his fight against alcoholism, he followed his analyst's advice to free his unpredictable inner being, in keeping with the theories of the Swiss psychiatrist Carl Jung.

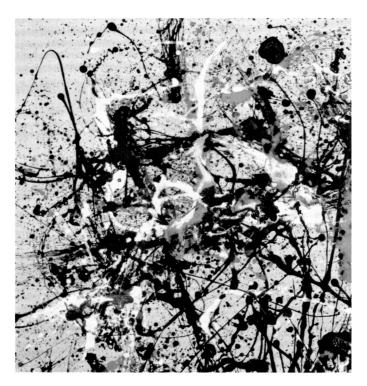

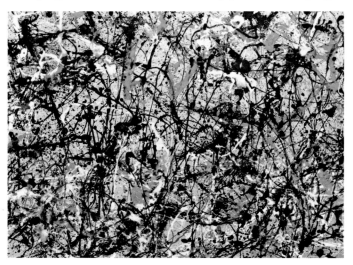

① DRIP METHOD

This area clearly shows Pollock's drip method. To achieve his spontaneous effect, he threw, splattered and dribbled paint onto the surface. Yet there is also a controlled element of application. Largely painted from right to left, the black enamel is used to suggest a flowing movement, while the brown paint creates a sense of background. The raw canvas showing through provides a sense of texture.

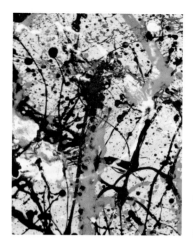

④ GESTURE

The flowing web of splattered lines reveals Pollock's wide gestures and unconscious moves as he lost himself in the painting. Many of the marks were made by Pollock dipping a small stick, household paintbrush or trowel into his paint and then quickly moving his wrist, arm and whole body, allowing the paint to fall in rhythms over the surface.

⑥ INTUITION

With its network of lines and skeins of paint, this painting might appear chaotic. Yet Pollock painted intuitively, creating a rhythm with some repeated patterns and shapes that are fairly appealing. While this was not deliberate, mathematicians have analysed his paintings and found fractals, which are the underlying ratios found in nature.

⑤ PAINT

Pollock used gloss enamel paints, which were easily available and more fluid than oil paints, but he still thinned them to enable greater flexibility. They also dried relatively quickly, so he could apply layers rapidly. This central area shows the interlaced mesh of the extremely restricted palette. In some places, the paint was applied so thickly that it formed pools that rippled as it dried.

⑦ LINES AND CURLS

A few years earlier, Pollock realized that flicking his paint quickly created straight lines, while dripping or flicking it slowly resulted in graceful curls and curves. Pollock's radical abstraction heralded a new freedom for painting Originally, he called the work *Number 30*, believing that titles affect viewers' preconceptions. He once said: 'There is no accident. . .a painting has a life of its own.'

Detail from *Water-Lilies – Setting Sun*, Claude Monet, *c.* 1915–26, oil on canvas, 200 x 600 cm (78 ¾ x 236 ¼ in.), Musée de l'Orangerie, Paris, France

The Impressionist artist Claude Monet translated the forms he observed in nature into paintings of light, colour and optical sensation. He worked intuitively as he applied paint to his monumental late canvases with painterly brushstrokes and expressive gestures. The scale, colours, textures, optical effects and abstractions of his water-lilies at the Musee l'Orangerie can be compared to Pollock's free style.

MOUNTAINS AND SEA

HELEN FRANKENTHALER

1952

oil on canvas
220 x 298 cm (86 ⅝ x 117 ¼ in.)
Helen Frankenthaler Foundation, New York, USA
(on extended loan to the National Gallery of Art, Washington, DC, USA)

ONE OF THE MOST influential artists of the mid 20th century, Helen Frankenthaler (1928–2011) was an Abstract Expressionist painter with a free, distinctive style featuring luminous colour, large-scale canvases and heavily diluted oils or acrylics. Influenced early on by artists including Pollock, Franz Kline (1910–62) and Robert Motherwell (1915–91), she is classed as a Colour Field painter, a part of Abstract Expressionism. Her distinct approach, especially her soak-stain technique, was created by pouring turpentine-thinned paint onto canvas, producing clear washes of bright colour that appear to merge with the canvas and reject all suggestion of three-dimensional illusionism.

Frankenthaler studied with a variety of artists, including Mexican painter Rufino Tamayo (1899–1991) and, in 1950, German-born painter Hans Hofmann (1880–1966). *Mountains and Sea* was the artwork in which, at the age of just twenty-three, she invented her method of painting that generated a new phase of Abstract Expressionism.

Always inspired by the landscape, in August 1952, Frankenthaler holidayed on Cape Breton Island in Nova Scotia, Canada. Working freely, she painted numerous small landscapes from direct observation in watercolours and oils on paper. When she began this large work in October, her memories of the spectacular views of Nova Scotia and her studies of them remained paramount in her mind. Although influenced by Pollock's drip method, Frankenthaler wanted to work differently. Unlike Pollock, who used enamel paint, she employed diluted oils and distinctive methods of application. She pioneered her soak-stain techniques in this painting, working on the floor and using a variety of paint tools to manipulate her pools of pigment. When the art critic Clement Greenberg brought the painters Morris Louis (1912–62) and Kenneth Noland (1924–2010) to her studio to see the painting, they became enthused and experimented with the technique themselves, which led to further developments in Colour Field painting that had started with Mark Rothko (1903–70). Louis later declared that Frankenthaler's work was the 'bridge between Pollock and what was possible'.

10/26/52

IN DETAIL

② THE INFLUENCE

Pollock's enamel paints remained on the surface of his canvases after they dried, but Frankenthaler's extremely thinned oil paints soaked into the canvas creating transparent, luminescent, veil-like compositions and natural, soft-looking colour. She also used far fewer layers and allowed the negative spaces – or shapes of raw canvas showing between colours – to be part of the work. Her natural spontaneity and sense of colour create a balanced, calming image and unlike Pollock, she references the real world.

③ THE COLOURS

While Frankenthaler does not attempt to convey depth or texture, her colour placement encourages viewers' eyes to move around the composition, through the large, open washes of colour. Misty, and resembling watercolour washes, her palette includes cobalt blue and yellow ochre, and probably alizarin crimson and viridian.

① THE INVENTION

In October 1952, Frankenthaler took a large, unprimed canvas and tacked it to her studio floor. Knowing roughly what she wanted to achieve, she made a few sweeping, gestural marks across the canvas with charcoal. Next, she diluted various clear oil paint colours with turpentine in separate coffee cans and then poured these individually, directly onto the canvas. Although aware of her general aim and the overall appearance she was trying to achieve, she worked intuitively. At the end of the afternoon, she climbed on a ladder and looked down at her painting. She later said that she was: 'sort of amazed and surprised and interested'.

④ THE LANDSCAPE

Although this image is an abstraction, it is not completely abstract because the focus is the landscape. The pared-down forms are informed by the Canadian scenery. Suggestions of sky, water and forest can be recognized between the negative space or areas of bare canvas. It is the sense of the place on a fine summer's day. The diluted cobalt blue in the centre top suggests a mountain peak, while to the centre-right, the deeper blue implies the sea. Green and pink suggest foliage and flowers. The ochre triangular shape could be a sail on the still, blue sea.

⑤ PAINT APPLICATION

After first pouring thin paint onto the canvas in varying amounts, Frankenthaler then used window wipers and sponges to push the paint around. She also lifted and tilted the canvas to make the paint move and form greater concentrations in certain areas. Drips and dots indicate real elements such as sea spray or areas of land. In this way, Frankenthaler's application was quite controlled and more deliberate than several other Colour Field painters. Although she worked instinctively, she also had a conscious purpose.

⑥ ABSTRACTION

Frankenthaler thought that abstraction enabled viewers to respond more individually than figurative art. Years later, she explained: 'When you first saw a Cubist or Impressionist picture, there was a whole way of instructing the eye or the subconscious. Dabs of colour had to stand for real things; it was an abstraction of a guitar or a hillside. The opposite is going on now. If you have bands of blue, green and pink, the mind doesn't think sky, grass and flesh. These are colours and the question is what are they doing with themselves and with each other.'

Pompeii, Hans Hofmann, 1959, oil on canvas, 214 x 132.5 cm (84 ¼ x 52 ¼ in.), Tate Modern, London, UK

Pioneering artist and teacher Hans Hofmann (1880–1966) emigrated from Germany to the United States in 1930 and ran an art school in New York from 1934 to 1958. He had already spent several years in Paris before World War I and therefore was significant in spreading European modernist ideas to the United States. While he influenced Frankenthaler as his pupil, she also inspired him. His style represented a fusion of methods and this painting, with its strong juxtapositions of coloured rectangles, explores ways of seeing colours. He called the effects he created 'push and pull'.

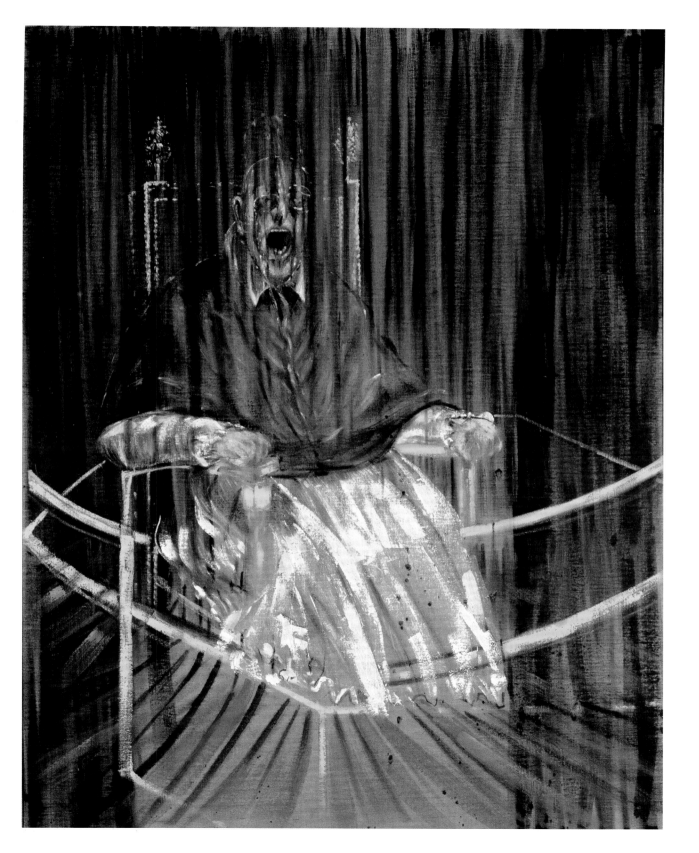

STUDY AFTER VELÁZQUEZ'S PORTRAIT OF POPE INNOCENT X

FRANCIS BACON

1953

oil on canvas
152 x 118 cm (59 ⅞ x 46 ⅜ in.)
Des Moines Art Center, Iowa, USA

BORROWING INSPIRATION FROM SURREALISM, film, photography and the Old Masters, Francis Bacon (1909–92) developed a distinctive style that made him one of the most widely recognized exponents of figurative art in the 1940s and 1950s. His subjects were always violently distorted, presented as isolated souls tormented by existential dilemmas.

Born to an English family in Dublin, he was named after his famous ancestor, the 16th-century English philosopher and scientist Francis Bacon. His childhood was impaired by asthma, which remained with him throughout his life. With the outbreak of World War I in 1914, his father took the family to London and joined the Ministry of War; they divided the postwar years between London and Ireland. Bacon's family relations were difficult as he dealt with his emerging homosexuality. In 1926, his father banished him after catching him trying on his mother's clothes. Surviving on a small allowance, he lived the life of a vagrant, travelling around London, Berlin and Paris. Impressed by an exhibition of Picasso's work he saw in Paris in 1927, he began to draw and paint, and also attended various free academies. The following year he settled in London, where he worked as a modernist furniture and interior designer. He also painted with Roy de Maistre (1894–1968), an Australian artist who experimented with abstraction. Because of his asthma, Bacon was exempt from military service during World War II. He spent 1941 painting in Hampshire before returning to London where he befriended Lucian Freud and Graham Sutherland (1903–80). Later, he described these years as being the start of his career.

Although largely self-taught, Bacon was fairly traditional in his approach and referred to other artists for inspiration; as well as Velázquez, these included Picasso, Van Gogh, Rembrandt, Titian, Goya, Delacroix and Grünewald. His own personal experiences attracted him to portraiture and other figurative work, and his paintings convey a striking emotional and psychological intensity. This response to Velázquez's *Portrait of Pope Innocent X* (right) is one of a series of more than forty-five variants he created without ever seeing the original painting, even when visiting Rome in 1954.

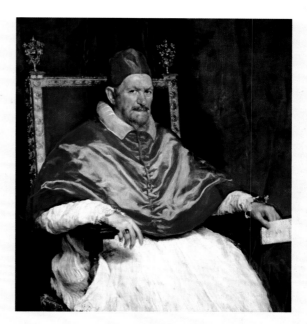

Detail from *Portrait of Pope Innocent X*, Diego Velázquez, 1650, oil on canvas, 141 x 119 cm (55 ½ x 46 ⅞ in.), Doria Pamphilj, Rome, Italy

Velázquez had known Giovanni Battista Pamphilj during his years as a nuncio (religious representative) in Madrid in the 1620s. In 1644, Pamphilj became Pope Innocent X, and while Velázquez was in Rome from 1649 to 1651, he was granted the honour of painting the pope's portrait. Set against a heavy damask background, Velázquez's depiction of the fabrics and surfaces, including silk, linen, velvet and gold, and play of light was inspired by Raphael and Titian. Using shades of red, the pope's clothing dominates the scene, infusing it with an atmosphere of power and fear. Even though the pope appears angry, he was delighted with the portrait, saying it was '*troppo vero*', or 'too true', and he presented Velázquez with a gold medal on a chain.

IN DETAIL

① FACE

Transparent curtains appear to fall through the pope's face and he is missing the top of his head. He emits a scream that removes all connotations of his power and authority. The face also echoes a screaming nurse shot by soldiers in the film *Battleship Potemkin* (1925) by Soviet director Sergei Eisenstein. Bacon explained: 'Another thing that made me think about the human cry was a book I bought when I was very young from a bookshop in Paris, a second-hand book with beautiful, hand-coloured plates of the diseases of the mouth, beautiful plates of the mouth open and of the examination of the inside of the mouth. . . . I attempted to use the *Potemkin* still as a basis on which I could also use these marvellous illustrations of the human mouth.'

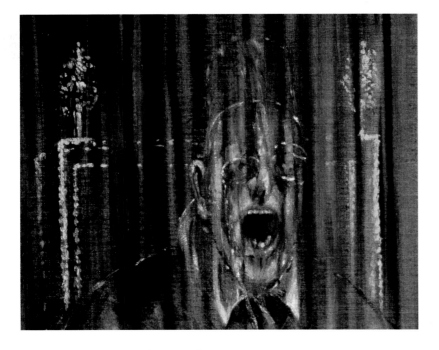

② GLASS BOX

The notion of a glass box or booth surrounding the pope creates a sense of human vulnerability. One of Bacon's favourite books was Nietzsche's *The Birth of Tragedy* (1872), which discusses the death of God, and includes the words: 'enclosed in the wretched glass capsule of the human individual'. Painted not long after World War II, it could be that the pope is being tried as a war criminal. Bacon said that his use of such cagelike structures was 'an attempt to lift the image outside of its natural environment'.

❸ HANDS

In Velázquez's painting, the pope's hands are elegant and composed. Here, they are roughly portrayed, gripping the seat in apparent terror. Bacon said he had nothing against popes, he merely sought 'an excuse to use these colours, and you can't give ordinary clothes that purple colour without getting into a sort of false Fauve manner.'

Motion and gesture fascinated Bacon and most of his work was an attempt to describe movement by the shape and direction of his brushstrokes. He also sought to express the human condition and used distortions to depict sensations rather than realities.

❹ COLOUR

Bacon exchanged Velázquez's red cape for purple, which is juxtaposed with its complementary colour of yellow, adding to the sense of discomfort. The white cassock is almost ghostlike and looks blood-spattered. Velázquez's gilded and stately throne has become a bright yellow chair, which all adds to the unsettling impression, while the dark colours of the background lend a nightmarish tone.

❺ METHOD

From 1947, Bacon painted directly onto the raw and unprimed side of his canvases. Because his oil paints immediately sank into this coarse side of the canvas, he could not alter or wipe away any marks. For him, any mistakes added to the distortion and expression of the work. This method of painting also meant he could create flat areas of colour that are devoid of brushstrokes.

❻ BRUSHMARKS

Vertical brushstrokes dominating this work have the effect of making the pope's head appear to be sucked upwards. The elongation adds to the sense of tension, while fanned marks at the bottom of the work and around the fingers suggest the desperate grip of the pope to remain in the chair. The broken yellow paint around him implies that the pope is trapped inside the painting.

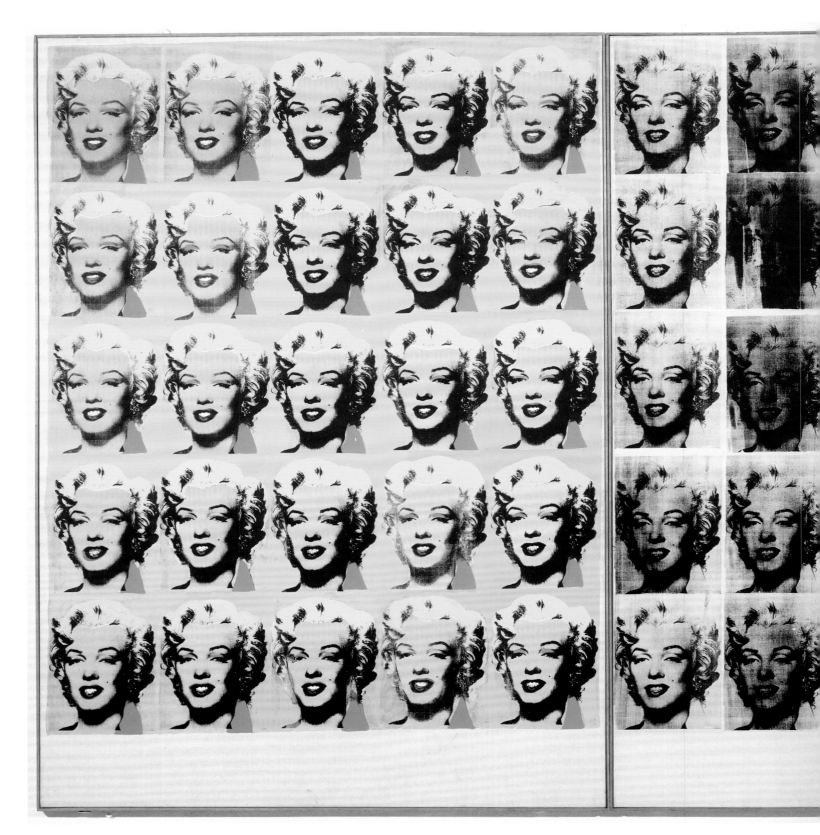

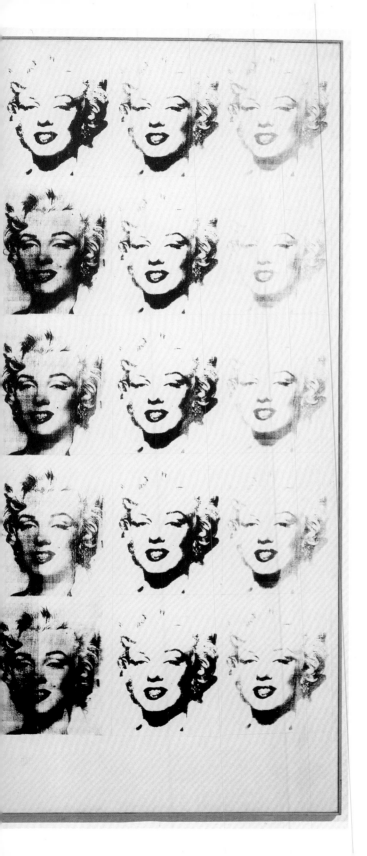

MARILYN DIPTYCH

ANDY WARHOL

1962

acrylic on canvas
205.5 x 289.5 cm (80 ⅞ x 114 in.)
Tate Modern, London, UK

ORIGINALLY A SUCCESSFUL COMMERCIAL artist, Andy Warhola (1928–87) became the internationally recognized, flamboyant Pop artist Andy Warhol. He challenged basic assumptions of what art is, and what materials, techniques and sources should be used, blurring the boundaries between high and low art.

The third son of Czechoslovakian parents, Warhol was born in Pittsburgh, Pennsylvania. He studied pictorial design at the Carnegie Institute of Technology from 1945 to 1949. On moving to New York, he worked as a commercial artist until 1960. Then he began making silkscreen prints, photographs and three-dimensional work, based on newspaper front pages, advertisements and other mass-produced images, including household goods such as Campbell's Soup cans, Coca-Cola bottles and Brillo pads, and celebrities including actress Marilyn Monroe and singer Elvis Presley. From his silver-painted studio he called The Factory, he expanded into performance art, filmmaking, sculpture and books, always exploiting and exploring consumerism and the media.

In 1962, Warhol held his first solo Pop art exhibition in New York at the influential Stable Gallery. It included his prints *Campbell's Soup Cans* (1962) displayed on a shelf to resemble a supermarket, visually expressing the culture of mass consumption that was seizing the US public. Using assistants, his detachment in the production of the prints also reflected the ambivalent nature of US society at the time: wealthy or poor, everyone consumed the same products, but class distinctions nevertheless remained firm. At the same show, he exhibited this work featuring Monroe, which fuses two themes: the cult of celebrity and death. The former is emphasized on the colourful panel, while the black and white panel that blurs and fades suggests mortality. Made of two canvases, the work references Christian diptychs made for the worship of religious icons, but Warhol has shown Monroe as a grotesque product of the media and a victim of her fame. Warhol's visual commentary on society's obsession with celebrity and the expansion of mass media was prophetic, and he initiated new attitudes towards art and artmaking that continue to this day.

② LIPS

Although this image was made with a mechanical procedure, Warhol ensured that the fifty reproductions of Monroe's face are not uniform, or perfect. Her naturally seductive lips have been covered with a block of red, slightly different on every face. Most are printed slightly off-register. About his repetitions, Warhol said: 'The more you look at the same exact thing, the more the meaning goes away, and the better and emptier you feel.'

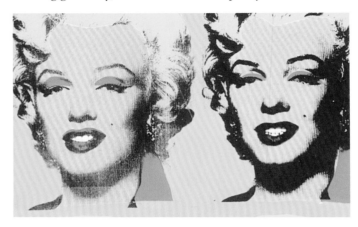

③ HAIR

Deliberately making Monroe's famed peroxide blonde hair a garish yellow, Warhol creates a sense of the unreal. The bright yellow clashes with the pink of her skin; the flatness of the paint is emphasized with black tonal marks. The hair looks artificial, like a wig. Unlike a commercial-art illustration that had to be perfect, Warhol left any mistakes or clogged paint on the final image thus emphasizing its artificiality.

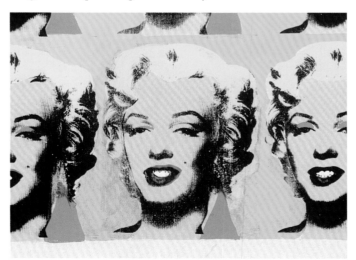

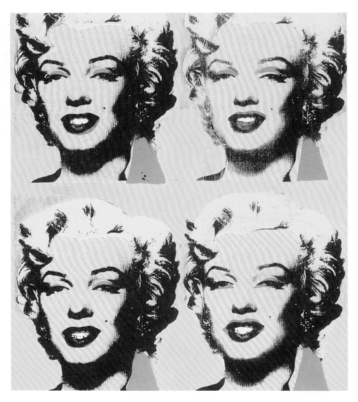

① EYES

In the four months after the tragic early death of Monroe in August 1962, Warhol made more than twenty silkscreen images of her, all based on the same black and white publicity photograph from her film *Niagara* (1953). Here, in manipulating the source photograph, Warhol has exaggerated her heavy eye make-up. On her pink skin, a crude slab of turquoise parodies the glamorous star's celebrity persona.

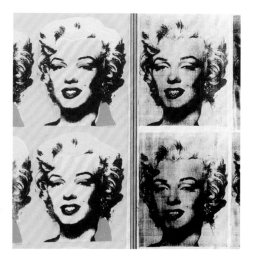

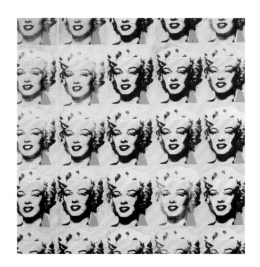

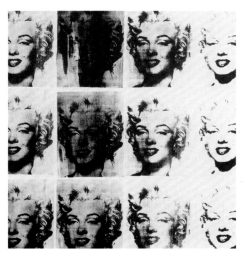

④ FLATTENING EFFECT

Monroe's expression is inscrutable, and the repetition has the effect of turning her face into an inanimate mask, evoking her ubiquitous presence in the media. Deliberately, Warhol has created a detached and dispassionate depiction, presenting Monroe as a flat image, changing her into an unreal, unemotional piece of publicity. Warhol was an award-winning illustrator and he could have made a precise and lifelike drawing of Monroe if he desired; instead, he was intentionally commenting on the culture in which he lived.

⑤ COLOURS

The colours used on the left side of the diptych are not attempts to capture realistic skin tones, purposefully making the images reminiscent of a publicity or magazine image. The same artificial colours being used across the left panel highlight the banality of the image. Pink is used for her face, bright yellow for her hair and bright red for her lips. The same turquoise is used on her eye shadow and part of her clothing, while the whole image is set on an orange background and black picks out facial features and dark tones in the hair.

⑥ SILKSCREEN PROCESS

Warhol had used the silkscreen process in his commercial work. Silkscreen is a form of stencil, normally prepared and printed by hand, but it can be put on the screen photographically, which is what Warhol did, making sure he and his assistants worked mechanically – deliberately opposing the methods of the Abstract Expressionists. He transferred the photographic image onto a fine mesh screen, where it was used as a stencil. The screen was placed over canvas and then acrylic paint was pushed through the mesh using a squeegee, or rubber blade.

Dada

Pop art originated in London with the Independent Group (IG) in the mid 1950s but soon attracted the interest of artists in New York. The IG was drawn to advertisements depicting US materialism and mass culture, and these became the central themes of Pop art. The concepts of Pop art had their roots in Dadaism, which surfaced in reaction to the atrocities of World War I. Influenced by several avant-garde movements, including Cubism and Futurism, Dada was diverse and irreverent: it encompassed performance art, poetry, photography, sculpture, painting and collage. German writer and performer Hugo Ball (1886–1927) staged the first Dada performance (above) in Zurich in 1916. Dada spread to other cities such as Berlin, Paris and New York but it was superseded by Surrealism.

WHAAM!

ROY LICHTENSTEIN

1963

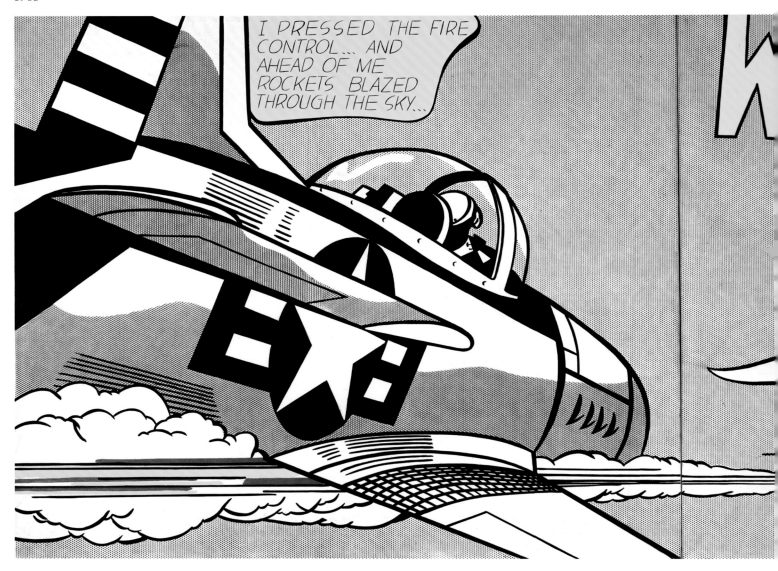

INSPIRED BY COMIC STRIPS and advertisements, US Pop artist Roy Lichtenstein (1923–97) was a prominent and controversial figure, both revered and reviled for his challenges to traditional understandings of fine art.

Lichtenstein studied at the Art Students League in New York in 1939 and at Ohio State University (OSU) from 1940 to 1943, where he created sculptural animal figures, portraits and still-life paintings influenced by Picasso and Braque. At OSU, he became influenced by his professor, the artist Hoyt L. Sherman (1903–81), who worked in a Fauvist style. After military service from 1943 to 1946, Lichtenstein returned to OSU for three years as a student and then taught there. From the end of the 1950s, he painted in a non-figurative, Abstract Expressionist style. However, he began incorporating

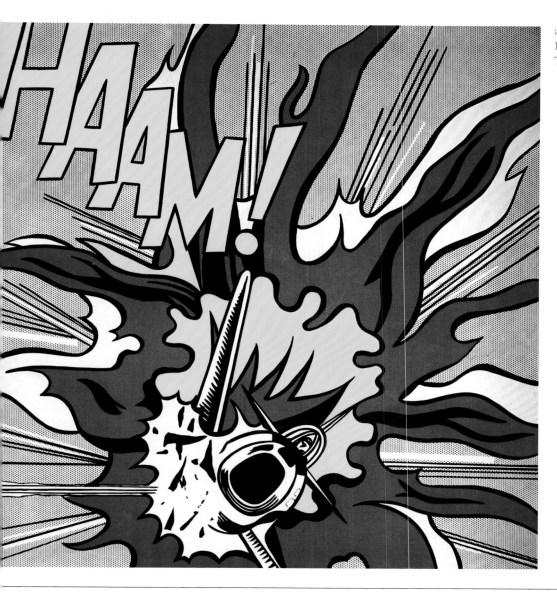

acrylic and oil on canvas
172.5 x 406.5 cm (68 x 160 in.)
Tate Modern, London, UK

figures into his canvases and some of his paintings featured hidden characters such as Mickey Mouse. In 1961, he produced *Look Mickey*, his first cartoon work using Ben-Day dots, a commercial printing style used for comic-book illustrations, in which small, closely spaced, coloured dots are combined to create contrasting colours and tonal contrasts. He exaggerated these dots in his paintings and the technique came to define his style. In 1961, art dealer Leo Castelli started displaying Lichtenstein's work at his New York gallery and the following year, Lichtenstein had his first solo show there. Influential collectors bought the entire exhibit before the show even opened. In the 1960s, he continued using the Ben-Day dot technique in images mostly adapted from issues of DC Comics, including *Whaam!*

① EXPLOSION

With its dramatic splatter of red, yellow, black and white paint, this explosion caused by a US missile blows up the enemy plane. The plane can be seen in the centre of the explosion, engulfed by flames. It is a picture of violence, but treated in this cartoon style, it conveys a sense of detachment. It is not a glorification of war, but an apotheosis of a boys' comic book. The word 'WHAAM!' in large lettering creates a light-hearted suggestion of the sound and effects in comic-book tradition.

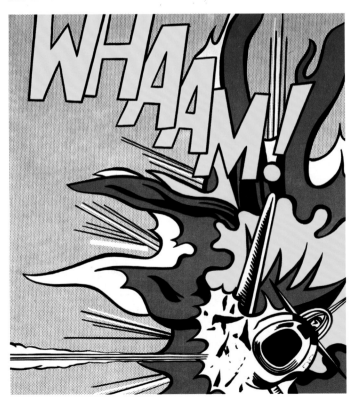

② THE US PLANE

At a dramatically foreshortened angle, the US fighter plane is formed of black lines, white areas and blocks of grey. The back of the pilot's head can be seen in the clear cockpit, all created with simple black and white lines. In a yellow speech bubble above, the caption explains the action.

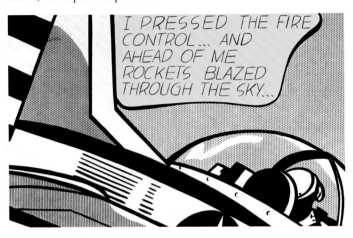

③ INFLUENCES

Lichtenstein shared Warhol's fascination for the visual languages of printed mass media and consumer culture of the 1960s. *Whaam!* is directly based on an image from the comic book *All-American Men of War* published by DC Comics in 1962 and drawn by Irv Novick (1916–2004). Lichtenstein translated the original image by hand on an inflated scale, altering some aspects, in a similar way that television programmes are changed when interpreted into films on the big screen. By scaling-up the comic book image to the oversized dimensions of traditional history paintings, Lichtenstein was commenting on US culture.

④ GRAPHIC STYLE

Lichtenstein's enlarged, precise graphic style reinforced the artificial nature of comic strips and advertisements, which was a consideration of Pop art. Flat images and planned brushstrokes were Pop art's reaction against the looseness of Abstract Expressionism. To assist his precise painting technique, Lichtenstein built an easel that rotated his canvases 360 degrees.

⑤ BEN-DAY DOTS

The technique Lichtenstein used blended aspects of careful hand-drawing and mechanical reproduction. He reproduced the image from the Novick illustration by hand and then projected his drawing onto his canvas. Lichtenstein traced the image onto the canvas and stencilled Ben-Day dots across it to create different colour and tonal effects.

⑥ LACK OF EMOTION

The image is devoid of emotion; it is a powerfully charged scene presented in an impersonal manner. Detachment emerges from the over-sizing, the mechanical execution and the restricted palette – not from the emotive subject. The spatial alignment leads viewers' eyes from left to right to accentuate the relationship between the action and its consequence.

⑦ THE MISSILE

Beneath the wing of this US fighter plane, a missile shoots forth. By magnifying his source material, using limited, flat colours and hard, precise drawing, Lichtenstein parodied familiar contemporary US images of heroes.

Counter-Composition in Dissonance XVI, Theo van Doesburg, 1925, oil on canvas, 100 x 180 cm (39 ⅜ x 70 ⅞ in.), Gemeentemuseum, The Hague, Netherlands

Although Lichtenstein continued his comic-style approach for the rest of his career, his influences came from a wide range of sources. These include ancient Egyptian art, Cézanne, Matisse, Picasso and the paintings of De Stijl artists, particularly Van Doesburg. This painting presents an arrangement of 45-degree angled rectangles created in a primary palette similar to that used by Lichtenstein in *Whaam!* The diagonals and strong colours create a sense of dynamism, while the precise visual elements were carefully planned – all aspects that Lichtenstein followed closely in his work.

TELEPHONE BOOTHS

RICHARD ESTES

1967

acrylic on masonite
122 x 175.5 cm (48 x 69 in.)
Museo Thyssen-Bornemisza, Madrid, Spain

CONSIDERED THE FOREMOST PRACTITIONER of
Photorealism, Richard Estes (b.1932) closely observes and
painstakingly portrays the built environment. He takes
photographs of his motifs from different angles and then
manipulates the images to reconstruct his sharp-focused
compositions that appear to present reality in minute detail.

Born in Kewanee, Illinois, Estes studied at the School of the
Art Institute of Chicago from 1952 to 1956. There, he became
fascinated by the paintings of Degas, Hopper and Thomas
Eakins. In 1959, Estes moved to New York and worked as a
graphic artist for magazine publishers and advertising agencies.
In 1962, he spent a year travelling and painting in Spain.
By 1966, he was back in New York and became a full-time
painter. Although he first included figures in his paintings, he
soon began portraying scenes of light-filled, anonymous streets
devoid of figures or narrative and emotional elements, focusing
on capturing the minutiae of architectural features, especially
reflections and distortions of perspective. By the early 1970s,
he was recognized for his exacting realism.

Estes based this image on photographs he took of a row of
telephone booths at the intersection of Broadway, Sixth Avenue
and 34th Street in New York. It is a manipulated version of
reality featuring distorted shapes and a restricted palette.

Riter Fitzgerald, Thomas Eakins,
1895, oil on canvas, 193.5 x 163 cm
(76 ¼ x 64 ¼ in.), Art Institute
of Chicago, Illinois, USA

Riter Fitzgerald was an arts critic who
championed Thomas Eakins (1844–
1916). Estes studied Eakins's paintings
at the Art Institute of Chicago and
determined to paint in a lifelike
manner even though painting and
realism were considered outdated.

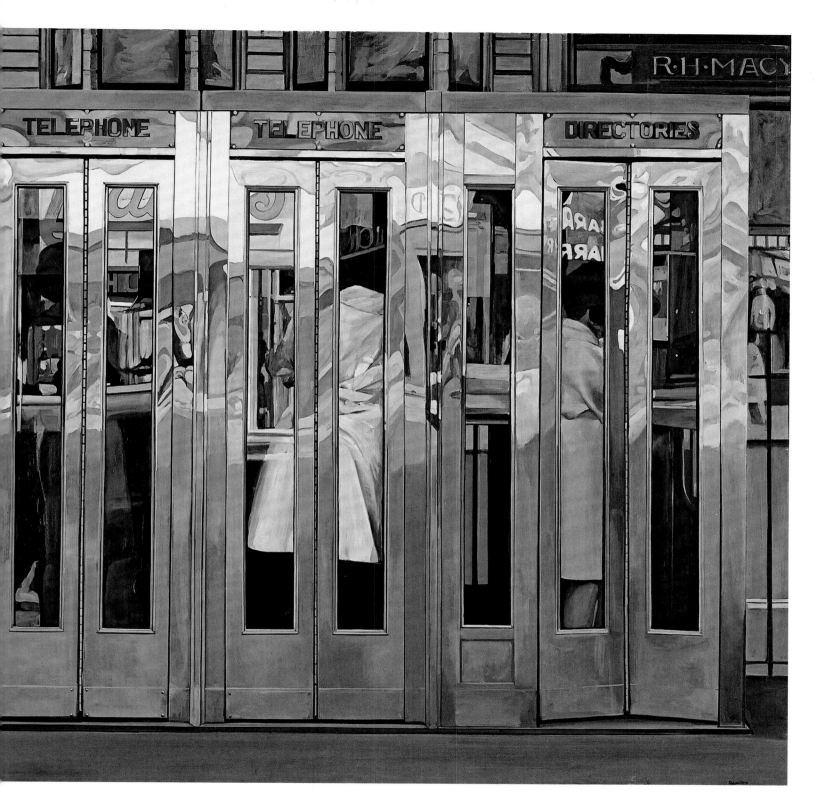

② F. W. WOOLWORTH

Below the precise capital letters of the word 'telephone' on this first booth, is the reflection of red lettering that can be seen to be 'F' with the beginning of 'W', indicating that opposite is a Woolworth's store. Further distorted red marks appear on the shiny reflective surface of the telephone-booth doors, with figures and streetlights indicated by those coloured shapes. The glass is misleading; it is both transparent and reflective.

③ THE PAVEMENT

Estes has not painted shapes and colours in the ground in front of the booths. This is a spotless street, serving to frame the booths and streetscape around. Using long, directional brushstrokes and dark matt grey, he painted horizontally, then used lighter grey paint dragged fairly dry across in the same horizontal movement. Finally, a tiny amount of dry cobalt blue was dragged across, to suggest the merest hint of reflection from the metal booth doors.

① YELLOW VEHICLE

The bright yellow of a vehicle can be determined behind the railings. Beyond the vehicle are pedestrians – one of Estes's few concessions to the inclusion of figures. They are waiting to cross the road; the 'Don't walk' sign is visible above them. A confusion of distorted reflections is created by the folded glass and metal door. There could be a figure inside the booth or it could be reflections. Also reflected in the glass are elements of the street opposite, at a diagonal angle to match the folded glass.

④ BLUE CALLER

Inside this telephone booth is a slim woman in cobalt blue. With her large 1960s' hairstyle, she is anonymous, her back is turned to the viewers, unaware of the artist's gaze. In front of her, the glass in the door reflects a colourful shop window opposite, superimposing a different aspect of the view onto her back. Estes has rendered her simply as coloured parts of the image.

⑥ ABSTRACTION

Deliberately selecting anonymous areas of the city, Estes created a subtle amalgamation of lines, marks and colours, some straight, some curving, some long, some short, to create intricate patterns that in the broad view make sense. While the painstaking detail mimics the accuracy of photographs, the size of the work enables it to be seen as numerous abstract shapes.

⑤ CREAM CALLER

Similar to the other booth, this telephone is also in use by a woman, this one wearing a cream coat. Larger in size, she is just as anonymous and indistinguishable. She is leaning slightly on the glass door, resting on one foot with the other crossed over it. Rather than a shop-front reflection, there appears to be a yellow cab driving past. No part of the telephone can be discerned in the interior.

⑦ APPROACH

Estes's meticulous, clean painting style emerged from his advertising days. The brushwork and gestures of paint are clear and precise, providing an almost impersonal clarity, with fine details that are generally missed but captured on camera. His methodical approach involved a certain amount of alteration from the photographs to achieve an aesthetic composition.

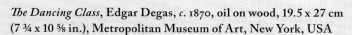

The Dancing Class, **Edgar Degas, *c.* 1870, oil on wood, 19.5 x 27 cm (7 ¾ x 10 ⅝ in.), Metropolitan Museum of Art, New York, USA**

Using photographs as references and arranging his compositions by using elements from several of them, cutting off aspects at the edges, utilizing unusual viewpoints and presenting distorted angles that people rarely notice except through a camera lens, Edgar Degas pioneered many of the ideas that Estes uses. From Estes's first studies in Chicago, he was interested in the ways in which Degas manipulated his paintings from original photographs. *The Dancing Class* is Degas's first depiction of a ballet class. Like *Telephone Booths*, the mirror reflections create disorientating shapes and angles that on close inspection do not make sense, but when seen from a distance become comprehensible.

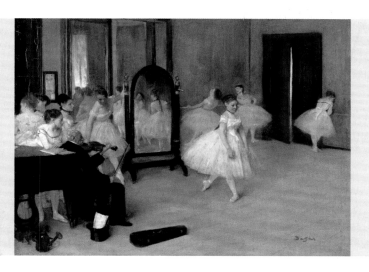

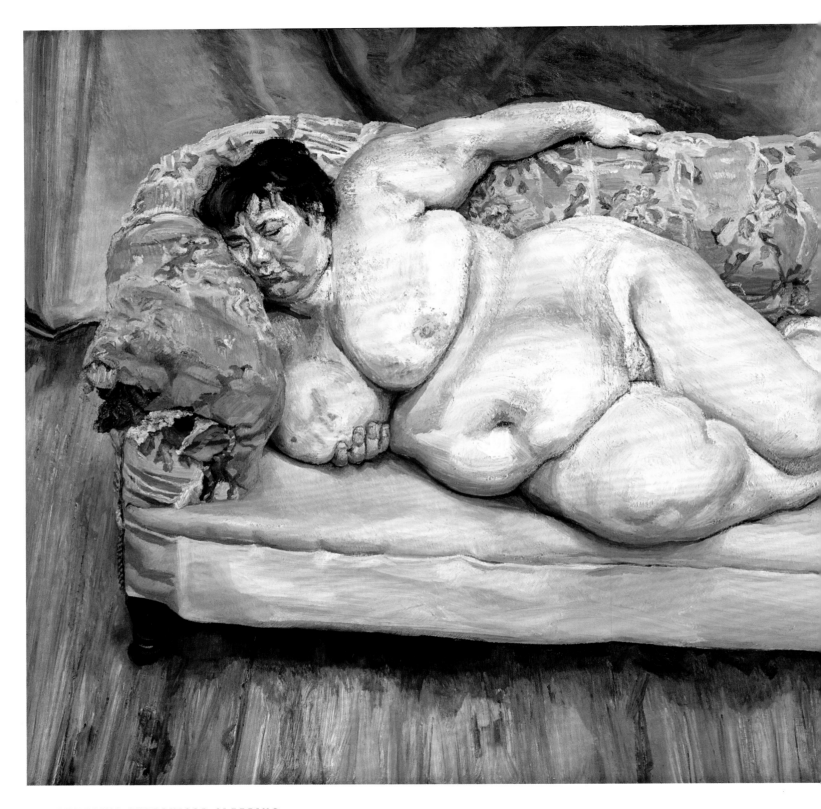

BENEFITS SUPERVISOR SLEEPING

BENEFITS SUPERVISOR SLEEPING

LUCIAN FREUD

1995

oil on canvas
151.5 x 219 cm (59 ⅝ x 86 ¼ in.)
private collection

NOTED FOR HIS PENETRATING portraits often presented from uncompromising viewpoints, German-born British painter Lucian Freud (1922–2011) had a highly individual style that at first exploited smooth paint with crisp contours and cool colours, and later became characterized by expressive, gestural impasto paint emphasizing textures and nuances of flesh. His intimate investigations are imbued with a stark and evocative psychological intensity.

In 1933, Freud moved with his German-Jewish family from Berlin to England to escape the rise of Nazism. Six years later, he began his artistic training at the East Anglian School of Painting and Drawing. During World War II, he served as a merchant seaman in an Atlantic convoy from 1941 but was invalided out of service a year later. He then entered Goldsmiths' College, London until 1943. Inspired by Grosz and Surrealism, Freud's early work included elements of fantasy. He became part of a loose group of figurative artists known as the School of London.

Queen Elizabeth II sat for a small portrait in 2001 but in general Freud posed friends, neighbours, models and family members in his studio, capturing them with descriptive brushmarks, thick paint and muted colours. In 2008, this painting was sold at auction in New York for $33.6 million (£17 million), which was a record price for a living artist.

Reflection (Self-Portrait), Lucian Freud, 1985, oil on canvas, 56 x 51 cm (22 ⅛ x 20 ⅛ in.), private collection

When Freud painted this he was aged sixty-three. It is a brutal exaggeration of his craggy features seen in harsh light with an emphasis on planes, angles and accentuated brushwork.

② FLESH

Freud's nude studies were a major aspect of his work. This model fascinated him for her fleshiness and curves. He created a sense of her three-dimensionality with the heavily modelled paint to describe deeply contoured forms in a sculptural manner. He used a limited tonal range and his palette included cremnitz white, yellow ochre, raw and burnt umber, raw and burnt sienna, red lake, viridian and ultramarine.

③ THE POSE

For this painting, Tilley began posing early in the mornings so that Freud could catch the first light. He stood up to paint this and is looking down on his subject. The highlights on her face and shadows in the creases contrast with and echo elements of the patterned fabric on the arm of the tatty sofa, while muted colours of soft olive green, dusky pink and a greyish-beige are repeated in parts of her skin.

① THE HEAD

Freud was introduced to his model Sue Tilley by nightclub host and performance artist Leigh Bowery (1961–94), another of his regular subjects. In addition to working as manager at the British government's Department for Work and Pensions, Tilley worked in Bowery's club in London, Taboo. Freud's brushmarks were descriptive of shape and structure. Here, her face drooping in slumber, he applied agitated marks in thick slabs and layers.

④ EXAGGERATION

Between 1993 and 1996, Freud painted four images of Tilley. This was the third painting. An extant photograph of this image shows how he exaggerated Tilley's shape, giving her a heavier stomach, broader knees and more pendulous breasts. This was not a flattering portrait, but an exaggerated exploration and expression of the nude. Tilley's powerful presence can be compared to a painting of Venus by Titian, Rembrandt or Rubens, but without any idealization.

⑤ METHOD

Tilley recalled: 'He would paint with us both facing the canvas, so he'd look at me and then turn around to paint.' From the 1950s, Freud always stood to paint and used coarse brushes. His brushmarks were carefully considered and this painting took him nine months. The portrait reflects both Tilley's and Freud's personalities. He applied a patchwork of brushmarks to create a sense of the physical surface as well as the emotional and spiritual inner life of the sitter.

⑥ PAINT APPLICATION

Freud began with a white ground and then drew Tilley's outline in charcoal. Subsequently he added details of the skin tone with directional brushstrokes and textural paint. His stiff brushes almost combed the paint surface as he gradually built the image slowly across the canvas. He emphasized the mass of the body as well as all aspects of the flesh on show, using variegated brushstrokes and layers of colour and shadow. Freud said: 'I want the paint to work as flesh does.'

Diana and Callisto, Titian, 1556–59, oil on canvas, 187 x 204.5 cm (73 ⅝ x 80 ½ in.), National Gallery of Scotland, Edinburgh, UK

Part of a series of seven paintings depicting mythological scenes from Ovid's *Metamorphoses* (AD 8), *Diana and Callisto* was painted for King Philip II of Spain. It portrays the moment in which the goddess Diana discovers that her maid Callisto has become pregnant by Jupiter. The drama and fleshy figures were particularly influential to Freud and he frequently studied the painting, analysing the method of Titian. Freud acknowledged that Titian taught him a lot about composition, particularly about how to convey a sense of drama, and the unusual, somewhat awkward pose of *Benefits Supervisor Sleeping* emerged partially through his admiration of Titian. In the 1970s, Freud regularly visited the National Gallery of Scotland in Edinburgh where he studied Titian's paintings of *Diana and Callisto* and *Diana and Actaeon* (1556–59; see p. 85). Captivated by the swathes of cloth and abundance of flesh filling the canvases, he once described them as 'two of the most beautiful paintings in the world'.

MAMAN

LOUISE BOURGEOIS

1999

bronze, stainless steel and marble
927 x 891.5 x 1,023.5 cm (365 x 351 x 403 in.)
Guggenheim Museum, Bilbao, Spain

ONE OF THE MOST important sculptors of the 20th century, Louise Bourgeois (1911–2010) used a multitude of materials and forms of expression over her long career. She remained a groundbreaking and innovative figure, heavily influenced by traumatic events from her childhood, particularly her father's infidelity to her mother. Always at the forefront of new developments in art, Bourgeois explored individual ideas in painting, printmaking, sculpture, installation and performance, using a wide range of materials and motifs. Many of her works suggest relationships between architecture and the human body. 'Space does not exist,' she declared, 'it is just a metaphor for the structure of our existence.'

Bourgeois was born in Paris. After the death of her mother in 1932, she began studying art. She enrolled in several schools and ateliers between 1933 and 1938, including the École des Beaux-Arts, the Académie Ranson, the Académie Julian and the Académie de la Grande-Chaumière where she was taught by Léger, before immigrating to the United States in 1938. Her often brooding and sexually explicit subject matter was unusual for women artists at the time. She began her involvement with the feminist movement in 1970, taking part in demonstrations, benefits, panels and exhibitions. During the course of her lifetime, Bourgeois's forms ranged from abstract to figurative, organic to geometric. She socialized in the prominent artistic circles of the time, circulating within a world of art historians, artists and gallery owners. Bourgeois studied psychoanalysis, ran her own print and book business, taught art and experimented with materials. After eleven years without a one-person show, she exhibited a new body of work in 1964, and then continued to exhibit regularly. It was not until her retrospective at the Museum of Modern Art in 1982 that Bourgeois's work received wide acclaim.

Bourgeois made her first 'Spider' sculpture in 1994. The largest of the series conveys strength, while the title *Maman* recalls a child's name for its mother, evoking softness and warmth. The sculpture symbolized Bourgeois's deceased mother and inspires awe because of its colossal size; this mother is universal, powerful and frightening.

Maternity, Albert Gleizes, 1934, oil on canvas, 168 x 105 cm (66 ⅛ x 41 ⅜ in.), Musée Calvet, Avignon, France

In 1938, before Bourgeois immigrated to the United States, she exhibited her own work at the Salon d'Automne with French artist Albert Gleizes (1881–1953) who was the self-proclaimed founder of Cubism and certainly an early exponent of the method. He was also important in the Section d'Or group and a powerful influence on the School of Paris.

② EGGS

Almost 9 metres (30 feet 5 inches) above the ground is this wire mesh sac containing grey and white marble eggs, hanging beneath the spider's body. They vaguely catch the light. The egg sac is supported by narrow, irregular ribs that repeat the ribbed spiral of the body. As a symbol of motherhood – and specifically of Bourgeois's mother – the eggs held securely in the abdominal cavity represent safety. With *Maman*, Bourgeois was confronting the 'trauma of abandonment' after her mother's death.

③ SCALE

This huge work was created to appear fragile, so the slender, pointed legs are deceivingly slim and tapered towards the ground, yet strong enough to support the structure. Bourgeois studied both mathematics and art at the Sorbonne between 1932 and 1935. An interest in proportion and ratio always remained an essential element of her work.

① LEGS

This monumental spider is supported on eight spindly, knobbly legs, which hold its body high above the ground. Each ribbed leg is made of separate, jointed sections and each ends in a sharp-tipped point at the base. The curving, arched legs evoke visions of columns and arches in Gothic cathedrals. Viewers are compelled to walk between the legs and underneath the body, prompting various emotions regarding the space, motherhood or spiders.

④ ALCHEMY

Kiefer has said that lead is 'the only material heavy enough to carry the weight of human history'. It is also a versatile material to use because it can change colour and shape. Lead was the metal from which alchemists hoped to make gold. Kiefer sees the desire to change one type of matter into another as having parallels with art. By turning paint and canvas into something else, he sees the artist's role as being comparable to alchemy of the past. Here, a large lead book embedded in the snow dominates the centre of the canvas.

⑤ PROCESS

Kiefer's process here is both direct and emotional. Before he begins, he knows what he wants to achieve, but his process changes as he works. He has explained: 'After you start a painting, there is a certain time when you have to decide how to proceed, which direction should it take, and it can be difficult. With each decision you leave a hundred other possibilities behind and it's impossible to know if you made the right choice.' The emotional, almost unfinished aspects here emphasize Celan's sadness and the bleakness of his memories.

⑥ LAYERS

Layers of paint create textures and powerful expressions. This image is full of mystery, sadness and horror. The use of a limited palette enhances the sculptural qualities of the paint. Kiefer's accomplished manipulation of so many materials emits both a sense of being natural and, conversely, man-made, and of being planned carefully and also intuitive. Similarly, while the work evokes the idea of loss, decay and destruction, the tree branches protruding from the canvas can be seen to represent new life, recreation and redemption.

Winter Landscape, **Caspar David Friedrich**, *c.* 1811, **oil on canvas, 32.5 x 45 cm (12 ¾ x 17 ¾ in.), National Gallery, London, UK**

Although not a direct influence, the oeuvre of Caspar Friedrich was familiar to Kiefer. As part of German tradition, Friedrich's work also became part of Kiefer's many layered meanings and references. Friedrich's *Winter Landscape* represents the hope for salvation through the Christian faith. In the foreground, a crippled man has abandoned his crutches as he raises his hands in prayer before a crucifix. In the background, a Gothic cathedral emerges from the mist, symbolizing the promise of life after death. Kiefer's *Black Flakes* recalls the spiritual symbolism in *Winter Landscape*, only the snow in Kiefer's melancholy representation is tinged with blood rather than appearing noble and magnificent as in Friedrich's painting.

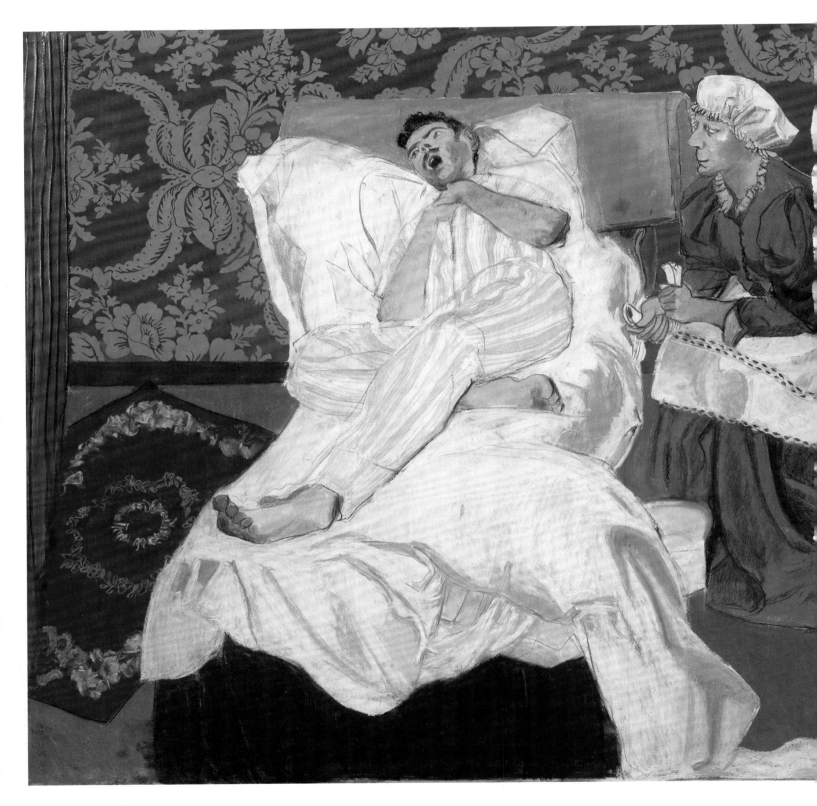

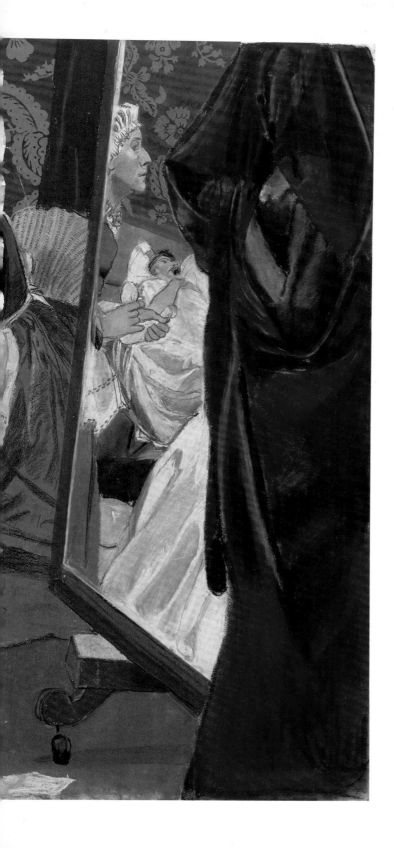

THE KING'S DEATH
PAULA REGO

2014

pastel on paper
119.5 x 180.5 cm (47 ¼ x 70 ⅞ in.)
Marlborough Gallery, London, UK

BORN IN LISBON, PORTUGAL in 1935, Paula Rego trained at the Slade School of Fine Art in London. From 1959 to 1975, she and her husband, the English artist Victor Willing (1928–88), and their three children divided their time between London and Portugal. In 1965, she achieved overnight success in Portugal with a somewhat controversial solo exhibition. Her earliest works were semi-abstract paintings which often featured elements of collage that she took from her own drawings. In 1976, she returned to London and a few years later, she abandoned collage and began using acrylic to draw directly on to paper. Unlike most contemporary artists, Rego works in a strongly narrative style, telling stories that she said developed out of the folk tales her great-aunt used to tell her as a child. Stories also became particularly central to her art at a time when she had little to do and Willing suggested she should try illustrating something. Using an essentially graphic style reminiscent of comic strips, her figurative paintings – which have illustrated *Jane Eyre* (1847), *Peter Pan* (1911), *The Return of the Native* (1878) and many other stories – are often bizarre and represent violent or political themes, or cruelty, fear, revenge and power between the sexes. Many are metaphorical with surreal elements, and all reveal her caustic wit and vibrant energy in a bold, strong style.

As well as literature and fairy tales, Rego has illustrated myths, cartoons and religious texts, frequently drawing on her childhood memories and Portuguese roots, while also suffusing them with a mysterious quality. She has insisted that her pictures are not illustrations or narratives, but stories, and she once said that she paints 'to give terror a face'. Using various techniques in painting and printmaking, she commented: 'I turn to etching, and lithography, with a sense of exuberance and relief. In printmaking you can give your imagination full-range and see the results almost immediately. So one image triggers the idea for the next one and so on.'

Her nostalgic, extravagant and ebullient 2014 series 'The Last King of Portugal' features a range of powerful, figurative images that merge history with family stories, memory and Rego's vivid imagination.

② DIGNITY

Rego portrays Manuel's final moments before he died in 1932 aged forty-two. His condition was a tracheal oedema; a swollen throat that may have been caused by poisoning. She shows the man leaning back against plump white pillows, clutching his throat, his eyes rolling as he gasps in pain. It is a terrible death, but she depicts the exiled king with dignity, creating a moment of sadness.

③ PYJAMAS

With a light touch and confident handling of pastels, Rego has portrayed the ex-monarch in pale blue and white striped pyjamas to convey the notion that whoever we are, when we die, we are all the same. This is a modern interpretation of the *vanitas*. Despite the horror of the moment, the man continues to demonstrate his elegance and royalty through his understated, languishing pose.

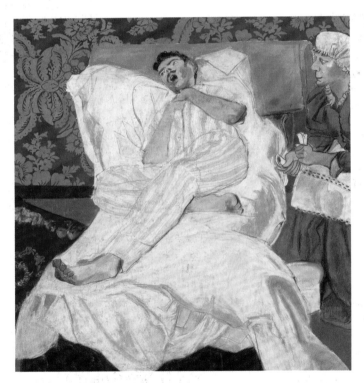

① HISTORY

The last King of Portugal, Manuel II, is sometimes known as 'the Patriot' and sometimes 'the Unfortunate'. In 1910, after the assassination of his father King Carlos I and his elder brother Prince Luís Filipe, Manuel fled from his country with his mother Queen Amélie of Orléans. The Republican revolution resulted in his permanent exile in Britain. As Rego also moved to Britain from Portugal, Rego shares some parallels with Manuel.

④ DELICATE FOOT

Rego works quickly. Her method of applying and using pastels has evolved from her skills with collage, painting and various methods of printmaking. Using layers of small and longer strokes, she has drawn Manuel's bare foot flexing as a dancer's, only his foot moves in pain rather than in time to music. His pale skin almost matches the white of his bed sheets, which are picked out with strong tonal contrasts in cool and warm greys, and serve to emphasize the young man's pallor as death approaches.

⑤ COLLAGE EFFECT

The uniformed maidservant watches her master as he tries to draw breath. Clutching medicine that will be useless to attempt to administrate, she is almost objective as she contemplates what to do. Her grey and white uniform adds another dimension to the floral patterned rug, stripes of Manuel's pyjamas and the patterned wallpaper behind her that resembles the heavy brocade of King Philip IV of Spain's clothing in Velázquez's painting (right). These contrasting patterns, colours and textures recall the effects of Rego's earlier collages.

⑥ MIRROR REFLECTION

As well as the visual effect of multiplying the patterns, colours and textures, and of distorting the view, the mirrored wardrobe creates surreal juxtapositions in the composition. In the reflection, the tiny man looks as if he is falling down and already dead, whereas the face of the maid resembles a religious icon, either an angel watching over him or a worshipper praying at an altar. The swathes of fabric with their contrasts in tone create a sense of muffled sound – as if within the mirror, silence has fallen after Manuel's death.

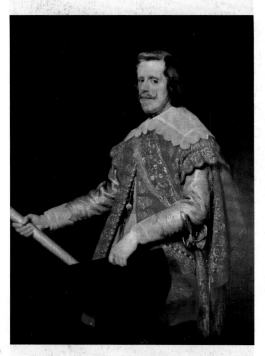

Philip IV of Spain at Fraga, Diego Velázquez, 1644, oil on canvas, 130 x 99.5 cm (51 ⅛ x 39 ⅛ in.), The Frick Collection, New York, USA

This is the only portrait of King Philip IV of Spain that Velázquez painted during the 1640s. It commemorates a successful siege by the Spanish against the French, so the artist makes his monarch appear noble and commanding. Yet in Velázquez's characteristic style, this is loosely painted, with free brushmarks capturing the effects of the textures and colours of the sumptuous fabrics, thrown forward against a dark background. Rego has always acknowledged the influence of Velázquez. Although Philip IV is shown healthy here and Rego depicts Manuel II dying, it can be seen how she has examined ways of presenting a sense of nobility and the contrasting textures of different fabrics.

Glossary

Abstract art
Art that does not imitate real life but consists of forms, shapes and/or colours, independent of subject matter.

Abstract Expressionism
Post-World War II US art movement characterized by a desire for freedom of expression and the communication of strong emotions through the sensual quality of paint.

Academic art
Sometimes also called Academicism, a style favoured by official European art academies, especially the French Academy in Paris, from the 17th to 19th centuries, to which successful artists conformed. Emphasizing the intellect and precise drawing.

Action painting
Technique in which paint is applied with gestural movements, often by pouring or splashing.

Aerial or Atmospheric perspective
To evoke illusions of distance, background objects are painted lighter, bluer and blurrier, with few details, emulating atmospheric effects.

Alla prima
Meaning 'at the first' or 'at once' in Italian, this is a style of painting completed quickly, usually in one session, while the paint is still wet. The French term is *au premier coup.*

Anamorphosis
A distorted two-dimensional image that assumes normal proportions when looked at from one side or in a curved mirror.

Art Deco
Taking its name from the '*Exposition Internationale des Arts Décoratifs et Industriels Modernes*' (International Exposition of Modern Decorative and Industrial Arts) held in Paris in 1925, Art Deco spanned the 1920s and 1930s. It affected all forms of design, from the fine and decorative arts to fashion, film, photography, transport and product design. The style is characterized by rich colours, bold geometric shapes and gilded, angular ornamentation.

Arte Povera
Italian for 'Poor Art'. Term coined by Italian critic Germano Celant to describe art made using everyday materials such as newspapers, rather than traditional materials such as oil paint. Predominantly created in the 1960s and 1970s by Italian artists.

Art Nouveau
International decorative style in art, design and architecture, popular from 1890 to World War I. Often consisting of organic, asymmetrical and stylized flora and foliage forms.

Automatism
A method whereby the act of painting, writing or drawing is based on chance, free association, suppressed consciousness, dreams and states of trance. As a means of supposedly tapping into the subconscious mind, it was adopted with enthusiasm by the Surrealists.

Avant-garde
Term used to describe any new, innovative and radically different artistic approach.

Barbizon School
French landscape painters active from 1830 to 1870 and part of the Realist movement. The group took its name from the village of Barbizon, where the artists gathered to paint in the forest of Fontainebleau.

Baroque
Style of European architecture, painting and sculpture from 1600 to 1750, which is typically dynamic and theatrical. The most well-known exponents were Caravaggio and Rubens.

Bauhaus
German school of art, design and architecture founded in 1919 by German architect Walter Gropius and closed by the Nazis in 1933. Artists such as Kandinsky and Klee worked there, and its trademark streamlined designs became influential worldwide.

Blaue Reiter, Der
German for 'The Blue Rider'. A group formed in Munich in 1911 by artists who epitomized German Expressionism with a particular focus on abstraction and spirituality. Kandinsky was the group's leader. The name refers to an important theme in Kandinsky's work, a horse and rider, which for him represented moving beyond realistic depictions. Horses were also prominent in Marc's work and for him animals symbolized rebirth.

Brücke, Die
German for 'The Bridge'. A group founded in Dresden in 1905 by German Expressionists, which had disbanded by 1913. The group espoused radical political views and sought to create a new style of painting to reflect modern life. Noted for their landscapes, nudes, vivid colour and use of simple forms. Members included Kirchner and Nolde.

Byzantine
Term for orthodox religious art created during – or influenced by – the Byzantine (eastern Roman) Empire from AD 330 to 1453. Icons are a common feature in the art of this era, which is also typified by exquisite mosaic church interiors.

Camera obscura
Latin for 'dark chamber'. An optical device used to project an image via a hole or lens onto a wall or surface such as canvas opposite. Popular from the 15th century onwards among many artists, including Canaletto, to help them to plan compositions with accurate perspective.

Chiaroscuro
Italian for 'light-dark'. Term used to describe the dramatic effects of strongly contrasting light and shade in paintings, popularized by Caravaggio.

Classicism
Term describing the use of the rules or styles of classical antiquity. Renaissance art incorporated many classical elements and other eras, such as the 18th century, have looked to ancient Greece and Rome as inspiration. The term can also mean formal and restrained.

Cloisonnism
A technique used by Post-Impressionists whereby flat colours are surrounded by strong dark outlines.

Collage
Style of picture-making in which materials (typically newspapers, magazines, photographs and so on) are pasted together on a flat surface. The technique first gained prominence in fine art through Picasso and Braque with Cubism from 1912 to 1914.

Colour Field
Term originally used to describe the work of Abstract Expressionists such as Rothko in the 1950s and Frankenthaler, Louis and Noland in the 1960s. Characteristic works are notable for their large areas of flat, single colours.

Commedia dell'Arte
Italian for 'comedy of professional artists'. Term used to describe comic plays performed in masks popular in 16th- to 18th-century Italy and France.

Composition
The arrangement of visual elements in a work of art.

Constructivism
Art movement founded in Russia *c.* 1914, spreading to the rest of Europe by the 1920s. Notable for its abstraction and use of industrial materials such as glass, metal and plastic.

Contrapposto
Italian term to describe a particular pose in which a human figure stands with his or her weight on one foot so the shoulders and arms twist away from the hips and legs.

Cubism
Highly influential and revolutionary European art style invented by Picasso and Braque, and developed between 1907 and 1914. Cubists abandoned the idea of a fixed viewpoint, resulting in objects portrayed

appearing fragmented. Cubism gave rise to a succession of other movements, including Constructivism and Futurism.

Dada
Art movement started in 1916 in Switzerland by writer Hugo Ball as a reaction to the horrors of World War I. It aimed to overturn traditional values in art. Notable for its introduction of 'readymade' objects as art and its rejection of the notion of craftsmanship. Core artists included Duchamp, Picabia, Arp and Schwitters.

De Stijl
Dutch for 'The Style'. Dutch magazine (1917–32) edited by Van Doesburg and used to champion the work of co-founder Mondrian and the ideas of Neo-Plasticism. The term is also applied to the ideas it promoted, which had a significant influence on the Bauhaus movement and on commercial art in general.

Divisionism
Painting theory and technique involving the application of small dots of paint in order to obtain colour effects optically rather than by mixing colours on a palette. Its most famous practitioners were Seurat and Signac. The technique is also called pointillism.

Expressionism
Term used to describe a 20th-century style that distorts colour, space, scale and form for emotional effect and is notable for its intense subject matter. Adopted particularly in Germany by artists such as Kandinsky, Nolde and Macke.

Fauvism
Derived from the French 'fauve', meaning 'wild beast'. Art movement from c. 1905 to 1910 characterized by wild brushwork, use of bright colours, distorted representations and flat patterns. Associated with artists such as Matisse and Derain.

Folk art
Term used to describe art that falls outside the category of fine art and that has been created by a non-formally trained individual. Its subject matter often involves family or community life and includes crafts, naive art and quilts.

Foreshortening
When objects are represented in close proximity, they are dramatically shortened or certain aspects are enlarged. Mantegna is recognized as a pioneer of the method.

Fresco
A method of painting with water-based pigments onto freshly plastered walls or ceilings. There are two different techniques. *Buon fresco*, also called 'true' fresco, is painted onto wet plaster. As the plaster dries, the fresco becomes integral to the surface. *Fresco secco* or 'dry' fresco is painted onto dry walls.

Futurism
Art movement launched by the Italian poet Filippo Tommaso Marinetti in 1909. Characterized by works that expressed the dynamism, energy and movement of modern life. Integral artists included Boccioni and Balla.

Genre painting
Painting that shows scenes from daily life. The style was particularly popular in the Netherlands during the 17th century. Narrative is a similar expression for this type of art. The term is also used to describe categories of painting, such as portrait or history.

Glaze
A thin, transparent layer of paint applied over dry, opaque layers or washes that adjusts the colour and tone of the underlying wash.

Gothic
European style of art and architecture from 1150 to c. 1499. Work produced during this period is characterized by an elegant, dark, sombre style and by a greater naturalism than the earlier Romanesque period.

Gouache
Also known as body colour, a type of water-soluble opaque paint. Because of its matt finish, it is fairly flat and has never been as popular with artists as oils or watercolours. Some watercolourists use white gouache for highlights, others use it to create thin washes or thick layers.

Grand Manner
A grandiose style of painting that flourished in the 18th century and was influenced by academia, ancient history and mythology, painted in an idealized and formulaic style.

Grand Tour
A journey around Europe generally taken by wealthy and aristocratic young men as part of their education during the 17th to early 19th centuries. The itinerary was designed to educate travellers in the art and architecture of classical antiquity.

Grisaille
From the French word 'gris' for grey. A method of painting only using different tones of one colour, usually grey, to produce strong three-dimensional effects. It was particularly used by painters of the Early Renaissance.

Ground
Also called priming, this describes a coating on a support – or surface – before a painting is started. A ground helps to seal and protect the support and provides a good surface for painting, often with a bit of tooth so the paint adheres well. Different supports require different grounds; for instance, canvas expands and contracts and so requires a flexible ground.

Hyperrealism
Used to describe a resurgence of exacting realism in painting and sculpture that followed Photorealism, or Superrealism, which began in the 1970s. While the earlier movement was detached and photographically accurate, Hyperrealism incorporates elements of narration or emotion. Proponents include Estes.

Iconography
Derived from 'eikon' in Greek, meaning 'image', describing imagery in a painting. Originally a picture of a holy person on a panel used as an object of devotion. In art, the word has come to be used to describe any object or image with a special meaning attached to it.

Ignudi
From the Italian *nudo*, meaning 'naked'. Michelangelo gave the name to the twenty seated male nudes he included in the Sistine Chapel ceiling, representing idealized male figures that resemble ancient Greek statues. Although the figures are not from the Bible, he incorporated them to create extra elements in his retelling of biblical stories.

Impasto
A technique whereby paint is thickly applied using a brush or palette knife, so that the strokes or marks remain visible and in some cases raised from the surface to provide texture.

Impressionism
Revolutionary approach to painting landscape and scenes of everyday life pioneered in France by Monet and others from the 1860s, and which was later adopted internationally. Often painted outdoors (*en plein air*) and notable for the use of light and colour as well as loose brushwork. The first group exhibition held in 1874 was mainly ridiculed by critics, particularly Monet's painting *Impression, Sunrise* (1872) which gave the movement its name.

International Gothic
A type of Gothic art that developed in Burgundy, Bohemia and northern Italy in the late 14th and early 15th centuries, characterized by rich, decorative patterns, colourful settings, classical modelling, flowing lines and use of linear perspective.

Intonaco
From the Italian *intonacare*, meaning 'to coat', this describes the final, smooth coat of plaster for a *buon fresco* that is applied to as much of the wall or ceiling as can be painted in one day.

Japonism or Japonisme
The craze for Japanese art that emerged after trade with Japan resumed after 220 years in 1858. Impressionism and Art Nouveau were particularly influenced by Japanese *ukiyo-e* woodcut prints.

Linear perspective
The attempt to convincingly depict three dimensions and depth on two-dimensional surfaces, perfected during the Renaissance, using a system of lines and vanishing points to create illusions of depth on flat or shallow surfaces.

Mannerism
Derived from '*maniera*', meaning 'manner' in Italian. A loose term to describe some art produced *c.* 1530 to 1580 in which altered perspective, vibrant colour, unrealistic lighting and exaggerated or distorted figures in elongated poses resulted in theatrical and sometimes disturbing images. It was based on the late styles of Raphael and Michelangelo and expanded on by artists such as Parmigianino.

Masonite
A type of hardboard made of steamed and pressure-moulded wood fibres, patented by engineer and inventor William H. Mason in the United States in 1924. Some artists use it as a support for their paintings.

Memento mori
Latin term that loosely translates as 'remember you will die'. It was a popular theme in medieval and Renaissance art and describes paintings or sculptures that were intended to move viewers to contemplate their mortality.

Mexican Muralism
Beginning as a government-funded form of public art after the Mexican Revolution of 1910 to 1920, it portrayed an official history of Mexico to educate citizens. Although many artists were employed, the three main Mexican Muralists were Orozco, Rivera and Siqueiros.

Minimalism
Style of abstract art – characterized by a spare, uncluttered approach and deliberate lack of emotive expression or conventional composition – which arose in the mid 20th century and flourished in the 1960s and 1970s.

Modernism
A broad term used to describe Western artistic, literary, architectural, musical and political movements in the late 19th and early 20th centuries. Applied to that which is typified by constant innovation, experimentation and rejection of the old, and works in which the adoption of the new is seen as being appropriate to the modern age.

Nabis, les
Derived from word for 'prophets' in Hebrew. Name used to describe a group of Post-Impressionist avant-garde Parisian artists of the 1890s who were Symbolist in approach and admired the work of Gauguin.

Naturalism
In its broadest sense, a term used to describe art in which the artist attempts to portray objects and people as observed rather than in a conceptual or contrived manner. More generally, it can also be used to suggest that a work is representational rather than abstract.

Neoclassicism
Prominent late 18th- and early 19th-century movement in European art and architecture, motivated by the impulse to revive styles of ancient Greek and Roman art and architecture. The term has also been applied to a similar revival of interest in classical styles during the 1920s and 1930s.

Neo-Expressionism
International movement in painting that started in the 1970s, influenced by the raw personal emotion and bold mark-making characteristic of Expressionism. Often figurative and typified by their large scale and use of mixed media on their surface. Artists include Kiefer.

Neo-Impressionism
Term coined by French art critic Félix Fénéon in 1886 to describe a French movement in painting started by Seurat and Signac that aimed to take a scientific approach to creating illusions of light and colour using Divisionism or pointillism.

Neo-Plasticism
Term invented by Dutch painter Mondrian in 1914 to describe his theory that art should be non-representational in order to find and express a 'universal harmony'. Mondrian's paintings are characterized by their restricted palettes and use of horizontal and vertical lines.

Netherlandish
Term used to describe art produced in Flanders – now Belgium – and the Netherlands, and developed by artists such as Van Eyck and Bosch. The style arose in the 15th century and evolved separately from the art of the Italian Renaissance, especially in the use of oil paint instead of tempera. The early Netherlandish period ended *c.* 1600; the late period lasted until 1830.

Neue Sachlichkeit, Die
German for 'The New Objectivity', this was a German art movement of the 1920s that lasted until 1933. It opposed Expressionism and is noted for its unsentimental style and use of satire. Artists include Dix and Grosz.

Northern Renaissance
The influence of the Italian Renaissance in northern European painting from *c.* 1500, incorporating the use of human proportion, perspective and landscape. After studying in Italy, Dürer was an early exponent. It was influenced by Protestantism as opposed to the Roman Catholic themes of Italian painting.

Orphism
French abstract art movement originated by French painter Jacques Villon (1875–1963) and characterized by its use of bright colour. The term was first used in 1912 by the French poet Guillaume Apollinaire to describe the paintings of Robert Delaunay, which he related to Orpheus, the poet and singer in Greek mythology. Its practitioners introduced a more lyrical element to Cubism. Klee, Marc and Macke were all influenced by the short-lived movement.

Orthogonal lines
In linear perspective, these lines are perpendicular to each other and point to a vanishing point. The term means 'at right angles' and is related to 'orthogonal projection', another method of drawing three-dimensional objects.

Pittura Metafisica
Italian for 'Metaphysical Painting', this is a painting style that developed from the art of De Chirico, in which there is a disconcerting image of reality and the everyday.

Plein air
See Impressionism.

Pointillism
See Divisionism.

Pop art
Term coined by British critic Lawrence Alloway for an Anglo-American art movement that lasted from the 1950s to the 1970s, notable for its use of imagery taken from popular cultural forms such as advertising, comics and mass-produced packaging. Practitioners included Warhol and Lichtenstein.

Post-Impressionism
Term used to describe various works of art and artistic movements influenced by, or reacting against, Impressionism. The phrase was invented by British art critic and painter Roger Fry, when organizing a group exhibition of the work in London in 1910. Artists include Cézanne, Gauguin and Van Gogh.

Pre-Raphaelite Brotherhood
British society of painters founded in London in 1848 that championed the work of artists active before Renaissance master Raphael. Members included Hunt, Millais and Rossetti. Their work is characterized by its realistic style, attention to detail and engagement with social problems and religious and literary themes.

Priming
See Ground.

Primitivism
Art inspired by the so-called 'primitive' art that fascinated many early modern European artists. It included tribal art from Africa and the South Pacific, as well as European folk art.

Putto (plural, putti)
Italian for 'cherub'. Winged, naked infant figure, usually male. Commonly found in Renaissance and Baroque art, created by artists such as Raphael.

Rayonism
An early form of abstract art that was influenced by Cubism, Futurism and Orphism, it emerged as a Russian avant-garde art movement from 1910 to 1920.

Realism
1. Mid-19th-century art movement characterized by subject matter depicting peasant and working-class life, exemplified by Courbet.

2. Term for a style of painting that appears photographic in its representational accuracy, irrespective of subject matter.

Renaissance
French for 'rebirth'. Used to describe the revival of art in Italy from 1300 influenced by the rediscovery of classical art and culture. The Renaissance reached its peak – the High Renaissance – from 1500 to 1530 with artists such as Michelangelo, Leonardo and Raphael.

Rococo
From the French '*rocaille*', meaning 'rock work' or 'shell work', referring to carvings in grottoes and on fountains. The term is used to describe the 18th-century French style of visual arts that was decorative in nature and often used shell-like curves and shapes.

Romanesque
A style of European art and architecture that dominated the 10th and 11th centuries and took its inspiration from the ancient Roman Empire.

Romanticism
Artistic movement of the late 18th and early 19th centuries. Broadly characterized by an emphasis on the experience of the individual, instinct over rationality, and the concept of the sublime, as in the landscapes of Friedrich and Turner and the expressive paintings of Delacroix, Géricault and Goya.

Sacra conversazione
Italian for 'holy conversation' or 'sacred conversation'. A style of painting that became popular during the Renaissance. Usually altarpieces, they are paintings of the Madonna and Child with various saints often from different periods in history, making a harmonious group around them.

Salon, The
Exhibitions held by the French Royal Academy of Painting and Sculpture, later the Academy of Fine Arts, in Paris from 1667 to 1881. Named for the Salon Carré in the Louvre, where the exhibitions were held regularly from 1737 onwards. It was highly prestigious to be selected to exhibit and those artists who were successful usually attracted patronage.

School of Paris
By the end of the 19th century, Paris became a central focus for artists from all over the world, and the term was used loosely to describe artists who lived and worked there in the early 20th century, including Picasso, Matisse, Chagall, Mondrian and Kandinsky.

Scumbling
A painting technique where a thin or broken layer of colour is brushed over another using dry paint so that some of the colour beneath shows through, creating a sense of depth and colour variation. From a distance, the colours mix optically.

Secession
Name used by groups of artists in Germany and Austria in the 1890s who 'seceded' from art institutions that they deemed conservative. Led by Klimt in Vienna.

Section d'Or
French for 'Golden Section'. Group of French artists who worked from 1912 to 1914 in a loose association. Their predominant style was Cubist and they were particularly concerned with mathematical proportion.

Sfumato
Invented by Leonardo da Vinci, *sfumato* describes a particular blending technique and derives from the Italian *fumare*, which means 'to smoke'. Shadows and dark tones blend softly through subtle gradations.

Social Realism
Term used to describe art of the 19th and 20th centuries that protested against adverse social conditions and the hardships of everyday life, and employed a broadly representational technique. Often used to describe muralists active in North America during the Great Depression such as Rivera and Orozco.

Stretching
To complete an oil painting on canvas, it is first stretched firmly over 'stretcherbars', or wooden supports, and stapled to them before being placed in a frame.

Suprematism
Russian abstract art movement. Its chief proponent was Malevich, who invented the phrase in 1913. Paintings are characterized by a limited colour palette and the use of simple geometric forms such as the square, circle and cross.

Surrealism
Movement in art and literature launched in Paris in 1924 by French poet André Breton with his publication of the 'Manifesto of Surrealism'. The movement was characterized by a fascination with the bizarre, the illogical and the dreamlike and, like Dada, sought to shock. Integral artists include Dalí, Ernst, Magritte and Miró. Its emphasis on chance and gestures informed by impulse rather than conscious thought (see Automatism), was highly influential for subsequent artistic movements such as Abstract Expressionism.

Symbolism
Term invented in 1886 by French critic Jean Moréas to describe the poetry of Stéphane Mallarmé and Paul Verlaine. Applied to art, it describes the use of mythological, religious and literary subject matter, and art that features emotional and psychological content, with a particular interest in the erotic, perverse and mystical. Predominant artists include Redon and Gauguin.

Synthetism
Term used by Gauguin, Bernard and their circle at Pont-Aven, Brittany in the 1880s. It denoted their philosophy that art should synthesize subject matter with the emotions of the artist rather than with observed reality.

Tempera
Derived from the Latin '*temperare*', meaning 'to mix in proportion'. Tempera is paint made with powdered pigments, egg yolk, or only yolks or whites, and water. Quick-drying and long-lasting, it reached its peak during the Renaissance before oil paints were adopted.

Tenebrism
From the Italian *tenebroso*, meaning 'obscure'. A term used to describe dark tonality in painting.

Triptych
A painting or carving, usually an altarpiece, in three panels, hinged together.

Trompe l'oeil
French for 'deceives the eye'. Painted optical illusions designed to fool viewers into thinking that what is seen is real.

Tronie
Dutch for 'face'. Common in Dutch Golden Age and Flemish Baroque painting. Usually anonymous portraits based on living models, with exaggerated facial expressions or depicting characters in costume. Although not commissioned, these were popular with the public and sold well.

Ukiyo-e
Japanese for 'pictures of the floating world'. Style of Japanese woodblock prints and paintings created from the 17th to the 19th centuries, noted for their apparent flatness, bright colours and decorativeness, typically featuring animals, landscapes and theatre scenes.

Underpainting
Usually neutrally coloured thin paint, applied to establish the darkest values before a painting is started. There are several different types of underpainting, including *verdaccio* (green-grey) and *imprimatura* (a transparent stain).

Vanitas
A genre of art, often still life, in which symbolic objects, such as skulls, broken instruments or rotting fruit, imply the transience of life and inevitability of death.

Vasari, Giorgio
Sixteenth-century Italian architect, painter and writer. Most famous for his *Lives of the Artists*, featuring biographies of Italian artists from the 14th to 16th centuries. First published in 1550, the book remains a cornerstone of art history.

Veduta (plural, vedute)
Italian for 'view'. A painting depicting a view of a townscape or landscape that is so accurate that the location is identifiable. Particularly associated with 18th-century Italian artists such as Canaletto.

Wet-in-wet
A painting technique. The application of wet paint to a wet or damp support. The results are soft and often undefined, with blurred edges.

Wet on dry
Similar to scumbling, a technique whereby wet, damp or fairly dry paint is applied over a dry support, which can affect the resulting colour.

Index of artworks

Index

Picture credits

All works are courtesy of the museums, galleries or collections listed in the individual captions.

8–9 The Art Archive / DeA Picture Library / G. Nimatallah 10 The Art Archive / Alamy Stock Photo 11 Cameraphoto Arte Venezia / Bridgeman Images 13 Wikimedia Commons: Emilia Ravenna2 tango7174, Author:Tango7174, URL: https://commons.wikimedia.org/wiki/File:Emilia_Ravenna2_tango7174.jpg, https://creativecommons.org/licenses/by-sa/4.0/ 14 Alinari Archives / Getty Images 19 © Heritage Image Partnership Ltd / Alamy Stock Photo 22–23 Bridgeman Images 26–27 © Heritage Image Partnership Ltd / Alamy Stock Photo 30 bl Leemage / UIG via Getty Images 30–31 Bridgeman Images 37 Mondadori Portfolio / Getty Images 38 bl Bridgeman Images 38–39 Bridgeman Images 41 © Heritage Image Partnership Ltd / Alamy Stock Photo 42 The Art Archive / DeA Picture Library / G. Cigolini 43 DEA / G. DAGLI ORTI / DeAgostini / Getty Images 46–47 Bridgeman Images 50 bl © The Trustees of the British Museum 50–51 Bridgeman Images 53 Hessisches Landesmuseum Darmstadt. Photo Wolfgang Fuhrmannek 54 The Art Archive / Vatican Museums, Vatican City / Mondadori Portfolio / Electa 63 Mondadori Portfolio via Getty Images 64–65 Bridgeman Images 68 The Art Archive / Mondadori Portfolio / Electa 72–73 The Art Archive / Vatican Museum Rome / Mondadori Portfolio / Electa 75 Chesnot / Getty Images 76–77 The Art Archive / Room of the Segnature, Vatican Palace, Vatican Museum, Vatican City / Mondadori Portfolio / Electa 80–81 Bridgeman Images 89 © Peter Barritt / Alamy Stock Photo 96–97 Peter Willi / Bridgeman Images 104 The Art Archive / Mondadori Portfolio / Electa 108–109 © SuperStock / Alamy Stock Photo 110–111 The Art Archive / DeA Picture Library / G. Nimatallah 114–115 Bridgeman Images 117 © Mircea Costina / Alamy Stock Photo 118 akg-images / Rabatti – Domingie 119 Artepics / Alamy Stock Photo 122 © SuperStock / Alamy Stock Photo 126–127 The Art Archive / National Gallery London / John Webb 130–131 Bridgeman Images 134 © ACTIVE MUSEUM / Alamy Stock Photo 138 The Art Archive 146 classicpaintings / Alamy Stock Photo 154–155 © Heritage Image Partnership Ltd / Alamy Stock Photo 160 bl The Art Archive / DeA Picture Library / G. Nimatallah 160–161 The Art Archive / DeA Picture Library 164–165 Photography A Reeve, Scottish National Gallery 167 Fine Art Images / Heritage Images / Getty Images 168 classicpaintings / Alamy Stock Photo 171 The Art Archive / Alamy Stock Photo 175 © Paula Rego (b.1935), purchased with assistance from the Art Fund and the Gulbenkian Foundation 2002. Photograph © Tate, London 2016 176–177 © Wallace Collection, London, UK / Bridgeman Images 180–181 © Heritage Image Partnership Ltd / Alamy Stock Photo 184 bl Cornélie, mère des Gracques de Jean François Pierre Peyron, Toulouse, Musée des Augustins. Photo Daniel Martin 184–185 Photo Travis Fullerton © Virginia Museum of Fine Arts 187 Collection Fries Museum, Leeuwarden, acquired with support of the Vereniging Rembrandt, the Mondriaan Stichting and the Wassenbergh-Clarijs-Fontein Stichting 190 The Art Archive / DeA Picture Library 193 © Lukas - Art in Flanders VZW / Photo Hugo Maertens / Bridgeman Images 202–203 Fine Art Images / Heritage Images / Getty Images 205 Photo © Munch Museum 206–207 Bridgeman Images 210–211 © Heritage Image Partnership Ltd / Alamy Stock Photo 230–231 The Art Archive / Musée d'Orsay Paris / Gianni Dagli Orti 233 Foundation E. G. Bührle Collection, Zurich 237 The Art Archive / Alamy Stock Photo 239 The Art Archive / Courtauld Institute of Art Gallery London / Superstock 242 Gift of Dexter M. Ferry Jr. / Bridgeman Images 246 Bridgeman Images 249 World History Archive / Alamy Stock Photo 250–251 M. Theresa B. Hopkins Fund / Bridgeman Images 258 National Galleries Of Scotland / Getty Images 262 Bridgeman Images 278 classicpaintings / Alamy Stock Photo 281 Peter Willi / Bridgeman Images 282 The Art Archive / DeA Picture Library 289 Photograph © The State Hermitage Museum / Photo by Pavel Demidov 290–291 Bridgeman Images 292 Matisse © Succession H. Matisse / DACS 2016 293 Matisse © Succession H. Matisse / DACS 2016, © Succession H. Matisse / Photo © RMN-Grand Palais (Musée de l'Orangerie) 296 DeAgostini / Getty Images 300–301 Purchased 1980, Photograph © Tate, London 2014 304–305 The Art Archive / Tate Gallery London / Harper Collins Publishers 308 Chagall ® / © ADAGP, Paris and DACS, London 2016, © Odyssey-Images / Alamy Stock Photo 309 Chagall ® / © ADAGP, Paris and DACS, London 2016, Gift of Alfred S. Alschuler, 1946.925, The Art Institute of Chicago 312 © ADAGP, Paris and DACS, London 2016, Granger, NYC. / Alamy Stock Photo 313 © ADAGP, Paris and DACS, London 2016, Artepics / Alamy Stock Photo 316 The Art Archive / DeA Picture Library / G. Cigolini 320 © DACS 2016, Photo © Boltin Picture Library / Bridgeman Images 321 © DACS 2016, De Agostini Picture Library / G. Nimatallah / Bridgeman Images 323 © Art Reserve / Alamy Stock Photo 324 © Peter Horree / Alamy Stock Photo 327 © ADAGP, Paris and DACS, London 2016, presented by Eugène Mollo and the artist 1953. Photograph © Tate, London 2014 328 © Estate of George Grosz, Princeton, N. J. / DACS 2016, © DACS, 2016, purchased with assistance from the Art Fund 1976. Photograph © Tate, London 2014 329 © DACS 2016 332 © ADAGP, Paris and DACS, London 2016. Photo © Christie's Images / Bridgeman Images 333 San Diego Museum of Art, USA / Gift of Anne R. and Amy Putnam / Bridgeman Images 335 © ADAGP, Paris and DACS, London 2016, akg-images 336–337 © Successió Miró / ADAGP, Paris and DACS London 2016. Photo © Boltin Picture Library / Bridgeman Images 340–341 © Heritage Image Partnership Ltd / Alamy Stock Photo 343 Granger, NYC / Alamy Stock Photo 344–345 © Georgia O'Keeffe Museum / DACS 2016, The Collection of the Frederick R. Weisman Art Museum at the University of Minnesota, Minneapolis. Museum purchase: 1937.1. 347 Alfred Stieglitz Collection, 1949.533, The Art Institute of Chicago 348 © ADAGP, Paris and DACS, London 2016. Photo © Christie's Images / Bridgeman Images 349 © ADAGP, Paris and DACS, London 2016, © Peter Horree / Alamy Stock Photo 351 Granger, NYC / Alamy Stock Photo 352–353 Bridgeman Images 355 akg-images / Schütze / Rodemann 356 © ADAGP, Paris and DACS, London 2016, The Art Archive / Private Collection / Gianni Dagli Orti 357 © ADAGP, Paris and DACS, London 2016. Photo The Philadelphia Museum of Art / Art Resource / Scala, Florence 360–361 © Salvador Dalí, Fundació Gala-Salvador Dalí, DACS 2016. Photograph © Tate, London 2014 363 World History Archive / Alamy Stock Photo 364 © Succession Picasso / DACS, London 2016, Bridgeman Images 365 © Imperial War Museums (Art.IWM ART 518) 367 ITAR-TASS / TopFoto 368 ©2016 Mondrian / Holtzman Trust, The Artchives / Alamy Stock Photo 369 Purchased 1982. Photograph © Tate, London 2014 372 © Banco de México Diego Rivera Frida Kahlo Museums Trust, Mexico, D.F. / DACS 2016, © Leemage / Bridgeman Images 373 © Banco de México Diego Rivera Frida Kahlo Museums Trust, Mexico, D.F. / DACS 2016, San Francisco Museum of Modern Art, Albert M. Bender Collection, gift of Albert M. Bender in memory of Caroline Walter; © Banco de Mexico Diego Rivera & Frida Kahlo Museums Trust, Mexico, D.F. / Artists Rights Society (ARS), New York 375 The Art Archive / Gianni Dagli Orti 376–377 © ADAGP, Paris and DACS, London 2016, akg-images 380 © The Pollock-Krasner Foundation ARS, NY and DACS, London 2016, The Metropolitan Museum of Art / Art Resource / Scala, Florence 381 Chronicle / Alamy Stock Photo 384–385 © Helen Frankenthaler Foundation, Inc. / ARS, NY and DACS, London 2016 387 © ARS, NY and DACS, London 2016, © The Estate of Hans Hofmann, purchased 1981. Photograph © Tate, London 2014 388 © The Estate of Francis Bacon. All rights reserved. DACS 2016, Bridgeman Images 392 © 2016 The Andy Warhol Foundation for the Visual Arts, Inc. / Artists Rights Society (ARS), New York and DACS, London. Photograph © Tate, London 2014 395 akg-images 396–397 © Estate of Roy Lichtenstein / DACS 2016, akg-images / Erich Lessing 399 © Peter Horree / Alamy Stock Photo 400–401 Museo Thyssen-Bornemisza / Scala, Florence 403 © FineArt / Alamy Stock Photo 404–405 © The Lucian Freud Archive / Bridgeman Images 405 br © The Lucian Freud Archive / Bridgeman Images 408 © The Easton Foundation / VAGA, New York / DACS, London 2016, © Stefano Politi Markovina / Alamy Stock Photo 409 © ADAGP, Paris and DACS, London 2016, © Peter Horree / Alamy Stock Photo 412–413 © Anselm Kiefer. Photo © White Cube (Charles Duprat) 413 br © Anselm Kiefer. Photo © White Cube (Charles Duprat) 416–417 © Paula Rego, Courtesy Marlborough Fine Art, London 419 World History Archive / Alamy Stock Photo

First published in the United Kingdom in 2016 by
Thames & Hudson Ltd, 181A High Holborn,
London WC1V 7QX

www.thamesandhudson.com

First published in 2016 in the United States of America by
Thames & Hudson Inc., 500 Fifth Avenue,
New York, New York 10110

www.thamesandhudsonusa.com

© 2016 Quintessence Editions Ltd.

This book was designed and produced by
Quintessence Editions Ltd.
The Old Brewery
6 Blundell Street
London N7 9BH

Project Editor	Carol King
Senior Designer	Isabel Eeles
Picture Researcher	Hannah Phillips
Design Concept	gradedesign.com
Production Manager	Anna Pauletti
Editorial Director	Ruth Patrick
Publisher	Philip Cooper

British Library Cataloguing-in-Publication Data
A catalogue record for this book is available from the British Library

Library of Congress Control Number 2016932146

ISBN 978-0-500-23954-4

Printed in China